# FROM BYZANTIUM TO MODERN GREECE

## HELLENIC ART IN ADVERSITY, 1453–1830

# FROM BYZANTIUM TO MODERN GREECE

## HELLENIC ART IN ADVERSITY, 1453–1830

From the Collections of the Benaki Museum, Athens

ALEXANDER S. ONASSIS PUBLIC BENEFIT FOUNDATION (USA)

BENAKI MUSEUM, ATHENS

PUBLISHED BY THE ALEXANDER S. ONASSIS PUBLIC BENEFIT FOUNDATION (USA)
in association with the BENAKI MUSEUM, ATHENS

This catalogue is issued in conjunction with the exhibition
FROM BYZANTIUM TO MODERN GREECE: HELLENIC ART IN ADVERSITY, 1453–1830
held at the Onassis Cultural Center, New York, from December 15, 2005–May 6, 2006

EXHIBITION

*Curator*
Angelos Delivorrias

*Assistant Curator*
Electra Georgoula

*Research Assistants*
Anna Ballian
Anastasia Drandaki
Kate Synodinou
Fani-Maria Tsigakou

*Coordinator in Greece*
Electra Georgoula

*Designer*
Daniel B. Kershaw

*Graphic Designer*
Sophia Geronimus

*Lighting*
Anita Jorgensen

*Installation*
David Latouche

*Conservators in the United States*
George Bisacca
Kathrin Colburn
Jonathan Derow
Leslie Gat
Florica Zaharia

*Conservators in Greece*
Naoum Kokkalas
Vasiliki Nickolopoulou
Anthea Phoca
Demosthenes Pimplis
Flora Stephanou
Olympia Theophanopoulou
Sofia Tossiou
Maria-Achtida Zacharia

CATALOGUE

*Editors*
Angelos Delivorrias
Electra Georgoula

*Essay Authors*
Dimitris Arvanitakis
Spyros I. Asdrachas
Anna Ballian
Angelos Delivorrias
Anastasia Drandaki
Paschalis M. Kitromilides
George Tolias
Fani-Maria Tsigakou

*Catalogue Authors*
Anna Ballian
Nano Chatzidakis
Maria Constantoudaki-Kitromilides
Anastasia Drandaki
Electra Georgoula
Alexandra Goulaki-Voutira
Sophia Handaka
Paschalis M. Kitromilides
Katerina Korre-Zographou
Chryssavgi Koutsikou
Mina Moraitou
Ioanna Papantoniou
Euphrosyne Rizopoulou-Egoumenidou
Kate Synodinou
George Tolias
Valentini Tselika
Fani-Maria Tsigakou
Maria Vassilaki
Nick Vassilatos

*Bibliography*
Maria Sarri

*Translator*
Alexandra Doumas

*Text Editors*
Pamela Barr
Mary Gladue

*Designer*
Sophia Geronimus

*Photographers*
Constantinos Manolis
Costas Manolis
Makis Skiadaressis

ERT

PUBLICITY SPONSOR
www. ert.gr

ISBN 0-9776598-0-1

Printed by Randem Printing, Inc.

Front cover:  Cat. no. 34. *Sailing Ship by the Coast of Hydra*. Mid-19th century. Unknown artist. Oil on canvas. Inv. no. 9043
Back cover:  Cat. no. 24. *Prelatic Pectoral* (front). Late 17th century. From Constantinople. Gold, gilt silver, rubies, emeralds, amethyst, enamel. Gift of Helen Stathatos, inv. no. 7660

# CONTENTS

# CONTRIBUTING AUTHORS

**Dimitris Arvanitakis**, Head of Historical Research Department, Benaki Museum, Athens

**Spyros I. Asdrachas**, Historian, Research Director Emeritus, National Hellenic Research Foundation, Athens

A.B.      **Anna Ballian**, Curator of Islamic Collection, post-Byzantine Metalwork and Textiles, Benaki Museum, Athens

N.C.      **Nano Chatzidakis**, Professor of Byzantine Art and Archaeology, University of Ioannina

M.C.-K.      **Maria Constantoudaki-Kitromilides**, Associate Professor of Byzantine Archaeology, University of Athens

**Angelos Delivorrias**, Director, Benaki Museum, Athens

A.D.      **Anastasia Drandaki**, Curator of Byzantine Collection, Benaki Museum, Athens

E.G.      **Electra Georgoula**, Head of Exhibitions and Publications Department, Benaki Museum, Athens

A.G.-V.      **Alexandra Goulaki-Voutira**, Professor of History of Art, School of Fine Arts, Aristotle University of Thessaloniki

S.H.      **Sophia Handaka**, Social Anthropologist, Department of Neohellenic Culture and Art Collections, Benaki Museum, Athens

P.M.K.      **Paschalis M. Kitromilides**, Professor of Political Science, University of Athens; Director, Institute of Neohellenic Research / National Hellenic Research Foundation, Athens

K.K.-Z.      **Katerina Korre-Zographou**, Professor of Social and Historical Folklore, University of Athens

C.K.      **Chryssavgi Koutsikou**, Archaeologist, Ephorate of Private Archaeological Collections, Hellenic Ministry of Culture, Athens

M.M.      **Mina Moraitou**, Assistant Curator of Islamic Collection, Benaki Museum, Athens

I.P.      **Ioanna Papantoniou**, Costume Specialist, President of Peloponnesian Folklore Foundation, Nafplion

E.R.-E.      **Euphrosyne Rizopoulou-Egoumenidou**, Associate Professor of Folk Art, Department of History and Archaeology, University of Cyprus, Nicosia

K.S.      **Kate Synodinou**, Curator of Neohellenic Culture and Art Collections, Benaki Museum, Athens

G.T.      **George Tolias**, Research Director, Institute of Neohellenic Research / National Hellenic Research Foundation, Athens

V.T.      **Valentini Tselika**, Head of Historical Archives and Manuscripts, Benaki Museum, Athens

F.-M.T.      **Fani-Maria Tsigakou**, Curator of Paintings, Prints and Drawings, Benaki Museum, Athens

M.V.      **Maria Vassilaki**, Associate Professor of Byzantine and post-Byzantine Art, University of Thessaly, Volos

N.V.      **Nick Vassilatos**, Historian, Greek Weapons Specialist, Scientific Advisor to the Academy of Athens

## PREFACE

The history and the genius of a nation are reflected not only in its political and military history but also in its artistic expression and cultural legacy.

This is particularly the case of the Hellenic nation as it sailed through the centuries. From the fall of Byzantium, through the Greek Enlightenment and the War of Independence, to the creation of modern Greece, the Hellenes found myriad ways to deliver to posterity exquisite artwork representing their achievements and aspirations during a particularly difficult period under Ottoman and Venetian rule.

At the same time, Hellenic art deeply influenced the art and culture of other peoples near and far. In particular the art of Balkan countries was deeply indebted to Hellenic art as it evolved through its Byzantine phase and later as the Greeks (or *ρωμιοί* i.e. east Romans as they were named at the time) gained influence in the *Terra Franca* under Ottoman rule. This art is the direct progeny of classical Hellas. This is attested, among others, by a comparison of what remains of ancient Greek figurative art, Hellenistic and Roman mosaics and frescoes, Fayum funerary portraits, early Byzantine secular and non secular art and their direct descendants. A form of art which evolved to a large degree separately from the western world Renaissance but remains vibrant and evocative to this day to the Europeanized eye. Later of course the fight for independence provided European artists with a cause to express their sensitivities in their own pictorial language.

In order to fully appreciate this major cultural and artistic legacy, the splendid collections of Hellenic art of the Benaki Museum are among the best sources of inspiration and knowledge. It is from these collections that the Onassis Foundation presents to the American public a rich array of masterpieces that shed light on a rather unknown but extremely productive and remarkable period of Greek artistic history.

The exhibition "From Byzantium to Modern Greece: Hellenic Art in Adversity, 1453–1830" constitutes another important step in the Foundation's constant endeavor to promote Hellenic civilization in its diachronic and universal sense.

For the realization of this wonderful exhibition, the Onassis Foundation wishes to express its great appreciation to the Benaki Museum; to its President, Mrs. Aimilia Yeroulanou; to its Director and Curator of the exhibition, Professor Angelos Delivorrias; to the Head of its Exhibitions and Publications Department, Ms. Electra Georgoula; and to all the people who worked so diligently in order to organize this major cultural event.

Anthony S. Papadimitriou, Esq.
*President*
*Alexander S. Onassis Public Benefit Foundation*

# PREFACE

The exhibition "From Byzantium to Modern Greece: Hellenic Art in Adversity, 1453–1830," presented by the Benaki Museum, Athens, at New York's Onassis Cultural Center of the Alexander S. Onassis Public Benefit Foundation (USA), is an especially important event that epitomizes the aims of the two collaborating institutions. On the one hand, it bears witness to the Onassis Foundation's success in promoting diverse aspects of Greek culture, thus heightening public interest in Hellenism throughout the United States and contributing to a deeper knowledge of its historical development. On the other hand, it confirms, once again, the Benaki Museum's aspiration and ability to transmit—not only in Greece but also abroad—a message of the achievements of Greek culture, either through the works of art in its collections or through the research and scholarship of its collaborators, which underpin its every exhibition and cultural activity.

With the vision of Angelos Delivorrias and the conviction that the dissemination of Greek culture is the Foundation's principal mission, the Benaki Museum eagerly responds to every invitation for cooperation, whether it comes in the form of efforts by the Greek state to publicize Greece abroad, or from other institutions in Greece—museums, municipalities, or cultural associations—or from foreign museums and international foundations.

Thus, it was only natural to respond with particular delight to the invitation from the Onassis Foundation to prepare this exhibition, which is organized with the aim of shedding light, through the works on view and the catalogue, on an era that is perhaps the least known in the long history of Hellenism, but a deeper understanding of which is an essential precondition for the knowledge of modern Greece.

The concept and the content of the exhibition are the result of the inspiration and scholarship of Angelos Delivorrias and his colleagues. Particular thanks are due to the authors of the catalogue as well as to the team at the museum, which, under the guidance of Electra Georgoula, was responsible for mounting the exhibition and editing the catalogue.

I address my warmest thanks to the President of the Onassis Foundation, Anthony Papadimitriou, and its board for taking this initiative; to the Executive Director of the Onassis Foundation in the United States, Ambassador Loucas Tsilas; and to the Director of Cultural Affairs, Amalia Cosmetatou, for our productive collaboration. The long friendship between the Benaki Museum and the Onassis Foundation, and our many previous collaborations, guarantee the success of this event as well.

Aimilia Yeroulanou
*President*
*Benaki Museum, Athens*

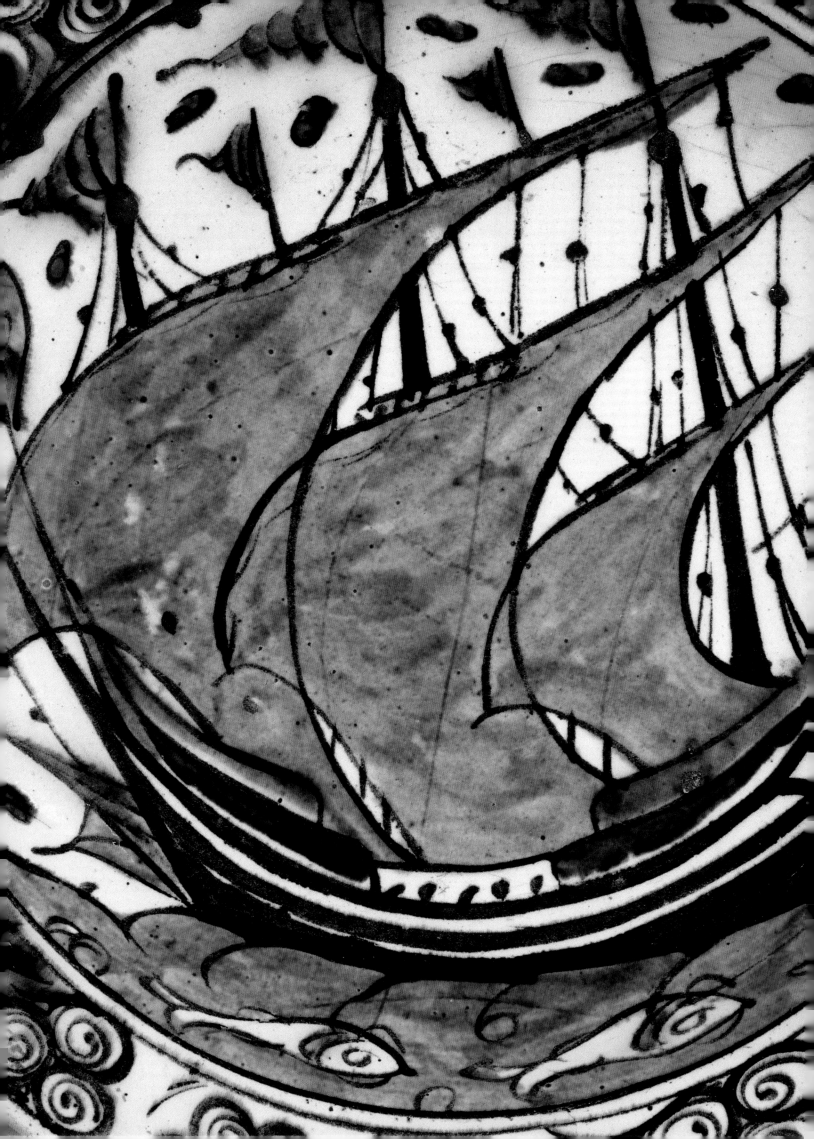

Angelos Delivorrias

Organizing an exhibition with demanding specifications is no easy task. This is particularly true when the exhibition aims to encompass a broad spectrum of historical and social, intellectual and artistic parameters while its material is constrained by the limited amount of information that can be transmitted by an equally limited selection of representative exhibits. Mainly, however, it is true when there is both a desire to "narrate" as much as possible as tersely as possible and, simultaneously, an awareness that the exhibition's success depends directly on how effectively it transmits a clear message to an audience that is not necessarily prepared to receive it. Given these preconditions, the exhibition "From Byzantium to Modern Greece: Hellenic Art in Adversity, 1453–1830" would have been an impossible venture without the repeated modifications of its concept, the successive reassessments of its thematic units and of the objects chosen to "illustrate" them, and the continual restructuring of its components— that is, without the time-consuming and laborious processes that only the vital support of the Onassis Foundation could help us to overcome, together, of course, with the fervent hope that the judgment of the public of New York would vindicate the final result.

There is no doubt that visitors to the exhibition will comprehend its content more easily if they decide to divide their attention equally between the aesthetic stimuli that the objects spontaneously arouse and the information transmitted through their explanatory reviews. In other words, if they give equal weight to the attraction they feel automatically upon seeing the objects on display and the mental challenge to uncover the messages distilled in the data of the relevant catalogue entries. Those visitors who have the patience to peruse the introductory texts to the individual sections, which coordinate the corresponding exhibition material, will understand even more. Only thus will they form a well-rounded picture of the historical framework, the social and economic conditions, and the intellectual and artistic needs that not only led to the production of the objects but also imposed the peculiarity of their forms. Thus, finally, visitors will be led smoothly from the inevitable partiality of the sampling logic that underlies the selection of the exhibits to the generative causes of a cultural production that, though little known and essentially undervalued, is nonetheless remarkably interesting and fascinating.

The period between the demise of the Byzantine Empire, with the fall of Constantinople to the Ottomans in 1453 and the outbreak of the Greek War of Independence in 1821, spans four centuries, a long time that was anything but favorable for the survival—much less the flowering—of culture. Byzantium, having gradually lost its control of the sea and its naval supremacy, had begun shedding its leaves as early as 1204, when the catalytic events of the Fourth Crusade led to the fragmentation of its territories. However, the carving up of a single geographical space into numerous feudatories triggered a series of intellectual and other internal mobilizations, which ultimately proved beneficial for shaping the self-awareness of modern Hellenism—and this despite the heavy losses in manpower, exacerbated by the incessant hostilities between Ottomans and Venetians, the migrations to the West, and the Greeks' constant efforts to cast off the yoke of bondage after the Ottoman Empire finally prevailed. Never-

Cat. no. 76. *Plate* (detail). Early 17th century. Iznik workshop, Asia Minor. Fritware.
Gift of Emmanuel Benakis, inv. no. 34

theless, within these adverse circumstances the unity of the Greek world was hammered out, with the cohesive elements of the resilience of an ancient and beautiful language and the unifying power of the Orthodox Church. It is to precisely these two factors, the Greek language and the Church, that the most important bequests of Greek creativity in those years are due.

I refer, of course, to the great poetic value of the anonymous folk songs and of the eponymous literature of the so-called Cretan Renaissance, not so much because these had impressed the European intelligentsia by the first quarter of the nineteenth century but because they have continued to interest international scholarship ever since. The same is true of ecclesiastical art—in particular of painting—from which the phenomenon of Domenikos Theotokopoulos (El Greco) emerged. In this case, however, the awakening of scholarly interest was late in compiling the established discipline in which the theoretical approaches of many research centers and many researchers today cross paths. These two sectors of seminal significance are the warp and the weft of the expressive canvas of a cultural reality marked by the persistent cleaving to the traditional forms of the Byzantine and even earlier Greek past, as well as the adoption of many of the European achievements, whether these be post-Renaissance directives of Italy or contemporary attainments of the Low Countries.

Less well studied and even less well known is the secular art of the period, to which the present exhibition is mostly dedicated in the hope that it will stimulate scholarly interest in this field, if not on a par with that shown in the art of Hellenic antiquity or the Byzantine Age, at least commensurate with the importance of its special physiognomy. The secular art of Hellenism under foreign rule, as a counterpoint to the dire circumstances of everyday reality in those years, lauds the joy of life with an unprecedented riot of color, with marital symbolism and its attendant wish for fertility, and with the discreetly denoted erotic disposition of its thematic repertoire. Indeed, because its semantics seem to emit a hymn to women in what was a patriarchal society, we could say that it reflects the structures of a very deeply rooted democratic conviction. As for the difficulties that the conceptual definition of its artistic products presents—that is, the essentially untenable gradations according to their "folk" or "bourgeois" formations—it should be stressed that any distinct differences concern quantitative, rather than qualitative, components. Whatever the case, elements from the imperial majesty of Byzantine tradition, the elegance of Western fashion, and the decorative grace of Oriental Ottoman sensitivity participated and were assimilated equally in forming the aesthetic idiom.

The considerable intellectual output from the late seventeenth to the early nineteenth century was imbued with the messages of the French Revolution and the ideas of the Enlightenment and widened horizons by crystallizing the demand for independence and animating revolutionary zeal. Decisive for the acceptance and the transmission of the revitalizing spirit was the mediatory role of a large number of economically flourishing Greek enclaves in major European cities of radiating importance. From Saint Petersburg to London, the communities of expatriate Greeks rapidly developed into nodal hearths of international trade that, by reviving centuries-old migrant mores, kept alive the memory of, and the direct contact with, their places of origin. Apart from their undisputed contribution to the spectacular growth of the Greek economy, it was through these diaspora channels that groundbreaking knowledge, revolutionary ideals,

and hope-filled prospects were disseminated alongside material goods. So, apart from the renewal of the intellectual armory, a tradition of benefaction was shaped as well, the fruits of which were enjoyed by the Greeks in their Ottoman-held homeland, where schools were founded and charitable foundations were established, teachers were paid and studies were funded in the leading educational institutions of the time, publishing was encouraged and the circulation of books was facilitated.

It goes without saying that among the basic coordinates of the "renaissance" tendencies are several other factors. In addition to religious tolerance, the relative forbearance of the Ottoman administration should be noted, which favored community organization for reasons connected with the collecting tactic of the taxation system. Nonetheless, the Greeks' survival was secured by the Doric frugality of their way of life, the yields from intensive cultivation of the land more than covering their subsistence needs. The remains of a truly indomitable effort to till the soil are visible to this day in many places, not least the barren islands of the archipelago. The auxiliary role—always on a domestic minor scale—of the pastoral economy and of a rudimentary cottage industry that satisfied the basic needs for products of metalworking, pottery, and carpentry should also be noted as underpinning this thrifty self-sufficiency.

This highly schematic picture is completed by the terms of the Russian-Turkish treaties that fostered the burgeoning of mercantile shipping in the Aegean Islands and coasts, together with the conditions that emerged thanks to the rediscovery of Greece by foreign travelers. Within the more general clime of Romanticism, the pull of the heritage of Hellenic antiquity, by promoting as ideals the reconnecting of intellectual sensibility with the sources of a heroic past, not only forged the principles of European consciousness but also nurtured the strong current of philhellenism. Indeed, during the post-Napoleonic period of the stringent conservatism of the Holy Alliance, the primarily moral support of the philhellenic movement was invaluable for the denouement of the Greek drama.

All these factors together, as well as many others that either have not been investigated thoroughly or do not require more analytical mention, led inevitably to the epic of the struggle for independence—to a violent conflict that soaked the Greek world with blood, reminding international public opinion that in this same land, in the past, human dignity had been pitched in battle against barbarity and had been prepared to pay the heavy price of freedom against the prospect of subjugation. The Greek struggle for independence, henceforth inscribed in the annals of history, was sung by Pushkin and Goethe, Schiller and Foscolo, Chateaubriand and Hugo, Shelley and Byron. It continues to teach us that a handful of men with soul and faith can set themselves against the superior military forces and the concentrated power of the established order.

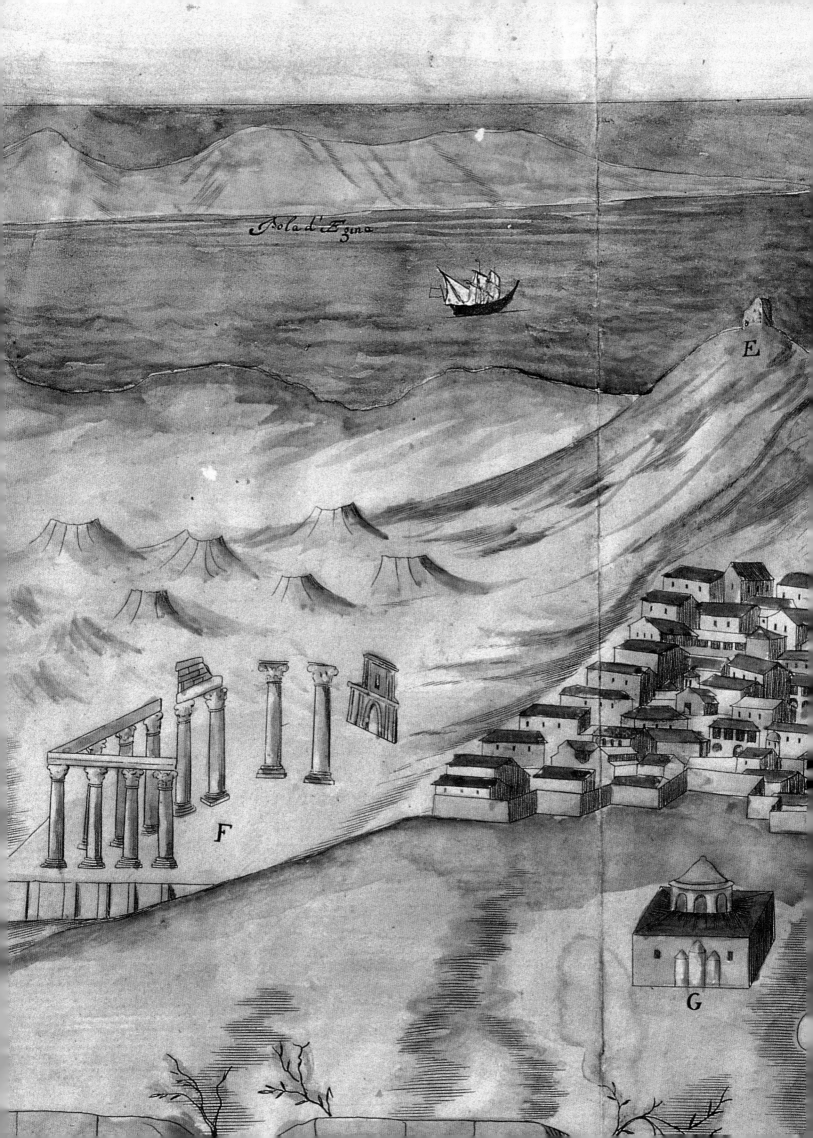

Isola d'Egina

E

F

G

# FROM CONSTANTINOPLE TO ATHENS:
## THE VAGARIES OF GREEK GEOGRAPHY AND THE HELLENIC WORLD, 1453–1830

Dimitris Arvanitakis

*Because now we, whom you lead and reign over,*
*are Greeks by race, as both our language and our ancestral culture attest.*
—Georgios Gemistos to Manuel II Palaiologos, 1418

*Today the Greek nation declares through its legal representatives in a national assembly,*
*before God and men, its political existence and independence.*
—Constitution of Epidaurus, 1821

The above quotes are to some extent illustrative of the course of events in the Greek world from shortly before the breakup of the Byzantine Empire in 1453 until the outbreak of the War of Independence in spring 1821. However, the concept of "Greek," as used, on the one hand, by the philosopher Gemistos (Plethon) and, on the other, by the Greek revolutionaries, has to be understood in its manifold meanings in order to give it its historical due. To avoid giving history a teleological character, we need to ask ourselves what gives this concept its meaning in each case, how it has fared in between, and what the term meant in the minds of those who used it along the way. With regard to inconsistencies and changes in perception, it may be useful to mention two examples, each relating, respectively, to one of the key historical moments mentioned above.

In the first example, shortly after the fall of Constantinople to Mehmet II, the Patriarch Gennadios was going to burn the works of Plethon, being completely unsympathetic toward his political theories and, above all, to the connection with ancient, pagan Greece. Gennadios declared that, though he spoke Greek, he did not consider himself to be a "Greek," because he differed from them in his way of looking at things. Were he to be asked what he was, he said he would reply: "A Christian."

In the second example, a few decades after the voting on the first Greek constitution, when a Greek state was already in existence, the German historian Jakob Fallmerayer was to doubt even the existence of Greeks on the Greek mainland in the nineteenth century. This theory was, however, effectively refuted by Greek historiography as well as by the disciplines of folklore studies and linguistics. The issue of the relationship between the ancient and the modern Greeks was a pressing one but took on a different cast as the Greek War of Independence showed the indisputable existence of the Greek nation.

These two moments are indicative of the complex and contradictory course that led to the forging of a Greek national consciousness, which emerged both from the historical experience and discourse of the Greeks themselves and from the perceptions of outsiders. Therefore, any narration of the fortunes of the Greek world is bound to be, whether consciously or not, simultaneously an investigation into the checkered career of the term "Greek": what did it mean in the writings of Plethon and what meaning did it take on in spring 1821?

Cat. no. 6. *The Bombardment of the Parthenon by Venetian Artillery* (detail). 1687. Giacomo Milheau Verneda. Watercolor on paper. Inv. no. 23149

## From Constantinople to Tinos, 1453–1715

After the fall of Constantinople in 1453, the conquest of Greek territory by the Ottomans continued apace, though remained incomplete until 1715 and the taking of Venetian-held Tinos. The indifference, or certainly the dilatoriness, of the western powers permitted Mehmet to continue his conquests unimpeded: in 1458–59 he captured the islands of the north Aegean (Thasos, Samothrace, Imbros, Lemnos) and the duchy of Athens; in 1460 he dissolved the despotate of the Morea in the Peloponnese; in 1461 he took the empire of Trebizond and in 1462 the island of Lesbos. Almost all the remainder of the fifteenth century was taken up by the belated and clumsy reaction of the Venetians, who were now anxiously eyeing the new overlords threatening their maritime bases in Greek territory. The two Venetian-Turkish wars (1463–79 and 1499–1503) gave the advantage for the most part to the Ottomans, since after 1500 the Venetian presence in the southern Greek mainland was reduced to Nafplion and Monemvasia. The larger islands in the Ionian, however, came under Venetian control. In addition to Corfu, which had been Venetian since 1386, Zakynthos (Zante) was taken in 1484 and Cephalonia and Ithaka in 1500, though Lefkada (Santa Maura) did not become Venetian until 1684.

The sixteenth century, and especially the reigns of the two great sultans Suleiman the Magnificent (1520–1566) and Selim II (1566–1574), saw the Ottomans make rapid advances. The first major milestone was the capture of Rhodes (1522), while the unsuccessful siege of Venetian Corfu by Haireddin Barbarossa (1537) signaled the start of a period of intense aggression that ended with the conquest of Chios and the Cyclades (1566). In the course of these operations, Venice lost all her possessions in the Peloponnese, and her eastern frontiers were now defined by an imaginary line drawn between Cyprus, which was ceded to the Venetians by the Lusignan dynasty in 1489, and Crete, Kythera, the Ionian Islands (except for Lefkada), Parga, and Butrint.

In the later sixteenth century Ottoman aggression broke out again in an attack on Cyprus (1570–71). However, the capture of this strategically and commercially crucial island led to the awakening of the western powers. Pope Pius V, Venice, and Spain formed a coalition against the Ottoman Empire, the Sacra Liga (Holy League). Thus on October 7, 1571, the Greek seas witnessed "the most glorious event that has ever been seen or will be," as Miguel Cervantes, an eyewitness, noted. This was the battle of Lepanto, known in contemporary sources as the *battaglia di Curzolari*, in which the Ottoman fleet was soundly defeated. In the opinion of Fernand Braudel, it marked "the end of a real inferiority complex for Christendom," because thereafter the West actually realized that the sultan's forces were not invincible. However, even though hostilities continued the following year and even though there were insurrections by Greeks in mainland Greece and Crete, the Sacra Liga was disbanded, and the treaty of 1573, between the Ottoman Sublime Porte and the Serenissima Republic of Venice, formalized Ottoman sovereignty over Cyprus.

The next act in the scenario of conflict was played out in Crete. The clash between Ottomans and Venetians assumed the form of a pan-European war, as many European powers rallied to the Venetian cause between 1645 (with the occupation of Chania in August of that year) and September 1669 (the surrender of Candia).

The victorious outcome of the Porte's campaign in Crete was not destined to be repeated, when it tried to capture Vienna a few years later (1683). Encouraged by this Ottoman defeat, a feeble Venice was convinced that it could avenge the loss of the Regno di Candia by reconquering its lost holdings in the eastern Mediterranean. It reconstituted the Sacra Liga (together with Germany and Poland and with the acquiescence of the pope) and the Greek peninsula was caught up in another war (see cat. no. 5). Generalissimo Francesco Morosini (nicknamed Peloponnesiaco) led a checkered campaign (1684–99) that brought few long-term benefits to the Serenissima: the doge's only gain was control of Lefkada (captured on

August 6, 1684). In two years (1685–87) the Peloponnese came under Venetian control, and Morosini's forces then attempted to expand their operations. On September 22, 1687, the Venetian fleet sailed into Piraeus. The Ottomans barricaded themselves on the Acropolis of Athens, demolished the temple of Athena Nike, and installed a gun emplacement. They were bombarded by the Venetians encamped on Philopappus Hill and the Pnyx. On September 26, 1687, a date known to few but a day of irredeemable and unforgettable devastation, a Venetian cannonball smashed through the roof of the Parthenon, which the besieged Turks were using as a gunpowder store (see cat. no. 6). Even though Athens surrendered on September 29, the Venetians quickly realized that they were not in a position to hold the city, exposed as it was to attack by the Turks. They abandoned Athens in April of the following year, taking with them some of the ruins of the Nike temple and the lion that adorned the entrance to the harbor of Piraeus (Porto Leone), which still graces the Venetian Arsenale. Although hostilities continued in central and western mainland Greece, with Greeks fighting alongside Venetians, when the Treaty of Carlowitz was signed in 1699 the Venetians took control of Lefkada, Aegina, and the Peloponnese, which they named Regno di Morea, perhaps to soften the blow of the recent loss of the Regno di Candia.

Venice promptly took measures to settle people in the depopulated Peloponnese, to organize it administratively and ecclesiastically, but its plans came to nothing. This venture was the final flickering of Venetian presence in the Levant. After the Treaty of Carlowitz, the Serenissima entered a period of stagnation, which in political terms means decline. This moment was singularly significant for Greece, because in the later seventeenth century the Greeks, disappointed by the Venetians and the Spanish, were to abandon old illusions and turn to new ones: in the same period, the policy of Peter the Great of Russia (1689–1725), and, in particular, his aggressive stance vis-à-vis the Ottoman Empire, reawakened old hopes about the role of the "blond race" (a myth circulating as early as the sixteenth century), which, in the consciousness of Greek Orthodox Christians, increasingly became identified with Orthodox Russia.

Peter's ambition—in contrast to the traditional Russian policy—was to find outlets to the Mediterranean, since the dynamic czar was intent on making Russia a European power. His turning toward the Black Sea, the Bosphoros, and, ultimately, the Aegean Sea, may have been tied up with the ideology of Russia's Byzantine heritage, but there were also obvious economic reasons for doing so. After his victory over Sweden (Battle of Poltava, 1709), Peter strengthened his relations with the Balkan peoples by declaring, for the first time, that Russia would not just stand by in the face of the sufferings of the Greeks, the Romanians, the Serbs, and the Bulgarians under the sultan's yoke. This stance was the basis of an important aspect of Russian policy, at least until the liberation of Greece. In this expectant climate, the czar turned on the Ottoman Empire and declared war. The war (1710–11) did not end happily for Russia (she lost Azov and saw the Black Sea closed to her), but the defeat was only a temporary setback to her plans and the Greeks' expectations. For many Greeks, Russia was now the "common mother of Orthodox Christians and sole hope and refuge of our unhappy nation in these times," as Ioannis Prinkos wrote in 1753. Fellow Russian feeling for the Balkans and especially for the Greek areas grew steadily more powerful and the future liberator of the Greeks began to look more and more like Russia.

For the time being, however, the sultan was able to turn his attention to his old adversary, Venice, which still had not come to terms with the gains it had made in 1699. In 1715, suddenly and with relative ease, he took back Aegina, Tinos, and the Peloponnese from the Venetians. The Treaty of Passarowitz (1718) meant the imposition of Ottoman rule throughout virtually all Greek lands; only the Ionian Islands and a few areas on the western Greek coastline were now exempt from the sultan's control.

## From Prince Alexis Orloff to Prince Alexandros Ypsilantis, 1770–1821

The late eighteenth century (possibly 1792) saw the publication—probably by Rhigas Velestinlis—of the *Oracles* of Agathangelos, penned by Archimandrite Theoklitos Polyeidis. This widely read text fired the Greeks' hopes of imminent liberation. These hopes were intensified after the accession to the Russian throne of Catherine II, wife of Peter III, later known as Catherine the Great. The new empress, wishing to emulate Peter the Great, not only declared war on the sultan (1768) but also, from as early as 1763, established contact with the Greeks through agents in the Balkans, Greek territory, Trieste, and Venice. Her plan included fomenting rebellion in Greek regions in order to cause diversions, while one of her military aims (mainly devised at the end of the century) was to drive the Ottoman Empire out of Europe and set up a "Grecian Empire," with Constantinople as its capital and a Russian prince as ruler; indeed, she had named one of her grandsons Constantine and had engaged Greek scholars among his tutors.

Despite all the preparation, the planned general uprising did not succeed. Essentially, only the Peloponnese rebelled, thanks to the support of many leading citizens, whereas the revolts in Roumeli (central Greece) and Crete were aborted. Even in the Peloponnese, the uprising did not last long: despite the contribution made by many locals and Ionian islanders and the presence of Alexis and Fyodor Orloff, the uprising of February 1770 had been suppressed by late June. The Russians' sole significant success was the scuttling of the Turkish fleet at Çesme (July 5, 1770), which gave them control of a large number of Aegean islands until 1774.

For the Greeks, the Treaty of Kutchuk Kainardji (1774) was a crucial step in their progress toward developing trade, a national consciousness, and reorientation. Its importance for Russia lay above all in ensuring it the right to intervene on behalf of the Christian populations of the Ottoman Empire and the concession of certain privileges for its fleet: ships under the Russian flag could now sail freely through the Straits of the Dardanelles.

In 1787 the Sublime Porte declared war on Russia, demanding the return of the Crimea, which had in the meantime been captured by the Russians. Russia again adopted the tactic of smoke-screen rebellions by the Greeks, in which the leading role this time was played by Lambros Katsonis, but without conspicuous success; in fact, Russia repudiated his continuing activity after the treaty of 1792.

The year 1792 also saw the Battle of Valmy. The political geography of Europe was changing, as the ancien régime gave way before the onslaught of the French Revolution. In Greek territory as well, the rules of the game were changing: in 1797 Napoleon's army dissolved the Venetian Republic and on June 19 General Gentili announced a new regime in the Ionian Islands, a change confirmed by the Treaty of Campoformio (October 17, 1797), whereby the islands were ceded to France.

Many years later, Theodoros Kolokotronis was to say: "The war-god Napoleon opened our eyes." The presence of French revolutionaries in the Ionian Islands, which had raised the hopes of many—including Rhigas Velestinlis and Adamantios Korais—was short-lived. They managed nevertheless in this brief time to chip away at the centuries-old system of rule by the "nobility" (*cittadini*) in the islands, as the fundamental revolutionary principles and, above all, a sense of ethnicity gained ground. The phobic behavior and the convulsive tremors experienced by the political system in Europe appeared in Greek territory, too. The allied Russo-Turkish fleet gradually occupied the Ionian Islands (starting with Kythera on September 22, 1798, and terminating with the capture of Corfu on February 25, 1799), ending the rule of the French revolutionaries. Not long before, Patriarch Gregorios V, in an encyclical that was circulated widely in the islands, had called upon the Ionians to expel the "atheist French."

The French forces were unable to resist, since they also had to face discontent among large portions of the population. The success of the Russians and the Turks produced the first state formed in Greek territory: the "Septinsular Republic" (Repubblica Settinsulare). On March 21, 1800, an act was signed in Constantinople giving it official recognition and the newborn republic was put on the same footing as the regime of Ragusa, under the suzerainty and protection of the Sublime Porte. Despite its aristocratic character and problematic nature, many Greeks placed their hopes in this newly created state: Adamantios Korais dedicated his translation of Cesare Beccaria's *Dei delitti e delle pene* (On Crimes and Punishments) to the "newly founded republic" and Eugenios Voulgaris also dedicated some of his books to it.

However, the rapid pace of developments was to lead to the breakup of the Septinsular Republic. The Treaty of Tilsit (July 7, 1807) brought the French (now no longer revolutionaries) back to the Ionian Islands, which became a province of France. After the fall of Napoleon, it was decided at the Paris Conference (November 5, 1815) that "the islands and their dependencies would constitute an independent state, under the direct and exclusive protection of His Majesty the King of Great Britain."

Thus the Ionian Islands began to experience life under a protectorate, which was to end in 1864 (with the union with Greece). For the rest of Greek territory, the early nineteenth century saw developments accelerate. The insurrectionist experience and the mass appeal of the uprisings, especially in the eighteenth century; the radicalization of ideology, mainly after the French Revolution; the growing power of merchants after 1774 and particularly during the Napoleonic Wars; and the activity of progressive men of letters both inside and outside Greek territory were some of the factors that contributed to producing the conditions necessary for a heightened awareness of the need for revolution and for more systematic preparation for it. The Greeks began to organize on the model of the secret societies of Europe: the example of Rhigas Velestinlis, despite its tragic outcome in 1798, was imitated by the most important Greek secret association, the Philiki Etaireia (Friendly Society), which was founded in Odessa in 1814. This organization, which in the seven years leading up to 1821 initiated Greeks of various classes, beliefs, aims, and mentalities into its membership, had the honor of preparing the national struggle. Despite internal disputes and problems, the head of the Philiki Etaireia, Prince Alexander Ypsilantis, aide-de-camp to Czar Alexander, declared the outbreak of the Greek War of Independence at Jassy (Iaşi) on February 24, 1821. Two aspects of earlier Greek thinking can be seen in this move: on the one hand, a harking back to Rhiga's thoughts about a pan-Balkan liberation and, on the other, the linking of Greek liberation with Russian policy. These ideas and others were to be put to the test in the future, but the Greek struggle for independence was now a reality.

## Men, Institutions, and Ideas: From the Fifteenth to the Eighteenth Century

Under the Ottoman Turks, the Orthodox community had been granted certain well-known privileges (inviolability, exemption from taxation, and incontestability of the patriarch and his successors; maintenance of the administrative and judicial jurisdiction of the patriarch). The jurisdiction of the patriarchate of Constantinople extended to the churches of Asia Minor, the Aegean and the Ionian Islands, the Balkan Peninsula, Wallachia, Moldavia, and Russia. The patriarch was the ethnarch (*millet-baçi*), the political and ecclesiastical head of the Orthodox subjects (*reyas*), thus acquiring not only ecclesiastical but also politico-juridical authority over the Christians. By appointing as patriarch (on January 6, 1454) Gennadios, who had opposed the unification of the churches, Sultan Mehmet satisfied the anti-papal faction and consequently impeded any agreement between the patriarchate and the Catholic Church in the West.

The Orthodox Church, thanks to its privileges, not only became the sole institution to function without interruption in Greek territory until the liberation but also the sole instrument for saving and perpetuating the memory of a Christian empire. This notion was of enormous importance, because the church, which underwrote all forms of elementary and higher education well into the seventeenth century, helped to create with unprecedented intensity a definite link in the minds of Greeks between Christianity (Orthodoxy) and the sense of identity and historical continuity. It was in this climate that Patriarch Gennadios wrote: "That is why, if at some time our cowed race is to see the sun shining more kindly over it, it is up to us priests and monks to create a new dawn of spiritual health." The Orthodox Church thus also took on a secular, political role, since it envisioned and shouldered the responsibility for the "reconstitution of a Hellenized Christian Empire" or, at least, of a "Hellenized Christian state." This explains why, in the early centuries of the Ottoman conquest, the church participated in, and even encouraged, rebel movements in Greek territory, hand-in-hand with descendants of imperial Byzantine families and even with Western leaders (such as Charles VIII of France) who laid claim to the throne of Constantinople. These movements culminated in the uprisings of the late sixteenth century. In 1597–98 Dionysios, metropolitan of Tirnovo (Bulgaria), descendant of the Byzantine Rallis and Palaiologos families and kinsman of the Kantakouzenos family, led an unsuccessful revolt for the liberation of the Balkans, following agreements with the patriarch of Constantinople and the prince of Wallachia, Michael the Brave. The rebellions led by Dionysios, metropolitan of Trikke (Trikala), nicknamed the Philosopher, or Skylosophos, in Thessaly (1600) and Ioannina (1611), in league with the Spanish, took a similar form. In the same period the Maniots rose up without success, following deals with Bishop Athanasios of Ochrid, the duke of Nevers, and King Philip III of Spain.

In order to understand the process of opinion forming in Greek territory, it should be pointed out that even though the church locked the Greeks into an exclusive identification with Orthodoxy in the early centuries, it made an essential contribution to preserving historical memory and continuity, language, and a certain cohesion of populations (through faith), even if this led to some confusion and even contradictions. On the other hand, this dynamic compounded the introspection of the Greek world, since now the church and a large part of Greek literary output were drawing on apologetics, texts inveighing against Islam and Catholicism, while at the same time condemning any contact with the ancient Greek world. Thus a movement that had begun in the closing centuries of Byzantium was checked and the Greeks were cut off from developments in Europe, which had significant consequences for the way in which they understood their own identity and subsequently shaped their national identity.

The position of the Orthodox Church and the patriarchate deteriorated when the crisis erupted in Europe between Rome and churches that followed the various aspects of the Reformation. Tension reached its peak after the Council of Trent (which ended in 1563), when Catholicism, with the Jesuits (Compagnia di Gesù) and the Capuchins in the vanguard, attempted a "turn toward the East," inspired by none other than Cardinal Bellarmino, the prelate who had condemned Giordano Bruno and Galileo Galilei. Papal propaganda sought to influence the Orthodox world through proselytism and by imposing the terms of the Synod of Ferrara-Florence (1438–39). At the same time, and for obvious reasons, it tried to cut short a dialogue that the Protestants (mainly the Tübingen theologians) had initiated with Constantinople, especially during the patriarchates of Ioasaph II (1556–65), Jeremiah II (1572–95), and Kyrillos Loukaris (who held office intermittently between 1601 and 1638). It is perhaps not insignificant that several of these patriarchs' names are linked with innovative efforts in the sector of education from as early as the late sixteenth and early seventeenth centuries.

The defensive stance of the church led to entrenchment and polemic against anything that overstepped the bounds of, or opposed, Orthodox thinking. This attitude did not, however, apply in Greek areas outside Ottoman domination, particularly in Crete and the Ionian Islands. There, the church did not take on a political role, since Venice was most circumspect in balancing the claims of the Orthodox and the Catholic churches. In the areas under Venetian rule, self-government was entrusted to the "community councils," which were made up of the so-called nobles (*cittadini*) and represented (theoretically at least) the population as a whole. Such Orthodox bishops, wherever they remained, had limited powers and their activity was monitored by the Venetian administration. This political philosophy of the Venetians created a far more "secular" mindset among Orthodox Christians, which was made all the easier by the potential for dialogue between rulers and subjects since the closeness between the two dogmas did not lead to the sort of separation experienced by Christians and Muslims on the Greek mainland. Such channels of communication encouraged osmosis, as indicated, from as early as the second half of the sixteenth century, by the flowering of a local literary output in Crete resulting from contacts with European culture. This interaction was cut short in 1669 but had already managed to imprint its achievements on literature, historiography, theater, and religious painting. Vincenzo Cornaro, author of *Erotokritos*, Michael Damaskenos, and Domenikos Theotokopoulos (El Greco) are the best-known names, but they are only a few of the many who enhanced the new reality in the Venetian-held territories—that is, the possibility of finding other ways of forming a Greek identity.

Men of letters who were active in the West shared the same ideal of disengagement from the prevailing religious thinking. This group includes not only the first Byzantine scholars (Demetrios Chalkokondylis, Ioannis Argyropoulos, Andronikos Kallistos, Manuel Chrysoloras, Iannos Laskaris, and so on), catalysts in generating the renaissance movement, but also others, who studied later in the West and adopted different ways of thinking, sometimes even espousing Catholicism (for example, Bessarion and Leon Alattios et al.). The following example is indicative: the case of the Cretan scholar Markos Mousouros (1470–1517), who was a colleague of Aldo Manutius and a teacher of Erasmus at the University of Padua. Previously, in Florence, Mousouros had been part of the circle of Marsilio Ficino, and at Manutius' printing press he published the first *Complete Works of Plato* (1513). It was to Mousouros and Battista Egnazzio that the Venetian Senate entrusted, in May 1515, the eight hundred manuscripts from the library of Cardinal Bessarion (d. 1472), which were to constitute the nucleus of the Biblioteca Marciana.

It was in Italy from as early as the sixteenth century that the first important centers of Greek education appeared. The creation of the Collegio Greco (1576) in Rome, by Pope Gregory XIII, certainly should be considered among the—in any case, self-confessed—aims of the papacy after the Council of Trent. Its purpose was to train spiritual cadres who would be sent to Greek areas in order to raise the level of spirituality among their compatriots. The most famous graduate of the college was Leon Allatios (1588–1669).

The Greek community of Venice (officially organized in 1498) was the basic reception center for Greeks. It was the most important expatriate community until the eighteenth century (numbering some 15,000 Greeks in 1585). It was an important trading center and significant educational foundations were established there or in Padua that provided Greeks with almost their only means of access to education in over three hundred years. In Padua there was the Collegio Cottuniano, founded in 1563 by Ioannis Cottounios, as well as the colleges of Ioannis Kokkos (1565) and of Ioannis Palaiokapas (1590). In 1665 the Collegio Flanginiano was founded in Venice with a bequest from the Corfiot Thomas Flangines (1579–1648); it was housed in a building designed by Venetian architect Baldassare Longhena, next to the preexisting "Greek School of Venice." In addition to the contribution made by these

foundations, the University of Padua, under the exclusive control of Venice and far from papal authority, was, until the eighteenth century, the alma mater of the Greek world. It took in hundreds of Greeks, not only from the territories under Venetian rule, and helped to create the men who subsequently—mainly, of course, through the church—brought their knowledge back to Greek territory.

In the areas under Ottoman domination, the leadership groups of the Greeks gradually began to coalesce, mainly from the seventeenth century onward, shaping a somewhat "mixed consciousness" as, on the one hand, they acted within the infrastructure (mainly administrative and economic) of the Ottoman state while, on the other, they saw themselves as leaders of the subjugated Orthodox world. These groups were the patriarchate, the heads of the communities, and the Phanariots. Alongside these groups, two others gradually emerged, though they did not yet aspire to leadership roles—the *klefts* (bandits) and the *armatoloi* (Turkish: *martolos*). Even though the *armatoloi* were instituted as a kind of guard to impose order in regions that were threatened mainly by the activities of the *klefts,* the two groups were not mutually exclusive and their members frequently exchanged roles. Nonetheless, their activity, especially in later centuries, created a strong mentality of rebellion, the importance of which became apparent in the late eighteenth century and, of course, at the time of the War of Independence.

The population of Ottoman-occupied Greek areas (villages, towns, cities) was organized in communities. The heads of the communities, working together with the officials of the Ottoman administration, decided on the distribution of taxes and the mediation of local issues, while in collaboration with the ecclesiastical authorities they also exercised the functions of magistrates, interposing themselves between the Ottoman authorities and their Greek subjects. The possibilities provided by the system of taxable farming as well as by the manner of electing local leaders led to the creation of a special Greek administrative hierarchy (*prokritoi, proestoi,* archons, and so forth) that slowly but surely managed to control the communities to a considerable degree.

The Phanariots, made up of descendants of the old Byzantine aristocracy and powerful merchants, succeeded not only in playing a part in the management of the affairs of the patriarchate but also in getting themselves appointed to highly important offices in the Ottoman administration (dragomans of the fleet, dragomans of the Porte, and so on). At the time of the Cretan war, the office of Grand Dragoman (or interpreter) to the Sublime Porte was held by the Phanariot Panayotis Nikousis (1613–1673), the first in a long line of Phanariots to hold the post. From 1709 until the War of Independence, the same group monopolized the office of Prince of the Danubian Principalities (Wallachia and Moldavia). The Phanariots, or at least some members of this group, were admirers of "enlightened despotism" in contact with Western culture (mainly French) and contributed to the organization of education, especially in the Danubian principalities during the eighteenth century. Demetrios Katartzis, Iosipos Moisiodax, Rhigas Velestinlis, Daniel Philippides, Gregorios Constantas, Athanasios Christopoulos, and other distinguished "renaissance" men of letters were linked with Phanariot circles.

Until about 1770, the Phanariots set the tone of intellectual life, endeavoring to impose their own ideals and political thinking (directed toward the creation of a "flexible morality," which would allow collaboration with the Ottoman administration) and pursued academic studies that would permit them to continue to occupy offices in the patriarchate and the Ottoman administration. The principal exponents of this ideal were Alexandros (1641–1709), Nikolaos (1680–1730), and Constantinos (d. 1769) Mavrokordatos. The Phanariots, educated as they were within the power structures of the Ottoman system, could not fully support the development of the political and scholarly ideas forged in the West and reworked in Greek territory by progressive intellectuals, who, toward the end of the century,

were to spearhead the neo-Hellenic Enlightenment. The turning point was the French Revolution, which revealed the contradictions and limitations in the mentality of the patriarchate and the Phanariots: the radical revival of consciousness—through the influence of the sciences and the principles of liberalism—and the consequent possibilities of violent overthrow of Ottoman rule lay outside the conceptual framework that these groups had been putting together for centuries and, at the same time, conflicted with the conception of the Greek identity that they had established.

For the Greeks, the eighteenth century was critical, both with regard to the domain of ideas and that of allegiances, since important economic changes were taking place (alongside the above-mentioned political changes and shifts in the areas of operations of the European powers and of Russia), mainly in the mercantile arena. These changes made it possible to break with the traditional forms (mentalities, identities, orientations), as new social subjects emerged, with a different perception of what was needed, what really was going on, and the nature of the alternatives.

As specialized studies have demonstrated, it was in the eighteenth century, for the first time since the Age of Discovery, that the eastern Mediterranean "returned" to the forefront of history. The European powers were increasingly active in the area of European Turkey, though it was basically Greek merchants who traded there. Large Greek cities were transformed into veritable "economic capitals" (Smyrna, Thessaloniki), while other trading centers also developed: Ioannina, Arta, Patras, Chios, Herakleion. The Greek merchants, initially involved in European trade—encouraged by the fact that they were included among the protégés of the advantageous terms of certain trade agreements, the so-called capitulations—gradually began operating independently from about the mid-eighteenth century. Eventually (mainly after 1774 and during the Napoleonic Wars, 1792–1815), they controlled a large part of the domestic and foreign trade of the Ottoman Empire, and, in particular, trade conducted to and from countries of Western and Central Europe (for example, Austria, southern Russia, and France), where important Greek communities were established. These communities, particularly in Vienna, Trieste, Leghorn (Livorno), and Odessa, now became centers of economic and intellectual development, places in which innovative views and orientations were cultivated. The Greek merchants of this generation were by now systematically organized in the process of trade and had large amounts of capital, land, and businesses in Western Europe. However, their experience of the West, coupled with their contacts with everyday Greek reality, soon made them realize the antiquated nature of the economy under their Ottoman masters: the high-handedness of the authorities, the system of privileges, and the climate of uncertainty impeded the investment of capital, while manufacturers who went beyond the cottage-industry stage were prevented from developing into true industrial units. The consul of France in Thessaloniki, Félixe de Beaujour, noted, "The despotism makes the fortunes fleeting, because it always ends up conquering them. It puts constraints on economic activity, because no one takes care to gain what he may lose. It hinders the circulation of money, which is hoarded in hands interested in hiding it." So, despite the growth of trade and shipping in the eighteenth century, the manufacturing sector went through a crisis and many experiments in modernization proved futile in the end.

The Greek merchants, who, according to an apt expression of the day, were the "trans-Balkan bourgeoisie," were aware of the economic deadlocks, and gradually, thanks to their experience of the European environment, gave ideological form to their doubts about these obstacles. Realizing that the "occupation" was hindering economic activity, they took another step toward consolidating the Greek identity (focusing on the contrast with their Ottoman overlord), thus sidestepping the approaches of the traditional leadership groups. "This opposition," Nicos Svoronos wrote, "between the bourgeoisie and the conditions of the Turkish conquest, which precludes every possibility of compromise, contributes to the

creation, among large segments of this new social class of Hellenism, of a revolutionary national ideology that, reinforced by the European ideology with which this group is in contact, contributes in its turn to the greater clarification of the national consciousness." In the late eighteenth and the early nineteenth centuries this radical conception went hand-in-hand with the opinions of certain intellectuals of the period and led to intense internal conflicts. The radicalization of some of the merchants led to an intensification of the social struggles, initiated mainly when these merchants claimed a role in, or even control of, the administration of local communities, in many instances forming "democratic parties" (for instance, Kozani, Kea, and Samos). We have now reached the climax of the Enlightenment, the climax of social tension: we are on the eve of the Greek War of Independence, the national revolution of the Greeks.

### The Creation of the Modern Greek State, 1830

The organizational preliminaries of the Philiki Etaireia—most important, the entrusting of the leadership to Prince Alexander Ypsilantis—led to the outbreak of the revolution in the Danubian principalities, which was proclaimed at Jassy (Iaşi), capital of Moldavia, on February 24, 1821. Although the uprising was crushed (June 7, 1821), failing to foment the concurrent insurrection of other Balkan peoples, as 1821 progressed revolution took hold in the entire Greek mainland. The initial unanimous condemnation of the uprising by the Holy Alliance failed to turn the tide, while the sultan's forces were able to suppress the insurgency only in some areas. The Greek successes put the revolution on a firm footing and heralded radical transformation in the region. Thus, whereas in the early years the only Greek support came from the continually swelling philhellenic movements in Europe and America, now European governments, seeing their interests in jeopardy, were gradually forced to change their policy of disengagement. The Greek struggle enhanced the internal dissensions within the Holy Alliance and led to its breakup. This became inevitable as of late 1825, when Nicholas I, the new czar of Russia, took steps to draw Britain and France into mediating a solution to the "Greek question."

In April 1827 Ioannis Capodistria was elected governor of Greece for a seven-year term, signaling an attempt at more effective organization at a political level on the part of the Greeks. The same year, the London Treaty was signed (July 6, 1827) between Russia, Britain, and France, committing them to true intervention in the "Greek question." Toward the end of 1827 the Greeks saw the fleet of the three great powers defeat the combined navies of Turkey and Egypt in the battle of Navarino (October 20, 1827). The involvement of the European powers made it inevitable that a favorable solution would be found for the Greeks. On February 3, 1830, the three great powers met in London, where they decided on the creation of the first independent Greek state and appointed Leopold of Saxe-Coburg as head of state. His resignation and the assassination of Capodistria on October 9, 1831 (perpetrated by his rivals within Greece, very probably with British connivance), led to the choice of Othon, the seventeen-year-old son of King Ludwig of Bavaria, as king of Greece on May 7, 1832. On February 1, 1833, the ships carrying King Othon dropped anchor at Nafplion, the first capital. Othon was to reign in a land laid waste, with a population of 750,000. Some two million Greeks were still living under British sovereignty in the Ionian Islands and under Ottoman sovereignty in central and northern Greece, in the Aegean Islands (except for Cyclades), and in Crete.

A small independent state, under the guarantorship of the three great powers, was born at the far end of the Balkan Peninsula. It may not have fulfilled the aspirations of many of the architects of the War of Independence, but it was a radical new reality. The Greeks were creating the first national state in the Balkans and the Eastern question was thus propelled into a new phase.

**Selected Bibliography**

Apostolopoulos 1989; Asdrachas 1979; Asdrachas 1988; Asdrachas et al. 2003; Bacchion 1956; Beck, Manoussacas, Pertusi 1977; Costantini, Nikiforou 1996; Dakin 1972; Dimaras 1999; Geanakoplos 1962; Gedeon 1976; Hassiotis 1970; Hering 1968; Holton 1991; Iliou 1975; Inalcik, Quataert 1994; *Ιστορία του Ελληνικού Έθνους* 1974–75, vols. 10–11; Layton 1994; Maltezou 1993; Miller 1908; Ortalli 1998; Panayotopoulos 2003, vols. 1–3; *Révolution française* 1989; Sakellariou 1939; Sugar 1977; Svoronos 1956; Svoronos 1972; Svoronos 1982; Svoronos 2004; Vacalopoulos 1961–80, vols. 1–5.

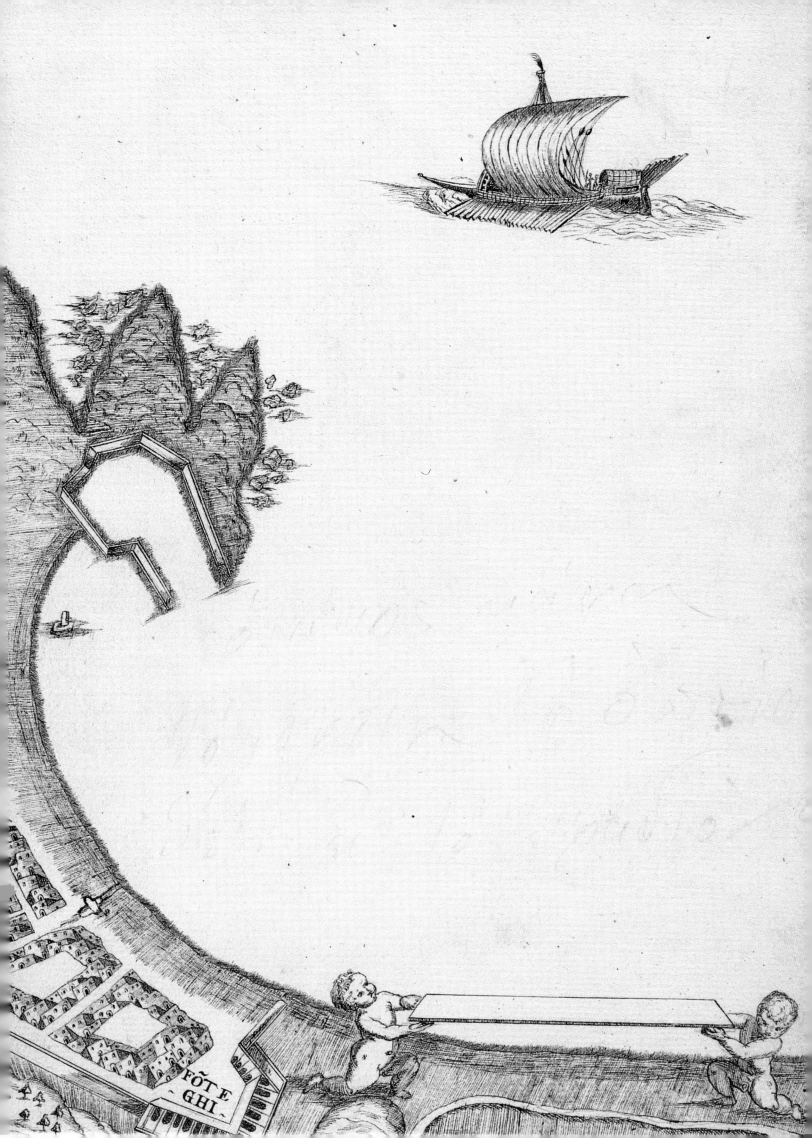

FÕT E
GHI

# CHALLENGED TERRITORIES:
## COMPETING CARTOGRAPHIC APPROACHES TO GREECE,
### FIFTEENTH–NINETEENTH CENTURY

George Tolias

The map of Greece took shape during the years of foreign domination. Between the fifteenth and the eighteenth centuries the Late Byzantine principalities and the Latin possessions in the Greek East were successively conquered and incorporated into the Ottoman world. The Greek lands were to become the sultan's lands. As result of the absence of a Greek state authority, the geographical definition of Greece and its cartographic representations were inspired by diverse political and cultural priorities in the emergent West, which was intensifying its penetration into the Greek East. Thus, the map of Greece took shape through varied and frequently rival approaches that served different political and cultural purposes but had a common ideological basis. Furthermore, in this processing, several traditions were blended: the cartographic practices of merchant mariners, the firsthand accounts of foreign travelers, the theoretical interpretations of the literati, and the strategies of the architects of colonial expansion. These readings were challenged by the ambitions of the Greek patriots as well as by the practical needs—initially maritime and subsequently devotional—of traditional Greek societies.

Within the adversity of foreign domination, when most Greek lands were part of the Ottoman imperial construction, Greece was to reemerge, for the first time since the Roman era, as a specific geographical region. The map of Greece was among the first regional maps of the "Old World" to be drawn by the Humanist cartographers of the fifteenth and sixteenth centuries. These early cartographic images are of a hybrid nature, combining elements from antiquity and later, and frequently include commentaries that are typically Humanistic in spirit, referring to the ancient glory of the Greek world and its present degradation. Animated by the didactic ethic of Humanism, they functioned as allegorical images of human vanity (see cat. no. 3).

With these works as a starting point, Italian cartographic workshops of the sixteenth century produced the basic models of the modern map of Greece. These new representations included the area south of Epirus, the Greece of the ancient Hellenic tribes as defined by Strabo and Ptolemy. Nevertheless, they stand out for their updated and reliable information, since they combine ancient data, firsthand accounts of contemporary travelers, and the empirical maritime cartography of portolan charts (see cat. no. 3). The modern cartographic model was complete by the mid-sixteenth century and was standardized and widely disseminated thanks to the printing press, becoming the basis of the maps of Greece found in atlases until the early eighteenth century.

During the same period, there was a burgeoning of the topography of Greek regions. The *isolarii* guided the public in the West to the landmarks of the Greek islands, at the moment the first analytical maps of the regions of Greece emerged. Regional topography of Greece was linked with the efforts of Venice to preserve the network of her eastern possessions, the Levante Veneto. Its highpoints were associated with important military events, such as the wars of Cyprus (1570–72) and Crete (1645–69) or the Venetians' temporary capture of the Peloponnese (1685–1715). This type of laudatory and propagandistic cartography aimed at celebrating victories and announcing to the European public the valiant deeds of the Venetians in their *regni* in the East (see cat. nos. 4–6).

The Venetians were not the sole claimants of Greek lands. The French primarily, but also the Dutch, the British, and later the Russians, were to embark on parallel economic or strategic penetrations into the Greek East. The commercial, political, and religious privileges that the French enjoyed in the Ottoman Empire since the capitulations of the sixteenth century opened the way for submitting the Levantine roadsteads to French influence (see cat. no. 1). The French initiatives came thick and fast, and from the late seventeenth century onward the map of Greece was to become a French affair. The French cartography of Greece in the eighteenth century, combining erudition and technological expertise, was based on new surveys in the field as well as enhanced mathematical accuracy and antiquarian interest.

Cat. no. 4. *Manuscript Atlas of the Fortifications of Crete*, Rethymnon (detail). 1646. Laurentius Longus.
Sepia on paper. Inv. no. 26167

29

The first signs of Greek claims, expressed mainly by the intelligentsia, appeared as early as the fifteenth century. Based on the work of the ancient Greek and Byzantine geographers, Greek Humanists were to delve deeper into the definition and content of a distinct historical and cultural Hellenic entity. A final crystallization of this process was the large mural map of ancient Greece, accompanied by its modern place names, published by Nikolaos Sophianos in Rome in 1540–42 (fig. 1). Sophianos' Greece encompasses the

Fig. 1 Nikolaos Sophianos. Map of Greece. Copperplate engraving, 2 sheets. Rome, printed by Francesco Salamanca, before 1558. Benaki Museum, Athens, inv. no. 26771

entire Balkan Peninsula and western Asia Minor and can be considered as an agent of prenational patriotism, which proposed a cultural (historical and religious) designation of Greece, presenting the waste Christian territories of the Byzantine Empire endowed with a Greek and Roman ancestry. The map displays Greece as part of the unified and Christianized Roman world and promotes the idea that Greece was an active component of Christian and Humanist legacy.

The map rapidly gained authority and became a standard reference work, opening up the notion of historical and comparative geography, an antiquarian field destined to hold a conspicuous place. Indeed, the antiquarian wave was to sweep the geography and cartography of Greece in its wake in the seventeenth and eighteenth centuries through an abundant production of maps, atlases, and descriptions of ancient Greece. Greek geography and cartography of the seventeenth and eighteenth centuries relied on this tradition and endowed it with an early national character. This new synthetic expression of the Greek antiquarian approach was proposed in the late seventeenth century by Meletios Mitrou in *Γεωγραφία Παλαιά και Νέα* (*Ancient and Modern Geography*) and by Rhigas Velestinlis in the monumental *Χάρτα της Ελλάδος* (*Chart of Greece*) published in 1797 (see fig. 1, p. 206). Rhigas' Greece covers the entire area of Sophianos' Greece, yet it is no longer the Roman Greece of early Christian times. In this work Rhigas displays the diaspora of the Greeks in time and space: from the ancient Greek colonies to the Hellenistic period, and from the Byzantine Empire to the Phanariot hegemony in the Balkans. In Rhigas' *Chart,* the emerging Greek national idea is linked with the complex imperial notions of Byzantium and the Ottoman Empire and, at the same time, drawn to the ideals of democratic Greek antiquity as perceived by Western Europe following the French Revolution.

These readings, a mesh of theoretical conceptions by the intelligentsia, do not reflect collective approaches, which are to be found in the vernacular—and usually anonymous—cartographic works of the period, such as the Greek portolan charts of the sixteenth and seventeenth centuries. This production was the outcome of the awakening of Greek shipping activities and of the merchants' responses to the Mediterranean vernacular cartographic practices to which they added their specific aesthetic and thematic preferences. The focal point in the illustrations of the Greek portolan charts shifted imperceptibly toward the northern regions: Thessaloniki is highlighted as the major commercial center of the region, while concurrently the network of shipping trade on the Danube appears, with the depiction of a powerful mercantile site in the Balkan heartland, possibly Vidini (see cat. no. 2). As far as the issue of "national" space is concerned, the Greek portolan charts are an indicator of the confusion and hesitations of the seafaring Greeks. The Ottoman emblem—the crescent—and the "Grand Turk" himself are characteristic vignettes, whereas the Greek hinterland is defined by such names as Grecia, Romania, Romelia, Albania, and even Schiavonia.

For those on land the situation was more complex. In the traditional rural societies, geography was conceived empirically. The management of land issues on a small scale was the concern of the "elders and practical men," who memorized the boundaries of property. On a larger scale, geographic areas remained linked with pilgrimage routes and the ecclesiastical administration and were defined through a system articulated by the dioceses and their parishes, the monasteries and their dependencies (*metochia*), and the major fairs held on religious feasts. For traditional, rural society, space (like time) was determined by devotion.

Sacred space was the subject of many depictions and descriptions. Greek initiatives relied again on earlier Western practices, which were transmuted through local traditional systems of perception and representation. Manuscript guides for pilgrims (*proskynetaria*) to the Holy Land and Sinai began circulating in the late sixteenth century and in illustrated versions during the seventeenth. They were followed by printed, illustrated guides for believers to Jerusalem and other sacred places of Orthodoxy: Mount Athos, Mega Spilaio, Virgin Soumela, Meteora. In the mid-seventeenth century, sacred Orthodox maps—monumental engravings representing Sinai, Athos, and Jerusalem—appeared. These works were based on Western topographical engravings but soon developed a rich local practice that combined traditional styles of Byzantine religious painting with elements of secular art and Western prints. These interesting topographical hybrids represented the meeting of the erudite with the vernacular, the religious with the secular, the West with the East (fig. 2).

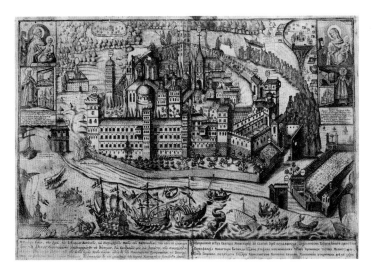

Fig. 2 *The Monastery of Vatopedi on Mount Athos.* Copperplate engraving. Vienna, 1767. Benaki Museum, Athens, inv. no. 27810

The printed illustrated *proskynetaria* and the sacred maps were among the first printed matter produced in Greek lands in the mid-eighteenth century. With the Athonite monasteries as its center, a local printing school arose whose influence was widely disseminated in Orthodox Christian lands. The formidable output of printed cartographic images of sacred places, though appearing in the margins of printed icons, is an interesting manifestation of the selective adoption of modern media for transmitting geographical information in the Orthodox world. The printed representations of sacred places had an impact on Orthodox painting too, inspiring mural decorations in churches and monasteries. Moreover, within this tradition fall several rare attempts to produce topographical representations of secular subjects, such as views of economic and cultural urban centers of the region (see cat. nos. 7 and 8).

The diverse Greek cartographic activities during the period of foreign rule thus derived from external Western prototypes that were assimilated to create fertile local mapmaking traditions. Through successive blossomings of the anonymous and vibrant vernacular culture, cartography functioned as a theater for presenting the organization of cultural, economic, and religious practices. In the case of erudite production, mapmaking functioned as a vehicle for expressing patriotic goals. All these competing cartographic approaches did not always mesh and did not converge upon a structured pattern. Rather, they constitute dynamic expressions that would be explicitly formulated after the founding of the modern Greek state.

**Selected Bibliography**

Asdrachas 1994; Avramea 1985; Papastratos 1990; Paris 2001; Tolias 1999; Venice 1986.

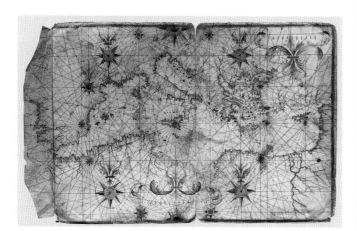

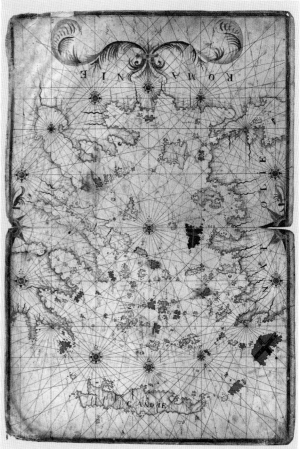

1. **French Manuscript Portolan
   Atlas with Two Maps**
   17th century
   Marseilles workshop
   Ink and egg tempera on vellum
   43.5 x 62.5 cm (open)
   Inv. no. 26733

The atlas is unsigned and undated. It was formerly considered the work of the Cretan chart maker Georgio Sideri (act. 1537–65), but the French lettering, the cartographic execution, and the ornamentation are all typical of mid-seventeenth-century workshops in Marseilles. The work displays stylistic similarities to the production of Jean-François Roussin, who was active in Marseilles, Toulon, and Venice between 1658 and 1680. The small portolan atlas comprises two charts, one pasted on the verso of the other to form a volume of just two sheets. The "cover" is a chart of the Mediterranean Sea and the "contents" is a chart of the Aegean, a combination related to the growing interest of France in Levantine trade.

On the chart of the Mediterranean Sea only coastal place names are marked, whereas on that of the Aegean the names of the surrounding regions are given: *Natolie* for Asia Minor, *Romanie* for Greece, and *Candie* for Crete. The islands of Rhodes and Chios are illustrated with the coat of arms of the Knights of Saint John of Jerusalem and of Genoa, respectively, even though the Ottomans had captured both islands during the sixteenth century.

Athens 1999, 111–12, no. 5 (G. Tolias); Astengo 2000, 156, Gr A1.

G.T.

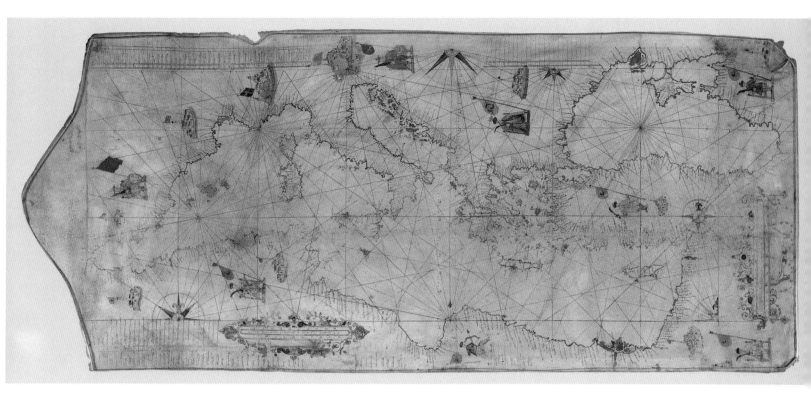

2. **Greek Manuscript Portolan Chart
   of the Mediterranean Sea**
   Late 16th–early 17th century
   Greek workshop
   Ink and egg tempera on vellum
   41.5 x 93 cm
   Inv. no. 36215

This extremely rare work is one of six surviving portolan charts and atlases with Greek lettering. The chart, unsigned and undated, is lavishly illustrated with vignettes representing Barcelona, Genoa, Venice, Konya, and three cities under an Islamic banner (in the Balkan heartland, in Tartary, and in Gaza), and another two on the northwest coast of Africa. Depicted on their thrones are the king of Spain, the Austro-Hungarian emperor, the Ottoman sultan, and the rulers of the Tartars, the Arabs, and Morocco. A figure of a standard-bearing janissary stands in the interior of Asia Minor and, in the hinterland of Libya, a Berber archer.

A characteristic specimen of the output of portolan charts in the Greek language, the work presents iconographic and stylistic parallels with two portolan charts produced by Nikolaos Vourdopoulos of Patmos in the early seventeenth century. Although the coloration and the iconographic motifs are inspired by the aesthetic of vernacular decorative art, a literary character distinguishes the work, as it includes five tables of place names, accompanied by numerical references figuring on the chart. This feature is interesting and unusual in the production of portolan charts, since the use of gazetteers in cartography is conventionally associated with scholarly taxonomies of geographical information.

The work seems to be unfinished, since the fifth and last of the gazetteers (the one in the Balkan heartland) is blank, while the coloring of the islands goes no farther than Corfu: the Greek islands and the larger islands of the Mediterranean have been left uncolored.

Athens 1999, 110, no. 4 (G. Tolias); Tolias 1999, 174–76, 206, AA1; Astengo 2000, 156, Gr A2.

G.T.

### 3. Painted Map of Greece

After 1585
After Stefano Buonsignori
Egg tempera on wood
110 x 88.5 cm
Gift of Helen Keckeis-Tobler, inv. no. 33115

The unsigned and undated map is similar to the map of Greece made by the Dominican cartographer Stefano Buonsignori in 1585 for the Guardaroba Medicea in the Palazzo Vecchio, Florence. In drawing the map, Buonsignori relied on Ptolemy's system of parallels and meridians, on the tradition of portolan charts, and on contemporary printed maps of Greece, in particular those published by Giacomo Gastaldi between 1548 and 1560.

The tradition of painted maps enjoyed its heyday during the sixteenth century, when the trend for decorating libraries and studies with artistic maps and images of natural curiosities spread to the upper social and economic echelons. The Guardaroba Medicea was Cosimo de Medici's private space for contemplation, a cosmographic gallery with maps drawn successively by the Dominican cosmographers Fra Egnazio Danti and Don Stefano Buonsignori between 1563 and 1586. The project aimed at demonstrating the cosmographical foundation of universal history. This peculiar function of the Guardaroba explains the mention of ancient and modern place names on the map as well as the comment added at the lower left, inside an ornamental cartouche with the Medici coat of arms, which refers to the glory, decline, and destruction of Greece.

The main difference between the two works lies in the addition, at the lower right of the Benaki Museum map, of a decorative scene representing an Egyptian coastal landscape, with two Bedouins and their pack animals resting beside a palm tree and gazing toward Greece. The Benaki Museum map may be a copy commissioned for a distinguished visitor to the Guardaroba. Nevertheless, the possibility that it comes directly from the cycle of maps in the Guardaroba Medicea cannot be ruled out; in other words, it may well be an original, duplicate work—the existence of two separate maps of Asia Minor in the Guardaroba permits speculation that more than one map of the various regions was executed. This hypothesis is reinforced by the high artistic and cartographic quality of the Benaki Museum map, by the similarity of the hand in the lettering, and by the identical dimensions of the two works.

Delivorrias, Fotopoulos 1997, 492, fig. 865; Athens 1999, 113–14, no. 7 (G. Tolias); Tolias 2002, 89–109, fig. 2. For Renaissance painted maps, see Fiorani 2005.

G.T.

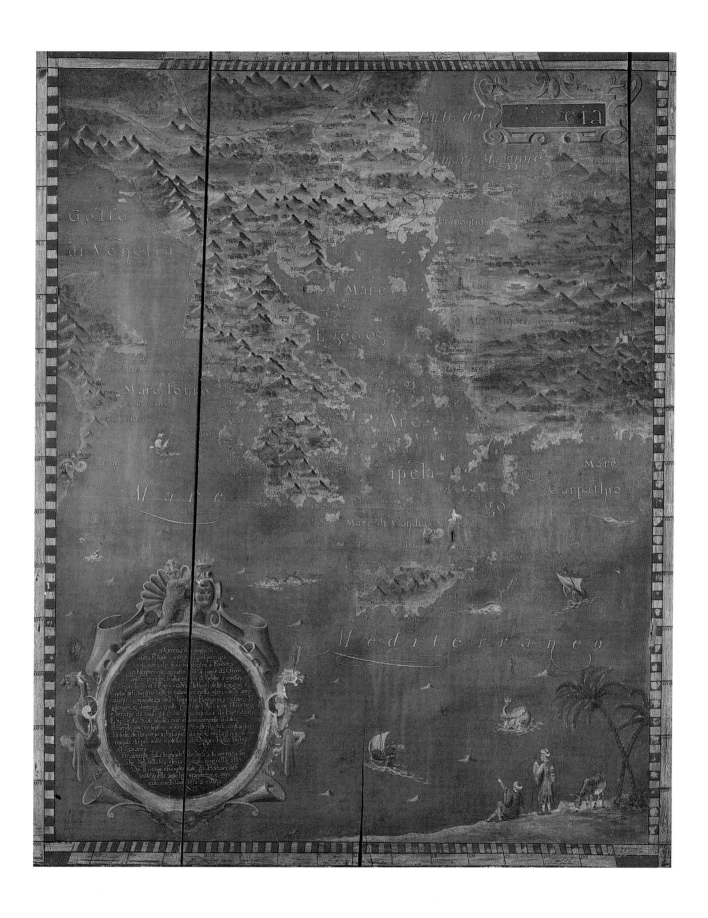

DISSEGNI
delle Parti del Regno di Candia
è
delli Luochi ad esso Soggetti
DELINEATI
dall'accurata diligenza
di
PENNA NOBILE PATRITIA.

L'ANNO M.DC.XXXXXVI.

4. **Manuscript Atlas of the Fortifications of Crete**
1646
Laurentius Longus
Sepia on paper, leather binding tooled in gold
43 x 60 cm (open), 41 folios
Inv. no. 26167

The topographical atlas of Crete, Kythera, and the islets around Crete is signed by Laurentius Longus (Lorenzo Longo) and dated 1646. It comprises forty-one folios and includes short introductory commentaries and seventeen topographical plans, with emphasis on the fortified sites.

We have no information about the activity of the engineer Lorenzo Longo in Crete. In 1546, when the atlas was completed, the Cretan war was already in its second year and the Serenissima Republic had dispatched a considerable number of officers to the island. We can, however, speculate that Longo was a member of Camillo Gonzaga's mission, which sailed into Souda Bay in September 1545 in order to inspect the fortifications and defenses on Crete. The technicians in Gonzaga's mission supervised the intensive repairs to the fortifications of Candia (Herakleion) until April 1546, when the siege of the city—destined to last twenty years—commenced. This hypothesis is strengthened by the fact that three plans in the atlas are devoted to the Paleocastro area, the "bastion of Herakleion."

Longo's plans, impeccable and assiduous, lack the luxury of the manuscript atlases of the *Regno di Candia,* executed by Venetian engineers in the late sixteenth and early seventeenth centuries (A. Degli Oddi, F. Basilicata, G. Corner, R. Monani, E. Nani). In drawing this last Venetian manuscript atlas of the kingdom of Crete, Longo relied on this prolific topographical tradition, enriched through his own surveys.

Athens 1999, 112, no. 6 (G. Tolias). For the activity of Venetian engineers in the Levant, see Venice 1986, 139–40. For the activity of Venetian engineers in Crete, see Porfyriou 2004, 65–92.

G.T.

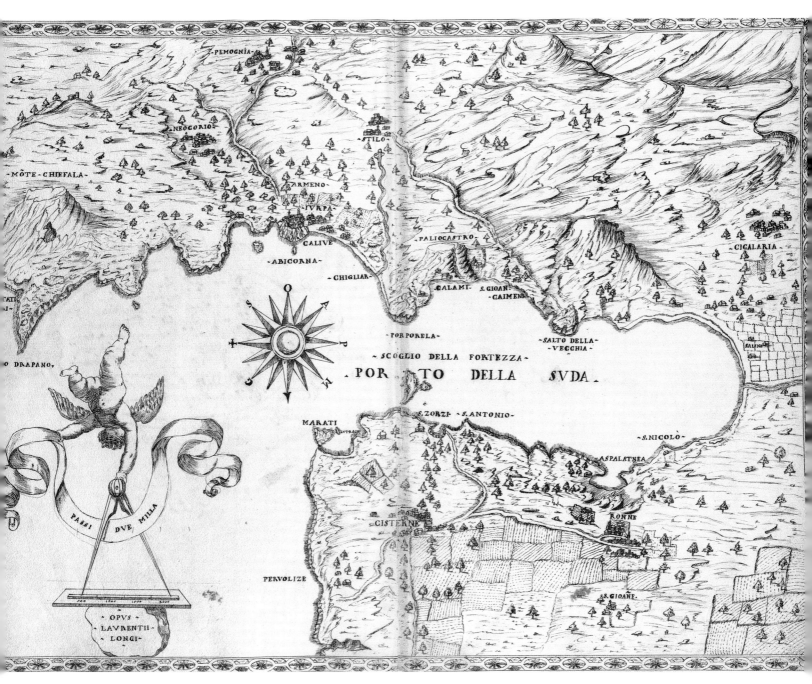

Souda Bay

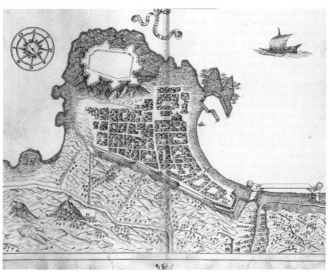

Rethymnon

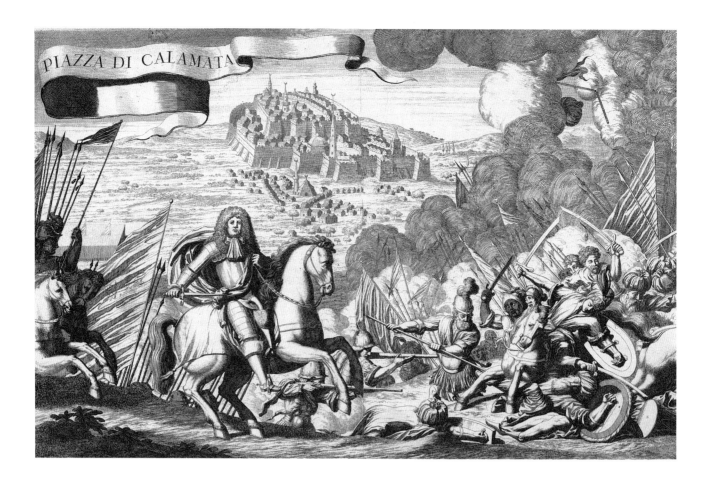

5. **The Siege of Kalamata by Venetian Troops**
1687
Vincenzo Maria Coronelli
Engraving
38.5 x 50 cm
Inv. no. 26653

The Venetians captured Kalamata in September 1685 during the Venetian-Turkish War (1685–87). The print depicts the siege of the city by General Königsmark, head of the Venetian troops. The war occasioned an intense production of printed works, topographical plans, and maps in which Coronelli's workshop played a leading role. In addition to their informative character, these works also had an important function as propaganda media, contributing to the rallying and the unanimity of the Venetian public. Five versions of the work survive, with variations in the decoration, from two of which General Königsmark is absent. Coronelli published two other plans on the subject of the battle of Kalamata. The prints circulated as loose sheets as well as in various volumes dedicated to the Venetian-Turkish War.

Athens 1999, 117–18, no. 12 (F.-M. Tsigakou). For another version of the siege of Kalamata by Coronelli, see Tsigakou 1981, ill. p. 16.

G.T.

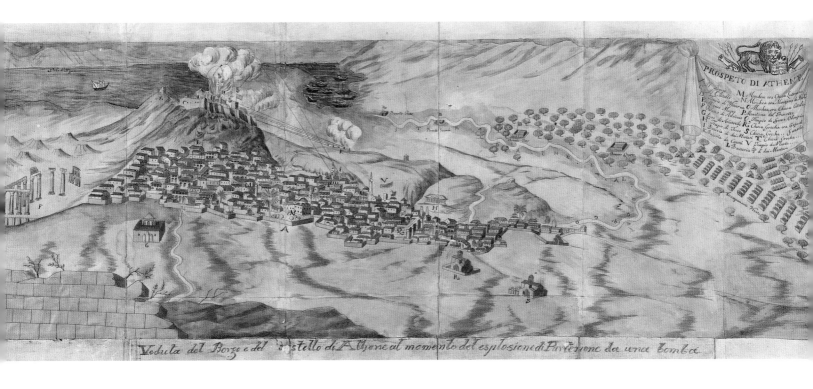

*Veduta del Borgo e del Castello di Athene al momento del esplosione di Partenone da una Bomba*

6. **The Bombardment of the Parthenon by Venetian Artillery**

1687
Giacomo Milheau Verneda
Watercolor on paper
28 x 70 cm
Inv. no. 23149

Giacomo Verneda, an artillery officer during Francesco Morosini's campaign in Greece (1685–87), took part in the cordon and capture of Athens (September 1687), under the command of General Königsmark. During the siege of the Acropolis, a Venetian shell destroyed the Parthenon, which the beleaguered Ottomans were using as a gunpowder store.

This watercolor is the most complete topographical map of Athens until that time and the first one drawn in situ, using detailed measurements and firsthand verification. Verneda's plan includes a key, in which contemporary buildings and ancient monuments are identified, the latter with errors due to the limited archaeological knowledge of the day (for example, there is reference to the lost "Liceo di Aristotle" and the monument of Philopappus is described as "Monte Museo"). There is a variation of this map in the Frari Archives of Venice.

The destruction of the Parthenon turned the attention of the educated public in the West toward Athens and its monuments, resulting in the circulation of several works relating to the city and its antiquities. Among these was the book *Atene attica: descritta da suoi principii fino all' acquisto fatto dell' armi veneti nel 1687* by Francesco Fanelli (Venice, 1707) in which Verneda's map was published, with additional errors in its annotation.

Tsigakou 1981, 192, ill. p. 17; Delivorrias, Fotopoulos 1997, 493, fig. 866; Athens 1999, 118–19, no. 13 (F.-M. Tsigakou). For printed versions of the plan, see Kondaratos 1994, 34, fig. 15; Mallouchou-Tufano 1994, 168, fig. 6.

G.T.

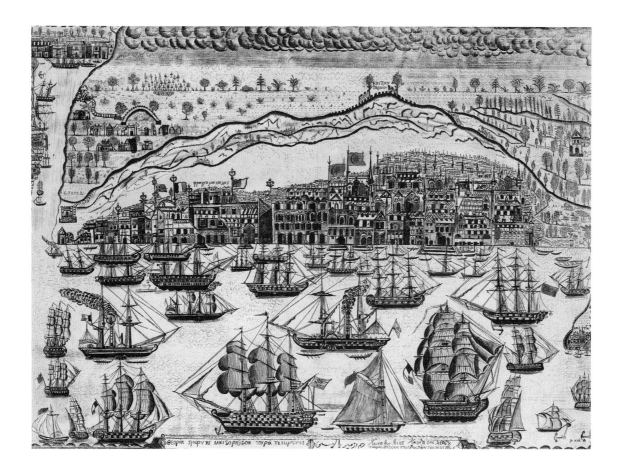

7, 8. **Views of Smyrna and Constantinople**

    1845 and 1851
    Constantinos Kaldis
    Colored engravings
    47 x 62 cm
    Inv. nos. 30412, 30411

The priest Constantinos Kaldis from Lesbos belongs to the tradition of Athonite printmaking, since he learned the "stamper's" art in the workshops of the monasteries on Mount Athos. From the late eighteenth century on, these workshops produced mainly printed icons but also maps of holy places and topographical views of various pilgrimage sites. Few works by Constantinos Kaldis have survived, and consequently it is difficult to confirm the places in which he worked. The two prints in the exhibition were etched and printed at Plomari, on the East Aegean island of Lesbos, where the vernacular engraver produced his final works.

Both prints are based on earlier Western ones, which have been assimilated into the distinctive Athonite topographical style. They are exceptions to the corpus of Athonite prints, since they are of secular subjects. The printmaker was, indeed, active outside Athos, where he executed nonreligious commissions. The subjects relate to the tradition of topographical murals depicting important commercial and cultural centers of the day that decorated the mansions of wealthy merchants by the mid-eighteenth century. Kaldis aimed to supply a wider public with inexpensive works of a decorative nature. The activity of merchants from Lesbos at Smyrna, Constantinople, and the Black Sea on the one hand justified the choice of subject and, on the other, provided the appropriate network in which the multiple printed works could circulate. In order to attract the largest possible clientele, both views are colored and the one of Constantinople is annotated with explanatory comments in Greek and Turkish.

It may be assumed that the entire endeavor did not meet with commercial success. The prints are extremely rare and did not lead to the production of other secular subjects. It is worth noting that Constantinos' son, Ioannis Kaldis, was to follow his father's profession. He, however, returned to the secure patronage of the monasteries of Mount Athos and distinguished himself as one of the most prolific Athonite "stampers" of the nineteenth century.

Papastratos 1990, vol. 2, 578–79, figs. 617–18; Delivorrias, Fotopoulos 1997, 508–9, figs. 900–901.

G.T.

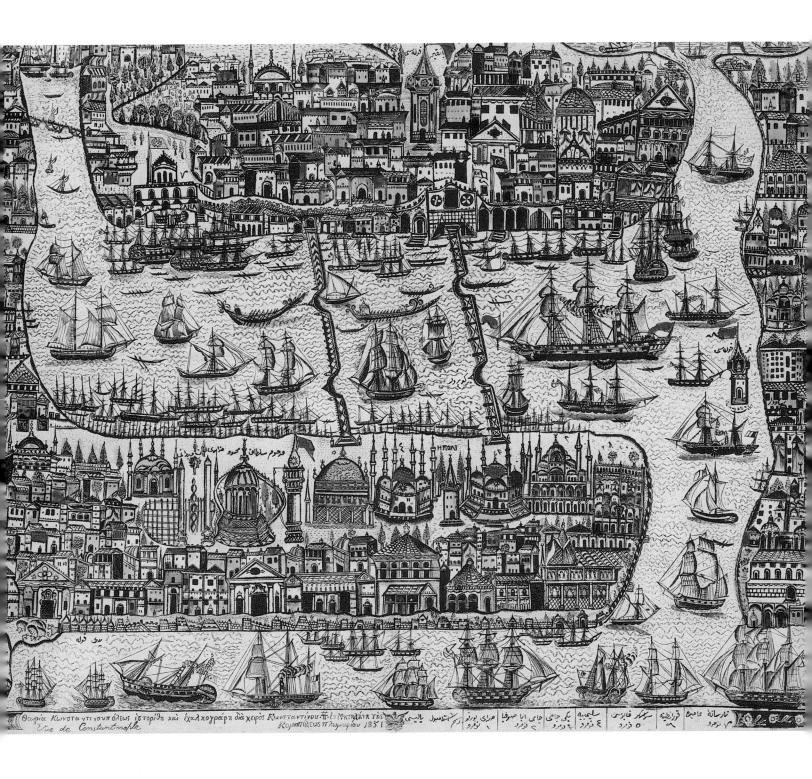

Θεωρία Κωνσταντινουπόλεως ἱστορίθη καὶ ἐχαλκογράφη διὰ χειρὸς Κωνσταντίνου Π. ἐν Μητηλήνη τῆς Κωμοπόλεως Πλωμαρίου 1851

Vue de Constantinople

# GREEK RELIGIOUS PAINTING
## AFTER THE FALL OF CONSTANTINOPLE:
## TRADITION AND RENEWAL

Anastasia Drandaki

The way in which religious painting developed after 1453—when Constantinople fell to the Turks—is a reflection of the course of Greek history. The stylistic trends that emerged remained firmly orientated toward the Palaiologan tradition as far as the basic range of iconography and painting techniques. Nevertheless, the Byzantine repertoire was frequently enriched with innovative elements that, as a rule, derived from Western painting or Ottoman decoration, depending on the background, education, or training of the painters and their patrons. This holds true, though not to the same degree, with respect to the prolific output of the areas under Venetian control and the heterogeneous religious painting of the Ottoman-occupied mainland.

The Cretan school of painting, which flourished from the early fifteenth century until the second half of the seventeenth, is the most important phenomenon in Greek religious art of this period. Apart from the large number of surviving works, our knowledge of the artistic production of the Cretan workshops is based on the precious archival material from the Regno di Candia kept in Venice. Legal documents in particular furnish a mass of information that allows us to follow the development of painting on the island until the conquest of its capital, Candia, by the Ottoman Turks in 1669.

In the fourteenth century, Crete, under Venetian rule since 1211, saw a spectacular increase in the number of painted churches, due mainly to the normalization of the political climate on the island. About 1400, however, there was a noticeable change in the quality of these painted programs. No longer simply a provincial echo of the prevailing stylistic trends of the period, the works often rank alongside the finest examples of late Palaiologan art. This artistic breakthrough, which had a decisive effect on the development of Cretan painting, was the result of the arrival on the island of painters from Constantinople, who, in the years preceding the fall of the city to the Turks, sought more congenial living and working conditions in Venetian territories and in Venice itself. They brought to Crete the distinctive traits of aristocratic Palaiologan art, offering patrons and painters new models and aesthetic criteria. Archival documents record the names of Constantinopolitan painters who were working on the island, traveling between Crete and Venice, and entering into apprenticeship agreements with aspiring Cretan painters. These sources, together with the extant paintings, also bear witness to a gradual change in the social status and self-esteem of the painters, who evolved from anonymous Byzantine craftsmen into well-known artists who signed their works. They were members of the Guild of Saint Luke and ran organized workshops that often collaborated on large commissions. In many cases the workshops were family-based but took on indentured apprentices, who not only were taught the art of painting but also often given basic schooling.

Angelos Akotantos, active in Candia during the first half of the fifteenth century and the most important Cretan painter in this early period, is a typical

Cat. no. 9. *The Adoration of the Magi* (detail). Ca. 1560–67. Domenikos Theotokopoulos (El Greco). Egg tempera on wood. Inv. no. 3048

example (fig. 1). Information from legal documents conjures up an image of a successful professional; a cultured, socially active man who traveled to Constantinople, probably to keep abreast of developments in his art. The picture derived from the sources is fleshed out by the many exquisite surviving icons signed Χείρ Αγγέλου ([by the] hand of Angelos) or confidently ascribed to him. His work is a creative mix of the Palaiologan tradition with elements of the International Gothic style, resulting in something entirely new. The foundation laid by Angelos and his contemporaries was to become the hallmark of Cretan religious painting: harmonious easy-to-read compositions, classicizing in style, with an emphasis on elegant figures, carefully balanced color schemes, and refined technique.

The foremost workshops of the second half of the fifteenth century, such as that of Andreas Ritzos and his son Nikolaos, painted icons, establishing iconographic types that hold few surprises yet are fascinating for their theological clarity and exquisite technique (see cat. no. 11). The relative standardization of iconography and style, typical of many works of the period, is perhaps explained by the mass production of Cretan icons. The sources mention extensive orders from both Orthodox and Catholic customers, not only from Crete and neighboring areas of Greece but also from Italy and Flanders. To meet the needs of this dogmatically mixed, international clientele, the Cretan painters also developed considerable skill in executing works that drew on Late Gothic models, with a more tender manner and softer modeling, in accordance with the tenets of this style (see cat. no. 10). The reproduction of established iconographic types was facilitated by the practice of using pricked cartoons (*anthibola*)—a standard practice in religious painting throughout the post-Byzantine period—by means of which the preliminary drawing was traced onto the wooden panel before painting.

An interesting development in Cretan painting from the early sixteenth century onward is a drastic reduction in wall paintings and a concomitant increase in icon production. This change, though insufficiently studied in the context of the particular conditions on the island, previously has been observed in the urbanized milieu of Italy and may be explained by analogous social developments in Crete. Icons were not the exclusive preserve of the aristocracy but were commissioned as individual acts of patronage by townspeople who had made their money in trade or in government service in the Regno di Candia, craftsmen, priests, or monks. Whether they were used for private devotion or dedicated in a church, these icons expressed their patrons' particular preferences with regard to iconography and style, and frequently bore dedicatory inscriptions including their names. This phenomenon differs radically from the collective commissions that had resulted in churches in rural areas being decorated with wall paintings for the liturgical needs of the community or from instances of churches painted at the behest of wealthy feudal lords or powerful prelates. An equally interesting aspect of the history of Cretan painting is the development of connoisseurship, which led to panels by well-known icon painters being treated not merely as religious objects but as works of art, on which a certain value—frequently a high one—was set, that adorned the residences of their owners as collectors' items alongside artworks imported from Western Europe.

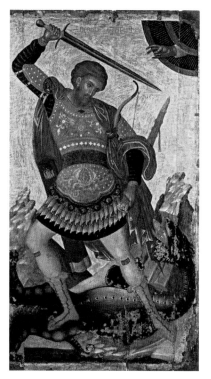

Fig. 1. Angelos Akotantos. Icon of Saint Theodore Teron Slaying the Dragon. Second quarter of the 15th century. Byzantine and Christian Museum, Athens

Fig. 2. Zorzis. Frescoes, west wall, nave of the *katholikon*, Dionysiou Monastery, Mount Athos. 1546–47

From the sixteenth century onward, Cretan wall painting, despite its restricted role on Crete itself, was to play a decisive role in the development of post-Byzantine religious painting, primarily outside the island. In the mid-sixteenth century the thriving economic status of the major monastic centers in mainland Greece allowed them to develop ambitious building programs that led to Cretan painters being invited to paint churches on Mount Athos and Meteora (fig. 2). Cretan artists such as Euphrosynos, Theophanes Strelitzas Bathas and his sons, and Zorzis were responsible for wall paintings and portable icons in the *katholika* (main churches) of the great monastic communities. Thus, the iconographic models and stylistic achievements of the now-mature Cretan school were grafted onto the art of these regions and found a host of imitators.

On Crete itself, the second half of the sixteenth century was a period of spectacular intellectual and artistic achievement. Constant contact with the Italian Renaissance and the trends developing in Venice created a situation in Crete that could be compared to the Serenissima itself. The founding of academies—cultural institutions specializing in literature, music, and drama—in all the towns on the island coincides with the special interest shown by the leading Cretan artists in Italian Mannerism. They no longer looked only to earlier Late Gothic models but turned to contemporary artistic movements in Italy and used these developments to breathe new life into Cretan painting, extending its repertoire and enhancing their styles. The appreciation and appropriation of Western models were encouraged by the trade in prints as well as by the presence of original paintings by Italian artists on the island. Cretan painters frequently traveled to Venice, where they came into direct contact with current trends. It was into this stimulating creative environment that Domenikos Theoto-kopoulos (El Greco) matured as an artist. In his early days as a Cretan master painter, he experimented with Italian Mannerist models before following his own unique path in European painting (see cat. no. 9).

From the late sixteenth century until the final fall of Candia to the Ottomans, Cretan painters looked back above all to the fifteenth century. The icons from the Lambardos family workshop are among the finest examples of this conservative tendency, in which established iconographic types were reproduced with impeccable workmanship (see cat. no. 12). The final effort to revive Cretan religious painting with elements from the Baroque took place in the second half of the seventeenth century, for the most part outside Crete, in the congenial environment of the Venetian-held Ionian Islands. Here, Cretan literati, artists, and a sizable portion of the urban population sought safe haven, as their native island was gradually occupied by the Ottomans. The values, iconography, and technique of celebrated Cretan painters who arrived in the Ionian Islands as refugees, such as Emmanuel Tzanes (see cat. no. 13), Ilias Moskos, and Theodoros Poulakis, were handed down to a younger generation of local painters through apprenticeships. This style of Cretan painting, which is frequently referred to as Creto-Ionian (see cat. nos. 14, 35), was to prevail in the Ionian Islands until about the mid-eighteenth century, when a more modern Western style arrived that detached religious painting from its reliance on the Byzantine legacy.

Cretan painting can be seen as the most brilliant and representative example of artistic creativity in Venetian-occupied Greece, spawning comparable artistic traditions in the Aegean Islands and on Cyprus. By virtue of its continuity and consistency, Cretan painting may be called a "school." It developed in the specific geographical area of Crete and can be studied alongside, and in the light of, historical and social developments on the island and the wider history of the Venetian Republic. By contrast, as might be expected, religious painting in Ottoman-occupied mainland Greece does not present similarly uniform characteristics, growing as it did out of a wide geographical area under quite different circumstances.

In the last quarter of the fifteenth century, an anonymous workshop, possibly based in Kastoria, was active for some thirty years (1483–1510), creating wall paintings for

monuments in the general area of the Balkans, from central Greece to Moldavia. The best known of these are the wall paintings in the old *katholikon* of the Great Meteoron Monastery, dated to 1483. The twisting figures that disturb the static hierarchy of the portraits, the vivid colors with a penchant for red, and the expressive movements typify the style that, though short-lived, is recognizable in later works in the region. The rendering of the subjects and the highly literate Greek inscriptions attest to the urban nature of this style, which shows awareness not just of earlier monuments in the region but also of Late Gothic art.

Elements of this style can be traced in the most important painterly trend to develop on the Greek mainland in the sixteenth century, the so-called local Epirote school, whose most famous representatives were three Theban painters: Frangos Katelanos and the Kontaris brothers, Georgios and Frangos. Their painted programs are characterized by expressiveness and narrative power that derive from the dynamism of Palaiologan painting mixed with elements of Late Gothic art. Their work also betrays affinities with contemporary Cretan iconography, while at the same time certain decorative details recall the Ottoman floral patterns that were so popular in ceramics, metalwork, and luxury textiles and that put in a discreet appearance in the margins of religious painting.

It is telling that the most important works in this manner are located in the wealthy town of Ioannina and in the major monastic centers in Greece, Meteora, and Mount Athos (see cat. nos. 15, 18). The inscriptions accompanying many wall paintings reveal the identity of the donors and provide a better understanding of the nature and purpose of this art. The patrons include some of the most eminent families in Ioannina and in powerful monastic communities of the sixteenth century, such as the Varlaam Monastery at Meteora and the Great Lavra on Mount Athos. In this context the urban, sophisticated character of the works and the quality of their execution, as well as the carefully thought out iconographic programs, are easily explicable. Unfortunately, the information on the distinguished patrons is not accompanied by data on the training of the painters, which would reveal more about them. However, from the texts of the donor inscriptions, which demonstrate great appreciation for the artistry, or from the presence in the iconographic program of subjects such as Saint Luke and the monk-painter Lazaros, with the tools of the painter's trade, we can discern, if only indirectly, the self-confidence of the artists and recognize that they enjoyed a status similar to that of painters in Venetian-occupied Crete.

The highpoint of this local Epirote style coincides with the time Cretan painters were invited to work at Meteora and on Mount Athos, often on monuments adjacent to those where their Theban and Epirote fellow artists were working for similar patrons. The simultaneous presence of the best representatives of both styles in the major Orthodox Christian centers of the period confirms, on the one hand, the economic vigor of these foundations and their desire to bring together the very best of contemporary religious painters to carry out commissions in accordance with a longstanding Athonite tradition of excellence. On the other hand, it raises the question of the relationship, similarities, and programmatic differences between the two "schools" that were working side-by-side and coexisting in their heyday. Indisputably, subsequent developments in religious painting were influenced decisively by both styles, not only in the sophisticated milieu of the monastic and urban centers but also in rural areas of Greece, where the art was addressed to quite different social groups.

The painters from the village of Linotopi in Epirus, whose artistic output can be traced for some eighty years (1570–1656) through inscriptions in monuments from Serbia to central Greece, are a case in point. This group of painters, who were linked by ties of kinship, exhibits the overriding influence of the art of the Kontaris brothers. In their work, however, the more sophisticated expressions of the sixteenth-century Epirote school were abandoned, along with the traces of Western influence, in favor of a simpler and more easy-to-read narrative iconography. These traits in the art of the Linotopi painters apparently

corresponded to the requirements of their patrons, who were mainly from semi-urban and rural populations. Moreover, it cannot be a coincidence that the Linotopi commissions show such close affinities with many other painted programs in the southern Balkans intended for just such a clientele.

In the above overview of the principal styles in Greek religious painting after 1453, Constantinople, capital of the Ottoman state and seat of the Orthodox patriarchate—the politico-religious institution that was the strongest rallying point and representative agent for Hellenism—is conspicuous by its absence. This omission is due to our scant knowledge of Constantinopolitan religious painting, though workshops undoubtedly existed, as well as of the artistic preferences of the powerful Greek nobles and prelates in the city. Given the close ties known to have existed between the powerful Athonite monasteries, the patriarchate, and other centers of power in the Orthodox world, we may cautiously suppose that the works commissioned for Mount Athos reflect the preferences and values prevailing in Constantinople. This supposition is bolstered by the patchy evidence of post-Byzantine icons known from Constantinopolitan churches, which can often be ascribed to Cretan or Athonite workshops, as well as by information about the presence in Constantinople of artists known to have worked on Mount Athos. Of undoubtedly Constantinopolitan provenance and reflecting the dictates of contemporary secular art are some eighteenth-century icons, naive in execution and decorative in spirit, painted in bright colors, with genre elements and elaborately carved wooden frames (see cat. no. 17). A similar spirit is also seen in more sophisticated contemporary works, such as the paintings of Constantinos Adrianoupolitis, some of which bear dedications on the part of high-ranking church dignitaries, while others are found in the patriarchal church of Saint George at Constantinople, confirming that the painter was expressing the tastes of official circles in the patriarchate. The icons by Adrianoupolitis render religious subjects in exuberant colors and in a calligraphic manner (see cat. no. 16). At the same time, they show a preference for elements borrowed from the Baroque, painted in the manner in which these were appropriated into post-Byzantine art by late-seventeenth-century Cretan painters such as Theodoros Poulakis.

### Selected Bibliography

Acheimastou-Potamianou 1983; Acheimastou-Potamianou 1991–92; Athens 1983; Baltimore 1988; Cattapan 1968; Cattapan 1972; Chatzidakis M. 1976; Chatzidakis M. 1985; Chatzidakis M. 1986; Chatzidakis M. 1987; Chatzidakis N. 1998; Chatzidakis T. 1982; Constantoudaki-Kitromilides 1998; Constantoudaki-Kitromilides 1999; Constantoudaki-Kitromilides 2001; Constantoudaki-Kitromilides 2003; Drandaki 2002; Garidis 1989; Georgitsoyanni 1993; Goldthwaite 1993; Kanari 2003; London 1987; Maltezou 1993; Papadopoulos 1998; Rigopoulos 1979; Semoglou 1999; Stavropoulou-Makri 1989; Tourta 1991; Vassilaki 1997; Vassilaki-Mavrakaki 1981; Vocotopoulos 1990.

## 9. The Adoration of the Magi

Ca. 1560–67
Domenikos Theotokopoulos (El Greco)
Egg tempera on wood
40 x 45 cm (panel), 56 x 62 cm (with frame)
Signed (bottom left): *XEIP ΔOMHNIKOY* (by the hand of Domenikos)
Inv. no. 3048

Augustus Mayer first published this little panel of the Adoration of the Magi in 1935 as a youthful work by El Greco (1541–1614), the name by which Domenikos Theotokopoulos is known. The critical fortune of the piece has been one of general acceptance and it now occupies an essential position within the artist's early oeuvre. The work depicts one of the oldest scenes in Christian art, the Adoration of the Magi, in a rather ambitious version for a painter with a Byzantine education, namely in an iconography and style revealing Renaissance and Mannerist taste.

The principal persons of the scene, the Virgin and Child, accompanied by Joseph, as well as two of the Magi are in what is meant to be an ancient building, with Renaissance architectural elements. The building is in ruins, in order to symbolize the decadence of the old order, which is to be replaced by the new one, through the incarnation of the Savior, the newborn Jesus. The divine child becomes a source of light in himself, illuminating the group around him and, in extension, the entire world, in the persons of the three Magi. Held by his long-veiled young mother, he reaches to the golden vessel offered by the most senior of the Wise Men, kneeling before him in adoration. The other two, one dark-skinned, are standing, while a retinue of attendants with horses accompanies them in a hilly landscape with trees and a distant town barely visible on the left.

The training of the painter in the Byzantine tradition, prevalent in Cretan workshops of the period, is betrayed by details of his technique. However, the influence of Venetian iconography and style is obvious (Bassano, Titian, Veronese), explicable by the presence of Italian paintings in Latin religious institutions and patrician houses of Candia, the capital of Venetian Crete. The majority of the sources used by the painter for specific figures have been identified in Italian engravings by Schiavone, Parmigianino, Boldrini, and Marco d'Angeli. The use of a number of engravings for this work attests to the availability of prints in Crete, also documented by archival sources, as well as to the painter's ability to combine elements from different sources.

The panel generally has been dated to El Greco's Cretan period, before his departure for Venice (1567). It is one of only three surviving works by El Greco exemplifying his Cretan production, the other two being the *Dormition of the Virgin* (Church of the Dormition, Syros) and *Saint Luke* (Benaki Museum, Athens). Although all three works show the influence of Western sources, *The Adoration of the Magi* exhibits the most Westernized iconography and style. Emphasis on color and light, of a distinctly Venetian character, and a Mannerist feeling for movement presage the painter's future tendencies. Some weaknesses and inequalities suggest that it represents one of El Greco's earliest attempts at a "modern" vocabulary. At that time, Renaissance and Mannerist trends had imbued other aspects of culture in Venetian-ruled Crete (architecture, applied arts, literature, and drama) and apparently were preferred by an audience with Humanist interests.

Mayer 1935, 205–7; Herakleion 1990, 150–54, no. 3 (M. Constantoudaki-Kitromilides); Constantoudaki-Kitromilides 1995, 107–10; Xydis 1995, 145–47; Delivorrias, Fotopoulos 1997, 284–85, figs. 475–76; Madrid–Rome–Athens 1999–2000, 360–61, no. 3, ill. p. 248 (M. Constantoudaki-Kitromilides).

M.C.-K.

**10. Icon of the Virgin Madre della Consolazione**
Second half of the 15th century
Cretan workshop
Egg tempera on wood, gold leaf
63 x 45 cm (panel), 94.5 x 61 cm (with frame)
Gift of Helen Stathatos, inv. no. 22059

The Virgin is depicted in half-length, holding the Christ Child in her right arm while resting her left hand lightly on his knee. The only adornment on her garments, in addition to the three established symbolic stars, is a gold-embroidered band of pseudo-Kufic motifs on the border of her deep red maphorion. Christ, turned toward his mother, holds a globe inscribed with a cross in his left hand and raises his right in blessing. He wears an elaborately decorated chiton and a vivid orange himation over his diaphanous undergarment. The figures are accompanied by Latin and Greek abbreviations, which, in conjunction with the manner of the work, indicate that it was probably painted for a Western patron of the Catholic faith. The icon is set in an elegant gilded frame, with colonnettes at the sides and a relief vegetal ornament at the top. Cretan woodcarvers specialized in such frames, inspired by Italian Late Gothic works, which surrounded not only Italo-Cretan paintings but also traditional Byzantine icons.

The iconographic type of the Madre della Consolazione, which this icon excellently reproduces, was crystallized in the thematic repertoire of Cretan icon painters in the second half of the fifteenth century, as deduced by dated examples from this period. Its success is confirmed by the numerous commissions recorded in notary documents as well as by the constancy of the iconographic type, which was preserved until the demise of the Cretan school. In the Benaki Museum icon, the refined, translucent modeling of the flesh, the dulcet incipiently smiling expression of the Virgin, and the soft drapery of the garments, which convey the rich texture of the textiles, reveal an accomplished artist of the second half of the fifteenth century, capable of rendering Western models with the competence that made Cretan painters famous to both the Catholic and the Orthodox public of the age.

Athens 1994, 229, no. 50 (A. Drandaki); Delivorrias, Fotopoulos 1997, 265, fig. 455.

A.D.

## 11. Composite Icon with the Virgin and Child and Angels

Second half of the 15th century

Attributed to Andreas Ritzos or his workshop

Egg tempera on wood, gold leaf

87.5 x 64.8 cm

Inv. no. 3051

The depiction of the enthroned Virgin and Child, flanked by two angels in imperial raiment, on the central panel is surrounded by a raised border with scenes of the Annunciation, Crucifixion, Deposition from the Cross, and Descent into Hell along the top and half-length portraits of saints on the other three sides. Represented on the left side, from the top down, are Saints John the Baptist, Peter, George, and Catherine, while on the right, correspondingly, are Saints John the Theologian, Paul, Demetrios, and Anthony. In the center of the lower register are portraits of Saints Constantine and Helena, surrounded by the hierarchs Saints Gregory, John Chrysostom, Basil the Great, and Nicholas.

The characteristics of the icon are closely associated with signed works by Andreas Ritzos (ca. 1421–1492), one of the most famous painters in Candia (modern Herakleion) at the time, who ran a family workshop with his son Nikolaos. The rendering of the Virgin, with the noble, rather triangular face, and details in the pose and the drapery of both central figures are repeated almost exactly in the icon of the Virgin and Child signed by Andreas Ritzos in the monastery of Saint John the Theologian on Patmos, while the portraits of several saints are encountered in other works by the painter that share the same coloration.

Three of the scenes on the border are repeated in another composite icon (formerly in Sarajevo) bearing the signature of Nikolaos Ritzos. Its recent publication facilitates our understanding of the Benaki Museum panel, since it confirms the use of the same working drawings (*anthibola*) for both icons from the workshop, while simultaneously presenting interesting variations in execution and manner. The figures in the Sarajevo icon are less elegant, the density and the precision of the gold striations in scenes such as the *Descent into Hell* are clearly inferior. These indicative comparisons reinforce the attribution of the Benaki Museum icon to the more competent painter Andreas Ritzos, even though it is certain that his assistants also participated in a host of works attributed to him. The few icons bearing his signature are indisputably the best creations of the workshop.

Athens 1983, 29–30, no. 18; Athens 1994, 232, no. 53 (M. Vassilaki); Delivorrias, Fotopoulos 1997, 269, fig. 459.
For the Sarajevo icon, see Vocotopoulos 2005, 207–26.

A.D.

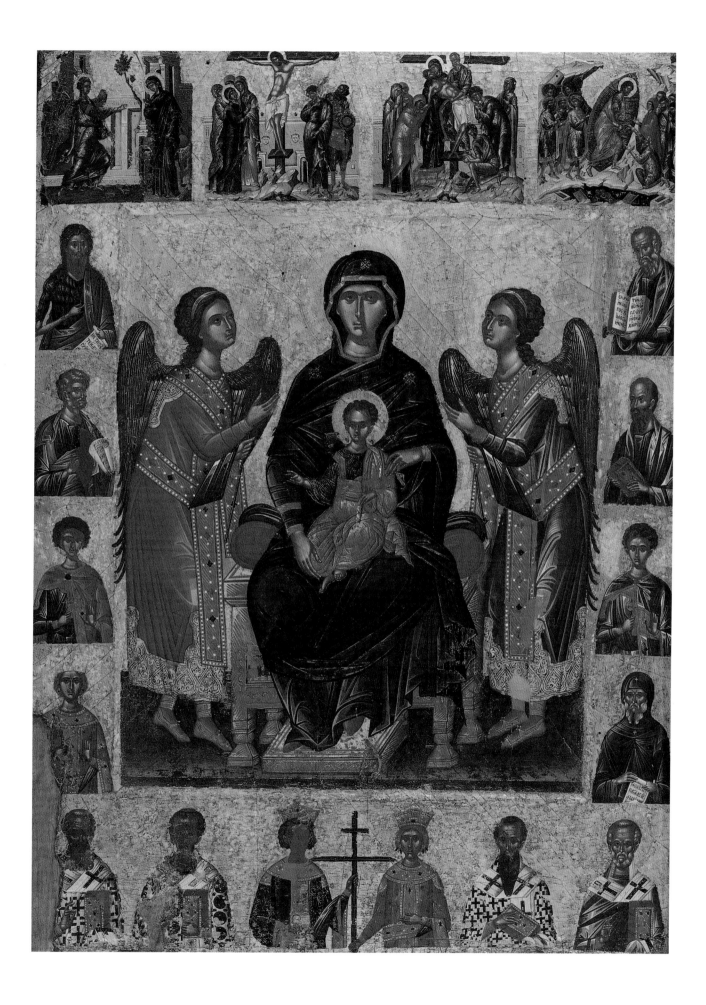

12. **Icon of the Virgin of Tenderness**

1609(?)

Emmanuel Lambardos

Egg tempera on wood, gold leaf, priming on linen

110.5 x 83.1 cm

Signature added in the eighteenth century (bottom right): *XEIP ΕΜΑΝΟΥΗΛ ΛΑΜΠΑΡΔΟΥ ΚΡΗΤΟΣ ΑΧΘ* (By the hand of the Cretan Emmanuel Lambardos 1609)

Inv. no. 2984

In this monumental icon the Virgin is depicted holding the Christ Child in her right arm (Dexiokratousa). Her left arm is passed under the body of Christ, who, with childish tenderness, touches his mother's chin with his hand. The Virgin, correspondingly, inclines her head so that her cheek rests against the little face of her son, in one of the most human moments in the iconography of the Incarnation of the Word. The figures' garments are typical of the representations of Virgin and Child in Cretan icons: a cerise maphorion with long, gold-embellished fringing for the Virgin, a grayish white chiton decorated with florets, and an orange, gold-striated himation for Christ.

The icon is striking for its emotional charge, transmitted by the pose and the expression of both figures. The faces are suffused with human warmth and affection, with a hint of melancholy in the gazes, an integral trait of this representation, which appears in Byzantine art from as early as the tenth century. According to the homilies of the Church Fathers, the fond contact between the Virgin and the Christ Child foreshadows the anguished embrace of the lifeless body of Christ by his mother, after the Passion. This iconographic type enjoyed wide dissemination among Cretan painters from the fifteenth century onward, and the icon by Emmanuel Lambardos reproduces with masterly skill one such early Cretan model.

The artist's signature in the lower part of the icon is a later addition, which probably repeats the effaced original inscription. The Lambardos family of painters was one of the most renowned in Candia (modern Herakleion) during the sixteenth and seventeenth centuries. The Benaki Museum icon is an excellent creation of the workshop and one of the finest works of about 1600, in which a balanced relationship between creative inspiration and elaborate execution is achieved.

Delivorrias, Fotopoulos 1997, 275, fig. 465; Drandaki, Vranopoulou, Kalliga 2000, 189–220.

A.D.

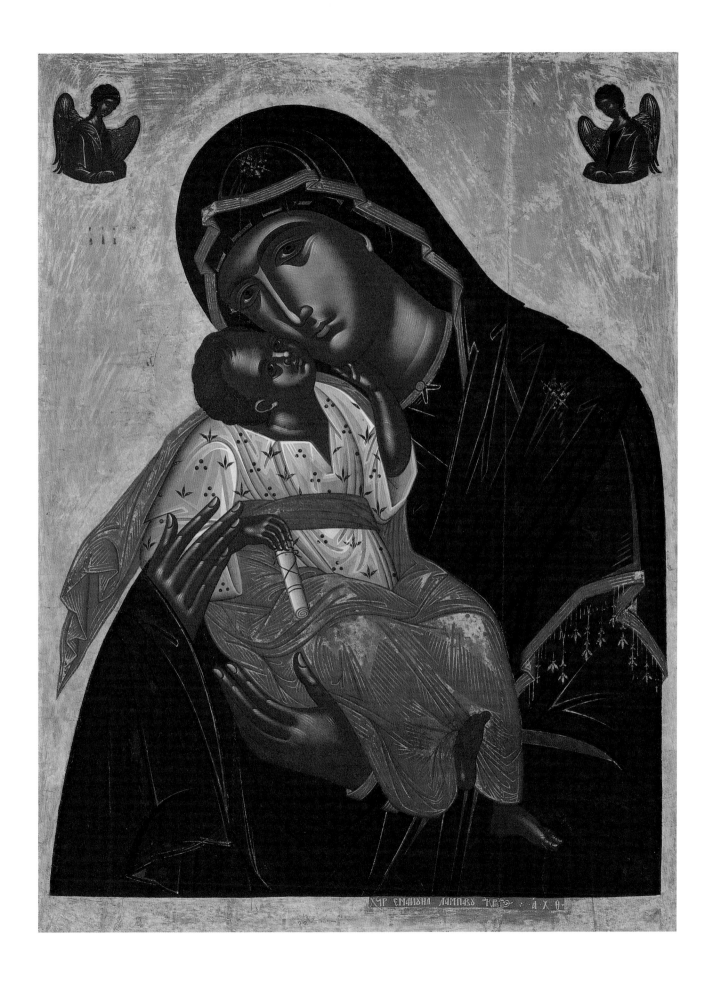

13. **Icon of Saint Mark**
   1657
   Emmanuel Tzanes
   Egg tempera on wood, gold leaf
   66 x 54.1 cm
   Signed (middle right): *XEIP EMMANOYHΛ IEPEΩC TOY ZANE αχνζ* (By the hand of Emmanuel Tzanes priest 1657)
   Gift of Damianos Kyriazis, inv. no. 11198

The Evangelist is depicted sitting on the back of an anthropomorphic lion, inside a building reminiscent of a Venetian mansion. He writes in an open book that rests on the lion's back and turns his head toward heaven, whence projects the hand of God. In his forepaws the lion holds an open Gospel book, in which the opening lines of Saint Mark's Gospel are written in calligraphic script.

This icon, which is in excellent condition, presents the basic characteristics of Emmanuel Tzanes' art in a mature composition. The modeling of the robust figure of the Evangelist is meticulous, with a distinctive emphasis on anatomical details of the veins and muscles. The halo surrounding the figure is elaborately decorated with spiraling leaves set against a punched ground, as is the case in most works by Tzanes after 1654. Saint Mark wears contemporary attire in bright, harmonious colors, with buttons and collar instead of the typical archaic chiton. The drapery is soft and undulous, naturally following the contours of the body. The influence of Western art is further confirmed by the impeccable geometric perspective of the paved floor, an element that occurs in other works by Tzanes. Likewise of Western inspiration is the placement of Mark on the back of the lion, which also serves as a lectern.

In his icon of Saint Mark, Tzanes affirms his ability to assimilate Western models selectively, renewing the vocabulary of late Cretan painting without creating a new iconographic composition of his own conception. Emmanuel Tzanes, priest, man of letters, and famous painter of his day, hailed from Rethymnon. He left his native city after the Ottoman conquest (1646) and lived and worked on the Ionian island of Corfu and in Venice. The artist's signature, written in red capitals on the gold ground of the icon, notes the date 1657, one year before he is known to have settled in Venice.

Drandakis 1962, 121; Athens 1994, 247–48, no. 66 (A. Drandaki); Delivorrias, Fotopoulos 1997, 292, fig. 483.

A.D.

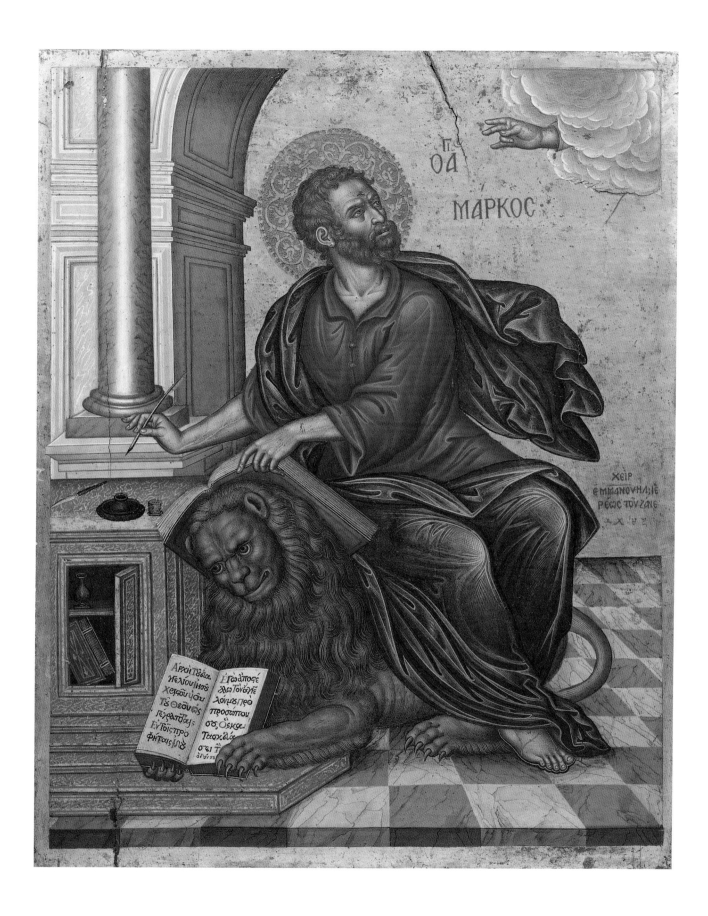

14. **The Beheading of Saint John the Baptist**

Second half of the 18th century

Egg tempera on wood

90.5 x 68 cm

Signature (of dubious authenticity, bottom right): *ΚΟΠΟC ΑΝΔΡΕΟΥ ΙΕΡΟΜΟΝΑΧΟΥ ΤΟΥ ΚΑΛΛΑΝΑ ΑΨΔ*

([By the] effort of Andreas Kallanas hieromonk 1704)

Gift of Aimilios Velimezis, inv. no. 3731

Represented in the open air, outside the prison visible in the background right, is the beheading of Saint John the Baptist by the executioner holding his sword in his raised right hand and two soldiers to whom Herod gives the relevant command. Slightly behind, on the left, Salome, flanked by ladies in her retinue, holds an empty bowl. In the background, in smaller scale, are complementary episodes: Herod's banquet takes place on a palace terrace, while outside a soldier displays the Baptist's severed head to the same female entourage, with Salome in the lead. Higher up, on the gold ground, small angels appear in white clouds. At the bottom right is a signature of doubtful authenticity.

This large icon depicts a subject that was particularly popular with Cretan painters of the sixteenth and seventeenth centuries and subsequently among painters in the Ionian Islands in the eighteenth century. Exemplary for elaborating this iconography were icons by Michael Damaskenos, Theodoros Poulakis, and Philotheos Skoufos. The painter of the Benaki Museum icon remained faithful to these models, in a direct and simple manner, while the work is distinguished by firm drawing, clear and vibrant colors, and, especially, attention and accuracy in rendering details of the Renaissance garments as well as the ladies' diadems and pearls. All these traits are frequently found in icons painted in the Ionian Islands during the second half of the eighteenth century.

Delivorrias, Fotopoulos 1997, 291, fig. 482; Chatzidakis N. 1998, 378–81, no. 51, figs. 238–39 (with earlier bibliography). For the iconography of the theme in icons from Crete and the Ionian Islands, see Vocotopoulos 1990, 51–53, no. 27, figs. 32, 34–35.

N.C.

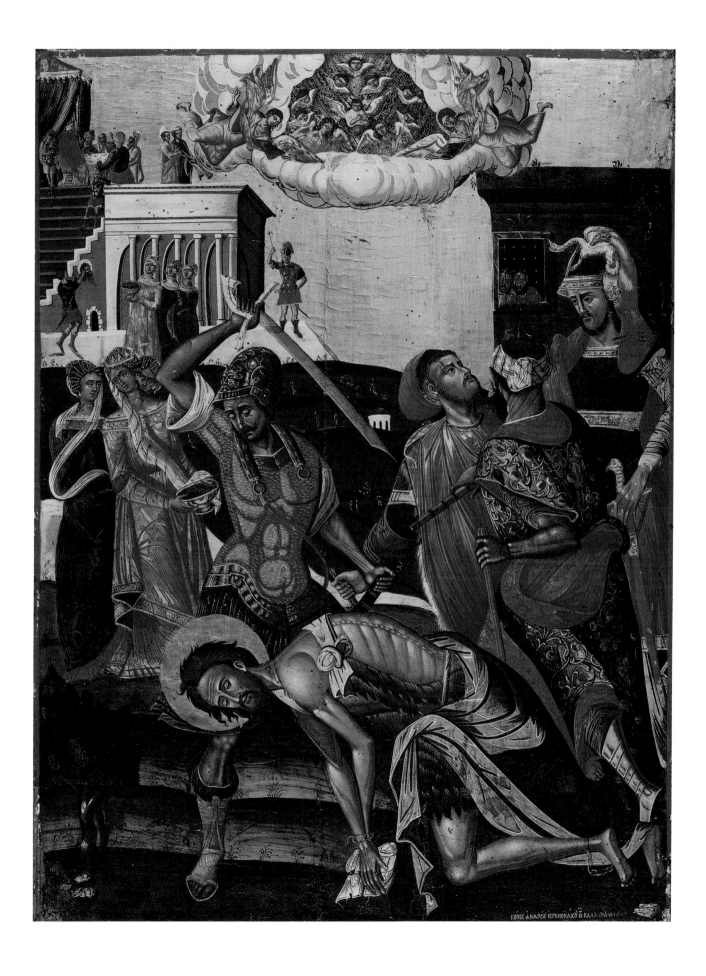

15. **Icon of Saint George with Scenes from His Life**
    Second half of the 16th century
    Workshop of Mount Athos
    Egg tempera on wood
    121.5 x 78 cm
    Gift of Constantinos Kyriazis, inv. no. 36279

The figure of Saint George, full length and in frontal pose, dominates the rectangular panel, which is framed by fourteen scenes from his life. The saint, in military uniform with rose-colored cloak, wears brown cloth boots and golden greaves. In his right hand he holds a spear and in his left the hilt of his sword. His military accoutrement is completed by the bow slung over his left shoulder and the quiver with arrows. Partially preserved in the upper corners are medallions with vegetal designs in gold and an inscription with the name of the saint.

The biographical cycle of the saint is articulated on the four sides of the central image, in the usual manner for vita icons of Saint George and other saints from the thirteenth century onward. The first extensive biographical cycle in monumental painting is found in the church of Saint Sophia at Kiev (1046–67), whereas only a few scenes are illustrated in later churches in Cappadocia. In the Benaki Museum icon, the narration commences with the interrogation of the saint before the emperor. Because he refuses to renounce Christianity, he is tortured: he is pierced with a spear, strapped to a wheel—from which an angel frees him—crushed on the chest by a stone, whipped, and put into a limepit. He destroys the idols of the temple. He works miracles: the raising of the dead and the raising of Glycerius' ox. He is visited in prison by Queen Alexandra, who embraces the Christian faith and is beheaded. There follows the issuing of the order to decapitate the saint, which takes place in the last division.

The handsome and imposing figure of the saint at the center, with slender proportions, aristocratic visage, and refined features, as well as the careful modeling of the flesh with tiny white brushstrokes on the rose underlayer bespeak a competent artist familiar with Cretan painting. These elements, in conjunction with the rendering of the hairstyle and the treatment of the drapery, the choice of colors, the decorated medallions, and the integral raised frame with a red band ascribe the icon to an Athonite workshop of the second half of the sixteenth century.

Unpublished. For the vita icons, see Patterson-Ševčenko 1999, 149–65. For the iconography of Saint George, see Mark-Weiner 1977.

C.K.

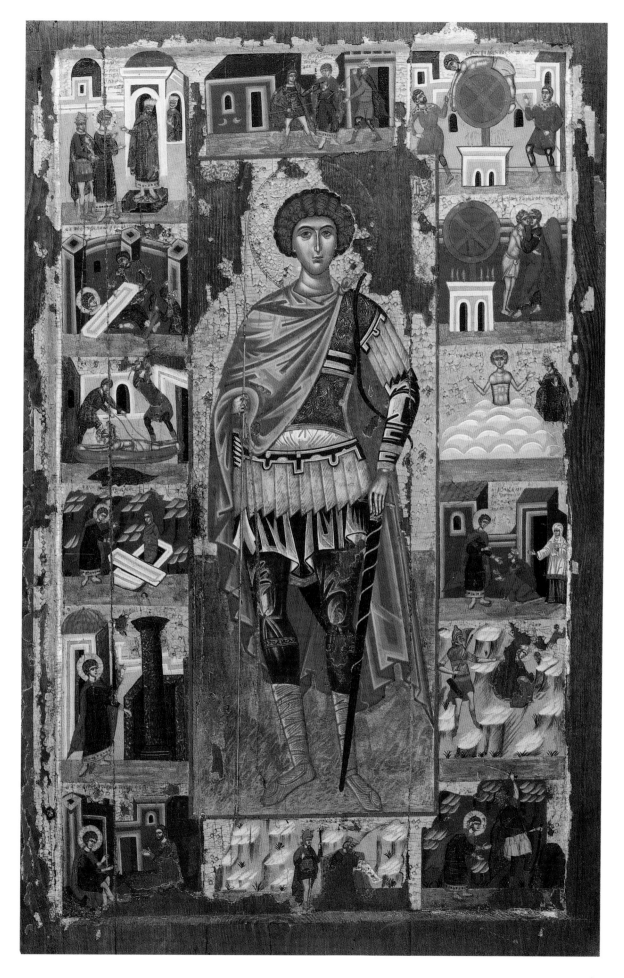

16. **Icon of Daniel and the Three Youths in the Fiery Furnace**
    1724–46
    Constantinos Adrianoupolitis
    Egg tempera on wood, gold leaf
    63 x 48 cm
    Inscribed (below): *δέησῃ του δ(ούλου) του θεού Μισαήλ, μητροπολίτου διδυμοτύχου, εκ νήσου Πάτμου*
    (Prayer of the servant of God Mishael, Metropolitan of Didymoteichon, from the island of Patmos);
    signed (bottom right): *κωνσταντίνου αδρια(νου)πολίτη* (of Constantinos Adrianoupolitis [of Adrianople])
    Inv. no. 3034

The icon represents the story of the three youths (Daniel: 3) and an episode with Daniel in the lions' den (Daniel: 6). Dominating the left side is the fiery furnace with the three youths inside, under the shelter of the archangel. Farther right is the gold statue of Nebuchadnezzar, in the midst of a crowd of worshipers, while in the foreground the king and his courtiers witness the miraculous salvation of the three youths. The kneeling and praying figure in prelatic vestments in front of them is the commissioner of the icon, the Metropolitan Mishael, as recorded in the inscription in the lower part. Another two episodes are depicted independently in the background. At the right, the three youths sit beside the river of Babylon, under a thick cluster of trees, surrounded by their musical instruments (Psalms 137:1), while above the golden statue, Daniel prays in the lions' den. The composition presumably expresses the desires of Metropolitan Mishael, who chose the Three Youths in the Fiery Furnace because he had the same name as one of them, and he combined them with the equally miraculous salvation of Daniel, reinforcing the salvationary prayer he wished to express through his commission.

The icon is signed by Constantinos Adrianoupolitis. In 1746 this artist executed icons for the patriarchal church of Saint George at Constantinople. These commissions attest that Constantinos was held in high regard in superior ecclesiastical circles of his day. His painting displays a penchant for the calligraphic and a love of the decorative, further heightened by vibrant colors. Certain iconographic traits recall works from the circle of Theodoros Poulakis, which follow Western prints and adopt an analogous palette. The Benaki Museum icon should be dated between 1724, when Mishael became Metropolitan of Didymoteichon, and 1746, when he died on his native island of Patmos.

Xyngopoulos 1936, 87–88, no 63, pl. 44; Delivorrias, Fotopoulos 1997, 293, fig. 484; Bitha 2003, 342–45.

A.D.

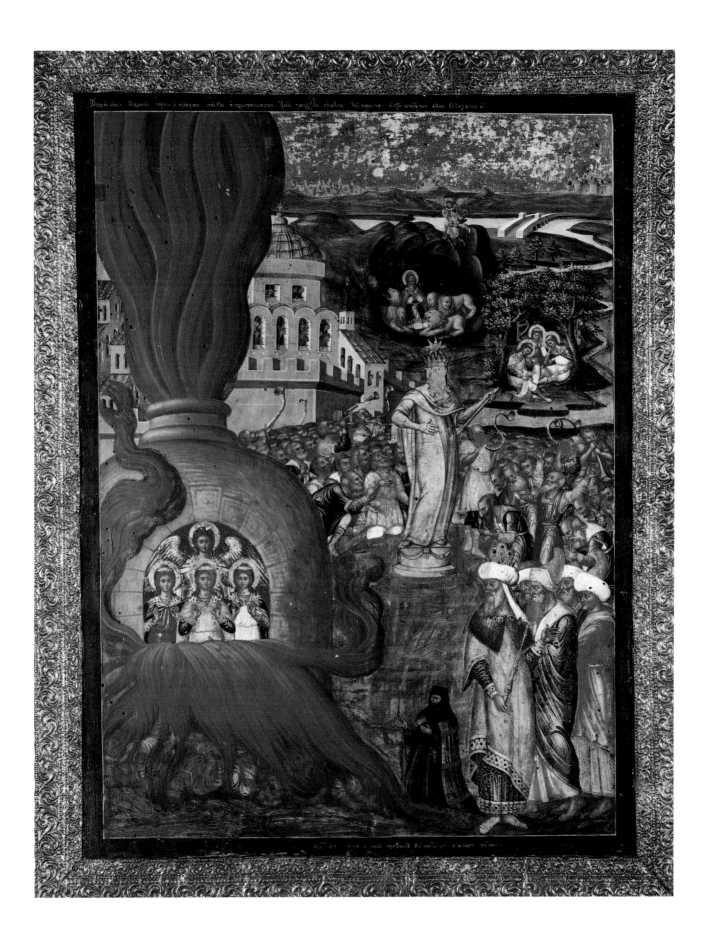

17. **The Second Coming**

   1754
   Avraam
   Egg tempera on wood, gold leaf
   55.5 x 73.5 x 5 cm
   Signed (bottom left): διά χειρός αβραάμ αψνδ απριλίου κδ (by the hand of Avraam, 1754 April 24)
   Gift of Androniki Kalenderi, inv. no. 38241

The representation of the Second Coming includes at the top the heavenly sphere with Christ the judge flanked by choirs of apostles, saints, and martyrs. The multifigured lower part of the composition is developed upon the earth-brown ground and depicts Paradise and the righteous on the right of the Lord and the "voracious maws of Hell" and the damned on his left. Each of the individual episodes is annotated with lowercase inscriptions, so that they are more easily understood.

The work, despite the rather naïve drawing, displays a narrative force that is based on the long tradition of the subject and the vivid coloration. An interesting feature of the scene is the incorporation of elements from everyday life, which are reflected in the dress as well as in the categories of persons arriving to be judged. Thus, noteworthy among the group of the damned, which is inscribed "the rich wrongdoers," are a few ecclesiastical archons and a host of princely figures in luxurious Ottoman attire. Correspondingly, opposite them in the group of the righteous are "the merciful nobles and high-priests" with numerous ecclesiastical leaders at the head, the iconography underscoring the believers' trust in the church hierarchy.

The signature of the painter Avraam and the date of completion of the icon are noted in the legible lowercase inscription at the bottom left. We have no other information on the painter, but both the stylistic traits of the icon and its confirmed provenance from Constantinople suggest that Avraam was active in the Ottoman capital, creating icons in the same artistic idiom as numerous other contemporary works of analogous provenance.

Unpublished.                                                                                          A.D.

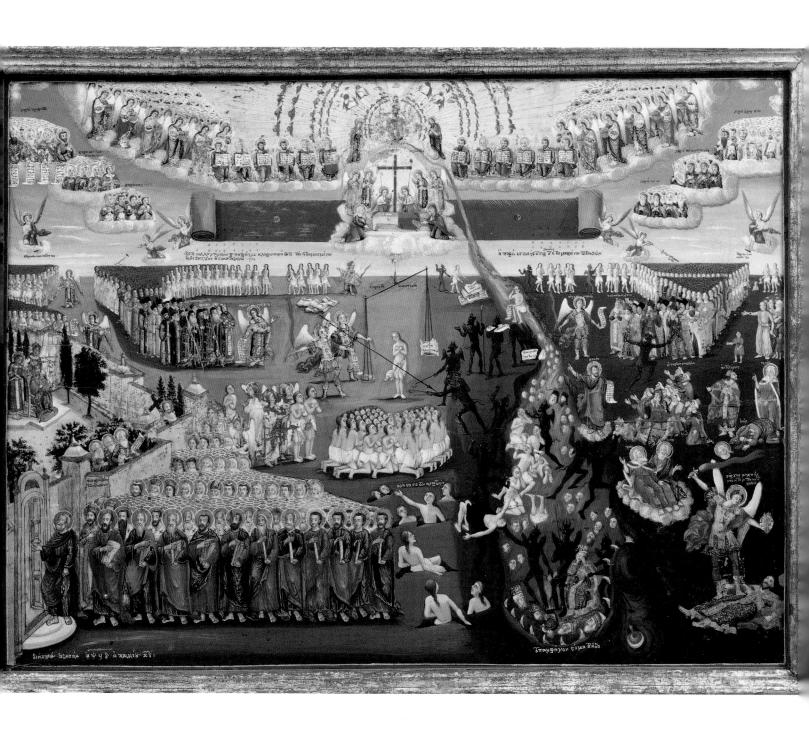

18. **Triptych with the Virgin Portaitissa of Iviron**
16th century
Workshop of Mount Athos
Egg tempera on wood, gold leaf
29 x 43 x 4.5 cm
Inscribed (on central leaf): *M(HT)HP Θ(EO)Y* (Mother of God); *Η ΠΟΡΤΑΙΤΙΣΣΑ* (Our Lady of the Gate);
*I(HCOY)C X(PICTO)C* (Jesus Christ); (on left leaf): *O ΑΓΙΟC ΔΩCΙΘΕΟC* (Saint Dositheos); (on scroll): *O ΥΠΑΚΩΗΝ
KTHCAMENOC METATA* . . . (The one who achieved obedience . . . ); (on right leaf): *O ΑΓΙΟC ΕΛΕΥΘΕΡΙΟC*
(Saint Eleutherios)
Inv. no. 8267

Depicted on the central leaf of the triptych is the Virgin and Child, with the appellation Portaitissa (Our Lady of the Gate). The subject reproduces the cult icon of the same name in the Iviron Monastery, one of the most venerated relics of Mount Athos, which is dated to the late tenth to early eleventh century. The red mark on the Virgin's cheek represents the wound that, tradition has it, was inflicted on the venerable icon by an Arab pirate's sword. Depicted on the left leaf, according to the inscription, is Saint Dositheos, a tormented figure of an ascetic in a monk's habit. In his right hand he holds the cross of martyrdom, which is barely visible, and in his left an open scroll with an inscription stressing the value of obedience, well suited for a monk who achieved sainthood as an ideal subordinate of Saint Dorotheos. On the right leaf is Saint Eleutherios, in prelatic vestments, holding a closed Gospel book and raising his right hand in a gesture of blessing.

The flesh is modeled over an olive-green underlayer, with ocher skin tones and white highlights freely executed in a painterly manner, emphasizing the volumes on the faces and hands. The work is distinguished by the expressive power of the figures and the translucency of the pigments, particularly apparent on Saint Dositheos' garb, beneath which the discreet incised and drawn preliminary sketch of the representation is discernible. The decorative aspect conveyed by the punched rosettes on the halos of the central figures is common in Athonite works of the seventeenth century and is probably due to a later embellishing of the triptych.

The shape, the stylistic traits and the iconography of the triptych link it to a good workshop at Mount Athos that was thoroughly familiar with the Palaiologan tradition. The similarities with sixteenth-century works are consistent with the wide popularity of the cult of the Virgin Portaitissa during this period. The combination of Saint Eleutherios with the rare depiction of Saint Dositheos, whose name was frequently given to monks, probably expresses the personal choice of the commissioner of the icon.

Baltimore 1988, 235–36, no. 79 (L. Bouras, with earlier bibliography). For the cult of the Portaitissa, see Chryssochoidis 2005, 133–42.

A.D.

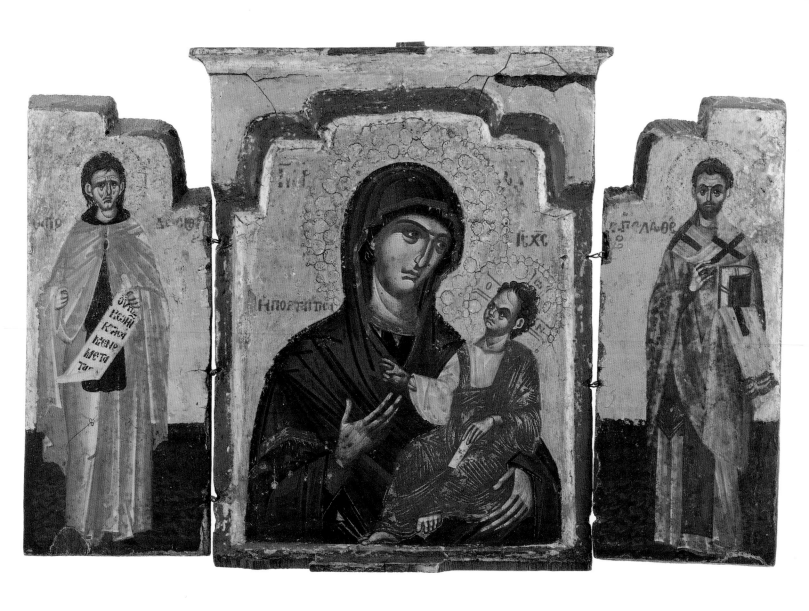

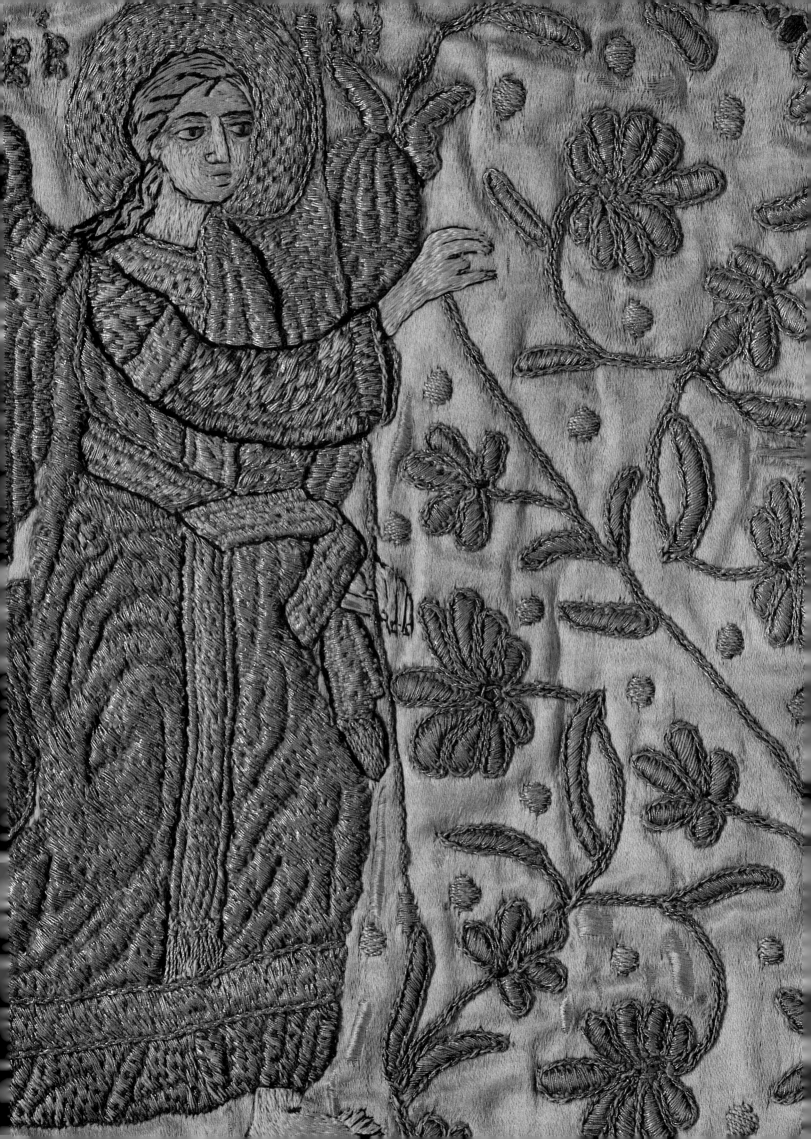

# SILVER AND GOLD:
## CHURCH PLATE AND LITURGICAL VEILS OF THE SIXTEENTH TO EIGHTEENTH CENTURY

Anna Ballian

The arts of silverwork and gold embroidery serve the needs of the church for sacred vessels, hieratic vestments, and liturgical veils. The traditional shape and iconography of these objects correspond to their preordained use and to the symbolic ideological content sanctified by the celebration of the Divine Liturgy. Ecclesiastical art is conservative to the degree that it expresses dogma and serves worship but is innovative to the extent that it follows the currents of secular art and is transformed through them. In the case of silverwork and gold embroidery, the same craftsmen frequently fashioned both ecclesiastical and secular works, using precious materials—silk and gold thread, silver, gilding, and glittering stones—in order to meet the worldly demand for social prestige.

The surviving works are predominantly representative of the Greek world under Ottoman rule and few are from the Venetian-held territories. Characteristic is the phenomenon of Crete: in contrast to the large number of portable icons, hardly any pieces of silverwork and no example of gold embroidery of certain Cretan provenance have survived. Yet the Venetian archives are extremely rich in information about gold jewelry and silver objects, which are recorded in contracts, dowry agreements, and wills. Although the echo of Byzantine gold- and silverwork still resonates, the descriptions more readily bring to mind the ornaments and vessels of the Renaissance and the Baroque. From a combination of archival records and documented artistic development in the urban centers of Crete, it is possible to attribute ecclesiastical (see cat. no. 23) and secular items of jewelry, outstanding for their associations with Venetian or more generally Western European art, to Cretan workshops. In the case of gold embroidery, the lack of works—or our inability to identify them—is striking in relation to the confirmed considerable output of the Cretan monastery of Arkadi in the 1660s, which was sufficient to supply monasteries on the Greek mainland as well (see cat. no. 19).

The role of the capital of the Ottoman Empire and the seat of the ecumenical patriarch was pivotal in the production of gold- and silverwork and gold embroidery. Our knowledge of liturgical vessels and vestments in the years just after the fall of Constantinople is scant. Ecclesiastical sources refer to extensive looting. Patriarch Sophronios wrote in 1464: "Because our homeland fell . . . many of the sacred objects of the faith were uncouthly trampled by the godless Turks, despotic icons . . . sacred vessels, chalices and Gospel books, holy crosses, and other sacred objects." Organized artistic activity is first evidenced in the sixteenth century, when the shock of the Ottoman conquest had subsided, and is linked with the founding or refounding of monasteries, decorating their churches with paintings, and equipping them with liturgical paraphernalia. The phenomenon initially was located on the Greek mainland and at the major monastic centers of Meteora and Mount Athos and may be associated with the monasteries' close connections with patriarchal circles, as attested in the sources. In the 1570s Patriarch Jeremiah splendidly renovated the patriarchal

Cat. no. 21. *Maniple* (detail). 16th century. Silk, gold and silver wire. Inv. no. 9323

69

church of Pammakaristos. The encomiastic description by Manuel Malaxos, spoken like a true Byzantine courtier, compares it to an earthly heaven, lavishly furnished with golden iconostasis, icons, hanging lamps, and a grand throne on which the patriarch sat as "lord and despot of the *oecumene* (universe)." All that has survived from Jeremiah's day are his wooden throne, a typical example of Ottoman decoration with inlaid ivory, and his *omophorion* (bishop's stole, or pallium), gold embroidered with religious scenes comparable to those on Athonite *epitrachelia* (stoles). In each case the intensive artistic activity of this period reflects the renewed prestige of the church, which derived from its institutional integration in the Ottoman administration and the consolidation of its economic holdings.

The works in the exhibition are explored within two selective parameters that are complementary and, to a significant degree, highlight the peculiar character of ecclesiastical art in this period. The first parameter concerns the identification of continuity or discontinuity with the Byzantine past, the second identifies the social agencies behind the donation of works of art.

The relationship with Byzantine tradition is multidimensional and directly recognizable—in fact, it has been invoked frequently—and sometimes excessively—as the sole characteristic of this art. However, it is important that this relationship is not seen in the repetition of established or crystallized art forms but in the development of the trends of the Late Byzantine period, which continued even after the Ottoman conquest. A case in point is the veil of the *epitaphios*, the iconographic and liturgical evolution of which continued unbroken from the Palaiologan era to the post-Byzantine period. The earlier symbolic depiction of the lifeless body of Christ, surrounded by the heavenly hosts, was gradually transformed from the late fourteenth century into a narrative image of the Lamentation (see cat. nos. 19, 22), in which all the historical persons from the Gospel are represented. In the case of salvers for blessed bread (*antidoron*), the link with Byzantine tradition is exclusively drawn from the sources. No such Byzantine salvers have survived, whereas from the sixteenth and primarily the seventeenth centuries onward, they are among the most characteristic and imposing silver plate donated to churches (see cat. no. 29). It seems that the distinction into patens for the consecrated bread of the Holy Communion and salvers for the blessed bread, which is encountered in fourteenth-century texts, later developed into a rule.

Continuity of Byzantine tradition is of additional interest when it is combined with changes in use and content. The double-headed eagle (see cat. no. 24) was widely used in the thirteenth and fourteenth centuries as an emblem and a symbol of royal power by the Palaiologoi and other imperial families. The emblematic use of the double-headed eagle, now denoting imperial ancestry, was continued in the sixteenth century by the descendants of the Byzantine princes. Michael Kantakouzenos (or Seitanoğlu) sealed his correspondence with the double-headed eagle, while Patriarch Jeremiah the *Tranos*—the prosonym denotes noble origin—used it in the decoration of the patriarchal throne. From at least the beginning of the seventeenth century, the double-headed eagle was established as the official seal of the patriarch of Constantinople, underlining the temporal nature of his office as leader of the Christians in the Ottoman Empire, and was used, by extension, by all the prelates of the church.

Cases of discontinuity in Byzantine tradition presuppose a break or an innovation, but since these are defined in relation to the past they may reveal

earlier experiences and trends. A particularly interesting example is the myrrh flask from Trebizond (see cat. no. 27). Despite the religious content of its inscription, the vessel bears no relation to other ecclesiastical objects for the same use but reflects the spirit and orientations of Ottoman art. It is a creation of Christian craftsmen in Trebizond, whose activity in the goldsmith's art is recorded from the reign of the Grand Komnenoi (1204–1461) until after the Ottoman conquest. Sixteenth- and seventeenth-century Ottoman sources refer admiringly to the skill of the Greek goldsmiths, who taught their art to the famed sultans Selim I (1512–1520) and Süleyman I (1520–1566), who were born in Trebizond and served as governors of the city before they ascended the throne of the Ottoman Empire.

The wearing of a miter by the patriarch of Constantinople was an innovation of the period after the Ottoman conquest, possibly under the influence of the Western church. It was introduced formally during the patriarchate of Cyril Loukaris, in the early seventeenth century, and subsequently was adopted by metropolitans and bishops. This innovation essentially follows the tradition of patriarchal appropriation of Byzantine imperial attributes and insignia. The phenomenon appears in the sources and the iconography from the early fourteenth century and is linked with the weakening of the institution of the emperor as the empire waned and the patriarch's assumption of an ecumenical leadership role. The substitution of the emperor for the patriarch, and the consequent attempt to identify political with religious authority, reached its peak with the introduction and establishment of the miter, which took the form of a Byzantine imperial crown or a princely and prelatic head covering (see cat. no. 26).

The second way of approaching the works presented concerns the patrons-donors and enables us to link the objects with the social strata that supported their production and use. Items in silverwork and gold embroidery usually are accompanied by dedicatory inscriptions that record the name of the donor, the expected recompense—in memoriam or for the salvation of the soul—the place or the church to which the donation was made, the year, and perhaps the name of the craftsman. The preservation of works, particularly of the sixteenth century, is sporadic, but from the seventeenth century onward the available material increases, facilitating the association of historical information with written testimony.

In the first centuries after the Ottoman conquest, donors were primarily members of the higher echelons of the church hierarchy, the patriarchal court, and the leading monastic circles, Orthodox Romanian princes and their courtiers, and powerful Christian notables who acquired wealth by undertaking services and offices in the Ottoman administration. In each case the dedications are of discerning taste and reflect the leading position of the church, which functioned as a centralized authority. They come mainly from workshops in major urban centers, which, in the case of Constantinople and the Danubian principalities, also served art at the court. Artistic production is characterized by two basic constants: the devotion to the legacies of post-Byzantine iconography and the quest for innovation through the currents of contemporary Ottoman or Western European secular art.

From the seventeenth century onward, the gradual weakening of central Ottoman authority had repercussions for the social formation and economic standing of the conquered subjects. In the great imperial capital the changes became obvious in the emergence of the class of Greek nobles,

the so-called Phanariots, who were appointed to the highest offices by the Sublime Porte, as well as in the creation of the economically powerful class of the "most noble negotiators," who were the heads of guilds in the capital, such as those of the furriers and the grocers. The involvement of lay nobles in the administration of the patriarchate progressively increased, paralleling their assumption of a prime role as donors and patrons. Silverwork and gold embroidery of the second half of the seventeenth and the early eighteenth centuries from Constantinopolitan workshops spearheaded contemporary trends, combining elements of Ottoman and Western European art, and created paradigms that were promoted in the provinces. Their quality and aesthetic depended on the status of the donors, which was high in the case of the combined patronage of the guild of furriers and of Neophytos, the metropolitan of Adrianople (see cat. no. 29). More in tune with market demands is the workmanship on the flabella of the Galata notable Kyritzis Laskaris, reflected in the ready-made medallions stamped from a mold (see cat. no. 31). Standardization was prescribed by demand and was accompanied by the increasing prevalence of decorative motifs from secular art. The Christian workshops in the Ottoman capital supplied the provincial churches with ecclesiastical silverware and liturgical textiles and the community primates with luxurious jewelry and garments, which were imitated in turn by local craftsmen.

Contacts between the Christian population of the Ottoman Empire and the semi-independent regions of Wallachia and Moldavia, as well as with the flourishing Greek communities in Western Europe—that in Venice predominant among them—played a decisive role in forming the aesthetic of the age and in introducing Western European models. In Jassy (modern Iaşi) and Bucharest, where Greek scholars, nobles, and prelates were settled, a climate that was protective of the Orthodox church was cultivated, under the leadership initially of the Romanian princes and later of the Phanariots. The Romanian princes dedicated ecclesiastical silverware at major Orthodox monastic and other religious centers. These objects were wrought by silversmiths of Transylvania, who, working in the mode of Central European art, adapted Orthodox iconography to German Baroque models. The Serenissima Republic of Venice continued to export luxury goods to the East until the eighteenth century, and the influence of Venetian silverwork is evident not only in the Venetian-held territories but also in the Ottoman-occupied lands. It is significant that from the sixteenth century on, the first printed Greek books, mainly ecclesiastical, were produced in the thriving Greek community in Venice. Illustrated with Venetian prints and promoted to even the most far-flung Christian communities, these volumes offered Greek craftsmen in the provinces models to reproduce and transform.

The preconditions for the standardization and secularization of ecclesiastical art, which are observed in the capital in the late seventeenth century, were intensified and diffused to the provinces in the eighteenth century, when the conditions of Ottoman decentralization favored the development of local communities. The phenomenon of building churches and of decorating them with paintings and furnishing them with equipment increased spectacularly, reflecting the extraordinary growth of Greek commerce and enterprise over a geographical spectrum spanning Asia Minor to the regions north of the Danube, wherever Greek communities were active and prospering. At the parish, village, or town level, the primates, together with the local ecclesiastical leadership and, in the case of urban or semi-urban centers, the guilds, directed artistic production,

which became an objective of local initiative and expressed local collective identity. The terms of artistic production changed; donors were no longer predominantly prelates and magnates but local dignitaries and affluent merchants. As a result, art bears the stamp of popular taste and displays a uniformity that is underlined by the universal adoption of Oriental Baroque and Rococo decoration, fostered primarily in the Ottoman capital. Social differentiation also affected the class of craftsmen, who increasingly signed their works. The traditional distinction of gold-embroidery workshops into urban and monastic still held. However, a large number of silversmiths, along with masons, master builders, and painters, coming from small settlements and main villages, were organized in itinerant family-based teams and worked on both secular and ecclesiastical commissions. The phenomenon of the secularization of ecclesiastical art is not unrelated to the improvement of living standards for Greeks and their interest turning to the West, whence the ideas of the Enlightenment were introduced, kindling the processes of shaping a national consciousness and subsequently claiming national independence.

**Selected Bibliography**
Ballian 1998; Ballian 2001a; Constantoudaki-Kitromilides 2000; Istanbul 1983; Johnstone 1967; Konortas 1998; New York 2004; Nicolescu 1967; Rogers, Köseoğlu 1987; Thessaloniki 1997b; Vlachopoulou-Karabina 1998; Zachariadou 1996.

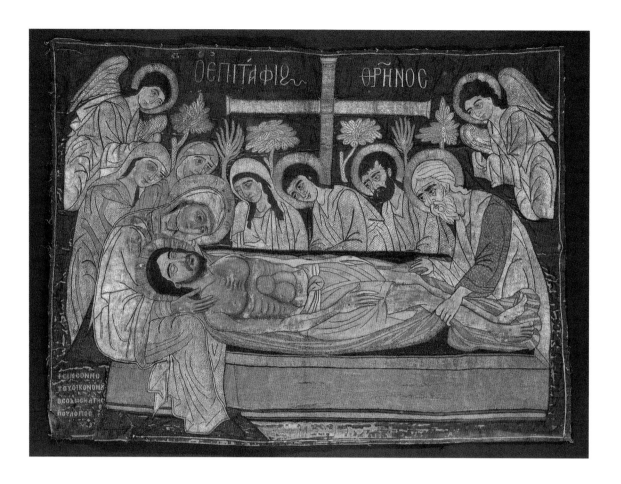

### 19. Liturgical Veil with the Lamentation

1599
Silk, gold and silver wire
Height 80 cm, width 107 cm
Inscribed (above): *Ο ΕΠΙΤΑΦΙΟC ΘΡΗΝΟC* (The Lamentation); (below left): *+CΙΜΕΟΝΗC ΤΟΥ ΟΙΚΟΝΟΜΟΥ ΘΕΟΔΩCΗΑ ΤΗC ΠΟΥΛΟΠΟC* (of Symeoni Oikonomou [and] of Theodosia Poulopos)
Inv. no. 9338

This type of liturgical veil, or *epitaphios*, is used as an image of the Lamentation in the Good Friday procession. The lifeless body of Christ lies upon a red stone between the Virgin and Joseph of Arimathea, accompanied by the three lamenting women, John the Evangelist, and Nicodemus. In the background stand the cross of Calvary and six small trees; at the sides, two angels bow, their hands covered in a gesture of respect.

The scene, devoid of the symbols associated with the Divine Liturgy, depicts instead historical persons from the Gospels, rendered with and emphasis on the large faces and prominent features, emanating restrained grief and sobriety. The embroidered representation acquires the character of a painted image, the models for which are to be sought in sixteenth-century depictions of the Lamentation in Athonite wall paintings or in portable icons such as those by the Cretan artist Emmanuel Lambardos.

The painterly effect and the absence of symbols of the heavenly liturgy differentiates this *epitaphios* from contemporary examples created in workshops in Constantinople, Meteora, and the Danubian principalities. The female names in the inscription—one of which might be of the embroideress—rule out the possibility of an Athonite workshop. The wide circulation of portable icons that could have been used as a model for the representation makes it complicated to attribute the veil to a specific workshop. Two possibilities for further investigation might be Constantinople, where various stylistic tendencies developed, or Candia, where, despite the lack of extant works from this period, the rich documentation of Cretan gold embroidery from the mid-seventeenth century onward suggests the existence of an earlier tradition.

Vei-Chatzidaki 1953, 12, no. 20; Athens 1994, 289, no. 128 (A. Ballian); Delivorrias, Fotopoulos 1997, 298, fig. 491. For examples of portable icons with the Lamentation, see Athens 2001, 348–55, nos. 128–31.

A.B.

20. **Stole**

1600

Silk, gold wire

Length 138 cm, width 27 cm

Inscribed (on neck): *ETEI ZPᵂ Hᵂ ΘΕΟΦΑΝΟΥΣ ιερ(ομον)αχ(ου)*
(In the year 1600 of Theophanis hieromonk [a reference to the embroiderer
or the owner of the stole]); (at the side of the figures, from top to bottom):
*M(HTH)P Θ(EO)Y* (Mother of God) and *IΩ(ANNHΣ) Ο ΠΡΟΔΡΟΜΟΣ*
(John the Baptist), *Ο ΑΓΙΟΣ ΙΩ(ANNHΣ) Ο ΧΡΙΣΟΣ(ΤΟΜΟΣ)* (Saint John
Chrysostom) and *Ο ΑΓΙΟΣ ΚΙΡΙΛΟΣ* (Saint Cyril), *Ο ΑΓΙΟΣ ΓΡΙΓΟΡΙΟΣ*
(Saint Gregory) and *Ο ΑΓΙΟΣ ΑΘΑΝΑCΙΟΣ* (Saint Athanasios),
*Ο ΑΓΙΟΣ ΒΑCΙΛΙΟΣ* (Saint Basil) and *ΑΓΙΟC ΝΗΚΟΛΑΟΣ* (Saint Nicholas),
*Ο ΑΓΙΟΣ ΓΕΩΡΓΙΟΣ* (Saint George) and *Ο ΑΓΙΟC ΔΗΜΗΤΡΙΟΣ*
(Saint Demetrios)

Inv. no. 9337

The stole, or *epitrachelion,* is the diacritical vestment of the priest, which is also
worn by the superior ranks of the clergy. A long strip of cloth that surrounds the
neck and hangs downward, held together on the chest with buttons or tiny bells, it
usually shows the Deesis—Christ, the Virgin, and Saint John the Baptist, followed
by hierarchs and saints in alignment—recalling the corresponding representation of
them on the walls of the sanctuary.

Represented on the neck, in three gold-embroidered medallions, are Christ
Emmanuel blessing and two angels turned toward him in reverence. On the rest of the
vestment the Virgin and Saint John the Baptist, hierarchs, and saints are arranged in
pairs in five zones separated by rosette bands. Saplings reminiscent of cypresses
adorn the ground, and in three of the zones the figures are depicted below peculiar
lobed arches.

The hierarchs are depicted frontally, with their familiar iconographic traits—
except Cyril, who does not wear his cross-patterned cap—and holding a Gospel
book. Special attention has been paid to depicting all the diagnostic elements of
episcopal attire. Outstanding in the outermost panels are Saints George and
Demetrios, in the secular dress of nobles. Although the workmanship of the stole is
not particularly skillful, the contrast between the gold embroidery and the relatively
plain red silk is impressive.

Vei-Chatzidaki 1953, 11, no. 19; Athens 1994, 288, no. 125 (A. Ballian); Delivorrias,
Fotopoulos 1997, 304–5, figs. 501–2.                                        A.B.

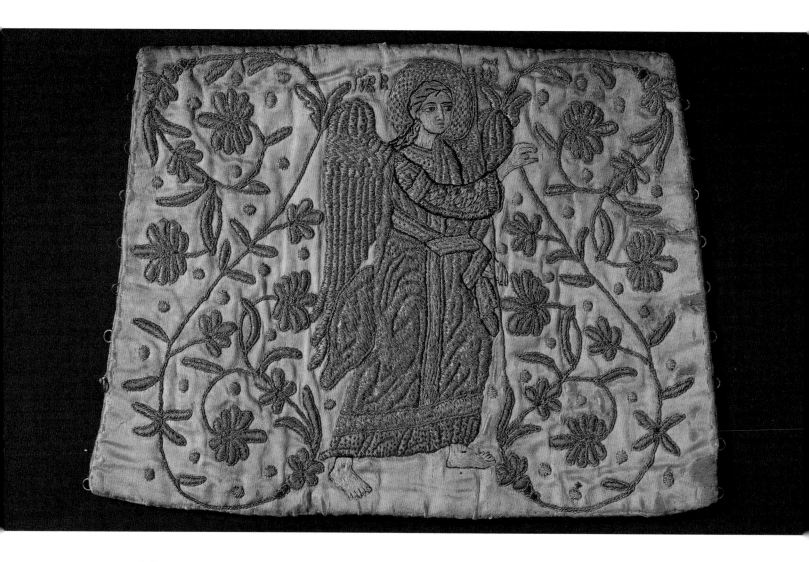

### 21. Maniple

16th century
Silk, gold and silver wire
Height 19 cm, width 27 cm
Inscribed (left and right of angel's head): ΓΑΒΡΙ ΗΛ (Gabriel)
Inv. no. 9323

Maniples are detachable cuffs worn by officiants of all ranks in the Orthodox Church to cover the lower edge of the sleeves of the inner garment and, like many other sacerdotal vestments, derive from the secular attire of late antiquity. Initially they were an accent of episcopal dress and were used for practical reasons during the rite of Baptism. However, after the fifteenth century the privilege of wearing them was extended to priests and later to deacons. A typical subject for the decoration of maniples in the post-Byzantine period is the Annunciation, with the archangel Gabriel represented on one and the Virgin on the other.

The embroidered representation is of the archangel Gabriel, turned in lively movement toward the side of the other maniple, now lost, on which the Virgin was depicted. The angel wears the deacon's stole, which falls from his left shoulder. He blesses with one hand and holds the glaive with the other. On the ground, the well-drawn foliate stems with flowers bring to mind lilies and replace the flower held by the angel of the Annunciation. The elegant, blond figure of the angel with serene facial features and the calligraphic treatment of his drapery point to a sophisticated workshop or a proficient embroiderer, while the discreet presence of the flowers probably indicates a date in the sixteenth century.

Vei-Chatzidaki 1953, 9, no. 5; Athens 1994, 288, no. 126 (A. Ballian); Delivorrias, Fotopoulos 1997, 307, fig. 507.

A.B.

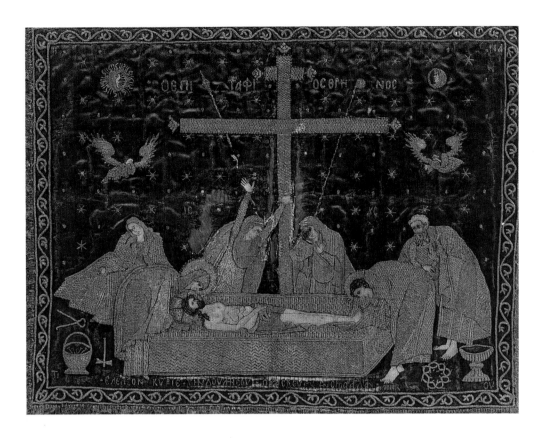

## 22. Liturgical Veil

16th–17th century
Silk, silver wire
Height 40 cm, width 53 cm
Inscribed (above): *O ΕΠΙΤΑΦΙΟC ΘΡΗΝΟC* (The Lamentation); (below): *ΕΛΕΗCΟΝ ΚΥΡΙΕ ΤΗΝ ΔΟΥΛΗΝ COY ΠΑΡΑCΚΕΥΗΝ ΤΗΝ CΜΑΡΑΓΔΑΝ* (Lord have mercy on thy servant Paraskevi Smaragda); (in each of the four corners): *ΙΓ ΝΑ ΤΙ ΟΥ* [a syllable of the name Ignatios, probably the embroiderer]
Inv. no. 34682

Represented on the veil is the Lamentation, with the Virgin and John the Evangelist bowing deeply over the dead body of Christ while Nicodemus and the three women lament with vigorous gestures. Characteristic is the figure of Mary Magdalene, who mourns with her arms raised. Dominating the starry ground is the double cross of the Resurrection, between the lance and the sponge, flanked by two little grieving angels with covered faces and the cosmic symbols of the sun and the moon. In the foreground are the rest of the instruments of the Passion: the basket with nails, the pliers and the hammer, the crown of thorns, and the vessel of vinegar.

The iconography of the scene, known both from Palaiologan models and from fifteenth-century Cretan painting, incorporates elements from Western art and transfers the emphasis to the dramatic content of the event. The tall, slender figures with small heads are reminiscent stylistically of Slavic and Moldavian gold embroideries of the fifteenth and sixteenth centuries, which were influential even in Constantinople. A similar iconography, characteristic of the seventeenth century, is encountered on the *epitaphios* by Pagonis from the Xiropotamos Monastery on Mount Athos, which is attributed to a Greek mainland workshop.

The liturgical veil is thought to have been used as an *antimensium*—that is, as a portable altar where there was no church, such as on a ship, in a military camp, or at a hermitage. However, the surviving examples of the sixteenth to seventeenth century are painted on linen with the symbols of the Passion or the Man of Sorrows and are always accompanied by inscriptions referring to their use and sanctification. It is possible that the Benaki Museum liturgical veil is a small *epitaphios* that served as an image of the Lamentation in the Good Friday liturgy.

Vei-Chatzidaki 1953, 8, no. 3; Athens 1994, 289, no. 127 (A. Ballian); Delivorrias, Fotopoulos 1997, 300–301, figs. 493, 495. For the *epitaphios* from the Xiropotamos Monastery, see Thessaloniki 1997b, 409–10, no. 11.23 (M. Theochari).

A.B.

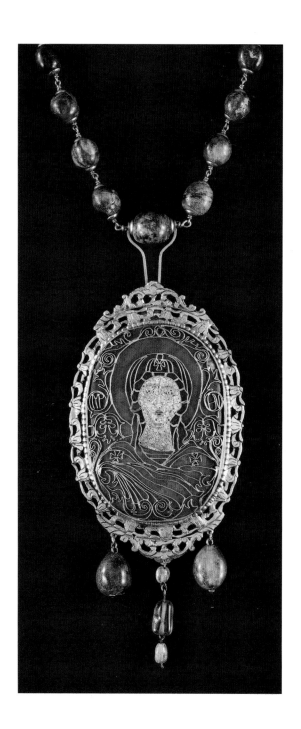

### 23. Pectoral

1580

Gilt silver, filigree, agate, emeralds, amethyst, enamel
Height 10.3 cm, length of chain 39.5 cm
Inscribed (on the silver leaf on the back): *+ENΓKOΛΠION.
ΑΓΙΟΝ. ΛΥΘΟΝ ΚΟΣΜΗΘΕΝ./ΔΩΡΟΝ ΘΕΙΟΝ
ΔΩΡΕΙΤΑΙ ΤΗ ΑΓΙΑ ΗΓΟΥΜΕΝΗ ΘΕΟΦΑΝΩ./ΕΤΟC.
Α.Φ.Π.* (Pectoral. Holy. Stone ornamented./Divine gift
donated to the Holy Abbess Theophano./Year 1580);
(on the front, in abbreviations): *M(ήτη)P Θ(εο)Υ* (Mother
of God)
Gift of Alexandra Choremi-Benaki, inv. no. 1799

Outlined on the brownish yellow agate set within a Renaissance
mount is a filigree figure of the Virgin modeled after post-Byzantine
icons. The face and neck are filled with white enamel, while the
garment covering the head and shoulders and the ground are
rendered with plain wire filigree, reminiscent of the revetments of
Palaiologan icons. The pendant is suspended from a chain
of emeralds and from its base hang emeralds and an amethyst.

The pendant features a rare application of filigree technique
in a figural representation. Twisted wire filigree with exclusively
foliate designs is usually associated with Venetian silverwork of the
thirteenth century. Its subsequent development in Venice is vague,
but in regions to which Venetian art infiltrated it is encountered
later combined with enamel, as in the Venetian-Byzantine hoard
of Chalkis (1470) and in early-sixteenth-century Hungarian pieces.

The combination of the Renaissance mount with the post-
Byzantine iconography and the singular use of the filigree technique,
alluding to Byzantine and Venetian luxury objects, possibly point
to a Cretan provenance. Despite the host of archival evidence of
Cretan goldsmiths and their works in notary documents from
the Duca di Candia, few examples have been identified. A list of
jewelry belonging to an abbess, drawn up in 1667, reveals the
wealth and variety of precious items that affluent bourgeoisie
ladies of Crete accumulated during the period of Venetian rule.

Delivorrias, Fotopoulos 1997, 318, fig. 519; *Greek Jewellery* 1999,
368–70, no. 133 (A. Ballian, with earlier bibliography).

A.B.

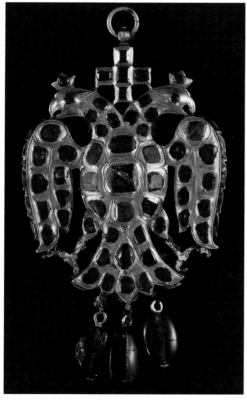

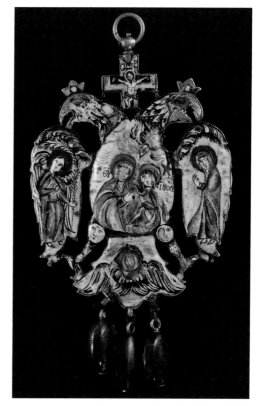

*front*                                                                                                    *back*

24. **Prelatic Pectoral**

Late 17th century

From Constantinople

Gold, gilt silver, rubies, emeralds, amethyst, enamel

Height 6 cm, width 4.7 cm

Gift of Helen Stathatos, inv. no. 7660

The pectoral is in the form of a double-headed eagle, the Byzantine imperial emblem that was transformed into a symbol of the Orthodox Church and hierarchy under Ottoman rule. The obverse, set with rubies and emeralds, classes the pectoral among the pieces of gem-studded Ottoman jewelry; on the reverse, the Virgin and Child, the Annunciation, and the Crucifixion are painted in enamel, which is a purely Western European technique.

The limited use of champlevé enamel is known in the Ottoman capital in the sixteenth century, in both Christian and Muslim works. From the early seventeenth century on, under the influence of European jewelers, primarily watchmakers from Geneva settled at Galata, Constantinopolitan jewelry gradually became enriched with painted and other types of enamel, which originally was confined to the back face, as in contemporary European jewelry.

Greek goldsmiths of Constantinople were renowned for their skill. In 1647 the Turkish traveler Evliya Çelebi reported that the best enameler in the city was the Greek Michael Simicioğlu, who made watchcases and knife handles that were sent as official gifts to the shah of Iran. He may be the same person as Michalakis of Galata, whose signature is on a watchcase now in the Islamic Museum, Jerusalem. The influence of Constantinopolitan jewelry is obvious in the court of the Georgian Orthodox princes of Mingrelia and of Czar Alexei Michailovich. The registers of the Russian imperial treasuries mention in 1656 and 1662 the name of the Greek jeweler Ivan Yuriev (Ioannis Georgiou). His presence in the czarist retinue may be associated with a number of ceremonial objects in the Kremlin Museum, reflecting the opulent aesthetic of the Ottoman court.

Constantinopolitan jewelry was praised in Greek folk songs, recorded in dowry contracts, and hoarded in sacristies such as those of the church of Saint George of the Greeks in Venice or Vatopedi Monastery on Mount Athos, where a similar gem-studded, double-headed eagle is kept. In works by the painter Jean-Baptiste van Mour (see cat. no. 61), the precious jewelry worn by the ladies of the Greek nobles and merchant-magnates of Peran vies in brilliance with that of the officials in the sultanic court.

Delivorrias, Fotopoulos 1997, 319, figs. 522–23; *Greek Jewellery* 1999, 442–45, no. 158 (A. Ballian, with earlier bibliography). For the pectoral from Vatopedi Monastery, see Ballian 1998, vol. 2, 515, figs. 459–60.

A.B.

### 25. Prelatic Pectoral

1624–39 or 1667–68

Ivory, gilt silver, niello

Diameter 7.7 cm

Inscribed (obverse, on the inner circle and against the niello ground): +*THN TIMIΩTEPAN TON XEPOYBIM KAI ENΔOΞOTEPAN ACYΓKPHTΩC/TON CEPAΦIM THN AΔIAΦΘOPOC Θ(EO)N ΛOΓΩN TEKOYCAN* (Worthier than the cherubim and incomparably more glorious than the seraphim, she who inviolate gave birth to the incorruptible Word of God); (obverse, chased on the outer circle): +*TOY ΠANIEPΩTATOY M(HT)POΠOΛITOY NIKOMIΔEIAC/KYP NEOΦYTOY +ΠOIMENOC TE KAI APXHΘYTOY/AYTHC ΠOΛITEIAC ΘEOΦPOYPHTOY* ([Dedicated by] His Holiness Metropolitan Neophytos of Nicomedia, the pastor and high priest of this God-protected city); (reverse, on the inner circle): *ΓEΓONEN H KOIΛIA COY AΓIA TPAΠEZA EXOYCA/TON OYPANION APTON X(PICTO)N TON Θ(EO)N HMΩN/EΞ OY ΠAC O TPΩΩN OY ΘNHCKEI* (Thy womb is become an altar bearing the bread of Heaven Christ our God, and whosoever eats of that bread shall not die); (reverse, on the outer circle): *BΛEΨON ANOΘEN ΘEE MOY ΠOIHTA MOY ΛYTPΩTA MOY/TPIΛAMΠIC KYPIA(P)XIA +ΦΩTAYΓHC TEΛETAPXIA/+ΔOΞA KPATOC EYΦHMIA KYBEPNOY THN EYCEBEIA* (Look down from on high, my God, my Maker, my Redeemer, thrice-brilliant dominion, radiant ceremony. Glory, might, praise! Guide Thou my piety)

Inv. no. 10400

This type of pectoral is known as *panagiarion* because it derives from a shallow vessel used in a special monastic rite dedicated to the Virgin (Panagia). The development of the rite into a common liturgical practice transformed it after the fourteenth and fifteenth centuries into a personal prelatic pectoral, with which church hierarchs celebrated the preordained rite when traveling.

The two ivory circular parts of the *panagiarion* are set in gilt-silver mounts and connected by hinges and a catch. Carved at the center of the outer faces are the representations typically found on the inside of *panagiarion*: on the obverse, the Virgin and Child in the midst of angels; on the reverse, the Hospitality of Abraham. The Virgin is surrounded by nine medallions containing Old Testament scenes, prophets, and saints. Correspondingly, ten medallions with figures of Apostles and Evangelists encircle the Hospitality. Depicted on the inner faces of the pectoral, in a double arcade, are the Twelve Great Feasts.

The representations in the medallions recall carved-wood diptychs or double-sided prelatic pectorals that usually feature Christ the Vine, surrounded by Evangelists and Apostles, and the Virgin of the Tree of Jesse, accompanied by her prophet forefathers. However, the scenes from the Old Testament around the Virgin are without parallel on pectorals. They derive from the iconography of the Tree of Jesse in monumental painting and are directly related to a group of wood-carved crosses of the sixteenth century, the so-called Laskaris crosses, which are decorated with Old Testament scenes on their base.

The rare use of ivory and the quality of the finely chased mounts, with inscriptions on the outer faces and Ottoman lotus palmettes, rosettes, and *saz* leaves on the inside, reveal the high status of the owner, who certainly frequented the patriarchal court. The metropolitan of Nikomedeia Neophytos (1618, 1624–39, 1667–68) is mentioned as donor of vestments to the Timios Prodromos and Virgin Kossyphoinissa monasteries in Serres. His outstanding ceremonial tunic made of an opulent Ottoman textile woven with silver and gold is now in the Benaki Museum.

Delivorrias, Fotopoulos 1997, 322–23, figs. 530–32; *Greek Jewellery* 1999, 432–35, no. 156 (A. Ballian, with earlier bibliography). For the so-called Laskaris crosses, see Ballian 2001b, 291–312.

A.B.

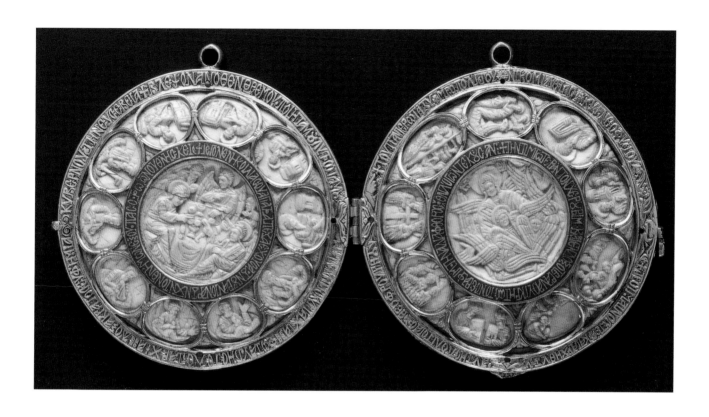

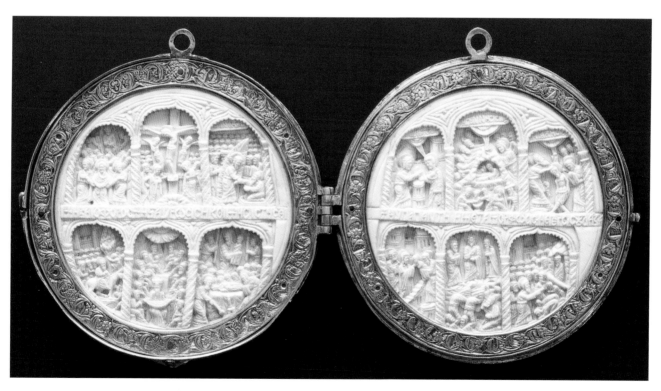

26. **Miter**

1739, repaired 1791
From the church of Saint George at Argyroupolis (Gümüşhane) in the Pontos
Embossed, chased, and partially gilded silver sheet, semiprecious stones, pearls
Height 25 cm, diameter 20 cm
Inscribed (around perimeter, below top): *ΑΦΙΕΡΟΘΗ ΠΑΡΑ ΤΟΥ ΚΥΡ ΛΑΜΠΡΙΑΝΟΥ ΥΟΥ ΧΑΡΙΤΟΝΟΣ ΕΙC ΤΗΝ Μ(ΗΤ)ΡΟΠΟΛΙΝ ΧΑΛΔΙΑΣ ΚΑΙ ΑΝΕΚΑΙΝΙΣΘΗ ΔΙΑ ΕΞΟΔΟΥ ΚΥΡΟΥ ΓΡΗΓΟΡΙΟΥ ΚΙΟΥΤΖΟΥΚ ΟΥΣΤΑ ΕΠΙ ΤΗ ΑΡΧΙΕΡΑΤΙΑ ΚΥΡΙΟΥ CΩΦΡΟΝΙΟΥ. ΚΑΤΑ ΤΟ ΑΨΚΑ* (Dedicated by Sire Lambrianos, son of Chariton, to the Metropolis of Chaldia and renovated at the expense of Sire Grigorios Küçük Usta during the prelacy of Sire Sophronios. In 1791)
Inv. no. 33703

The heavy gilt-silver miter is in the form of the gold-embroidered cylindrical miters modeled after the head coverings of monks. Represented on the front is the Deesis, with Christ Great High Priest, the Virgin, and Saint John the Baptist followed by the Apostles beneath an arcade. On the flat top is a cross with the Evangelists in medallions. The ornamentation includes filigree floral motifs, semiprecious stones, granulation, and nail heads.

An inscription of 1739 on the bronze case of the miter as well as an entry of 1762 in the manuscript codex of the church of Saint George reveal that the miter was donated to the archbishop of Amida Agathangelos by the chief miner of Argana, Grigor Aga. From the early seventeenth century, Pontic miners settled in the ecclesiastical province of Amida (modern Diyarbekir), working in the rich mines of Ergani and Keban nearby. They were administratively and ecclesiastically dependent on Gümüşhane, which in the eighteenth century became the Ottoman Empire's basic source of metals. The privileged treatment of Gümüşhane miners by the Ottoman administration enabled them to extend their activity to the heartland of Asia Minor, where they created mining colonies. The inscription of 1791 records the renovation of the miter by the same Grigor Aga, who had been promoted to general chief miner of Gümüşhane. The sultan himself, as a token of favor, had given him the nickname Küçük Usta, or "short master miner." The history of Gümüşhane, which Greek literati named Argyroupolis (silver town) in the nineteenth century, goes back to the sixteenth century, when silver ore was discovered below the Byzantine castle of Tzanicha (Ottoman Canca).

Amsterdam 1987, 330–32, no. 238 (A. Ballian); Athens 1994, 279, no. 114 (A. Ballian); Ballian 1994, vol. 1, 15–22, vol. 2, pls. II, 7:2; Delivorrias, Fotopoulos 1997, 317, fig. 518.

A.B.

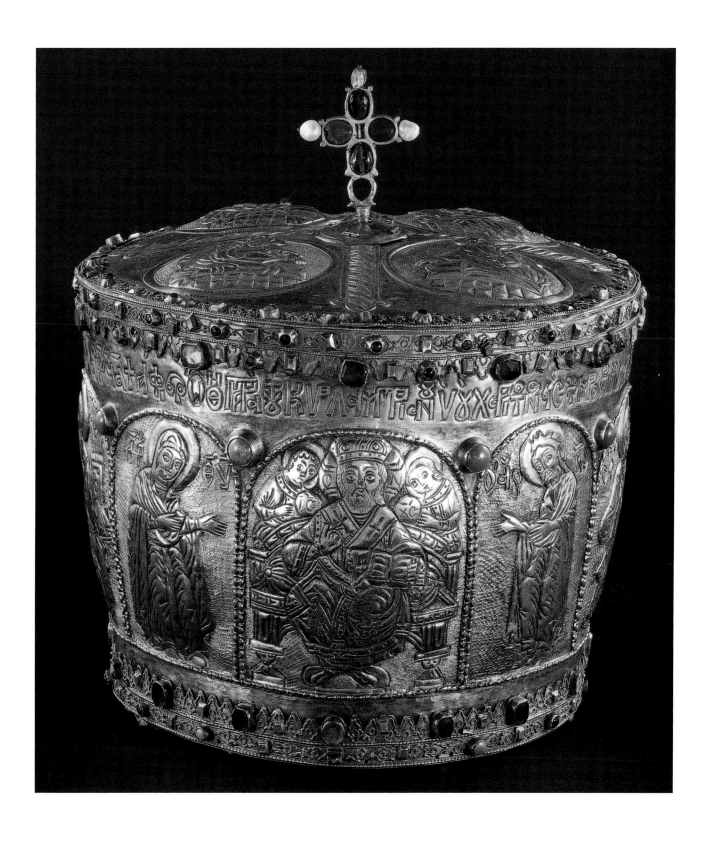

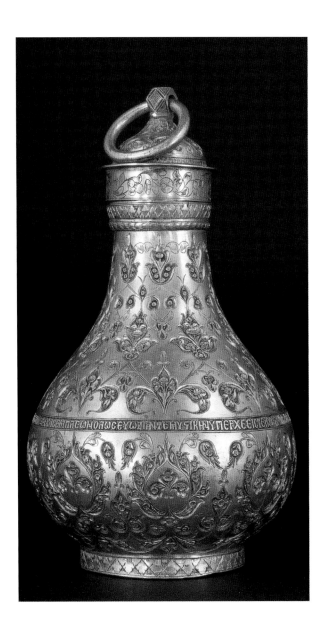

27. **Myrrh Flask**

1670

From Trebizond in the Pontos

Chased, chiseled, and engraved gilt-silver sheet

Height 17 cm

Inscribed (around body): Ω CKEYOC AΓNON
Ω CKEYOC XAPICMATΩN Ω CKEYH ΠOIOYN
EKΛOΓHC ΛEΛOYMENOYC APΩMATΩN
ΠEΦYKAC EMΠΛEΩN OΛΩC EYΩΔIAN TE
MYCTIKHN YΠEPXEEIC TEΛOYCAN ΠICTOYC
TOY XPICTOY EYΩΔIAN 1670 (O pure vessel,
O vessel full of graces, O vessel chosen by the baptized,
you are full of perfumes by nature and [you] pour a
mystic fragrance that gives the faithful the fragrance
of Christ, 1670)

Inv. no. 33792

The flask contained the holy myrrh with which the believer was anointed in the mystery of the chrism, after baptism. Its shape is Islamic. The overall surface of the flask is covered with large palmettes and an ogival grid, highly embellished with finely worked flowers upon a deeply chiseled ground. The typical Ottoman style of the decoration brings to mind Bursa opulent silks or Iznik ceramic panels. Of different character is the engraved floral ornament on the rim, which reflects the new trends taking shape in the capital of the empire at this time, under the influence of European art (see cat. no. 31).

A work of rare skill, the myrrh flask could be the subject of the reference by the seventeenth-century Turkish traveler Evliya Çelebi to the wonderful creations of the Christian goldsmiths of Trebizond, such as flasks, sprinklers, and knife handles. The date 1670 in the poetical inscription in archaizing style defines the most troubled period in the history of Pontic Greeks. From the mid-seventeenth century on, they were caught up in a maelstrom of persecution, apostasy, and forced Islamization, which came to a head in 1665 with the Ottoman seizure of the Greek Orthodox cathedral of Trebizond. As counterpoint to the wave of renegades to Islam, the inscription praises the mystic qualities of baptism in the Christian faith and symbolically offers comfort and solace to Christians.

Amsterdam 1987, 370–71, no. 280 (A. Ballian); Ballian 1991, 123–37, fig. 1; Athens 1994, 273, no. 102 (A. Ballian); Delivorrias, Fotopoulos 1997, 336, fig. 555.

A.B.

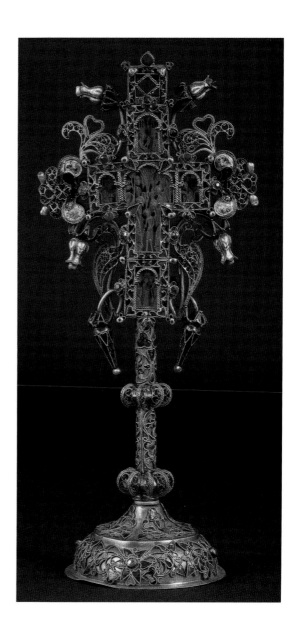

28. **Blessing Cross**
    Late 18th century
    Possibly from Kalarytes, Epirus
    Gilt silver, filigree and painted enamel, pearls and
    glass gems, carved wood centerpiece
    Height 25 cm
    Inv. no. 14022

The wooden cross is carved with scenes of the Twelve Great Feasts on a pierced architectural ground. Represented at the center of one face is the Baptism, with the Annunciation and the Presentation of Christ in the Temple at the ends of the vertical bar. On the other face, correspondingly, are the Crucifixion with the Transfiguration and the Resurrection. At the ends of the horizontal bar on both faces are representations of the Evangelists.

Miniature woodcarving of religious scenes was a monastic occupation, and, indeed, the texts mention that Athonite monks earned their livelihood from this craft. Wood-carved crosses of this type date no earlier than the late fifteenth century and originally were provided with a plain wooden handle but no base. From the early seventeenth century on, they gradually began to be decorated with a precious mount and a silver handle, and by the end of the century they acquired a base as well.

The mount of the cross is wrought with fine filigree foliate motifs, combined with painted and filigree enamel, emphasizing the tulips and palmettes that sprout from the sides of the cross. The large, three-petaled, heart-shaped flowers differ from those of Ottoman inspiration in the earlier filigree works (see cat. no. 32), on which the entire ground is riotously covered. A similar cross of 1798, kept in the sacristy of the Vatopedi Monastery on Mount Athos, is signed by the goldsmith Nikolaos Kertzos from Kalarytes. The inhabitants of the mountain village of Kalarytes in the Pindos range, like those of neighboring Syrako, were famed goldsmiths. Their works are dispersed in monasteries and churches on mainland Greece and the Ionian Islands, where they sought refuge after the uprising in 1821 and the destruction of their villages by Ottoman forces.

Delivorrias, Fotopoulos 1997, 339, fig. 561. For the cross kept in Vatopedi Monastery, see Ballian 1998, vol. 2, 527–29, fig. 473.

A.B.

29. **Salver**

1668

From the church of the Birth of the Virgin at Adrianople, Eastern Thrace

Partially gilded, chased, and engraved silver sheet

Diameter 41.2 cm

Inscribed (on rim): +*ΔICKON EME XPYCEON NEOΦYTOY APXIEPEOC EN KAIPOIC ΠANTEC TEYΞAN EHC ΔAΠANHC COIC IEPOIC ANAΞ ΓPAΨON KAΛON OYNOMA BIBΛOIC YΨIMEΔON ΠANTΩN EYCEBEΩN / MAKAPOI EN ETH AΠO X(PIΣT)OY 1668* (Everyone made me, the gold salver, in the time of Archbishop Neophytos at his expense. O king, write in your holy books the lovely name, the most eminent of all the pious ones. Let them be blessed. The year from the birth of Christ 1668); (around boss): +*O ΔHCKOC T(O)YTOC YNE TIC ΠANAΓIAC TA KOΛYKPAΓHA TON ΓOYNAPAΔON* (This salver is [a dedication] of the furriers to the church of the Virgin [in the neighborhood] Kolykragia); (above the representation on boss): *O AΓHOC HΛIAC* (Saint Elijah); (on back): +*του ανγελι και του μιχου κε του κοσταντα τον κερο που ηταν επητροπη ο καραμανλις ο καρατζας εσκαψε το δισκο τουτο* (Karatzas the Karamanli carved this salver at the time Angelos and Michos and Costantas were on the committee)

Inv. no. 34326

The salver has a flattened integral boss, a bottom decorated entirely with a honeycomb design, and a narrow horizontal rim. The shape of the salver, which recalls corresponding Middle Byzantine dishes of hardstone or silver, was widely used in the Renaissance and Baroque periods.

Represented on the boss is Prophet Elijah, patron saint of the guild of furriers, which donated the salver. He is seated within a rocky wilderness landscape, his head turned toward the crow that brings him food. The iconography of the scene is familiar from post-Byzantine painting. However, in this representation the saint does not wear the usual shaggy sheepskin and is shown bald and with features that bring to mind Saint John the Theologian. Noteworthy is the engraved rendering of the subject, with fine shadows denoting volume and depth, revealing Western models or a craftsman trained in Western engraving. According to the inscription, the goldsmith Karatzas, who fashioned the salver, came from Karamania in central Asia Minor. As documented by sixteenth-century European travelers and later Greek sources, craftsmen from Karamania worked in Constantinople, specializing in gold- and silverwork.

The honeycombed bottom may be associated with Ottoman silver bowls, the earliest of which are stamped with the *tuğra* of Bayazid II (1481–1512): one is in the Benaki Museum and the other in the Smithsonian Institution. The small animals—deer, lioness, winged griffin, and double-headed eagle—interspersed in the inscription on the rim are encountered on similar types of bowls that are often of Balkan provenance and Christian manufacture.

Neophytos, metropolitan of Adrianople (1644–88) and subsequently patriarch (1688–89), was a forceful personality, who is characterized in the metrical archaizing inscription with Homeric epithets accorded exclusively to Zeus. Some of the precious donations of his time are now shared between the Benaki Museum and the Byzantine Museum in Athens, where there is a similar salver with a separately made, possibly later, boss. The salver is stamped with a *tuğra,* the sultanic monogram used as an assay mark for testing the purity of the silver.

Athens 1992–93, 28–29, no. 2; Athens 1994, 272, no. 99 (A. Ballian); Delivorrias, Fotopoulos 1997, 342, fig. 565.

A.B.

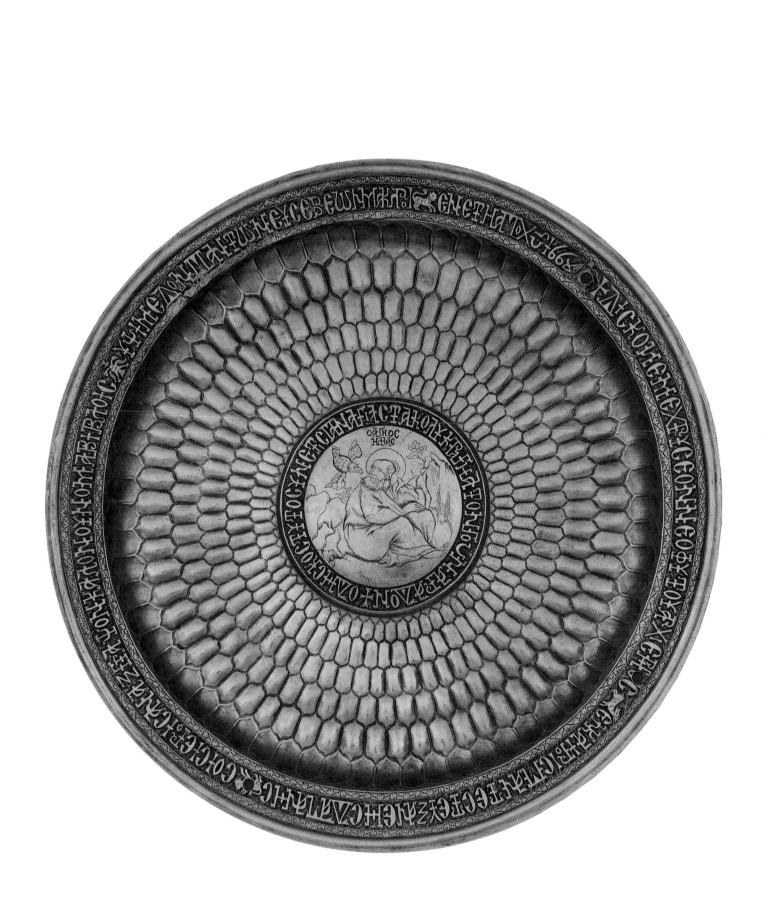

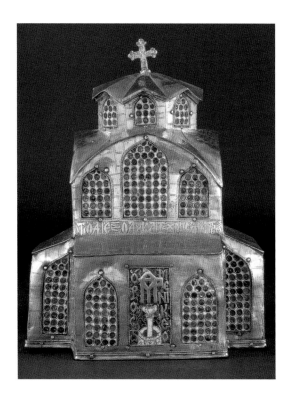
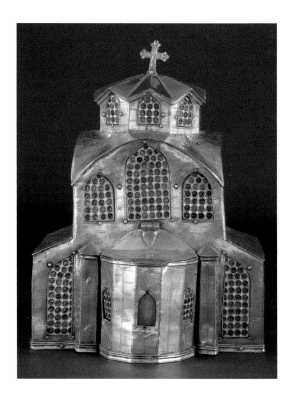

30. **Church-Shaped Casket**

1613

From the Timios Prodromos Monastery at Serres, Macedonia

Gilt silver, champlevé and filigree enamel, copper core

Height 22 cm, length 17 cm, width 17 cm

Inscribed (at base of drums): *ΓΕΓΟΝΕ ΔΙΑ ΧΑΡΙΤΙ ΤΟΥ Χ(ΡΙΣΤ)ΟΥ ΤΩ ΠΑΡΩΝ ΚΙΒΩΤΙΟ ΔΙ ΕΞΟΔΟΥ ΚΑΙ ΤΕΧΝΗΣ ΔΗΜΗΤΡΙΟΥ ΧΑΤΖΙ ΑΦΙΕΡΟΘΕΙ ΤΗ ΑΓΙΑ ΜΟΝΗ ΤΟΥ ΠΡ(Ο)ΔΡ(ΟΜΟΥ) ΖΡΚΑ* (The present casket was made for the grace of Christ at the expense and art of Demetrios Hadjis [and was] dedicated to the Holy Monastery of the Prodromos 1613); (on plaquette on front): *ΟΡΟΣ ΤΩ ΜΕΝΙΚΕΟ* (Mount Menoikio) and *ΠΡ(Ο)ΔΡ(Ο)Μ(ΟΥ)* [monogram of the monastery]; (inside): *ΔΗΜΗΤΡΙΟΣ ΧΑΤΖΙΣ ΜΟΝΑΧΟΣ ΖΡΚΑ ΕΠΙ ΤΗΝ ΗΓΟΥΜ(ΕΝΙΑ) ΤΟΥ ΠΑΝΟιω(τα)του ιερομοναχου κυρου Τιμοθεου* (Demetrios Hadjis monk 1613 in the abbotship of the Most Holy hieromonk Sire Timotheos) Inv. no. 13970

The casket follows the tradition of Byzantine caskets in the form of churches, which were used as censers, or ciboria. The apse of the church served as a container for the incense or the eucharistic bread and has a moveable lid. Although not an exact replica of the main church of the Timios Prodromos Monastery, the casket reproduces certain of its architectural features, such as the large semicircular drums and the low dome with peculiar roofing and eight windows. Represented on the plaquette on the façade is the monumental stoup (*phiale*) that stands in the churchyard, in front of the entrance. The large pointed arched windows with white enameled ground clearly imitate the plaster windows of Ottoman monuments with the circular openings of colored glass, which are here rendered by lustrous green and blue enamel.

The excellent quality of the casket reflects the social status of the monk who dedicated it. He is identified as the nobleman Demetrios, who is mentioned in the monastery codex as donor of sacred vessels and sponsor of the infirmary that was built in 1613. He withdrew to the monastery as monk David, securing, in accordance with Byzantine practice, a friary—accommodation, sustenance, and a servant—for the sum of six thousand Ottoman silver coins. The Timios Prodromos Monastery, dedicated to Saint John the Baptist, was one of the most important Late Byzantine monastic foundations in the area of Serres, which managed to ensure a privileged status under the Ottoman administration and thus to keep its prestige and land holdings. It was at this monastery that Patriarch Gennadios Scholarios (1454–56, 1463–65) retreated and spent the last years of his life.

Athens 1994, 270, no. 96 (A. Ballian, with earlier bibliography); Delivorrias, Fotopoulos 1997, 330–31, figs. 546–47. For the codex, see Odorico 1998, 120–22.

A.B.

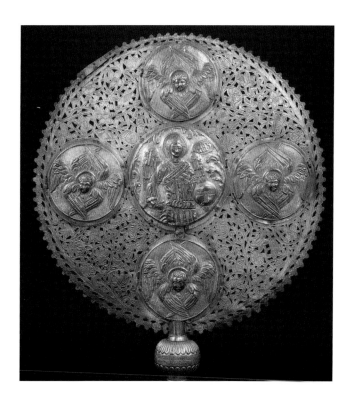

31. **Pair of Flabella**

1690

From the church of Saint John at Galata, Constantinople

Pierced, engraved, embossed, and partially gilded silver sheet

Height 48 cm, diameter 32 cm

Inscribed (on spherical knob of each flabella): +ΕΓΙΝΑΝ ΤΑ ΠΑΡΟΝΤΑ ΑΠΟ ΤΗC CΙΝΑΞΕΟC ΤΟΝ ΧΡΙΣΤΙΑΝΟΝ ΚΑΙ ΔΙΑ CΙΝΔΡΟΜΙC ΤΩΝ ΕΠΙΤΡΟΠΟΝ ΤΩΝ ΤΕ ΚΙΡΙΤΖΙ ΛΑCΚΑΡΙ ΚΑ(Ι) ΚΙΡΙΤΖΙ ΜΑΥΡΟΥΔΗ ΚΑΙ ΑΛΕΞΑΝΔΡΗ ΑΠΕΡΓΙ ΤΟΥ ΕΚ ΧΗΟΥ ΚΑΤ ΕΤΟC CΤΗ 1690 (The present [flabella]were made by the congregation of the Christians and the contribution of the wardens Kyritzis Laskaris and Kyritzis Mavroudis and Alexandris Apergis from Chios in the year 1690); (on central medallion): ΑΡΧΙΣΤΡΑΤΙ(Γ)ΟC (commander in chief [the archangel Michael])

Inv. no. 33891

Flabella, or *hexapteryga*, are liturgical fans symbolizing the heavenly hosts that praise and protect the enthroned God. Riveted to each face of the pierced-work disks are five medallions, probably made in a mold. Represented in the central medallion is the archangel Michael, in imperial raiment, holding a double-edged sword and a globe; in the four smaller medallions are six-winged seraphim. The handle, hollow to allow for the insertion of a wooden pole for carrying the flabella in procession, has an inscribed spherical knob.

The finely executed pierced work on the disks imitates the decoration on European watches, with characteristic daisies and large open flowers with a cross-hatched center. From 1630 onward, this style swept across Europe and reached the Ottoman court through imported European watches with intricate workmanship and through Genevan goldsmiths and watchmakers who periodically worked in Galata, serving the needs of the Ottoman court and the affluent citizens of the capital. The floral style, which suited Ottoman taste for large naturalistic flowers, was adopted by both Christian and Muslim goldsmiths. Watches and other silver objects with pierced-work decoration similar to the flabella, made for the Ottoman court, are today housed in the Topkapi Museum, Istanbul. A similar floral arabesque is found on flabella of Constantinopolitan provenance in the Panachrantos and Aghias monasteries, both on the Cycladic island of Andros. The church of Saint John at Galata belonged to the Chiot community in Constantinople, and the donor, Kyritzis Laskaris, played a leading role in its purchase.

Brussels 1982, 157, O.24 (L. Bouras); Ballian 1991, 123–37, fig. 2; Delivorrias, Fotopoulos 1997, 364, fig. 607.

A.B.

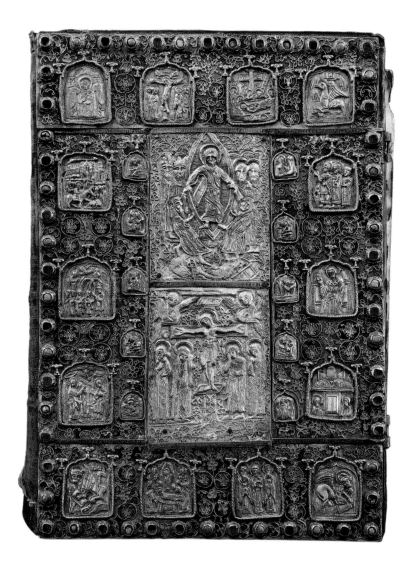

32. **Cover of a Printed Gospel Book**

1710

From the church of Saint John the Theologian at Evkaryon, Saranda Ekklisies, Eastern Thrace

Cast, pierced, and hammered gilt silver, filigree enamel, niello, turquoise, glass

Height 33 cm, width 23 cm, thickness 5 cm

Inscribed (in zones on both sides of the cover): *ΚΟΣΜΙΘΕΝ ΚΑΙ ΑΦΙΕΡΟΘΕΝ ΤΟ ΙΕΡΟΝ ΕΥΑΓΚΕΛΙΟΝ (ΕΙΣ ΤΗΝ) ΕΚΛΙΣΙΑΝ ΤΟΥ ΑΓΙΟΥ ΚΑΙ ΕΝΔΟΞΟΥ ΑΠΟΣΤΟΛΟΥ ΙΩΑΝΗ ΤΟΥ ΘΕΟΛΟΓΟΥ ΕΙΣ ΧΟΡΑΝ ΑΦΙΚΑΡΙΟΥ ΔΙΑ ΔΑΠΑΝΙΣ ΤΟΝ ΕΥΣΕΒΟΝ ΧΡΙΣΤΙΑΝΟΝ ΕΠΙΤΡΟΠΙΣ ΚΑΙ ΣΙΝΔΡΟΜΙC ΚΥΡ ΚΩΝΣΤΑΤΙΝΟ ΚΑΙ ΕΞΑΡΧΟΥ ΕΠΙ ΚΟΣΤΙ ΙΕΡΕΟΣ ΑΡΧΙΕΡΑΤΕΥΟΝΤΟΣ ΚΥΡΙΟ ΑΘΑΝΑΣΙΟΥ ΤΟΥ ΝΕΟΥ ΕΦΙΜΕΡΕΥΟ(Ν)ΤΟΣ ΚΑΛΟΓΙΑΝΙ ΚΑΙ ΒΑΣΙΛΙ ΚΑΙ ΧΡΙΣΟΤΕ ΔΕ ΔΙΑ ΝΟΣΜΙΜΑΤΩΝ ΕΠΤΑ ΠΑΡΑ ΤΙΣ ΕΥΣΕΒΕΣΤΑΤΙΣ ΚΙΡΑΣ ΚΑΛΙΣ ΣΙΝΒΙΑΣ ΚΩΝΣΤΑΤΙΝΟΥ ΚΑΙ ΕΞΑΡΧΟΥ ΙΕΡΕΩΣ ΧΙΜΕΥΤΟΥ ΕΠΙ ΕΤΟΣ 1710 ΚΕ ΕΝ ΜΗΝΙ ΑΠΡΙΛΙΟΥ ΣΤΙΣ ΠΕΝΤΕ*
(The holy Gospel book was decorated and dedicated in the church of Saint John the Theologian in the village of Afikari at the expense of the pious Christians, when they were wardens, and with the contribution of Sire Constantinos and exarch, in the time of the priest Costis and the metropolitan Athanasios the Young, when Kaloyanis and Vasilis were vicars, and was gilded with seven coins [given by] the most pious Lady Kali, wife of Constantinos, and exarch, priest enameler, on the fifth of the month of April in the year 1710)

Inv. no. 34157

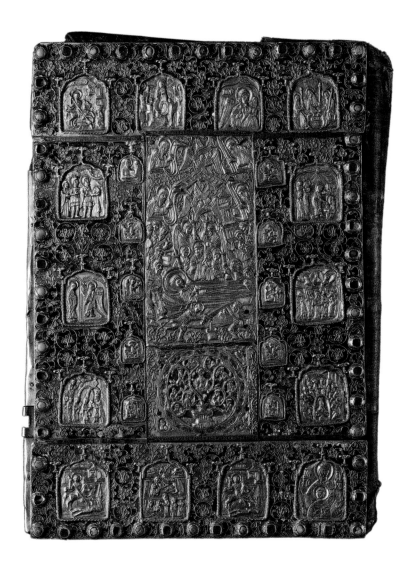

The Gospel book was printed in Venice in 1687 at the press of N. Saros. The later, luxurious cover is decorated with cast plaquettes of various sizes that are surrounded by dense floral motifs in filigree against a blue, turquoise, and green ground. A row of stones in deep floral Ottoman sockets runs round the edge. Represented on the rectangular plaquettes on the front are the Resurrection and the Crucifixion; on the back are the Dormition of the Virgin and the Tree of Jesse. The rest of the arched plaquettes show scenes from the Twelve Great Feasts, saints, prophets, and symbols of the Evangelists.

This type of cover is a developed and luxurious variation of Gospel books with a leather binding to which cast plaquettes with religious representations are affixed combined with those bearing Ottoman foliate decoration. Beginning in the second quarter of the seventeenth century, covers of this type acquire more enamel and the technique of filigree enamel gradually dominates. A group of signed works with filigree enamel from the seventeenth century can be attributed to Trikala in Thessaly. Other important workshops producing filigree enamel are known to have existed at Tsiprovak and Philippoupolis (modern Plovdiv) in Bulgaria, where many of the filigree works dedicated in the Bačkovo Monastery probably were made.

Although floral filigree enamel has a pronounced Ottoman character, it is rarely found on objects made for the court. However, the technique predominates in church silver of the seventeenth to eighteenth century, several examples of which can be attributed to Christian workshops of Constantinople or their circle.

The inhabitants of the small village of Evkaryon, or Afkari, near the town of Saranda Ekklisies in Thrace, were dyers (*boyacıs*), who went to Constantinople in the summer months to ply their trade. After 1798 they settled permanently in a suburb on the Bosphoros, which gave their occupation its name, Boyacıköy.

Athens 1994, 278, no. 112 (A. Ballian); Iconomaki-Papadopoulos 1994, vol. 1, 229–34, vol. 2, pls. XXVI–XXVII, 120–23; Delivorrias, Fotopoulos 1997, 381, fig. 651.

A.B.

# ECONOMY AND MARITIME TRANSPORTATION IN THE LEVANT, FIFTEENTH–NINETEENTH CENTURY: STABILITY AND CHANGE

## Spyros I. Asdrachas

In a discussion on Greek shipping prior to the founding of the Greek State, emphasis tends to be placed on the last thirty years of the eighteenth century and the first two decades of the nineteenth, with highpoint the years of the Continental Blockade; the same applies to trade. This focus is the result of the notion that economic phenomena and their means merit historical observation when they are intensive and, perhaps to a lesser degree, extensive. Nevertheless, highpoints presuppose long periods of normalcy—in this case, in trade and maritime transportation: both constitute a continuity that is differentiated by the quantities of goods put in circulation, the corresponding means of transportation and the shifts in points of departure and destination.

Greece today, like the fragmented Greek territory before the formation of the national state, has a highly indented coastline and a dense archipelago: these physical features, among others, helped overcome the difficulties of overland traffic, even in the interior of the islands, and stimulated the expansion of activity at sea. Furthermore, no unit of the archipelago was capable of ensuring self-sufficiency in food supplies; consequently, the imbalance existing in most islands between population and agricultural resources resulted in the creation of an economic continuum both between the islands and between the islands and the mainland coast. The instruments of this economic continuum were ships.

Fixed points of trade, including international, were the "stage towns" (*skales*), the harbors into which imports and goods from the hinterlands flowed, by the available means of land transportation, the caravans, which at once served long-distance trade and, through their dealings en route, consolidated local markets. These fixed points, for the most part identified with large conurbations, functioned mainly as centers for distributing goods in all directions, notwithstanding the consumer character of the most powerful ones, especially the capital of the Ottoman Empire, Constantinople. Many fleets crossed paths in the eastern Mediterranean—through warfare, piracy (on land and sea), and trade—at the same time also liquidating loot.

Even before the fall of Constantinople, most regions of the Byzantine Empire had become vassals to two overlords: the Turks and the Latins. The Turkish conquest was crystallized in the Ottoman conquest, and the Latin, in the Venetian. In the context of these two conquests local fleets were created in the Adriatic, Ionian, and Aegean Seas. From 1592 until 1776 the Black Sea was a closed Ottoman "lake" to which, in contrast to the situation in the past, the fleets of other states were prohibited access. In the orbit of the Ottoman Empire, the shipping fleets acquired, in addition to an ethnic association, a religious one, which strengthened the nature of the former without overshadowing it. Other osmoses, not the least of them cultural, gave the men of the sea common characteristics: like those on land, who experienced varying political domination, so too the seafarers created their own patois, or lingua franca, in which they communicated and were recognized. This language assimilated words and expressions of the Mediterranean tongues, terms, and idioms pertaining to the

Cat. no. 34. *Sailing Ship by the Coast of Hydra* (detail). Mid-19th century. Unknown artist. Oil on canvas. Inv. no. 9043

technicalities of seafaring, with principal vehicle navigation. The two sovereign powers were unable to divide the eastern Mediterranean between them. It was also ploughed by the ships of other powers that were economically superior, in particular those of northern European countries, with a marked presence from the sixteenth century, and of France in the eighteenth century. Neither were they able to abolish the economic continuum, the economic frontier which supersedes the national.

For example, the Venetian possessions in the Ionian Sea were obliged to maintain communication with the Ottoman-held Greek mainland, since the islands were not in a position to secure self-sufficiency in foodstuffs. These contacts not only directly served the needs of their economies but also indirectly contributed to the inclusion of these local economies in the sphere of international mercantile relations: they satisfied the subsistence needs of the islanders, allowing them concurrently to apply themselves to monocultures of crops, such as olives and grapes, responding to international demand. The same took place, mutatis mutandis, with regard to raising stock and, to a degree, cottage industries.

Both historiography and contemporary sources concentrate mainly on international trade, leaving in the background those transactions that are the stuff of daily life and the wheels that turn the domestic economy, the trade goods that are its substance, the attendant traffic, and the institutional formations through which it operates. Foreign trade, in which the Italian city-states, primarily Venice and Genoa, initially played a leading role, took the form of an exchange of raw materials and processed products: the West was interested in obtaining from the East "exotic" products as well as foodstuffs, above all grain. In the eighteenth century the East was to export first and foremost its agricultural produce, followed by products of animal husbandry and, to a lesser degree, those of cottage industries. Foodstuffs were to hold a steady position, which was intensified by adverse climatic circumstances in the West, but Western exports were also to include dietary staples. The products of the East primarily met the needs for raw materials for Western industries. Cotton and wool, both fibers and yarns, beeswax and hides, and in lesser quantities dye pigments and coarse textiles were the most conspicuous commodities of Eastern export trade, to which two others—strongly localized geographically—were added during the seventeenth century: olive oil and currants. Basic recipients of olive oil were the Western manufactories, especially soap factories (which is why ash was a supplementary product too), while the currant owes its spread in the Ionian Islands and the northern Peloponnese, and even the western Greek mainland, to the change in dietary habits in Northern Europe, particularly England, where sweetmeats were popular. The structure of rural cultivations in Greek or mixed regions of the Ottoman Empire, as well as in the Venetian possessions, while maintaining the variety of Mediterranean crops, underwent partial changes due to demands abroad as well as the diversification of consumer models at home, as was the case with the spread of tobacco-growing from as early as the seventeenth century. Nonetheless, the economy should not be studied only from the perspective of international transactions and the contingent maximizations and differentiations.

The products of human toil and whatever nature offers are destined to become, in part, merchandise, while a large share of them is consumed without passing through the market. These goods are circulated via land and sea routes, over distances great and small. They are represented in the market in unequal

manner: the maximum supply and variety are concentrated in the markets of the major cities, in the bazaars, which also respond to the needs of everyday consumption. Market regulations from as early as the fifteenth century bear witness to the assortment of goods available, and sometimes, as is the case with the cereals with which the capital was supplied, the provenance is mentioned too. More eloquent are the tariffs, which indicate both the breadth of varieties and the impressive range of transportation, including by sea. Not all movements presuppose a long voyage; nonetheless, the short voyages are those which make the network of large-scale shipping more tightly knit.

We are not, of course, in a position to know the size of the fleets or the flotillas of each island and of each coastal urban district on the mainland. Nevertheless, all indications suggest that islands had their own means of transportation, that they were not isolated or involved exclusively in agricultural and stock-raising occupations. In fact, even livestock, small or large, was carried by boat to their island pastures. Later, particularly during the eighteenth century and the early nineteenth, when documentation proliferates, we see that the island fleets, though unevenly distributed, present strong local concentrations that in certain cases reach one hundred vessels. In short, the islands received or dispatched ships and, with these, received or sent off merchandise. Among the early records of this circulation are the customs duties recorded in local Ottoman laws and in the Acts of the islands' community authorities. The local fleets were not entirely peaceful: pirate flotillas anchored in sheltered coves off the islands and the mainland coasts, the Turkish ones with the compliance of the Capudan pasha (admiral). Indicative with regard to the Greek islands is the case of the Ottoman pirates of Lefkada—many of them renegades—during the seventeenth century and earlier, a vivid picture of whom is given by the Turkish traveler Evliya Çelebi. Western pirates and corsairs also ploughed the Eastern Mediterranean, calling in at the islands and affecting not only their economies, by liquidating their plunder, but also their mores. Wars opened wide the field, in which the island populations took part with their ships. But it was not the local fleets, which were more or less peaceful, that were the driving force in maritime transportation. The volume of international trading transactions was provided by the European fleets, western and northern: the first, Italian and Spanish, were the main nautical rivals of the Ottoman Empire, until the Russian naval power entered the Mediterranean stage in the last thirty years of the eighteenth century.

Throughout the eighteenth century in the eastern Mediterranean the French fleets and trade with Marseilles were predominant, and had restricted the activity of the British. The presence, however, of the Northerners, the Italians, and the Ragusans continued, whereas at the same time the presence of the Austrians, the imperials as they were called, intensified. With the opening up of the Black Sea (1783), an additional arena of economic activity was accessible to international trade and navigation, focusing on the movement of Russian grain. In the nineteenth century the Ionian Islands, now a British Protectorate, gained control of navigation on the Danube and in the Black Sea, with protagonists the Cephalonians and the Ithakans. In the meanwhile, other strong local fleets, Greek or under Greek influence, had emerged: Missolonghi, Hydra, Spetses, and Psara all benefited from the political conjuncture that culminated in the Continental Blockade. Meanwhile, older maritime ports and established maritime routes continued to thrive. Indeed, with the creation of ports francs,

such as Ancona and Trieste, travel increased to both; the same happened with voyages to the ports of southern Russia. It goes without saying that the development of the local Greek fleets in no way affected the composition of the cargoes: merchants and carriers, who were frequently one and the same, continued to respond to foreign demand, whether it was stable or fluctuating. In other words, they penetrated the defined system of transactions and relationships, securing for themselves an important place in it. But this had a direct effect on their own economies, which were of course local but at the same time had supra-local—indeed international, organic, and, obviously, dominant—interconnections.

The main field of activity for Greek ships was the eastern Mediterranean and the Adriatic, and with the opening of the Black Sea to freedom of navigation, its ports in southern Russia rose to prominence, as noted. Shipping routes were largely determined by Venetian settlements in the East, originally in Cyprus and Crete and subsequently in the Ionian Islands, of which Corfu became, after the loss of Crete, an obligatory port of call on voyages to and from Venice. British ships, however, led the field in the export of currants from the British Ionian Protectorate; indeed, in some islands, such as Zakynthos, they replaced local vessels in supplying the currant producers with grain from the Ottoman-held mainland. Study of the arrivals and departures of ships from eastern Mediterranean harbors during the eighteenth and the early nineteenth centuries reveals the almost overwhelming presence of Western vessels, even though Greek and Turkish ships held first place in Alexandria. On the other hand, in the departures from the main ports of the Ottoman state, such as Thessaloniki, bound for those of the eastern Mediterranean, Greek ships predominate. In the Venetian nautical ambit, the Greek ships of the Venetian possessions were mostly occupied in the Adriatic and indeed Venice, but this sea lane also affected other routes with starting points outside the dominion of the Serenissima Republic in the East, such as the routes that began from the island of Lesbos. By the eighteenth century Greek ships were sailing through the western Mediterranean, sometimes under fictitious French ownership, to pass even into the Atlantic Ocean.

Greek ships sailed under various flags and sometimes unfurled an ad hoc one of their own. Greek captains, who were Ottoman subjects but enjoyed Russian protection after the First Russo-Turkish War of Empress Catherine, flew the Russian flag. At the same time, they took care to have their own consular representation in the Italian cities and on Corfu—in other words, they experienced a special identity within the framework of the Ottoman Empire.

The voyage was a business enterprise distinguished by a broad spectrum of economic relationships which connected its human agents: usually, shipowners and merchants formed partnerships in view of a voyage, which made provision for the export of merchandise with returns in cash or in cash and kind. To this end they set up temporary trading companies; sometimes the carriers chartered the ship without additional obligations other than the possible contracting of a loan with the carrier. As elsewhere, the system of co-ownership of ships also obtained in the Greek fleets. The captain of the ship was not always its owner or co-owner; in Crete, for example, the owners of ships were as a rule Turks and the masters were Greeks. Pivotal to voyages were bottomry loans with high and staggered interest, depending on the port of destination, subject to the risks of the sea. The terms regulating a mercantile voyage were codified in the local maritime laws of Hydra in the early nineteenth century. The

lenders, who were also simultaneously shipowners and merchants, took a share of the profits. The seamen were remunerated either with a wage or with proportional participation in the profits, while at the same time they had the right to transport on their own behalf small quantities of crummy goods (*paccotiglia*). The legal framework of maritime mercantile enterprises perpetuated the nautical customs that held sway throughout the Mediterranean until the adoption of the Napoleonic commercial code in the early nineteenth century.

Greek shipping in the Mediterranean is part of a general pattern of maritime transport dominated by the fleets of western and northern Europe. The importance of Greek shipping increased from the second half of the eighteenth century onward, parallel with the increasing participation of Greeks and Balkan peoples in trade, both import and export. Political circumstances were propitious for the development of fleets, in particular those of Hydra, Spetses, and Psara, but these suffered fluctuations that verged on crisis before the War of Independence in 1821. The freighters of the Greek ships were also Greeks—whatever that cultural term entailed; the same agents continued to use ships of other territories, too, depending on schedules. The routes of the ships did not change over time but their frequency altered, while new destinations, such as Malta and the Black Sea harbors, were established alongside the ports francs. Domestic communication, from island to island and from island to mainland coast, continued to exist but with greater intensity, consequence of the growth of transactions beginning in the second half of the eighteenth century. The same applies to the island nodes, such as Chios, which were increasingly busy with local and foreign sea traffic. Domestic Greek maritime traffic presents the picture of a network with rather loose interconnections but with remarkable longevity and resilience.

**Selected Bibliography**

For issues raised in the text, see Asdrachas et al. 2003. For maritime history and traffic in the ports, see Constantinidis 1954; Efthymiou-Hadzilacou 1988; Frangakis-Syrett 1992; Harlaftis 1996; Kardassis 1998; Katsiardi-Hering 1986; Katsiardi-Hering 1989; Kremmydas 1973; Kremmydas 1974; Kremmydas 1986; Leon 1972; Maximos 1940; Sfyroeras 1960; Svoronos 1956; Triantafyllidou-Baladié 1988. For navigation on the Danube, see Phocas 1975. For shipyards, see Bekiaroglou-Exadactylou 1994. For maritime law, see Maniatopoulos 1939.

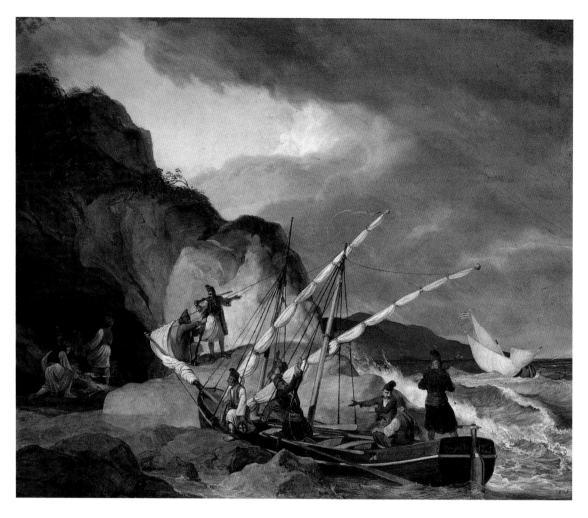

## 33. Greek Sailors

1831
Carl Wilhelm von Heideck or Heidegger (1788–1861)
Oil on zinc
35.5 x 40.5 cm
Signed and dated (bottom right): *C. v. hdk 1831*
Inv. no. 11180

Greece is surrounded by the sea and has an archipelago of some three thousand islands and islets, yet Greek seamen did not achieve international recognition until the War of Independence, when some of the most spectacular victories were associated with their remarkable nautical abilities and courage. In addition to the many and varied scenes inspired by the naval battle of Navarino (1827), the life of Greek seafarers captured the imagination of nineteenth-century writers and artists.

The German baron Carl Wilhelm Freiherr von Heideck (or Heidegger) was not only a talented amateur draftsman but also enjoyed a distinguished military career. In 1826 King Ludwig I of Bavaria sent him to Greece as commander of the corps of military advisers, who were to instruct the Greeks in the tactics of war. When the conflict was over, Heideck was appointed commander of the city of Nafplion, the first capital of liberated Greece. He left the country in 1829 but returned three years later as one of the three Bavarian regents accompanying King Othon (r. 1833–62). After returning to Germany in 1835, Heideck painted a number of Greek subjects. The date inscribed on this picture indicates that, like most of his oils, it was executed in his Munich studio from drawings he had made on the spot. The work attests to Heideck's particular penchant for genre themes and the picturesque. There is little heroic about this scene, since Greek naval achievements were no longer a contemporary event. Instead, Heideck chose to represent an incident in the daily life of Greek seamen, suggesting their vigor, gaiety, and lives of adventure.

Washington, D.C., 1991, 134–35, no. 55; Delivorrias, Fotopoulos 1997, 547, fig. 961. For the painter, see Tsigakou 1981, 63, 139, 154, 202–3, figs. 36, 55.

F.-M.T.

34. **Sailing Ship by the Coast of Hydra**
Mid-19th century
Unknown artist
Oil on canvas
90 x 73 cm
Inv. no. 9043

After the mid-eighteenth century, coastal towns and islands such as Hydra developed into important maritime centers as a result of the privileges secured for them in the Russo-Turkish treaty of Kutchuk Kainardji (1774). The rapid rise of Greek shipping contributed not only to enhancing the Greeks' national awareness but also to the reevaluation of European preconceptions about the decadent inhabitants of Greece in bondage. The island of Hydra in the Argosaronic Gulf, a few miles from Piraeus and now one of Greece's most cosmopolitan holiday resorts, is a narrow, barren rock in the sea. The town was built there in the late eighteenth to early nineteenth century, as the inhabitants accrued wealth by exploiting the blockade of the Mediterranean imposed during the Napoleonic Wars. Hydriot seamen were a conspicuous presence during the last three decades of Ottoman rule in Greece, while during the War of Independence many distinguished themselves in the struggle at sea, such as Andreas Miaoulis (1769–1835), Manolis Tombazis (1784–1831), and Georgios Kountouriotis (1782–1858).

The anonymous painter of this picture has immortalized the sailing ship flying the Greek flag as it enters the port of Hydra. The cannon at the right still stands at the harbor entrance and identifies the island depicted, while the small cluster of people gesticulating animatedly adds a note of immediacy to the scene.

Unpublished.

F.-M.T.

35. **Icon of Saint Nicholas with Scenes of His Life and Miracles**

1733

Laskaris Leichoudis

Egg tempera on wood, gold leaf, priming on linen

66 x 54.5 cm (panel), 83 x 72 cm (with frame)

Inscribed (below the throne of Saint Nicholas): *ΧΕΙΡ ΛΑСΚΑΡΕΩС ΙΕΡΕΩС(?) ΤΟΥ ΛΕΙΧΟΥΔΟΥ ΕΥΤΕΛΟΥС Κ(ΑΙ) ΕΛΑΧΕΙСΤΟΥ ΚΟΠΟС./Ο ΝΙΚΟΛΑΟС ΠΡΕСΒΥС ΩΝ ΕΝ ΓΗ ΜΕΓΑС Κ(ΑΙ) ΓΗС ΑΠΟСΤΑС, ΕΙС ΤΟ ΠΡΕСΒΕΥΕΙΝ ΖΕΕΙ, ΕΚΤΗ ΝΙΚΟΛΕΩ Γ΄ ΕΦΑΝΗ ΒΙΟΤΟΙΟ ΤΕΛΕΥΤΗ. ΑΨΛΓ* (By hand and toil of Laskaris Leichoudis, humble and insignificant priest. Nikolaos being a great intercessor on earth, though he has left the earth, lives to intercede. On the sixth of [December] the end of life appeared to Nikolaos. 1733); (on the ground of the scene of the First Ecumenical Council): *Διά δαπάνης και εξόδου, του δούλου του Θεού Αθανασίου Δελαπόρτα* (At the cost and expense of the servant of God Athanasios Delaportas)

Inv. no. 3032

Saint Nicholas seated on an elaborate throne is depicted in the central panel, surrounded by ten scenes of his life and miracles. Dominating the middle of the upper and lower sides are two large scenes: above is the saint's dispute with the heretic Areius at the First Ecumenical Council, where Nicholas demonstrated his stalwart devotion to the true faith, while below, placed symmetrically, is the saint's dormition. The remaining episodes document the miraculous qualities of Saint Nicholas, through which he secured for the faithful salvation from difficulties of all kinds: he gives charity to the impoverished father of the three girls, he saves the three generals from calumny and death, he casts down the idols, and, in two scenes, he rescues ships and voyagers from certain drowning.

The icon by the Cephalonian priest and painter Laskaris Leichoudis is distinguished by its accurate draftsmanship and emphasis on decorative details. All the individual elements of the iconography, as well as of the palette, which is based on bright shades of pink and green, echo the influence of Cretan painters such as Theodoros Poulakis (ca. 1620–1692) on the art of the Ionian Islands. Both Poulakis and his successors, Leichoudis among them, followed models mainly from Flemish prints, which circulated widely in Venetian-held territories. The good quality of the icon is consistent with the social status of the commissioner, who was a member of a renowned Cephalonian family.

Saint Nicholas is one of the most popular saints of the Orthodox Church. Although he left no ecclesiastical treatises and did not die a martyr's death, it is precisely the believers' trust in his miraculous powers that led to the great reverence for him over the centuries. His miracles at sea in particular, which consistently appear in his iconographic cycles, established him as the patron saint of mariners.

Amsterdam 1987, 320, no. 221 (M. Vassilakes-Mavrakakes); Chatzidakis, Drakopoulou 1997, vol. 2, 156, fig. 89. For the iconographic cycles of Saint Nicholas, see Patterson-Ševčenko 1983.

A.D.

36. **Votive Offering in the Form of a Sailing Ship**
    19th century
    Carved bone, embroidered linen, cast lead, iron
    Height 18 cm, length 15 cm, width 3 cm
    Gift of I. Axelos, inv. no. 14170

The deftly made, three-dimensional votive offering (*tama*) of a single-mast sailing ship was assembled from preexisting pieces (*objets trouvés*). The metal mast, from which hangs a linen sail embroidered with animal and plant motifs, is nailed to the bone hull. A cast-lead figure of a sailor, probably manufactured abroad, leans against the aft rigging.

The dedication of spiritual and material offerings as a means of coping with life's difficulties is typical of Greek Orthodox tradition. *Tamata*—effigies of humans or of possessions, which are hung on or near icons of saints—are votive objects through which man's communication with the divine acquired material substance. Very often seafarers or their relatives put their ships under the protection of saints, offering models of the vessel either when it arrived home or when it was in danger at sea. This practice is apotropaic in character, since man's aim is to appease the supernatural forces, notably the sea, in which many hazards lurk.

This particular *tama* is rare, not only because it is probably the creation of a skillful dedicator but also because it is assembled from existing objects. The reuse of materials for making *tamata* was, and still is, common practice. Indeed, in popular places of pilgrimage, where large numbers of votive offerings accumulate, a portion of them frequently is recycled to produce new ecclesiastical vessels.

Amsterdam 1987, 364, no. 270 (M. D. Karagatsi); Delivorrias, Fotopoulos 1997, 431, fig. 749; Handaka 2004, 220–23, fig. 222.

S.H.

**37, 38. Votive Offerings in the Form of Sailing Ships**

Late 19th–early 20th century

From Chios

Embossed and incised silver

Height 17 cm, length 20 cm; height 18 cm, length 27.5 cm

Gift of Mikes Paidousis, inv. nos. 36254, 36255

These handmade votive offerings (*tamata*) are fashioned from thin sheets of silver, pierced and cut out in the shape of the sailing ship they represent. The details of the rigging are etched and hammered.

The first ship combines the hull of a *trechantiri* (fishing boat) with the classical rigging of the goleta-brig, but without the jib sails and with light masting. Inscribed on the main sail are the names of the vessel, *Evangelistria* (Virgin of the Annunciation), and her owner, Epameinondas Tellis. Represented on the stem and the stern are three sailors. The craftsman has tried to convey movement with restrained realism, presenting the ship as if sailing on a rough sea. The votive offering is stamped with a *tuğra*, or sultanic "hallmark," indicating that it was made in a workshop in Ottoman territory. The second ship is also of the goleta-brig type, with full rigging and sails, executed in fine detail, while the Greek flag flutters on the after mast.

The handcrafting of embossed (or repoussé) and incised votive offerings was particularly widespread from the nineteenth century until the 1920s, when their mass production in presses began. The so-called silver boats are distinguished by the intricacy of their construction and the high quality of the metal, traits that reveal, among other things, the affluence of merchants in the eighteenth and nineteenth centuries. Moreover, they almost always represented actual ships, often dedicated to the Virgin, the Prophet Elijah, Saint Nicholas, and other protective saints.

The few "silver boats" that have survived bespeak the inventiveness and skill of their creator. There are notable examples in the Church of the Annunciation to the Virgin on the island of Tinos, one of the principal places of pilgrimage in Greece. The earliest textual evidence of such votive offerings is dated 1774 and concerns a silver-boat replica dedicated to Saint Nicholas on Psara that was lost after the destruction of the island in 1824.

Amsterdam 1987, 364, no. 269 (M. D. Karagatsi). For examples of metal votive offerings, see Handaka 2002, 147–65 (with earlier bibliography).

S.H.

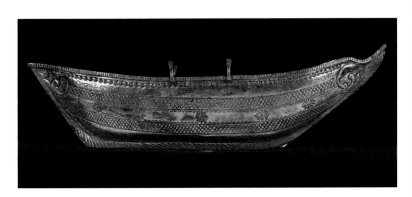
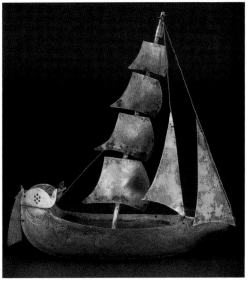

39, 40. **Votive Offerings in the Shape of a Sailing Ship and a Rowboat**
Late 19th century
From Asia Minor
Sailing ship: gilt silver; rowboat: embossed and incised silver
Sailing ship: height 24 cm, length 23 cm, width 6.5 cm; rowboat:
height 5.5 cm, length 19.5 cm, width 4 cm
Inv. nos. 34053, 39150

These rare examples of three-dimensional votive offerings (*tamata*) are made from silver sheets soldered in such a way as to accurately render the shape of the vessel they represent. In their elaborate incised and embossed decoration, faithful representations of the outfits of a ship coexist with additional ornaments invented by the craftsman.

The sailing ship is not a true reproduction of a known vessel type. It has a peculiar hull with an external rudder, a raised poop deck with gunwale, and a forecastle. The rigging recalls that of a brig, but the ship has a mast with four mainsails and two jibsails affixed with top tackles. On the outside a riband is incised along the length of the gunwale, possibly denoting the bedecking of the ship for launching or some other celebration, and on the prow is a female face as a figurehead.

The rowboat has a ferry hull with angulated stern and curved prow, distinguished by its slightly concave edge. Silver sheets clad the ends of the cover, while at the center of the boat is a fine zone of silver, perforated with a hole from which the *tama* was suspended. The hull is decorated with zones of alternating spiral and cross-hatched patterns that surround a central strip with rayed rosettes. Two garlands adorn the stem and stern.

Three-dimensional ship votive offerings, which were hung from the ceiling of the church, frequently below hanging lamps, and not on the icons like their two-dimensional counterparts, hold a special place in churches as basic elements of their decoration of a highly symbolic nature. The coexistence of ship *tamata* with hanging lamps recalls the tradition of offering boat-shaped lamps in late Antiquity, an earlier example of which, now in the Museo Archeologico, Florence, is a fourth-century A.D. lamp in the shape of a ship, with the Apostles Peter and Paul at the tiller and the helm, respectively.

*Tamata* are essentially anonymous artworks. However, as evidence of miracles, several have acquired their own "biography." Although the circumstances of the creation of these particular examples are unknown, they nevertheless tell an important story, since they were brought to Greece along with other ecclesiastical heirlooms by Greek refugees from Asia Minor who were forced to leave their ancestral homes after the Greek defeat in 1922.

Florakis 1982, figs. 116, 117; Amsterdam 1987, 364, no. 271 (M. D. Karagatsi); Delivorrias, Fotopoulos 1997, 431, fig. 748. For boat representations in traditional art, see Makris 1972, 267–98.

S.H.

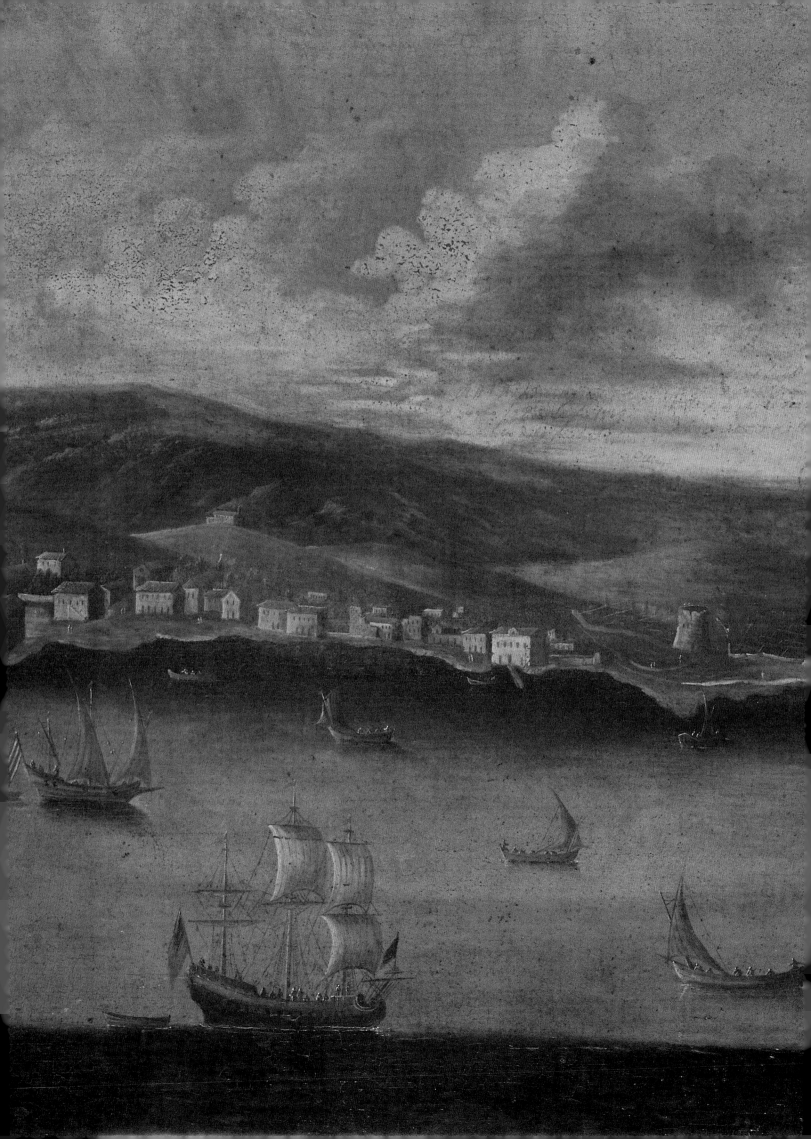

# GREECE THROUGH THE EYES OF
# ARTIST-TRAVELERS

## Fani-Maria Tsigakou

History has need of illustrators. During the long period of foreign rule, when historical circumstances prohibited the development of local production in the visual arts, Greece was fortunate in having its "portraitists"—that is, the foreign artist-travelers who immortalized the land and its people. Their drawings, watercolors, and oil paintings of Greek subjects, together with prints in illustrated travel publications, constitute a rich archive of visual documents that are valuable for the study and reconstruction of the neo-Hellenic past (see cat. nos. 5–8, 33–34, 41–61).

In their images of the Greek land, foreign artist-travelers have recorded—in addition to the physical elements—the unseen correlations between Western Europe and Greece, as these were formed through historical, social, and cultural intersections. The image of Greece past, as it emerges through European works from the fifteenth to the eighteenth century, is linked to the pulse of the ancient heritage and the revivals of antiquity that characterized European artistic currents such as the Renaissance and Neoclassicism. Forgotten during the Middle Ages and far from the main trade routes connecting East and West, most of Greece remained isolated and unknown, with the exception of the coasts and the islands of the archipelago, which were either along the sea routes of the Mediterranean or coincided with ports of call on the itineraries of pilgrims sailing past the Greek shores. The interest of the West in depicting the land of Greece was manifested initially through the mapping of the Greek islands and coasts, in the portolans and *isolarii* of the fifteenth and sixteenth centuries (see cat. nos. 1–2). The first account of archaeological peregrinations in the Hellenic world is that of the traveler Cyriaco de Pizzicoli (1391–1452), who has been dubbed the "medieval Pausanias," while the earliest testimonies of the European view of Greece can be seen in illustrated travel publications of the fifteenth century, such as Bernhard von Breydenbach's *Peregrinationes ad terram sanctam* (Mainz, 1486) and Hartman Schedel's *Liber chronicarum* (Nuremberg, 1493). Moreover, in the seventeenth century, the protracted Venetian-Turkish war brought a spectacular increase in the circulation of illustrated publications with Greek subjects (see cat. nos. 4–6). The engraved Greek images of the fifteenth, sixteenth, and seventeenth centuries usually were created by amateur artist-travelers who accompanied either exploratory or military missions, and they display summary, conventional, and frequently inaccurate topographical views or stereotypical representations of costumes (see cat. nos. 51–61) that are cramped within the confines of the woodcut block or the engraving plate, trapped in a codified iconographic language.

The teachings of antiquity, which left their impression on the Renaissance—and whose echo was paramount until the mid-eighteenth century—were guided by Greco-Roman tradition. However, the innovative spirit that captivated Europe during the fifteenth and sixteenth centuries, interwoven with the revival of classical studies (animated by the Byzantine literati, who revealed the entire spectrum of ancient letters to their European students), created a fertile climate

Cat. no. 50. *View of the Town of Argostoli on Cephalonia* (detail). Late 18th century. Unknown artist. Oil on canvas. Inv. no. 11182

for the reappraisal and study of Greek antiquity. Unfortunately, the increase in European interest in Greek antiquity was not unrelated to the epidemic of "antiquity hunting." Consequently, the formation of the earliest European collections of Greco-Roman antiquities from the Mediterranean took place in the seventeenth century and mainly was due to the diplomatic representatives of the English and the French courts.

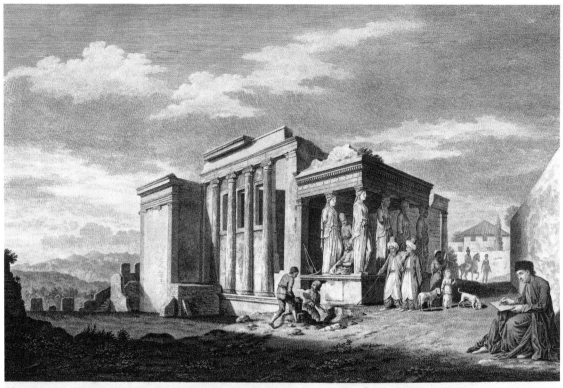

*Stuart delin.* — *Published by James Stuart, Oct.ʳ 17, 1787, according to Act of Parliament*

Europe's dialogue with Greek antiquity was to be reinstated in the eighteenth century, the Age of Enlightenment. In this period the educational journey to Italy—the so-called Grand Tour—was obligatory for sons of the aristocratic families of Europe, especially of Britain. When the Napoleonic Wars cut off Western Europe to European travelers, Greece, as part of the Ottoman Empire, benefited from Turkish neutrality and attracted a majority of the travelers on the Grand Tour. From 1751 to 1756 the British painter James Stuart (1714–1788) and his compatriot the architect Nicolas Revett (1720–1804) resided in Athens under the auspices of the Society of Dilettanti, a club of British connoisseurs and antiquarians founded in 1734 with the aim of promoting ancient Greek taste (fig. 1). The fruit of their labors was the four–volume magnum opus entitled *Antiquities of Athens Measured and Delineated* (London, 1762– 1830), a landmark publication in the history of archaeology and of taste, since the theoretical approach, in combination with the meticulous illustrations, formed a new aesthetic conception that was to overshadow the perception of antiquities through the affected "painting of ruins."

If this publication revealed what had been rescued of ancient Greek architecture, the one who resurrected the spirit of ancient Hellas was the German theorist Johann Joachim Winckelmann (1717–1768), whose essays laid the foun-

Fig. 1 *Stuart Sketching the Erechtheion.* Engraving. From J. Stuart and N. Revett, *Antiquities of Athens Measured and Delineated* (London, 1762–1830), vol. 2. Library, Benaki Museum, Athens, inv. no. 2403

dations of the disciplines of art history and archaeology. Winckelmann proclaimed that "ancient Greece was sole source of models of life and learning," expositing to the European public a glowing picture of the conditions that fostered creative activity in ancient Greece and setting in motion the idealization of Hellenic antiquity. Artists concentrated on a creative, historical remodeling of the ancient Greek world, while a new thematic repertoire was elaborated, bringing to the fore ancient Greek subjects in which moral and social values were extolled. At the turn of the eighteenth century, as the Greek idea of beauty together with the dominance of norm over form dominated European aesthetics, the "Greek style" was mirrored not only in painting but also in a panorama of artistic activities, sweeping along with it literature, dress, and the applied and decorative arts. Concurrently, public and private buildings inspired by authentic Greek orders legitimized the sovereignty of the Greek Revival movement in Europe and America. Before the second half of the nineteenth century was over, most examples of the Greek orders had been adopted by famous European and American architects of the time.

It was within this clime that, by the early nineteenth century, the journey of the cultivated European to Greece had become established. For travelers of the period, the visit to Greece was—in addition to a fascinating trip—a reverie, an exploratory pilgrimage to a place sanctified by time. The genius loci of Greece was a unique experience for the foreign visitor, charged with the magnetic pull that the rediscovery of the ancient Greek world had exerted in previous centuries. However, the vista of the deforested Greek landscape—the result of centuries of occupation and destruction—appeared unworthy of the ruins and disappointed visitors, who sped to "correct" it and to render it through calligraphic, artistic conventions. Thus they conscripted the views of the most distinguished exponents of the idealized landscape of classical sites, namely Claude Lorrain (1600–1682) and Nicolas Poussin (1594–1665), which offered the most accommodating formula for compositions featuring Greek ruins and at the same time secured the iconographic illusion of a living antiquity. Consequently, most early-nineteenth-century "Greek views" simply provide a satisfactory representation of some eponymous ancient Greek edifice, which is set in a fitting but indeterminate landscape within an appropriately archaizing atmosphere in which everything is suffused in a golden glow—a visual cliché that constituted a mechanical reference to the "Golden Age." The extremely interesting dimension of the topography of ancient Greek sites—that is, the way in which the geophysical constituents reveal the affinity between history and myth and endow them with a deeper content—was of no concern to the landscape painters. On the contrary, the geophysical peculiarities of the location were usually modified, depending on the desired result, into a "stage set"— given that the common desire of European painters and their clients was for "Greek pictures with noble ruins"—that remodeled a scenery that satisfied the nostalgic quest for the classical world (see cat. nos. 42–44).

The Greek landscapes of the majority of nineteenth-century Romantic artist-travelers convey no melancholy or compassion for a country in bondage. What they express is primarily the confused vision of a paradise in which restless souls found refuge. There was no place for contemporary references in this dream world (see cat. no. 45). The inhabitants of Greece are usually depicted in the landscapes as miniature figures in festive costumes, either grazing their flocks like Virgilian shepherds or reclining nonchalantly on broken columns,

enjoying the view. With paradisiacal images such as these, foreign artists awoke pleasant memories in those who had made the journey to Greece or satisfied the curiosity of those who had not, while in each case they charmed the beholders, at once revealing to them the land of classical perfection and an accessible vacation venue. Such were the images that captured and intensified the European intelligentsia's interest in the fate of the small enslaved country— the wellspring of the cultural heritage of mankind—until the Greek revolution was destined to cancel the leading role that ancient Greece had played for centuries, perpetuating a fixed framework for beholding Greek reality.

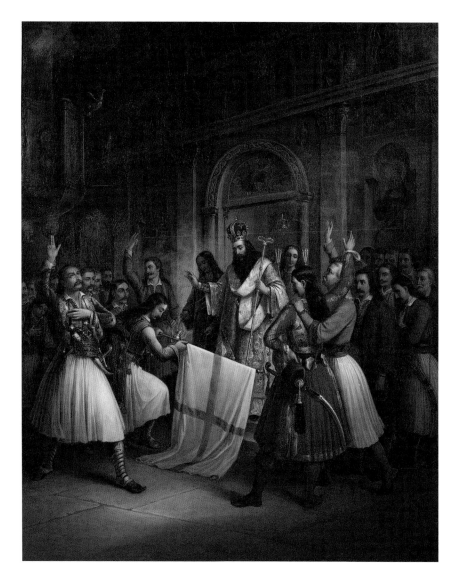

Fig. 2 Theodoros Vryzakis (1814–1878). *The Oath Being Taken in the Church of Aghia Lavra*. Oil on canvas. 1851. Benaki Museum, Athens, inv. no. 8970

The Greek uprising, which liberal thinkers greeted with enthusiasm, fired the forces of Romanticism, enriched European artistic inspiration with a new phantasmagoric repertoire, and re-baptized the "Greek" images (see cat. nos. 123–28). Pictorially, the combination of the religious, classical, Oriental, and heroic elements of the Greek War of Independence provided a first-class thematic repertoire for European artists; moreover, the subject was so familiar to the European public that artists used it to indirectly express their protests against their own governments (see cat. no. 128). The struggle of the Christian Greeks held enormous appeal for the international public, reviving the spirit of

the Crusades. Religious propaganda passed into the artistic vocabulary as a series of motifs in which the Greeks are projected as modern martyrs for the faith (fig. 2). Equally potent was the classical heritage of ancient Hellas as a motivating force for the Greeks, one they defended with self-sacrifice worthy of their ancestors. Missolonghi (see cat. no. 126) passed into philhellenic literature as "modern Thermopylae," while the Greek freedom fighters of 1821 entered the philhellenic repertoire alongside the heroes of the classical pantheon. Without doubt the element that above all gave flight to the Romantic imagination was the dramatic series of oppositions that the Greek revolution encompassed. The Greeks' struggle against the Turks symbolized the conflict between civilization and barbarity, between the cross and the crescent, between freedom and oppression. The revolutionary iconography was widely disseminated thanks to the prints that circulated with remarkable frequency, so that the European and American publics were visually familiar with the events and the personalities that the philhellenic press daily brought to the fore. Consequently, an industry of philhellenic bric-a-brac, of little artistic pretense, developed, bearing witness to the commercialization, as well as the popularity, of the philhellenic spirit—a phenomenon that was not, in the end, unrelated to the outcome of the Greek struggle.

The artist-travelers' works with Greek subjects challenge today's viewers to undertake imaginary wanderings in time and space. They are an invaluable tool for invoking historical memory, while offering—thanks to the variety of their stylistic idioms—eloquent testimony to contemporary aesthetics and shedding light on nineteenth-century European artistic currents and ideological conceptions. Even so, we should bear in mind that in seeking the Greek world through the iconography of travelers, the researcher is looking at the artistic versions of a dialogue between fact and fantasy, given that the "Greek" images themselves contain elements of endogenous and exogenous testimony. Consequently, we must consider the "Greek picture gallery" of artist-travelers as a source of information that challenges the viewer to read some clues to the past, conscious of the fact that it is a past that is simultaneously represented and undermined.

## Selected Bibliography

Athens 1995; Baumstark et al. 1999; Bordeaux–Paris–Athens 1996–97; Haugsted 1996; Navari 1989; Rome 1986b; Thornton 1983; Tsigakou 1981; Washington, D.C., 1991.

41. **View of the City of Hermoupolis on the Island of Syros**
1842
Wilhelm von Weiler (act. 1830s–1840s)
Watercolor on paper
33 x 45 cm
Inscribed: *Syra 1842*
Inv. no. 24008

The Cycladic island of Syros, which was a Venetian possession for many centuries (1207–1566), developed into a bastion of the Catholic faith. Shortly before the Greek uprising in 1821, it experienced considerable prosperity, and its harbor became abuzz with trading activity. During the Greek War of Independence, refugees from the neighboring islands sought a safe haven there, and after the liberation they built the town of Hermoupolis ("city of Hermes", named after the god of commerce), which became the capital.

The island benefited from King Othon's (r. 1833–62) policy of drawing up plans for the country's major cities. Responsible for the design and execution of the urban plan of Hermoupolis was the Bavarian engineer Wilhelm von Weiler, who was based on Syros between 1837 and 1842. While involved with implementing the urban plan, he also designed and constructed several important public buildings.

In this view of Hermoupolis, as seen from the south, the town extends along the harbor against a background of mountainous countryside. The conical hill covered with houses, which rises prominently at the left, is San Giorgio, on which the medieval town of Ano Syros was built in Venetian times. Hermoupolis appears in the middle ground, stretching between Ano Syros and the waterfront. In this skillful, picturesque composition, Weiler achieved a fluidity of design that did not alter the reality of the scene. All topographical and architectural details are accurate, and the play of light is rendered convincingly. This watercolor remains an interesting document of the early years of Hermoupolis, which served as the main port of post-revolutionary Greece until the last quarter of the nineteenth century, when it was overtaken by Piraeus.

Travlos, Kokkou 1980, 75–76, pl. 7b; Washington, D.C., 1991, 128–29, no. 52; Delivorrias, Fotopoulos 1997, 587, fig. 1036.

F.-M.T.

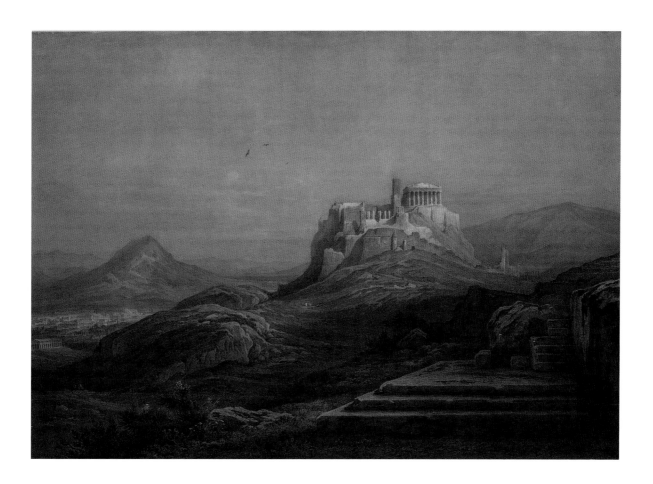

42. **View of the Acropolis from the Pnyx**

1863

Rudolph Müller (1802–1885)

Watercolor on paper

62.5 x 89.5 cm

Signed and dated (bottom right): *Rud. Müller Rome 1863*

Inv. no. 25193

The site from which this view is taken is known as the Pnyx, which means a "tightly crowded place." Closely associated with the history of ancient Athenian democracy, the Pnyx was where the People's Assembly (*ecclesia of the deme*), the most important representative body of the city-state of Athens, held its sessions. This natural rocky terrace facing the Acropolis forms a platform of three steps, clearly depicted in the foreground, which served as the podium from which orators addressed the citizens. This partial view shows the west side of the Acropolis and, at the left, part of the city. It also offers a reliable record of Athenian houses, most of which are simple, two-story constructions typical of the early Othonian period, in addition to public buildings such as the royal palace, which was completed in 1842. Set against a limpid, violet sky in the background are the mountains and hills of Attica—Lycabettus Hill at the left, Mount Hymettus in the middle, and Mounts Parnes and Pendeli in the far distance.

The Swiss landscape painter Rudolph Müller traveled extensively in the Mediterranean before finally settling in Rome after 1860. It was there that he painted this view from drawings he had made on the spot. Here, Müller has caught both the grandeur of the site and the translucent atmosphere of Attica. Moreover, he has carefully chosen his tonal effects to invest the picture with allegorical significance. The Acropolis, rising like a golden mass from the darkly shadowed and solemn Pnyx to dominate the city below, alludes to a Romantic vision of the sacred rock and its monuments, as the glorious expression of creative genius that emerged from the combination of ideal cultural, social, and political conditions.

Washington, D.C., 1991, 30–31, no. 3; Delivorrias, Fotopoulos 1997, 572, fig. 1006.

F.-M.T.

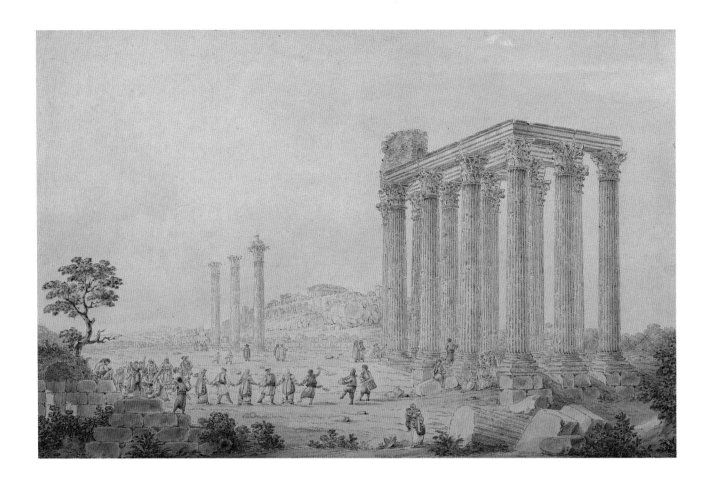

43. **View of Athens with the Acropolis and the Olympieion**
Early 19th century
Louis-François Cassas (1756–1827)
Watercolor on paper
33 x 51 cm
Inv. no. 40166

This view, seen from the verdant banks of the Ilissus, features the Acropolis and the Temple of Olympian Zeus, also known as the Olympieion. Formerly referred to as Hadrian's Palace or the Pantheon of Olympian Zeus, this colossal temple, the largest in Greece, was consecrated in A.D. 131–32 by the Roman emperor Hadrian, a great benefactor of Athens. Of its original 104 gigantic Corinthian columns, only sixteen survived in the nineteenth century. The temple incorporated Hadrian's Arch, which is barely visible between the columns. The ruined brick construction perched at the left end of the temple's epistyle was a hut that in the early 1800s housed a stylite, a hermit living on top of a pillar. The houses clustered on the southeast slope adequately represent the appearance of Athens before the War of Independence. The gifted artist has assiduously rendered details of the dress of the Athenians participating in the scene of music and dance in the foreground, which imparts a festive air to the composition.

Louis-François Cassas, a French landscape painter and architect, accompanied the *comte* de Choiseul-Gouffier to his embassy in Constantinople in 1784. Until 1787, he toured Greece and the Levant at Choiseul-Gouffier's expense, making numerous drawings that were greatly admired by visitors to his atelier in Rome, where he settled after 1827. In 1813, in collaboration with J. M. S. Bence, Cassas published a monumental folio of aquatints entitled *Grandes Vues des principaux sites et monuments de la Grèce et de la Sicile et des sept collines de Rome* (Paris, 1813).

Unpublished. For the artist, see Tsigakou 1981, 194, pl. III; Boppe 1989, 196–210, 278–79; Navari 1989, 23.

F.-M.T.

44. **View of the Plain of Marathon**
    1854
    Edward Lear (1812–1888)
    Oil on canvas
    33 x 53 cm
    Gift of Stamos J. Fafalios, in memory of his father, inv. no. 33626

Until the late nineteenth century, when the ancient *tymvos* (burial tumulus) was brought to light in excavations, the Plain of Marathon, theater of the proud victory of the Greeks over the Persians in 490 B.C., was simply a name. In this watercolor Lear has conveyed the historic import of the place without a trace of literary bombast but with a lyrical disposition and an acute sense of the Greek light. The limpidity of the atmosphere, the vast horizons, and the sensitive modulation of color recall the water-colors painted by Lear, one of the most popular representatives of the school of British watercolorists.

   Lear is considered a painter of Greek landscapes par excellence, thanks to the quantity of his Greek works, which number more than three thousand, their thematic variety, their authenticity, and his special approach to the countryside. He lived on Corfu between 1847 and 1864, exploring and drawing places off the usual paths of foreign travelers. The paintings in his account of his travels, *Journals of a Landscape Painter in Greece and Albania etc.* (London, 1851), express his sensitive attempts to enhance the historical associations of the sites depicted, while his monumental album *Views in the Seven Ionian Islands* (London, 1863) is regarded as an outstanding testimony of the landscape and environment of those isles in the mid-nineteenth century. Lear's Greek compositions surpass those of his fellow artists because they contain recognizable features of the specific locations they depict and are by no means inferior in creating a suggestive atmosphere.

Unpublished. For the artist, see Thessaloniki 1997a.

F.-M.T.

45. **View of the Town of Thebes**
     1819
     Hugh William Williams (1773–1829)
     Watercolor on paper
     47 x 68.5 cm
     Signed and dated (lower right): *H. W. Williams 1819*
     Gift of Sir Steven Runciman, inv. no. 25194

Thebes, the chief town of Boeotia, occupies the site of the ancient acropolis of Cadmeia. During the heroic times that followed its founding, Thebes was the site of numerous dramatic events that inspired some of the greatest Greek tragedies, such as *The Seven against Thebes* by Aeschylus and *Oedipus Rex* and *Antigone* by Sophocles. In the nineteenth century, however, a visitor was presented with nothing but a name and the countryside. Seen in the foreground are the banks of the River Ismenos, not far from the spring where Oedipus washed off the blood after unwittingly slaying his father. At the time this watercolor was painted, bushes and dense foliage lined the banks. Thebes appears in the middle ground. The ancient aqueduct that supplied the town with water until the late 1800s is visible at the left. The elegant outline of Mount Helicon, the dwelling place of the Nine Muses in antiquity, fills the background. Here, as in most of his Greek views, Williams managed to invest the topography with an atmosphere of serenity and an evocation of nostalgia for the bygone age of Greece.

   The Scottish artist Hugh William Williams made an extensive tour of Greece in 1817. He published an illustrated account of his travels in two volumes entitled *Travels in Italy, Greece, and the Ionian Islands, in a series of Letters* (Edinburgh, 1820) and a set of engravings *Select Views in Greece* (Edinburgh, 1827–29). His contemporaries considered him to be the artist who most effectively captured the light and the true spirit of "the glory that was Greece." Indeed, his Greek views earned him the sobriquet "Grecian Williams."

Tsigakou 1981, 116–17, fig. 23; Washington, D.C., 1991, 120–21, no. 48; Delivorrias, Fotopoulos 1997, 497, fig. 871. For the artist, see Tsigakou 1981, 23, 30, figs. 16, 28–29, pls. XVI, XXVI.

<div align="right">F.-M.T.</div>

46. **View of the Village of Portaria on Mount Pelion**
Ca. 1806
Edward Dodwell (1767–1832)
Aquatint on paper
24.5 x 34 cm
Inv. no. 26646

Mount Pelion, on the Magnesia Peninsula, is the easternmost limit of the Thessalian plain. It held a particular fascination for travelers, with its charming landscape and its mythological associations, since it was the dwelling place of the centaur Cheiron, tutor of Jason and Achilles. Portaria, which is thought to be one of the oldest villages on Pelion, is on its western slope. Situated upon a smooth ridge, the village is characterized by a dense network of streets. Its well-built houses display the distinctive features of Pelian architecture—namely, a heavy stone foundation, timber balconies, and sloping roofs tiled with schist. This typology is among the provincial architectural expressions crystallized in Greece in the late eighteenth and early nineteenth centuries.

The aquatint comes from *Views in Greece* (London, 1821), a folio of aquatints by the British topographer Edward Dodwell, many of which were created in collaboration with the Italian artist Simone Pomardi (1760–1830). This view is accompanied by the following description:

> Mount Pelion is adorned with about twenty-four large and opulent villages. Portaria, which is one of the most considerable, is situated high up the southern acclivity of the mountain, in the midst of a varied profusion of trees, which form cooling arbours and embowering shades, while the streets are irrigated by numerous streams.... The poetical fancy of the ancient Greeks has left the majestic elevation of Pelion with a never-fading glory of mythological wonders and classical charms.

Tsigakou 1981, 105, 200, fig. 13. For Pelian architecture and a similar view of the village of Portaria by Simone Pomardi, see Leonidopoulou-Stylianou 1988, 11–90, fig. 84.

F.-M.T.

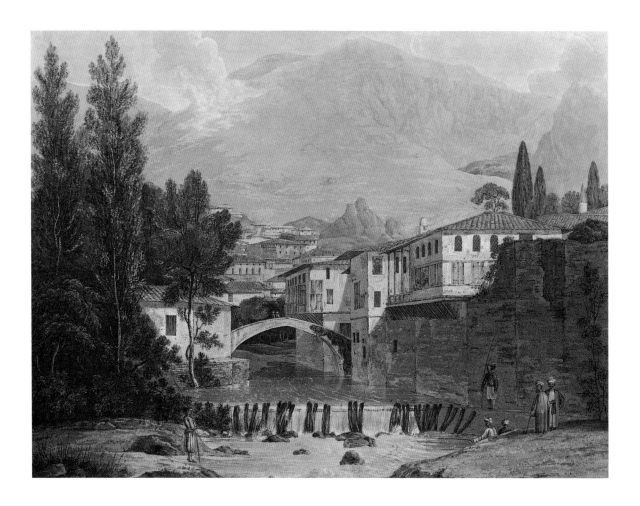

47. **View of the Town of Levadia**
1804
William Walker (1780–1868)
Colored aquatint engraving on paper
42 x 35 cm
Inscribed: *View of Livadia, ancient Levadia. London. Published by W. Walker Dec. 1 1804. Drawn by Walker. Engraved by W. I. Bennett*
Inv. no. 26726

The nineteenth-century traveler who ascended the northeast slope of Mount Helicon reached Levadia, the only other town in Boeotia that was of comparable importance to Thebes. At Levadia, the classically minded tourist could visit the site of the oracle of Trophonios, which in ancient times was second in repute only to the oracle of Apollo at Delphi. This view depicts a part of the town, which extends at the foot of Mount Helicon. The well-built houses attest to the prosperity of the inhabitants, logical as Levadia was the main urban center in eastern central Greece under Ottoman rule. Running through the heart of the town is the Erkyna torrent, which issues from the mountain and spills over the rocky bed in the middle ground. The composition is at once topographically convincing and pleasing, revealing the gracefulness of the natural scenery and the picturesque rustic architecture. Local touches, such as the figures in the foreground, impart a narrative quality to the view and heighten the sense of reality.

The British artist William Walker visited Greece in 1803 in the company of architect Robert Smirke. Upon returning home, he exhibited eighteen Greek subjects at the Royal Academy between 1805 and 1833. Walker was not one of the considerable number of British travelers to Greece who had been drawn by the antique ruins but was interested in the land as it was in his day. His Greek works—unfortunately few—are distinguished by topographical fidelity and thus constitute authentic sources of visual information on Greece during Ottoman times.

Tsigakou 1981, 114–15, 200, fig. 22. For the artist, see Athens 1995, 81–82.

F.-M.T.

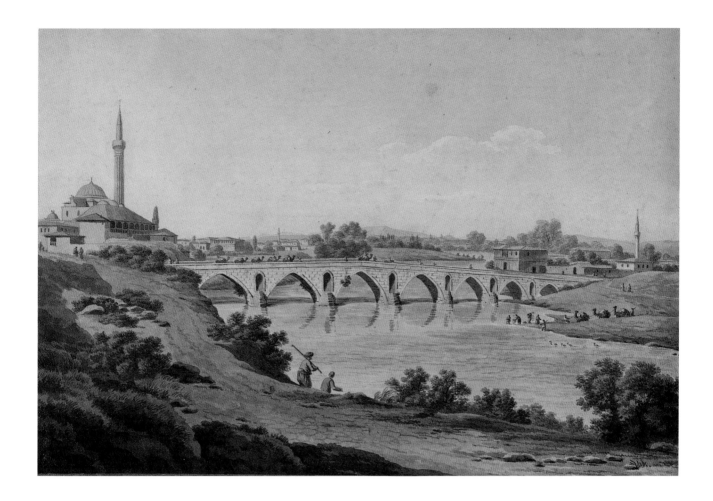

48. **View of the Town of Larissa**
    1805
    Edward Dodwell (1767–1832)
    Watercolor on paper
    38 x 54 cm
    Inscribed: *River Peneus at Larissa 4 June 1805—the mosque is covered with lead. Distant mountain called Agrafa*
    Inv. no. 35045

Greek vernacular architecture includes a great tradition of building bridges, from flat wooden examples to arched stone ones that display a considerable variety of form. The difficulty of constructing them in regions with limited access led to the creation of a highly imaginative popular lore surrounding setting the foundations and the tragic fate of master masons. In the Plain of Thessaly, through which the Peneios flows, an important network of roads had developed since Byzantine times. It was reinforced by more than one hundred bridges, six of which span the river. During the period of Ottoman rule, Larisa was one of the main commercial centers of Thessaly and the bridge there was the symbol of the town, closely linked with its history. It is considered to be a Byzantine construction and was praised by many foreign travelers who passed that way. It had nine arches with eight relieving openings above its central piers. The forked arches bear witness to Persian influence. The bridge was blown up in 1941, during World War II, when the British retreated, and was totally destroyed by the Germans in 1944.

The British topographical draftsman, antiquarian, and collector Edward Dodwell ventured twice to Greece: in 1801–2, accompanied by Sir William Gell (1774–1836), and in 1805. He published the following works on the country: *Views in Greece* (London, 1821) and *A Classical and Topographical Tour through Greece, during the Years 1801, 1805 and 1806* (London, 1819).

Unpublished. For the artist, see Athens 1995, 80. For the architecture of bridges, see Doris 1969, 50–61.

F.-M.T.

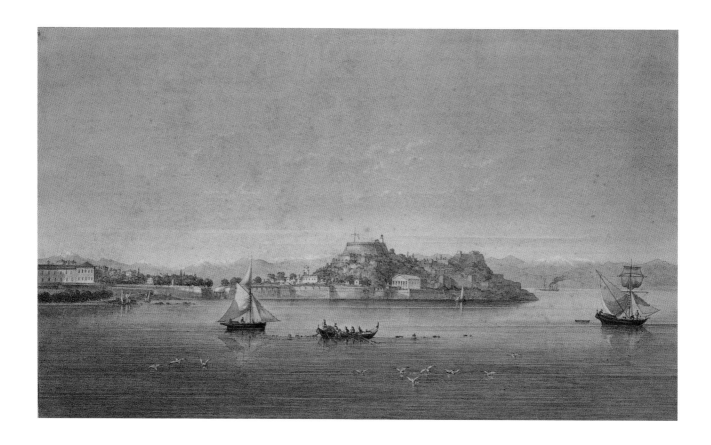

### 49. View of the Port of Corfu

1826
Joseph Schranz (1803–after 1853)
Watercolor on paper
28 x 46 cm
Inv. no. 22993

Corfu has benefited greatly from its geographical position, three kilometers from the coast of Albania and Epirus, and eighty kilometers from the Italian mainland. It served for centuries as the main seat of administration of the Ionian Islands. The present view, from the Bay of Garitsa toward the south of the town, opens on the left with a long two-story mansion, the nineteenth-century Palace of Saints Michael and George, which served as the residence of the British high commissioner. Then follows the Esplanade, which separates the town from the Citadel, an old fortress built in the sixteenth century by the Venetians on a promontory with two hills. Farther to the right a bridge spans the small canal dug between the Esplanade and the Citadel. The building in the form of a Doric temple overlooking the Bay of Garitsa was the Anglican church of Saint George. In the distance, the unbroken range of the mountains of Albania and Epirus fringes the horizon.

Joseph Schranz, a marine painter and lithographer, came from a family of landscape and marine artists from the island of Malta. He visited the Ionian Islands in 1826. From about 1832, his permanent residence was Constantinople, whence he paid several visits to Greece in the 1840s. The elegant composition of this watercolor affirms the artist's meticulous style and use of bright colors. Thanks to his successful rendering of sunlight, Schranz has brought together the townscape and the features of the surrounding countryside while capturing the play of sunshine over the water.

Washington, D.C., 1991, 108–9, no. 42; Delivorrias, Fotopoulos 1997, 584, fig. 1032. For the artist, see Azzopardi 1987, 48–50. For a similar painting by Schranz, see Tsigakou 1981, 199, pl. VIII.

F.-M.T.

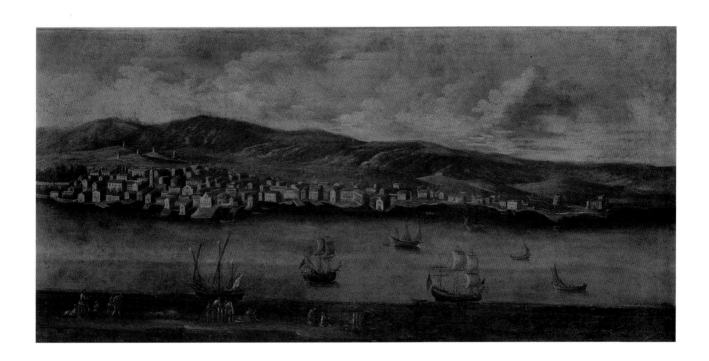

50. **View of the Town of Argostoli on Cephalonia**
    Late 18th century
    Unknown artist
    Oil on canvas
    63 x 129 cm
    Inv. no. 11182

The Ionian Islands (Cephalonia, Corfu, Paxoi, Lefkada, Ithaka, Zakynthos, and Kythera, farther south), which lie off the west coast of Greece, fell prey to many foreign conquerors over the centuries. Cephalonia, the largest island, was theater of revolutionary movements in the eighteenth and nineteenth centuries and played an active part in the Greek War of Independence and the movement for the union of the seven islands with Greece, which took place in 1864. Argostoli, capital of Cephalonia since 1757, was an important center and birthplace of eminent Greek men of letters.

The view of the town is linked with eighteenth-century European landscape paintings, which had to be accurate memoranda with limited aesthetic pretensions. It gives a panoramic vista of the town, in which the natural landscape, the harbor, and every detail of the buildings are precisely rendered. In the foreground, engaging incidents and people in local costumes bring the setting to life. In this view—rare in terms of age and size—of Argostoli, the anonymous artist conveys a sense of theatrical perspective in the composition but has commendably preserved a visual record of most of the buildings in the town, which was razed by catastrophic earthquakes in 1867 and 1953.

Delivorrias, Fotopoulos 1997, 584, fig. 1031.

F.-M.T.

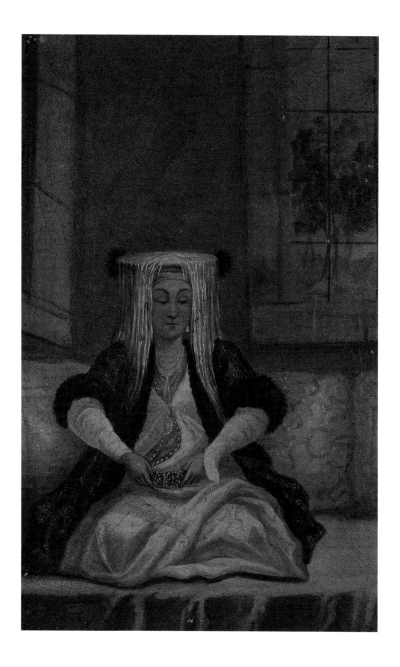

51. **A Greek Bride**
Ca. 1760–70
Francis Smith (d. before 1780)
Oil on canvas
38 x 24.5 cm
Gift of Damianos Kyriazis, inv. no. 11185

The bride is seated cross-legged on a high dais, ready to receive relatives and friends in order to show off her clothes and trousseau. Her outfit—one of the two customary types of urban bridal costume during the Ottoman period—consists of one or two pairs of pantaloons, a diaphanous selvedged chemise and a dress with tightly buttoned long sleeves, a sash worn low on the hips, and a short-sleeved overcoat trimmed with dark fur. The peculiar headdress is dominated by the characteristic, almost flat, oval head covering with reddish brown pompoms, one right and one left, to which is affixed a gossamer veil that also covers the face.

Among the various testimonies bequeathed to us by the foreign artist-travelers who visited Greece in the seventeenth, eighteenth, and nineteenth centuries, the depictions of costumes are particularly important. The imaginative combination of the various garments and accessories that make up the Greek costume and the wealth of jewelry fascinated foreign travelers, who recorded them pictorially, often with a dubitable degree of accuracy.

In this painting as well as in cat. nos. 52 to 56, the artist clearly has copied works by Jean Baptiste van Mour (see cat. no. 61). The British painter Francis Smith accompanied Lord Baltimore on his journey to the Middle East in 1763. In 1769 he published an album entitled *Eastern Costumes*, which includes twenty-six copperplate engravings annotated *engraved from the collections of the R. H. Lord Baltimore* that are copies of original works by van Mour.

Delivorrias, Fotopoulos 1997, 503, fig. 888. For the painter, see Boppe 1989, 292.

I.P.

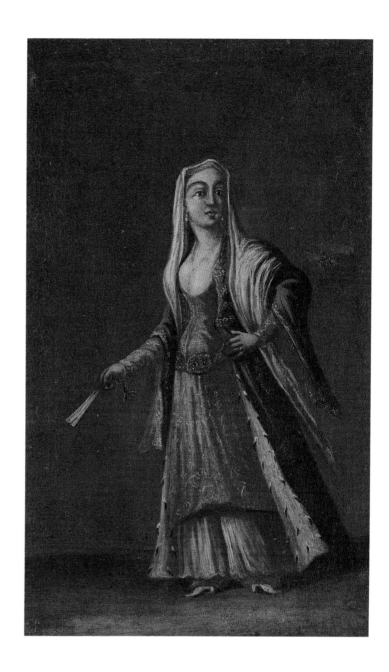

52. **A Greek Lady of Smyrna**
    Ca. 1760–70
    Francis Smith (d. before 1780)
    Oil on canvas
    39.5 x 24.5 cm
    Gift of Damianos Kyriazis, inv. no. 11189

The picture probably depicts a bride before being bedecked, wearing a similar costume to that in cat. no. 51. Here, the overcoat, also trimmed with fur, has wide pointed sleeves and the dress appears to have been hitched up, revealing the bottom of the pantaloons.

Delivorrias, Fotopoulos 1997, 503, fig. 889.

<div align="right">I.P.</div>

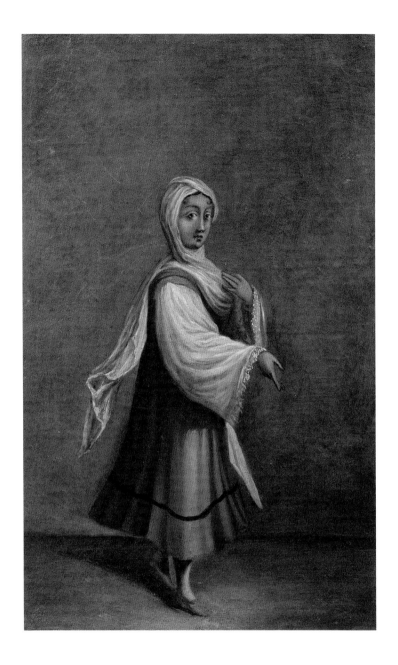

53.  **A Woman of Tinos**
     Ca. 1760–70
     Francis Smith (d. before 1780)
     Oil on canvas
     40 x 25 cm
     Gift of Damianos Kyriazis, inv. no. 11187

The woman from the Cycladic island of Tinos is wearing a white chemise with wide sleeves, a sleeveless pink dress with a horizontal pleat above the hem—characteristic of Greek island costumes—that is drawn like a brown ribbon. Draped freely on her head is a shawl. The painter copied the costume from a painting by Jean Baptiste van Mour and rendered it in his own imaginative manner.

Unpublished.

<div style="text-align: right">I.P.</div>

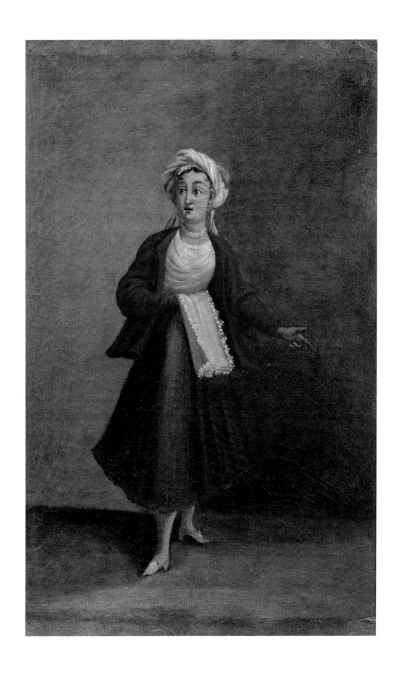

54. **A Woman of Kalymnos**
    Ca. 1760–70
    Francis Smith (d. before 1780)
    Oil on canvas
    37 x 26 cm
    Gift of Damianos Kyriazis, inv. no. 11186

The woman of Kalymnos, depicted in a costume that Jean Baptiste van Mour ascribes to Patmos, indicates the unreliability of Francis Smith's illustration. Perhaps both artists give erroneous information, since the costume in the oil painting includes garments, such as the white chemise and the red jacket, that are not in keeping with the dress of either the place or the period. The costume possibly recalls the dress of Paros (see cat. no. 57).

Unpublished.

I.P.

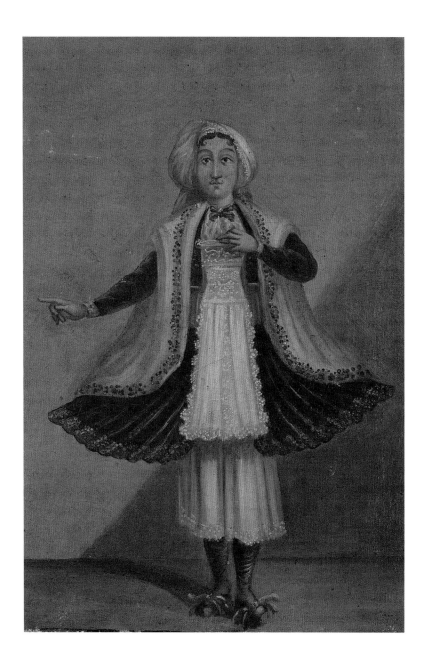

55. **A Woman of Naxos**
    Ca. 1760–70
    Francis Smith (d. before 1780)
    Oil on canvas
    35 x 25 cm
    Gift of Damianos Kyriazis, inv. no. 11188

The woman of Naxos, also taken from a painting by Jean Baptiste van Mour, is illustrated in a costume that was later described convincingly by Pitton de Tournefort (1656–1708) and even more clearly by Choiseul-Gouffier (1752–1817). The footwear and the basic garments, which are more or less the same in all the islands of the Cyclades, are strongly reminiscent of Western European *houpelandes*. The skirt, frequently high-waisted and densely pleated, is held out by hoops (crinoline), which make it easier for the woman to sit down. The bodice is sometimes the same as the skirt, as here, or similar to the wide-sleeved chemise. The rather inelegant opening of the dress—for the event of pregnancy—is covered by an apron that matches the chemise and the shawl.

Delivorrias, Fotopoulos 1997, 503, fig. 890.

I.P.

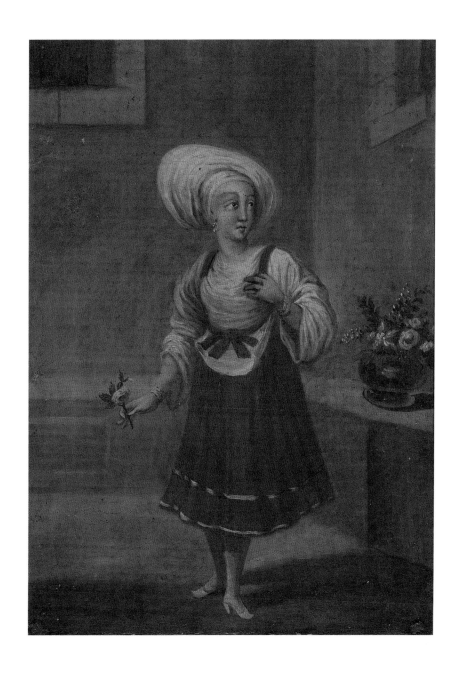

56. **A Woman of Chios**
    Ca. 1760–70
    Francis Smith (d. before 1780)
    Oil on canvas
    37 x 26 cm
    Gift of Damianos Kyriazis, inv. no. 11184

The Chiot woman in the picture, again based on an original work by Jean Baptiste van Mour, is reminiscent of a Parisian lady at an aristocratic ceremony with peasant girls. Here, Francis Smith debases somewhat the refined elements in van Mour's work, mainly by using bright red on the skirt.

Delivorrias, Fotopoulos 1997, 503, fig. 891.

I.P.

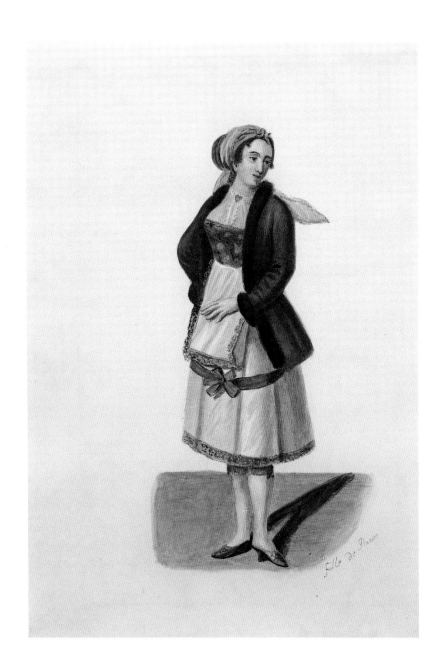

57. **A Woman of Paros**
 Early 19th century
 John Collings
 Watercolor on paper
 17.5 x 22.5 cm
 Inv. no. 23074

The painting may be a copy of a watercolor by G. W. Graf von Rumpf of about 1768 that renders a quite credible depiction of the female costume of Melos. Here, the woman of Paros wears a similar ensemble, comprising a chemise-dress, a stomacher, an apron, and a red jacket trimmed with fur. A broad green ribbon girds her body at mid-thigh and on her head is a reddish cap covered by a yellowish shawl.

 Figures of Greeks in local costumes, mainly of the Aegean Islands, are included in several illustrated travel accounts of the period. In this watercolor and those following (cat. nos. 58–60), John Collings, about whom no biographical details are known, followed the dictates of the day and added his own, not necessarily accurate, testimony regarding Greek costumes.

Unpublished.

I.P.

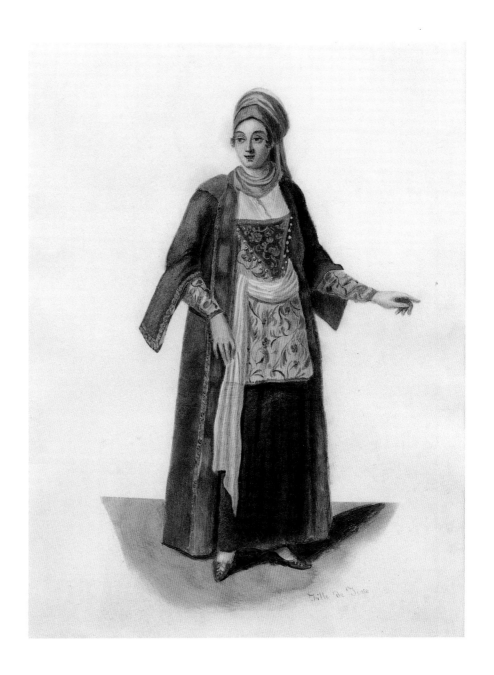

58. **A Woman of Tinos**
    Early 19th century
    John Collings
    Watercolor on paper
    17.5 x 22.5 cm
    Inv. no. 23071

The woman of Tinos is depicted in a strangely rendered costume, which, as is often the case, a traveler must have described to the artist. The woman appears to be wearing a skirt, a stomacher, and a long blue bodice with green overcoat, while a yellow scarf swathes her head in a simple manner. The costume is possibly similar to that depicted in cat. no. 60, which was common in the Greek archipelago.

Unpublished.

I.P.

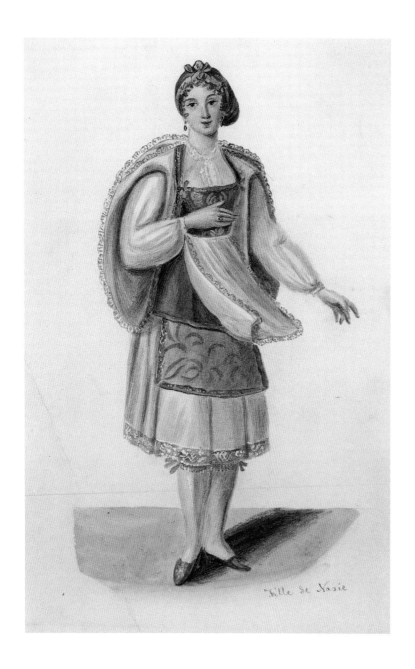

*Fille de Naxie*

59. **A Woman of Naxos**
   Early 19th century
   John Collings
   Watercolor on paper
   14 x 21 cm
   Inv. no. 23073

The woman is dressed in the short costume ensemble of the Cyclades, which impressed European travelers, who described and illustrated it in their books from as early as the seventeenth century. The woman wears fine stockings, held in place below the knee by a garter and a pink bow, and mules. Her bodice has long sleeves fitted tightly around the wrists. The chemise, with voluminous long sleeves, has been lifted up and fixed on the shoulders for a coquettish effect. The dress usually was short, from knee to thigh length, as here. The opening of the dress—to allow for a pregnancy—was fastened most inelegantly in front, for which reason various pieces of attractive cloth were added inside (here, pink brocade) and out (here, a kind of white apron). The hair was plaited in braids, which were coiled, creating imaginative headdresses in combination with the kerchiefs or scarves.

Unpublished.

I.P.

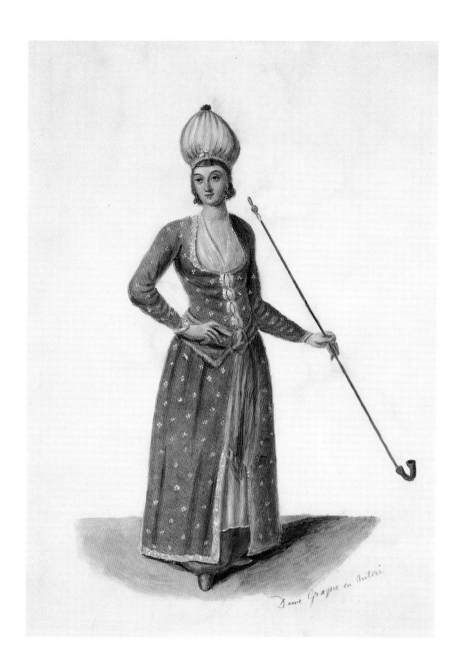

60. **A Greek Lady Smoking a Pipe**
    Early 19th century
    John Collings
    Watercolor on paper
    17.5 x 27.5 cm
    Inv. no. 23072

The woman is depicted in a costume ensemble in the Ottoman fashion. She wears at least one pair of pantaloons, a flimsy selvedged chemise, and a dress of green brocade. A red shawl is tied just below the waist in place of a sash. The white gossamer turban seems to have been wound on a hard towerlike cap of sultanic type, which possibly was worn by women too. She is smoking a pipe, perhaps indicating that she belonged to a harem.

Delivorrias, Fotopoulos 1997, 501, fig. 883.

I.P.

61.  **A Greek Lady of Constantinople**
     Early 18th century
     Attributed to Jean Baptiste van Mour (1671–1737)
     Oil on hardboard
     34 x 26 cm
     Inv. no. 9039

The painting depicts a bourgeoise Greek lady in luxurious attire. She wears a version of the female urban costume of the Ottoman Empire. The available iconography shows that it was the customary dress, with variations, of all Greek women, primarily those living in the islands, Cyprus, and Constantinople. Here, it comprises a flimsy chemise with selvedges, a rose-colored skirt, and a gold cloth stomacher combined with a black bodice that has silver buttons on either side of the opening, holding the waistcoat in place with a red cross-laced ribbon. Its ends may have held the gossamer apron in place. On top of all these garments is an overcoat of thick European brocade, trimmed with white ermine tail fur. The pointed sleeves are edged on the top seam and the cuff with gold braids and bobbin-lace tassels. The woman's hair is parted down the middle, with ringlets on the temples. The turban is wound from a diaphanous red tippet. She is heavily made up with beauty spots and wears earrings resembling a bunch of grapes, a choker of two strings of pearls fastened behind with ribbons, and a four-link solid chain with a pendant. This type of costume usually is completed by ankle-length pantaloons, a petticoat, colorful stockings, and mules, which are not visible in the picture.

The woman's restrained expression of vanity, the vivid chromatic harmonies, and the immediacy with which the painter enhances the opulence of the garments and the intricacy of the jewelry are traits far removed from the theatrical exoticism of Orientalist portraits and bear instead the stamp of familiarity of an authentic testimony. The work can be linked with similar portraits by Jean Baptiste van Mour, which are identified by an opulent atmosphere yet do not bely the naturalistic rendering of details.

The painter Jean Baptiste van Mour (1671–1737), of Flemish origin but belonging to the French School, made his home in Constantinople from the last quarter of the seventeenth century until his death. Enjoying the favor of high society, he painted many portraits of foreign ambassadors, Greek Phanariots, and Turkish officials. His oeuvre is widely known thanks to a series of one hundred portraits commissioned by the French ambassador to the Sublime Porte (1699–1710), the *comte* de Ferriol (d. 1712). These works were engraved and published in a monumental album entitled *Recueil de cent estampes représentant différentes nations du Levant, tirées sur les tableaux peints d'après nature en 1707, et 1708, par les ordres de M. de Ferriol ambassadeur de Roi à la Porte. Et gravées en 1712, et 1713, par les soins de M. Le Hay* (Paris, 1714).

Delivorrias, Fotopoulos 1997, 502, fig. 887; Papantoniou 2000, 148, fig. 187. For van Mour, see Boppe 1989, 12–55.

I.P. and F.-M.T.

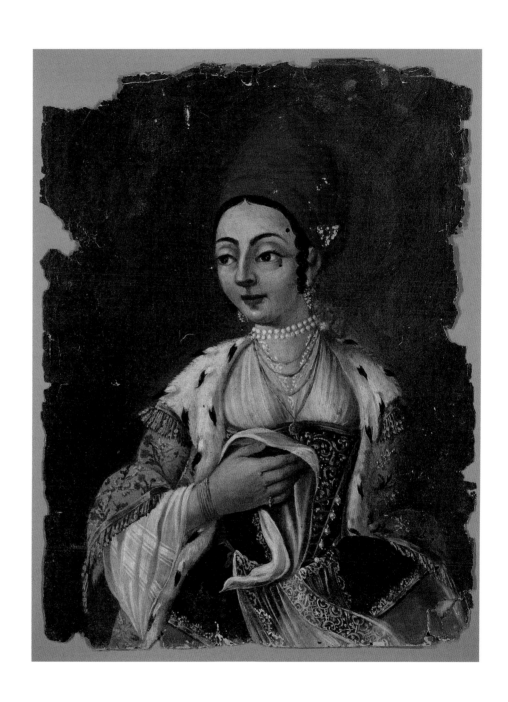

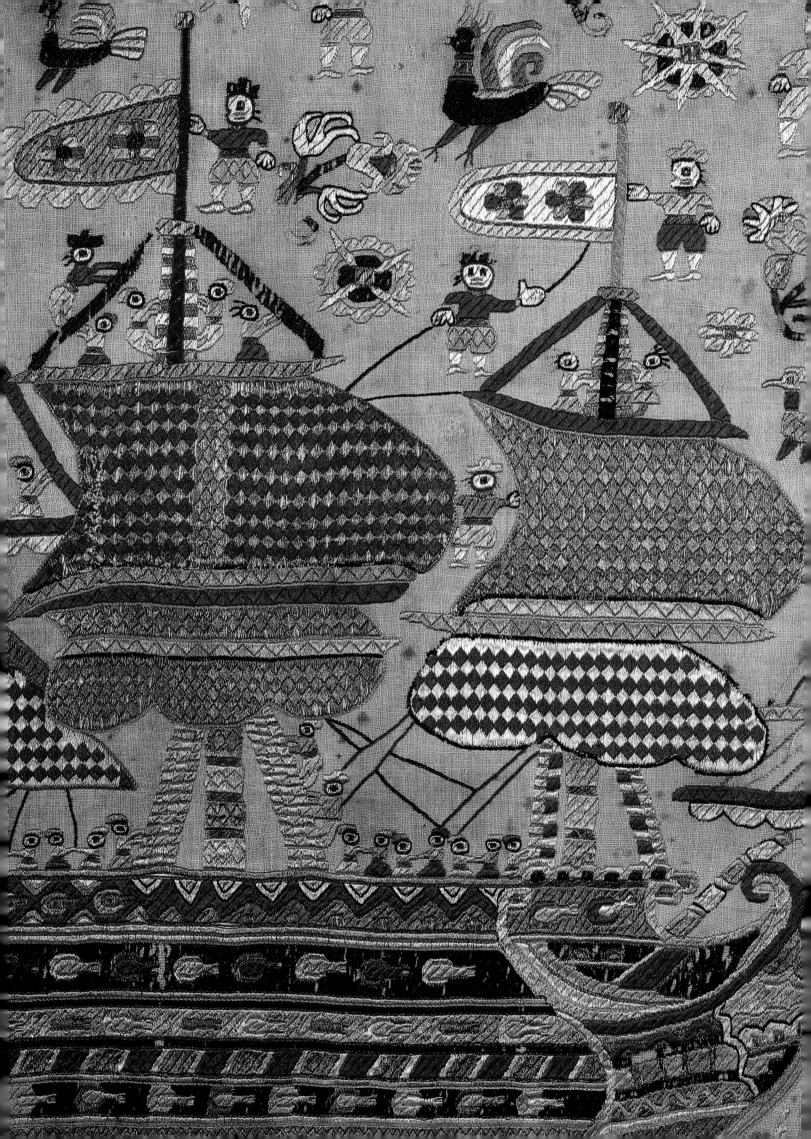

# SOME THOUGHTS ON THE SECULAR ART OF HELLENISM UNDER FOREIGN RULE

## Angelos Delivorrias

This text, by necessity brief, begins with the observation that whereas ancient Greek art has been studied assiduously in breadth and depth and is relatively well known to an international audience, the same cannot be said of other eras of Hellenic artistic creation. The Byzantine art of medieval Hellenism, for example, continues to be less well known despite the interest expressed in it during the twentieth century, which awakened public awareness through widely influential temporary exhibitions and portended a more promising scholarly future. The same is true, even more so, of artistic activity in the post-Byzantine period, even though there is no shortage of bibliography on ecclesiastical art, in contrast to its contemporaneous and equally important secular counterpart, which continues to elude us and has not stimulated a satisfactory degree of scholarly curiosity. Thus it has not been subjected to the necessary processes of repeated distillations, to those exhaustive probes that hold the promise of decoding the secrets of its semantics and the canons of its aesthetics—in other words, deciphering its verbal discourse.

The reasons for the inertia in research should be sought in a somewhat depreciatory evaluation that is difficult essentially to conceal. It stems from the unfortunate labeling of the secular art of the centuries after the fall of Byzantium as "folk" or "vernacular" and the consequent facile and superficial pronouncements on the simplicity, the naïveté of its expressive idiom. The impasse in tracing it is overburdened, moreover, by the Procrustean methodological approaches to the available material from the standpoint of folklore studies or anthropological, ethnological, sociological, and other kindred disciplines from whose vocabulary the concepts of morphological and stylistic singularity are absent. Thus, together with the concomitant factor of overt ethnocentric sentimentality, the significance of the coordinates of time and space in the historical dimension of artistic production and its generative causes has been downgraded. Thus are explained the misleading classifications of its creations, guided by their supposedly "handicraft," "traditional," or "applied" character. I shall not dwell on these taxonomies, not only because I do not believe in them but also because serious doubts have begun to be expressed more generally about their literal accuracy and their significant correspondence.

In repeating yet again that the need for expression, or rather the manifestation of artistic sensitivity, can only be understood on the basis of the pure criteria of art history, I shall stress once more the value of the parameter of historicity for the perception of any creation. Historicity both fires its substance and animates its physiognomy. As most of the texts in the present volume demonstrate, however, historicity is also responsible in large part for the misfortunes of the secular art of post-Byzantine times. The destruction, plunder, and fragmentation of its components during the troubled years of foreign rule were compounded after the War of Independence by the rapid changes in fashion that came with the European orientation of the Greek state. Finally, the collecting mania of recent times bears a serious share of responsibility for the loss of the

Cat. no. 83. *Cushion Cover* (detail). 17th century. Linen embroidered with silk thread. Inv. no. 6389

133

geographical provenance of many of the scattered remnants that have been gathered. Otherwise, it would be difficult to explain the mutually conflicting attributions of the embroideries, for example, scavenged by foreign travelers in the second half of the nineteenth century, before they ended up in European trade, their provenance meanwhile forgotten.

It is not, however, only the origin of the creations that escapes us but also the date. The rarity of absolute chronological data and epigraphic testimonies, coupled with the cavalier attitude of research, has ingrained the debatable view that almost all the surviving artistic production is related to the economic heyday of Hellenism in the eighteenth and nineteenth centuries. If this is indeed the case, then we are obliged to conclude that between the fifteenth and the eighteenth century Greek regions were devoid of people. Among the further difficulties that the approach to and the interpretation of the related phenomena presents, in terms of the more general cultural climate of the period, is the fact that the available sources are scant and barely helpful, as the snippets of information they contain are disparate and have not been coherently assessed. The folk songs, for example, the poetic counterweight of visual artistic creation, for all their inspired and potent imagery, contain neither express references nor even circumstantial allusions to works of art. Consequently, it is difficult not only to approach the aesthetic evaluation of the art forms but also to understand the mechanisms of their perception—in other words, the definitive function of the social parameter in their composition. Without doubt contemporary testimonies include a still-unprocessed fund of dowry contracts and wills, the laconic entries of which provide stimuli mainly of interest for the study of terminology. The opposite is the case with certain textual and visual testimonies of foreign travelers, who draw important elements from the everyday life, customs and mores, architecture, and dress of the period.

In order to sketch, at least schematically, the history of secular Hellenic art in the centuries of foreign rule in such a way as to encourage the unprepared reader to venture on a personal path of exploration, the material of even the most representative exhibition catalogue would by no means be sufficient. For this reason, the text that follows is accompanied by illustrations of a rather large number of extra works, and a considerable bibliography is offered so that interested persons can find whatever else was deemed essential to be cited but not illustrated. Nonetheless, the reader should not form the erroneous impression that these additional references exhaust the gamut of a

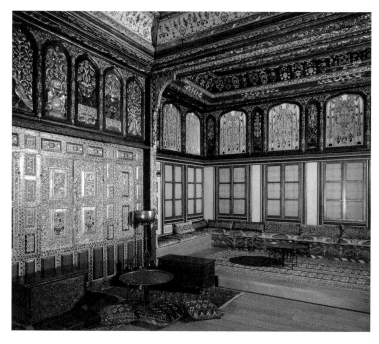

Fig. 1  Reception room from a mansion in Kozani, Macedonia. Mid-18th century. Benaki Museum, Athens, inv. no. 29752

Fig. 2  Reception room from a mansion in Kozani, Macedonia. Mid-18th century. Benaki Museum, Athens, inv. no. 21190

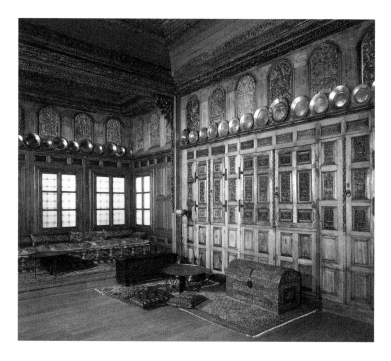

creation of far broader scope. Mainly, however, he or she should not overestimate the bold global assessment of such a thorny issue, because it may easily obscure the significant aspects of individuality that theoretically justifies the artistic context and orients the philosophical ponderings of aesthetics.

Of the individual sectors of secular art in the years before the War of Independence—with the exception of music, dance, and, above all, poetry, which had begun to impress the European intelligentsia by 1825, when Claude Fauriel published the *Chants populaires de la Grèce moderne*—architecture was without doubt the most fortunate scientifically. Thanks to a host of systematic studies and thorough documentation, a general typology of buildings and settlements, both on the mainland and the islands, has been consolidated. In the Ionian Islands and Crete, the Dodecanese, Cyprus, and the Cyclades, the influence of Western Late Gothic and, following that, of the Italian Renaissance tradition, was decisive. Indeed, in some cases avant-garde morphological models were adopted with a speed that would rival even today's pace of information transmission.

In the Cyclades specifically, an architectural canon of austere simplicity was formed, with its dazzling white coloration and unrivaled elegance, emphasized from the seventeenth century by ornate stone decorative elements. Schist or marble fanlights for ventilation were adorned with incised and champlevé relief decoration (see cat. no. 62). Doors and windows were frequently surrounded by marble frames carved with vegetal motifs, as in the case of a demolished mansion on the Cycladic island of Ios, the remnants of which are now housed in the Benaki Museum. Lintels bore coats of arms and symbols referring to the owners' social status. Fountains (see cat. no. 64), which sometimes acquired monumental dimensions in the central squares of settlements, were adorned with elaborate relief representations. Among the most important creations of this period are the marble *iconostases* (icon screens) of many island churches, that testify to the high level of sculpture that, following its Byzantine past, did not hide its abhorrence of the pagan roots of statuary (see cat. no. 63).

A different style prevailed in central and northern Greece. The houses were two storied, with a stone ground floor and a first floor, of lighter construction, jutting out above (see cat. nos. 46–47). This type was widely diffused throughout the southern Balkans, the East Aegean Islands, and Constantinople, where it appears to have originated. In the mansions of the prosperous classes, the reception rooms, frequently with high quality carved wood paneling on the walls and ceilings, convey a sense of fairytale opulence (figs. 1, 2). In several cases the surfaces were covered with frescoes, their compositions offering the sole surviving examples of a quasi-monumental painting style. Apart from the common floral and vegetal motifs, which document the wide dissemination of the European Rococo during the eighteenth century, the iconographic repertoire was dominated by views of cities—real or imaginary—harbors, and ships, behind the seemingly cosmopolitan dimension of which a certain disposition toward escapism can be discerned (fig. 3). The rare representation of a hunting scene of 1763 (fig. 4) also must be symbolic, as inferred from thematically analogous creations in wood carving (fig. 16).

The rapidity of the modernization of Greek society and the indifference of the Greek state, which exacerbated the destruction of the northern Greek mansions, are also responsible for our patchy knowledge of the thematic repertoire of their murals. The same is true of the catastrophic earthquakes of

Fig. 3 Mural with a view of Constantinople. From the mansion of George Schwarz in Ampelakia, Thessaly. 1798

Fig. 4 Mural with a hunting scene. From the mansion of Manousis in Siatista, Macedonia. 1763

Pelion in 1955 and 1965, which razed the corresponding testimonies of other equally important cultural centers of Hellenism under foreign rule. Nevertheless, from what has been salvaged it is surmised that mythological subjects were not unknown in the eighteenth century, whereas historical ones were entirely lacking, at least in the period prior to the struggle for independence. Consequently, the valuable testimony of a composition in egg tempera on wood, perhaps from western Macedonia and now in the Benaki Museum, probably depicting episodes in the Russo-Turkish hostilities of 1828–29, if not of 1853–56, and of much larger dimensions than usual, cannot be dated before 1830.

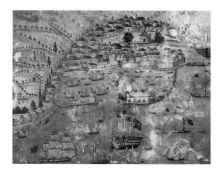

Fig. 5  Mural with a view of Herakleion and its harbor. From the demolished mansion of Fazil Bey in Herakleion, Crete. Ca. 1800. Historical Museum, Herakleion

It should be noted that in northern Greek wall paintings, the human figure appears rarely and is always diminutive. The reasons for this elude us at present but are certainly not unrelated to the importance accorded to the landscape, the home, and the outlet to the sea. The same applies to those wall paintings known from other Greek regions, such as the few fragments from a demolished mansion of about 1800 at Candia (modern Herakleion) in Crete (fig. 5) or the better-preserved murals in mansions on Lesbos, the Krallis residence in Molyvos of about 1830, and the Vareltzidaina one at Petra of about 1790–1800 (fig. 6). Lesbos is the source of another ensemble of wall paintings (fig. 7), but as is the case with most of the works traded through antique shops, the precise data on their identity have

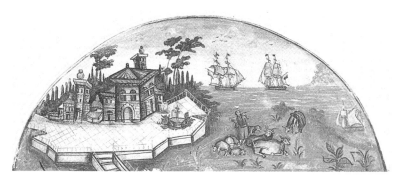

Fig. 6  Mural with a view of a coastal city. From the Vareltzidaina mansion at Petra, Lesbos. Ca. 1790–1800

been lost. Examples of wall paintings have not been located on other Aegean Islands, or, to be more exact, none has been publicized. Nevertheless, it is highly unlikely that at least the wealthiest houses of the leading citizens were not adorned with murals, as was surely the case in most other Greek regions.

As far as the painting of the period, any number of unsubstantiated views circulate, one being that there were no portable secular paintings. This view is being revised thanks to the discovery of a view of Rethymnon, painted in oil on canvas and dated not much later than the mid-seventeenth century (fig. 8). At present, it is the only known example of an independent painting. It belongs stylistically and thematically to the same tradition as the murals of Crete (fig. 5), the east Aegean (figs. 6–7), and central and northern Greece (fig. 3), suggesting that comparable creations probably existed in earlier periods. In addition to the views of cities, there were apparently portraits as well, as borne out by

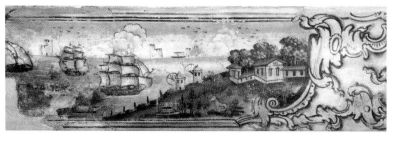

Fig. 7  Part of a mural with a view of a coastal city. From a mansion in Mytilini, Lesbos. Late 18th century. Benaki Museum, Athens, inv. no. 35254a

documentation from the Ionian Islands and a large number of depictions of donors in the wall paintings and portable icons of numerous churches. To this category belongs the miniature portrait of Archbishop Cyprian of Cyprus, who died a martyr's death on July 9, 1821, which must have been painted prior to the outbreak of the War of Independence, probably on the occasion of his ordination in 1810 (fig. 9). In one way or another, expressively codified in the prelate's facial features is a typology already crystallized by the end of the eighteenth century and, indeed, not unrelated to parallel trends in European painting (see cat. no. 61). In the case of the view of Rethymnon, the prominence

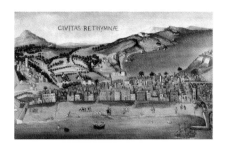

Fig. 8 *View of Rethymnon and the Surrounding Area from the East.* Oil on canvas. Mid-17th century. Town Hall, Rethymnon

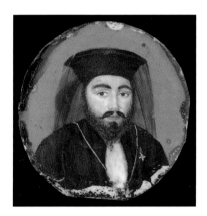

Fig. 9 Miniature portrait of Archbishop Cyprian of Cyprus (1756–1821). Watercolor. Ca. 1810. Benaki Museum, Athens, inv. no. 8445

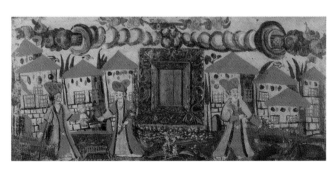

Fig. 10 Lid of a painted chest showing female figures in front of an imaginary hamlet. From Samos. 18th century. Benaki Museum, Athens, inv. no. 21005

of the landscape, in conjunction with the topographical accuracy of the depiction, stands emphatically in contrast to the miniature scale of the human figures, whose rendering in idealized idyllic moments of daily life has absolutely no relation to reality.

The diminution of human scale observed in the murals (figs. 4, 6), however, does not occur in a series of wooden chests painted in egg tempera, in which the human figure is enhanced and glorified (see cat. no. 67). Most of these chests were found on Lesbos and, for reasons unknown, have completely escaped the attention of scholars. Their production must have flourished on Lesbos, even though an example from Samos (fig. 10) points to the parallel development of independent workshops on other islands in the archipelago. In fact, the known limited number of chests will doubtless increase, provided, of course, that scholarly interest overcomes the deficiencies of the existing literature and the shortcomings of research. Only then will the subtle narratives and diffuse erotic nuances in these representations be appreciated. Only then will the primal place of the female in a world that, without adequate evidence, has wrongly been condemned as strictly male dominated, become more immediately apparent.

If the representation on one such chest in an Athenian private collection (fig. 11) is by the hand of the same artist who painted the murals in the mansion at Petra on Lesbos (fig. 6), as seems more than likely, then the techniques of egg tempera and fresco—with the independent traditions of their methods and materials—must have been employed simultaneously. After all, this was already the case since the Middle Byzantine period and during the Renaissance. In order to confirm the proposed correlation, however, it has to be checked against other corresponding stylistic coincidences. For example, the enigmatic representation on another chest from Lesbos (fig. 12), in which close affinities are detected in the design and the coloration to those of an ensemble of wall paintings from the same island (fig. 7), points out the need for stylistic attributions of the surviving works. Inscribed in the desiderata of future research are the definition of particular painting styles—demanding an exhaustive comparative approach—the distinction of individual creators, and the refutation of the myth of their anonymity, which has bedeviled the meaning of so-called folk or vernacular art to a distressing degree. Inscribed likewise is the need to elucidate the nowadays obscure substrate of the creations in the visual arts of this period, with the additional aid of sartorial clues from the much better studied history of costume.

Among the most important and earliest examples of the genre are the fragments of another chest from Lesbos, with two female figures from a reception scene, probably on the balcony of a mansion (fig. 13). It may be dated to the eighteenth century, based on the confident line of the drawing, an indeterminate Islamic grace, the sensitive rendering of the details, and the vividness of the colors. In the Dodecanese, the osmosis of Western and Eastern influences resulted in a different painting idiom (see cat. no. 68). Among the mostly unpublished creations prudently gathered in the Rhodes Decorative Arts Collection during the period of Italian occupation (1912–48), one example dated 1790 portends the happy conclusion of research probing into deeper layers of historical time. These are wooden decorative elements from the partition separating the platform of the

sleeping area in houses (see cat. no. 68), leaves of cupboards from the sitting room, or parts of oblong pieces of furniture, such as settles, that were also intended for storage. Works of comparable aesthetic and corresponding thematic repertoire are also identified on Patmos, but on that island creations of other stylistic trends crossed paths (fig. 14). The same painting tradition, if not the circulation of the products of the Dodecanesian workshops, seems to have radiated to more island centers, as documented by the female figures depicted on another example in the Rhodes Decorative Arts Collection, which are clearly rendered in costumes of Astypalaia.

As the indications for the dissemination of the neo-Hellenic visual artistic discourse multiply, the necessity for a more systematic probing into its secrets naturally follows. Such an exploration can be achieved only by widening the conspectus and increasing the available material. For example, the extant evidence regarding painting in the Cyclades is minimal and even less illuminating. Indicative is the representation of a female figure on a wooden jewelry box in the Benaki Museum, on which the over-simplification of the design, the looseness of the composition, and the insipid two-tone effect make it difficult to decipher whether it represents the demise or the maturity of the local tradition and stimulates minimal serious deliberation about the earlier phases of expressive inquiries.

On the other hand, the depiction on a leaf from a cupboard door from the reception room of a mansion on Siphnos is valuable, not only for the inscribed date 1804 but also for the remarkable clarity with which it delineates the aesthetic horizon at the turn of the eighteenth century (fig. 15). Here, the figures of a nobleman and a noblewoman, of equal importance conceptually and in absolute symmetrical correspondence, in an alluringly genteel conversation, are rendered in a manner that—as noted with reference to the portrait of the archbishop of Cyprus (fig. 9)—now held sway throughout the Hellenic world. The work is especially significant because discernible in its style is the personality of a painter also known for ecclesiastical creations. For it is in these years that the principles of a common visual discourse in both secular and ecclesiastical painting become apparent. These were soon to find their fullest expression in the creations of the main painter of the visions of Greek independence, Panayotis Zographos. Indeed, if Zographos documents the prevalence of these principles in the Peloponnese, which is devoid of earlier examples of painting, the unknown artist who painted the "Renaissance of Greece" (see cat. no. 136) confirms their spread to islands in the Aegean at about the same time.

I have insisted, perhaps more than I should, on the chapter concerning painting, not only to defend the undervalued charm of an essentially unknown testimony or to point out the scholarly interest provoked by the decipherment of its semantic code. I have done so mainly to emphasize how much persistent and multidimensional preliminary work is required in order to gain more complete control of the elusive material. However, many unanswered questions hover around the equally unknown chapter of secular wood carving, demanding once more that research turn its attention, at least superficially, to the chests that, depending on their technique of execution and their style, can also be attributed to a large number of autonomous local traditions.

One chest of outstanding beauty from Epirus, with a hunting scene, is a fine later example from the mid-nineteenth century (fig. 16). Its stylistic affinity with carved wood *iconostases* (icon screens) of the same period once more

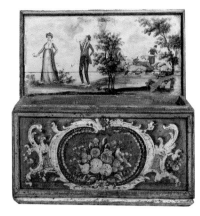

Fig. 11 Painted chest showing on the lid a couple in Frankish dress in a romantic landscape. From Mytilini, Lesbos. Late 18th–early 19th century. Private collection, Athens

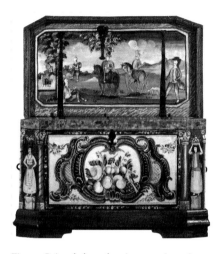

Fig. 12 Painted chest showing an enigmatic figural scene on the lid. From Mytilini, Lesbos. Late 18th century. Benaki Museum, Athens, inv. no. 37951

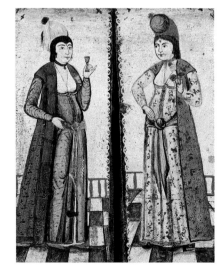

Fig. 13 Fragments of a painted chest showing two female figures from a reception scene. From Mytilini, Lesbos. 18th century. Benaki Museum, Athens, inv. nos. 8908, 8909

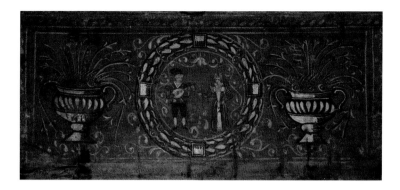

Fig. 14 Lid of a painted chest showing
a noblewoman and a troubadour
in medallion. From Patmos(?),
Dodecanese. 18th century.
Decorative Arts Collection, Rhodes

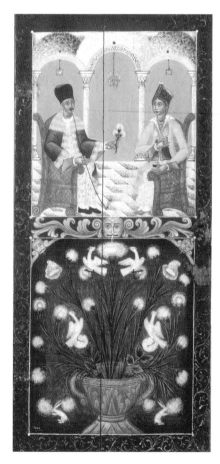

Fig. 15 Leaf of a painted cupboard
door showing a noblewoman and
a nobleman in conversation. From
the reception room of a mansion
on Siphnos, Cyclades. Inscribed 1804.
Collection of Olga Karatza,
Kastro, Siphnos

confirms the internal unity linking secular and ecclesiastical art. The same applies to an elaborately carved mariner's chest with subjects inspired by the Greek War of Independence (see cat. no. 135). At present, no hard and fast chronological conclusions can be drawn about the other groups with distinctive traits. Indicative is the case of the most numerous group, in which not only the date but also the geographical provenance remains undetected (fig. 17). Speculation that these chests were produced in some workshop center on the Dalmatian coast, if not in Venice itself, which is based on the provenance of the glass vessels stored in some examples from Skyros (see cat. no. 66), is strongly challenged by the laws of statistics, given their numerical superiority and wide dissemination in Greek regions. By counter-proposing Corfu as the possible production center of the type, based on the oral testimony of Athenian antique dealers, I shall point to an equally numerous group of chests without doubt from Greek workshops that develop the same decorative motifs, increasingly simplified, during the late nineteenth and early twentieth centuries. I have to confess, furthermore, that I have considerable reservations about the conventionally accepted but completely unfounded dating of the original type to the nineteenth, or even the eighteenth, century.

Of particular value for promoting the research process is the one and only known securely dated carved wood chest inscribed 1772. It belongs to a stylistically independent group, without parallel, that can perhaps be ascribed to one of the East Aegean Islands. This chest, for the present unpublished, is in the Benaki Museum, where in recent years representative examples from different workshop traditions have been systematically gathered and studied. Within the framework of these efforts, the fog shrouding the workshops of Chios, for example, is beginning to lift somewhat, even though very few chests survived the destruction of the island by the Ottomans in 1822. They are, however, impressive, with their unparalleled clarity of form, pronounced horizontal outlines, and vertical axes at the edges, decorated with alternating overlying pairs of male and female figures (fig. 18). The reconciliation of the Italian-Renaissance spirit with the neo-Hellenic aesthetic is obvious in the workmanship. Indeed, its referring to a time not long after 1566, when the Ottoman masters succeeded the Genoese in Chios, would suffice—without additional indications—for a first rough dating of the work to the seventeenth century.

The physiognomy of Peloponnesian wood carving has recently begun to emerge clearly as well, following the reconstitution of a group of chests from the Mani, including the front of a chest carved with an extremely rare multifigural narrative composition of a dance that stands out stylistically (see cat. no. 69). This creation is rightfully placed among the most precious heirlooms of neo-Hellenic sensibility, a status attributed to any new finds that have led, through intricate argumentation, to further revelations. I refer specifically to the wood carving in champlevé relief that was widespread during the period of Venetian occupation of the fifteenth and sixteenth centuries in Crete, as exemplified by the superb representation of dragon slaying on the front of a chest in an Athenian private collection (fig. 19). The picture of Cretan wood carving is now being filled in by certain works, sometimes associated with workshops in Venice, such as the

Benaki Museum's renowned large chest with a scene of a naval battle that comes from Pholegandros (fig. 20).

It would be remiss not to also note the widespread tradition of a stylistically independent category of chests with decorative motifs of inlaid mother-of-pearl and ivory, not so much because their aesthetic refers directly to the Islamic East but because ecclesiastical decoration, mainly in the northern Greek regions, frequently makes use of its peculiar technique. Among many examples that again confirm the internal integrity of neo-Hellenic expression is a chest from Thrace or possibly Macedonia, in the Benaki Museum, incised with the name of the craftsman and the date 1768 that is outstanding for its delicate workmanship.

Chests were essential functional items of the household, which, with the exception of the islands, had little furniture. Low platforms (*sofas*) with cushions and hand-woven textiles substituted for chairs, while low tables with large copper trays decorated with chased motifs witnessed the flourishing craft industry of metalwork in Epirus and the Peloponnese, whose trade saw the wide circulation of its products (figs. 1–2). The skill of northern Greek craftsmen by the eighteenth century is illustrated in the Benaki and other museum collections by a special class of tin flasks with embossed representations. There is no lack of other, often intricate metal objects from earlier periods and different centers in the Hellenic world, such as the Benaki Museum's brass brazier from Crete. It bears Turkish stamps and the signature of an otherwise unknown craftsman, Petros, yet it is difficult to confirm whether or not it is the creation of a local workshop. The difficulties encountered in each effort to locate production centers are articulated by the paucity of surviving material and the poor preparatory research. Partly to blame for the dearth of examples, and hence the inability to make comparative deductions, is the fact that immediately after the end of World War II, whatever had survived was consumed by metal industries as raw material to satisfy imperative new needs. Exactly the same happened, to a greater degree, with secular silverware, which, judging from textual evidence, must have brightened the houses of the more affluent classes. Nevertheless, some idea of the quality of these pieces can be formed from several examples of ecclesiastical silverware (see cat. nos. 26–32), since the same craftsmen evidently worked on both secular and ecclesiastical commissions.

Predominant in the decoration of the interiors of houses were extensive arrangements of ceramics on the shelves and the walls of reception areas. Assemblages of this kind still survive intact on Skyros and in the Dodecanese, mainly on Rhodes, and the best cases are made up of imported products of various workshops from Italy (see cat. nos. 78–80), Asia Minor—Iznik (see cat. nos. 75–77), Kütahya and Çanakkale (see cat. nos. 73–74), North Africa, and regions of France or Central Europe. Together with imported fine glassware from Venice and, later, Constantinople, they present their own testimony of the spectacular growth of shipping and trade from the seventeenth century onward.

Local pottery continues to be less well known with the exception of the better-studied production of utilitarian domestic vessels and large storage jars. Nonetheless, disparate information collected during recent years points to the unbroken continuity of a tradition whose roots lie deep in the Byzantine era. A vessel dated 1837 (see cat. no. 72) shows that the technique

Fig. 16 Wood chest carved with a hunting scene. From Epirus. Mid-19th century. Benaki Museum, Athens, inv. no. 12999

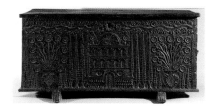

Fig. 17 Wood chest carved with flower vases, cypress trees, and a building. From Skyros, Sporades. 18th century. Benaki Museum, Athens, inv. no. 8717

Fig. 18 Wood chest carved with alternating overlying pairs of male and female figures at the edges. From Chios. 17th century(?). Benaki Museum, Athens, inv. no. 35286

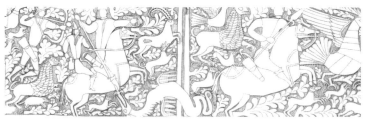

Fig. 19 Drawing of the representation of dragon slaying on the front of a carved-wood chest. From Crete. 17th century. Private collection, Athens (drawing: K. Mavraganı)

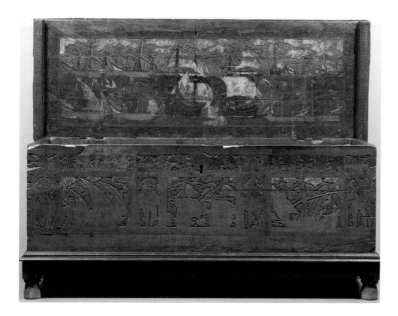

Fig. 20 Chest of North Italian art decorated with a scene of a naval battle in poker-work. From Pholegandros, Cyclades. 16th century. Benaki Museum, Athens, inv. no. 8720

Fig. 21 Drawing of the incised (*sgraffito*) and glazed composition on a jug depicting a sailing vessel and her crew flanked by the mounted saints George and Demetrios. 18th century. Benaki Museum, Athens, inv. no. 8682 (drawing: K. Mavragani)

of underglaze *sgraffito* decoration lived on until the first quarter of the nineteenth century. Analogous finds from excavations in Larisa indicate that the workshop center could have been in Thessaly. This does not of course mean that the same workshop tradition was absent from other regions or that it was possible to alleviate the pressing needs of the market solely by importing pottery from abroad. Whatever the case, outstanding among the few extant early vases is a large jug decorated with the unique—as far as we know—representation of a women's dance (see cat. no. 71). Another even older jug, possibly of the eighteenth century, is decorated with a multifigural composition of a maritime episode, drawn with naturalistic grace and unprecedented narrative style (fig. 21). Other categories of ceramics are represented in the Benaki Museum, such as monochrome pottery and pottery with appliqué modeled elements. A rare example of pottery with painted decoration, dated 1791 and signed by the craftsman Demos, can perhaps be associated with the output of western Greece, where related parallels have been brought to light in the upper levels of recent archaeological excavations.

Purely female creativity and its contribution to forming the *Zeitgeist* are imprinted primarily in weaving, but the surviving evidence of this most ancient craft is characterized by rather boring repetitive patterns of geometric motifs. Because they do not etch their chronological mark on the deeper, more interesting aspects of history, I shall discuss selectively works of the flourishing weaving tradition on Crete, with woven decorative zones of representations that are narrative in character. It is in Crete that the technique of floating weft (*skoulati*) dominates, projecting the designs of the decoration in relief upon the surface of the textile. The usual monochrome white would not rule out the attribution of this weaving innovation to the period of Frankish rule.

Neo-Hellenic needlework presents an even greater gamut of creations in the truly vast variety of its localized style. It is adduced from the few securely dated examples of the seventeenth century, in foreign museum collections, that the two stylistically homogenous categories of the embroideries of Crete—household embroideries on bedspreads, sheets, and pillowcases of the bridal bed (see cat. no. 81) and embroideries of costumes, on the hems and sleeves of women's chemises—fall into the earliest phases of neo-Hellenic needlework and into a tradition that must have been formed during the period of Venetian occupation. From the corresponding stylistic coincidences in the two likewise distinct categories of embroideries of the Dodecanese and of Skyros, one may conclude that the same is true of other regions, even though embroideries from only one category have survived: in Attica, for example, only the embroidery of costumes has been preserved (see cat. no. 93), or in Epirus, where the earlier embroideries of the house (see cat. nos. 85–86) bear absolutely no relationship to those adorning obviously later costumes (see cat. no. 94).

Despite differences in technique and aesthetics—that is, in the distinction between embroideries with freely drawn designs (*grafta*) and an intense naturalistic/painterly rendering of subjects and those made in counted thread-

work (*metrita*), with their enhancement of abstract geometric motifs—a common denominator of the decorative spirit is a general disposition toward efflorescence. The organization of the representations always obeys the strict rules of symmetry and the filling ornaments in the field evoke a sense of horror vacui. In several cases the riotous imagination of the design and the spectacular quality of the execution put Greek embroideries on a par with paintings. In the embroideries of Skyros, for example (see cat. nos. 83–84), beyond the dexterous needlework, the precise design, and the delightful colors is the unexpected originality of the subjects, the fact that the representations are not repeated mechanically. Above all, however, remarkable is the frequently anthropocentric core of the compositions, with the overt nuptial symbolism of their significative substrate. The same basic traits are encountered in the embroideries of Epirus (see cat. nos. 85–86), which display a surprising painterly dimension and an explicit narrative structure. Two other groups of embroideries, of different style, are ascribed to Epirus—to Ioannina specifically—but the burning question of whether they represent other evolutionary stages in a single tradition or are associated with other tribal communities of a multiethnic population has not been posed and, of course, has not been answered. Outstanding from the Ionian Islands are the embroideries of Lefkada (see cat. no. 87), which add a certain barely perceptible Byzantine aura to a technique familiar from the West.

In the Cyclades, even though each island elaborated its own particular embroidery tradition, the fragmentation and dispersion of the extant material precludes secure attributions. The embroideries of Naxos, which are distinguished by monochromy and imaginative combinations of foliate motifs, can be confidently identified. But most of the white embroideries of the Cyclades cannot be attributed to specific centers, despite the exceptional interest of their representations—as a rule, geometric compositions—which seek a more exact geographical delineation. The human figures on some embroideries from Anaphi (see cat. no. 82) and Siphnos (fig. 22) are rendered with the power of a truly masterly reduction to idealized models of geometric inspiration, while the aesthetic of their rhythmic and repetitive alternation is evocative of a musical melody.

I shall bypass the minor contribution of the East Aegean Islands to pause at the embroideries of the Dodecanese, represented by a bed tent from Rhodes (see cat. no. 89). An even more impressive intact bed tent from the same island and a superb version of an uncut example from Patmos are both in the Benaki Museum. On the last, the discreet use of gold thread refers to a unique embroidery tradition from the once-thriving Greek communities in Asia Minor (see cat. no. 88). Here, the gold yarn overshadows the working of the subject in polychrome silks, symptomatic of the direct influence of Ottoman tradition. Nevertheless, the naturalistic rendering of the female figures depicted in a fantastical garden seems to copy painted representations from the East Aegean Islands (see cat. no. 67). In contrast to the secure Byzantine origin of ecclesiastical embroidery (see cat. nos. 19–22), the relation of secular embroidery to Byzantium is a matter for hypothesis, with the precious gold-embroidery tradition of Epirot costumes a starting point (see cat. no. 94).

It is just as difficult to estimate, on the basis of present data and of research weighed down by past efforts to discover its ancient Greek roots, to what extent Byzantine memories are preserved in the female costume. Instead of the tripartite distinction into the basic garment of local variations—chemise,

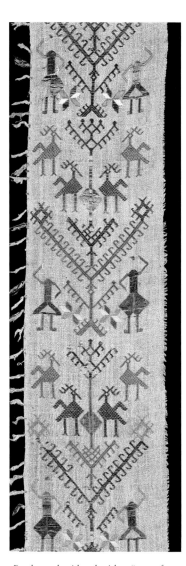

Fig. 22 Border embroidered with a "tree of life," confronted birds, and alternating pairs of men and women. From Siphnos, Cyclades. 17th–18th century. Benaki Museum, Athens, inv. no. 6526.

dress, or overcoat—or even their bipartite classification into urban and rural types, recent studies focus on the affinities between the groups of costumes from northern Greek regions and neighboring areas, as well as on the influence of Ottoman fashion in the dress of the upper classes (see cat. nos. 51, 52, 58, 60, 61). In the Aegean Islands, the effects of the Western tradition, a vestige of the period of Frankish rule (see cat. nos. 53–57, 59), are conspicuous. As can be appreciated from a Cretan dress of stunning beauty in the Benaki Museum, it is difficult to underestimate the catalyzing intervention of the Italian Renaissance in shaping its aesthetic.

Most island costumes would be unknown today had they not attracted the interest of foreign travelers, who recorded them pictorially, often with a dubitable degree of accuracy. Apart from the costumes that are preserved intact, of Andros, Siphnos, Ios, and Amorgos—the last two thanks to the sole examples in the Museum of the Historical and Ethnological Society of Greece, Athens—just a few disparate pieces have survived from the rest of the Cyclades. More fully preserved are the costumes of islands in the Dodecanese: of Rhodes, Symi, Kalymnos, Nisyros, and Castelorizo. Among the most resplendent is the costume of Astypalaia, which combines a Western aesthetic with a nuance of Byzantine glory (see cat. no. 92). Outstanding from the islands of the East and the North Aegean are the costumes of Chios, Mytilene, Psara, and Thasos; from the Sporades, even more spectacular are the costumes of Skyros and Skopelos. To those costumes of Euboea that are known, thanks to research carried out by the Peloponnesian Folklore Foundation in Nafplion, a dazzling bridal dress from Kymi, which is comparable to the loveliest female garments of all periods, was recently added.

The costume of Attica, with the riotous color and singular designs of its embroideries, creating the effect of a kaleidoscopic mosaic, emanates a much more Byzantine feeling (see cat. no. 93). Its exceptional type is represented by the rare, famous golden costume in the Benaki Museum, a luxurious bridal dress of imperial majesty, destined for the highest social classes (fig. 23). In addition to the many other equally fascinating costumes of Asia Minor, of Thrace and Macedonia, of Epirus with its intricate gold-embroidered overcoat (see cat. no. 94), of the Ionian Islands with its Italian influences, of Thessaly, and Western and Central Greece, mention should be made of the costume of Tanagra in Boeotia, for the austerity of its black needlework highlighted in gold. The only costume of the Peloponnese that is well preserved and well studied is that of Corinth. This enumeration is dry and lifeless, but it was imposed by the need to extol, albeit schematically and without the necessary accompanying illustrations, a unique phenomenon of local variations in the history of costume. It is also hoped that it will stimulate the reader's curiosity for a first contact—through the bibliography at least—with the unbelievable variety of local versions of attire, a variety that simultaneously composes a panorama of exemplary expressive independence and a model for the woman's status in the social milieu.

I have left until last the jewelry, the absolutely essential accoutrements to the costumes in order to enhance feminine beauty. The oldest pieces are of gold, decorated with enamel and pearls, and are encountered throughout the insular Greek world, from the Ionian Islands and the Cyclades to the Dodecanese and Cyprus (see cat. nos. 95–98). The dependence of their morphology on European jewelry, specifically Italian, as well as their dating to the sixteenth and seventeenth centuries follows their wide circulation during the period of Venetian

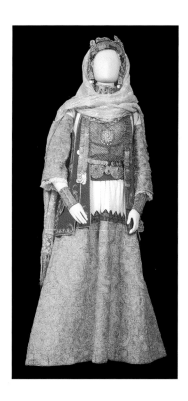

Fig. 23 The "golden" bridal costume of Attica. Benaki Museum, Athens, costume no. 16

rule, while their exceptional dissemination seeks a flourishing workshop center, with Candia (modern Herakleion) the most likely candidate. Some of the most exquisitely elegant masterpieces of neo-Hellenic gold working, with the theme of the ship (see cat. nos. 95–96), must have been wrought in the Cretan capital. The tradition continued in the eighteenth century, when the steady preference for filigree technique to fashion lacey surfaces was accompanied by a perceptible decrease in the use of enamel (see cat. nos. 99–103) and by a love of composite forms that kept alive something of the hauteur of Byzantine magnificence (see cat. no. 99).

Historical circumstances, ease of movement and changes in fashion split up original sets of jewelry, or parures, of many of the independent ensembles of female adornment, with exception the less opulent jewelry of the nineteenth century that accompanied the costumes of Attica. These pieces, in the best cases, are worked in gilded silver, with a host of chain elements and real or false pendant coins (see cat. no. 93). The most fully preserved sets of jewelry from other regions are from Saframpolis (Safranbolu) in Asia Minor. All the individual components—frontlets, diadems, earrings, necklaces and pectorals, belts, bracelets, and rings—with their characteristic glowing corals, survive (see cat. nos. 112–15). The date 1837 on a belt buckle (see cat. no. 112) permits the hypothesis that this workshop production—a tradition formed in the eighteenth century, with distinct influences of Ottoman decoration—continued until the early nineteenth century. On the contrary, two earlier, perhaps more stunning parures, from the regions of Epirus (see cat. nos. 104–7) and Macedonia-Thrace (see cat. nos. 108–11), are difficult to reconstitute. Nonetheless, in all the systems of adornment, irrespective of localized stylistic differences, the basic components of Greek jewelry are flowers, whose optimism is sometimes enhanced by the symbolism of birds.

In the post-Byzantine period, the same artists served both secular and ecclesiastical art. It is also certain that the influences that secular art received and assimilated from the West and the East, as well as its exchange with analogous expressions of the southern Balkans, did not erase its roots in the world of Byzantium. This art, despite the broad spectrum of autonomy presented in local independent versions, despite the distinct differences between its richer "urban" and poorer "rural" formations—in other words, despite the variety of its manifestations—is permeated by a significant uniformity of manner. Even though, apart from rare exceptions, its works have been bequeathed to us anonymously and without chronological indications, there is absolutely no doubt that they were created by specific persons and at given moments. This correlation will become clearer as the research process is liberated from the constraining stereotypes of a supposed "timelessness" in such a way as to distinguish the cadences of the evolutionary rhythms and if, instead of the meta-physical, platitudinous attribution of the act of creation to the "community spirit," it begins to seek the breath of individual contributions.

The artists of the period did not transcribe their milieu realistically and never depicted moments of everyday life. Instead, they envisioned a dreamlike reality, completely unlike to the painful experiences of historical circumstances. Distinguishable behind the euphoric colors of the gardens filled with fruit, flowers, and birds is faith in marital symbolism and its attendant wish for fertility, articulated by the paramount importance of the female figure, despite the male-dominated patriarchal structures of society. Even the undoubtedly

heroic dimension with which the male figures are projected as eminent nobles, brave hunters, or intrepid captains can be understood only through the reflections of the imaginative mirrors of the female consciousness.

The secular art of Hellenism under foreign rule, with the abstract outlining or the naturalistic rendering of its subjects, with two-dimensional or perspectival depictions, with allusive or explicit formulations, with faithful transcriptions or fantastical transubstantiations, reveals a message of optimism. Behind the successive layers of influences that it has received and assimilated, behind the decorative exuberance of its individual artistic expressions, behind its apparent functionalism in relation primarily to architecture, the composition of an anything but simple—in fact, an extremely complex—phenomenon begins to take shape. A phenomenon that has man as its core, who is praised even when his figure is absent from many of the artistic testimonies. Indeed, it is a sad fact that the historical conjunctures prevented the development of this art in the inspirationally stimulating arena of the public domain by confining its flowering to the private space of the home.

### Selected Bibliography

For music, folk song, and dance, see Anoyannakis 1991; Beaton 2004; Hunt 1996; Sifakis 1998; Watts 1988. For architecture, see Dimacopoulos 2002; Makris 1976; Philippides 1982–91; Philippides 2003; Sinos 1976. For stone carving, see Florakis 1980; Goulaki-Voutira, Karadedos, Lavvas 1996; Karagatsi 1996; Rizopoulou-Egoumenidou, Seretis 2000; Zora 1966. For painting and decorative arts, see Garidis 1996; Makris 1981; Meletopoulos 1972; Philippides 1999; Skopelitis 1977. For wood carving, see Binos 1965; Hadjimihali 1950; Kefalas 1979. For silverware and metalwork, see Kaplani 1997; Koutelakis 1996; Papadopoulos 1982. For pottery, see Korre-Zographou 1995; Kyriazopoulos 1984; Vroom 2003, 69–77, 291–301, 335–57. For woven textiles, see Anagnostopoulou 1990; Kyriakidou-Nestoros 1965; Makris 1961; Rokou 1994; Stathaki-Koumari 1987. For embroidery, see Ioannou-Yiannara 1987; Johnstone 1972; Taylor 1998; Wace 1957. For costumes, see Hatzimichali 1979; Hatzimichali 1984; Papantoniou 1978; Papantoniou 1989; Papantoniou 2000; Papantoniou, Kanellopoulos 1999. For jewelry, see Korre-Zographou 2002; Mazarakis-Ainian 1995; Papamanoli 1986; Zora 1981. For secular art in general, see Hagimihali 1937; Papademetriou 1999; Papademetriou 2000; Papadopoulos 1969; Zora 1990–92; Zora 1994. For the Benaki Museum collections of secular art, see Delivorrias 1976; Delivorrias 1980; Delivorrias 1991; Delivorrias 1994; Delivorrias 1997; Delivorrias 2000, 83–173; Delivorrias 2001a; Delivorrias 2001b; Delivorrias 2002; Delivorrias 2003; Delivorrias, Fotopoulos 1997, 394–487; Fribourg 1984; *Greek Jewellery* 1999, 357–498; Goulaki-Voutira 2002; Polychroniadis 1980.

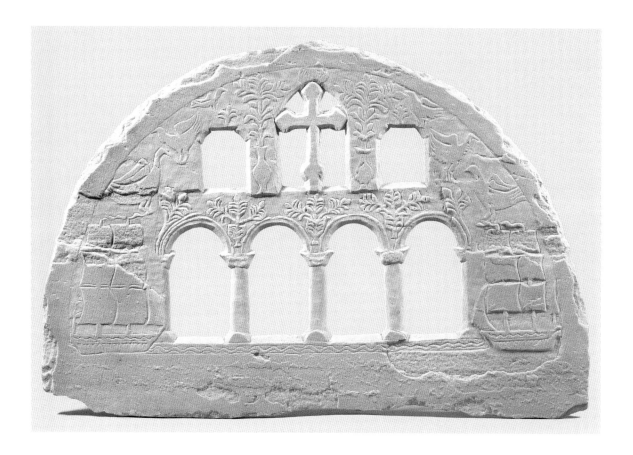

62. **Fanlight**
   18th–19th century
   From Tinos, Cyclades
   Tinos marble
   Width 104 cm, height 68 cm, thickness 2 cm
   Gift of Ilias and Aikaterini-Nina Mariolopoulos, inv. no. 29549

The arched fanlight has two rows of openings, with an inscribed cross in the upper middle. At the sides is symmetrical decoration of small ships with three tiers of sails and birds in heraldic arrangement, confronted and addorsed. Vessels with flowers fill the spaces between the openings. There are incised wavy lines on the base of the arch and the gunwales of the ships.

Fanlights—perforated screens above doorways—allowed light and air to enter houses and other buildings. Although widespread in the Aegean region, they are associated almost exclusively with Tinos, where they are known locally as *kamaria* (arches) because of their semicircular shape. In addition to their functional role and decorative character, they also acquired a protective significance, since apotropaic motifs coexist with diverse ornaments—ships, vessels with flowers, birds, and so on— that are encountered in standardized form on other carved marble objects, such as fountains, gravestones, and iconostases (icon screens). These are primarily eighteenth- and nineteenth-century creations that continue to be reproduced today in the marble-carving workshops of Tinos, mainly for the tourist market.

The fanlight in the Benaki Museum displays affinities with Tenian fanlights but cannot be attributed to a specific craftsman. Stylistically it belongs to the earlier examples, in gray schist or marble, which were carved in champlevé relief with incisions reminiscent of the aesthetic of "white embroidery," whereas the later pieces, carved in higher relief, typically show a more naturalistic treatment of the motifs.

Goulaki-Voutira 2002, 116, fig. 9. For fanlights in general, see Delivorrias 1997, 314–16. For other examples of marble fanlights from Tinos, see Florakis 1980, 100–101, figs. 71–169; Delivorrias, Fotopoulos 1997, 400, figs. 682–85.

A.G.-V.

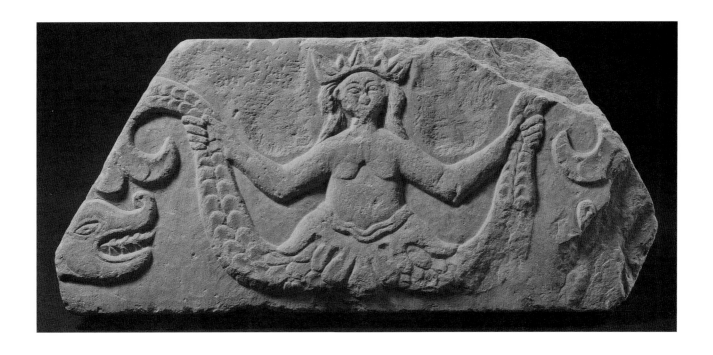

### 63. Relief of a Twin-Tailed Mermaid

Second half of the 18th century
From the Aegean, probably the Cyclades
Cycladic marble
Width 64 cm, height 29 cm, thickness 6 cm
Gift of Dionissis Fotopoulos, inv. no. 29066

The mermaid is shown in a frontal pose, with her arms outstretched and holding in her hands the tips of her twin, scaly tails, which begin from a foliate ornament around her waist and curve upward. Her breasts are bare, her hair is long, and she wears a coronet. At left, below the tail fin, is the head of a dragon, with a tongue of flame issuing from its open mouth. A second dragon, of which only the end of the nose is preserved, existed on the right side.

The relief, without parallel in the Aegean region, probably formed part of the decoration of the upper registers of a marble *iconostasis* (icon screen). The subject of the mermaid is encountered on carved wood icon screens from the Greek mainland and seems to have had an apotropaic nature, here reinforced by the presence of the dragons. The correlation of the relief with an island workshop in the Aegean is based on the dragon head, which is linked typologically with corresponding motifs decorating the base of the cross on the architrave of marble icon screens of the second half of the eighteenth century, particularly on Andros and Naxos.

The mermaid's coronet alludes to depictions of the Virgin, Saint Irene, Saint Catherine, and the Life-Bearing Source. Bare-breasted mermaids are also encountered on carved wood icon screens on Zakynthos (Zante) from the late seventeenth century and probably indicate Italian influences. Moreover, the motif of the twin-tailed mermaid is seen in ornamental carving on the exterior of cathedrals in northern Italy (Modena) from as early as the twelfth century and seems to have its origins in the ninth-century *Liber monstrorum*, which contains figures of a cosmological nature.

Delivorrias 1997, 313, fig. 40; Delivorrias, Fotopoulos 1997, 398, fig. 680; Goulaki-Voutira 2002, 119–20, fig. 14. For marble icon screens on Andros and Naxos, see Goulaki-Voutira, Karadedos, Lavvas 1996, 84–90, 92–101, pls. 11–14, 18, 20, figs. 50–53, 56, 64, 78–79, 84–85. For the mermaid motif on the decoration of cathedrals in Modena, see Franzoni, Pagella 1984, 76–77. For the mermaid theme in Greek folk art, see Zora 1960, 331–65.

A.G.-V.

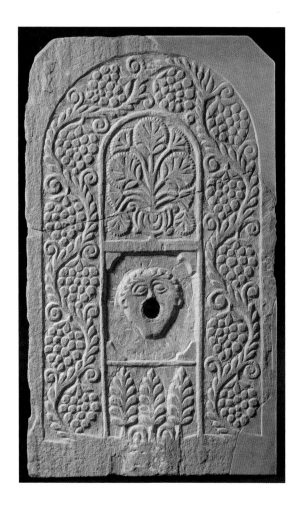

## 64. Fountainhead

Mid-18th century
Perhaps from Tinos, Cyclades
Cycladic marble
Height 64 cm, width 37 cm, thickness 5 cm
Gift of Dionissis Fotopoulos, inv. no. 31170

Carved in relief on a rectangular plaque is an arched zone decorated with a spiraling stem bearing bunches of grapes. The inside of the arch is divided into three successive horizontal panels. The lower panel shows three cypress trees; the middle one, an apotropaic head en face with a hole for the spout in the place of the mouth; and the upper one, a vessel with schematic carnations.

The decoration of fountainheads includes some important works of vernacular stone carving; from large public fountains with architectural arrangements and lavish decoration to less elaborate constructions that at their simplest, are relief stone plaques, either independent or incorporated in a building. To this latter category belongs the Benaki Museum fountain, the provenance of which must be Tinos, since it is stylistically related to certain Tenian marble lintels. The schematization of the plant pot and the stylized carnations is in the folk vein, which is characteristic of the mid-eighteenth century.

The presence of the apotropaic-protective head on fountainheads seems to be associated with religious beliefs about the preciousness of water for life. The vegetal and floral decoration is thought to have its origins in the tradition of offering a vessel with flowers at fountains on Tinos.

Delivorrias, Fotopoulos 1997, 397, fig. 677; Goulaki-Voutira 2002, 118–19, fig. 13. For other examples of fountains from Tinos, see Florakis 1980, 103–6, figs. 201–24. For fountains in general, see Delivorrias 1997, 314–16, figs. 43–44, 47. For the presence of the apotropaic head on fountains, see Korre 1978, 80–89.

A.G.-V.

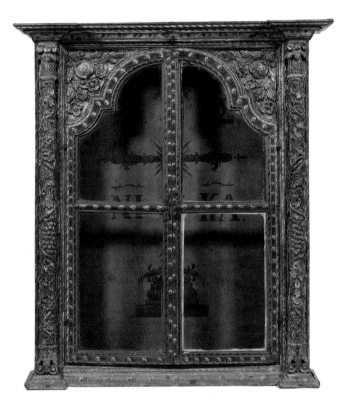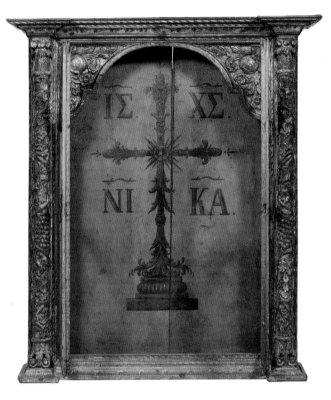

65. **Icon Stand**

Late 18th century
From Crete
Carved and painted wood
Height 84 cm, width 70 cm, thickness 17.5 cm
Inscribed (on painted inside surface): *I(ΗΣΟΥ)Σ / Χ(ΡΙΣΤΟ)Σ ΝΙ/ΚΑ* (Jesus Christ Conquers)
Inv. no. 27521

The icon stand resembles a window frame in shape. Two semi-columns with composite Corinthian capitals stand upon a horizontal base and uphold the rectangular cornice with moldings. The shafts of the semi-columns are decorated with spiraling vines bearing leaves and bunches of grapes. The two panels of the icon stand have an arched top, and the two spandrels formed to the right and the left are ornamented with flowers and leaves. A row of flowers is painted around the openings, while all the projecting elements of the carved wood decoration are highlighted in colors. Painted on the inside of the icon stand is a large cross upon a base, inscribed between its arms.

Such "cupboards" held icons—which is why they are known as *iconostasia* (icon stands)—as well as wedding crowns. The use of icon stands in the private space of home is linked especially to the womenfolk and represents the survival of a practice encountered early in Byzantium. It was particularly widespread in Greek homes after the fall of Constantinople and still continues in villages with strong traditional roots.

The Benaki Museum icon stand comes from Crete and its decoration includes elements of both stone and wood carving, which flourished on the island during Venetian rule.

Unpublished. For the use of icon stands in Byzantium, see Herrin 1982, 65–83; Mathews 1998, 45–46. For their use after the fall of Constantinople, see Gouma-Peterson 1988, 48. For stone and wood carving on Crete during Venetian rule, see Kazanaki 1974, 251–83; Kazanaki-Lappa 1991, 175–80; Kazanaki-Lappa 1993, 435–84.

M.V.

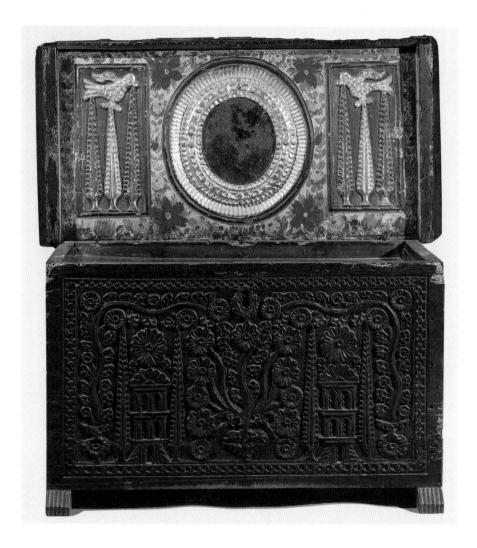

66. **Chest for Storing Bottles**
    18th century
    Probably from Skyros, Sporades
    Carved and painted wood
    Height 47 cm, length 81.5 cm, width 40.5 cm
    Inv. no. 8721

The front of the chest is carved in low relief within a rectangular frame. Garlands with floriated stems run round three sides of the frame and surround the decoration, which consists of a vase of flowers at the center and imaginary building façades amid cypress trees to the left and right. Daisies act as filling motifs. On each of the narrow sides is a movable iron handle.

Inside the lid of the chest is embossed and painted decoration in three registers. At the center is an elliptical mirror surrounded by concentric zones of relief ornament. To the left and right is a rectangular frame with three cypress trees; one a dove perches on the middle. The ground is painted with white buds and red blossoms. The interior of the chest is divided into twenty-four compartments intended to hold bottles containing precious liquids, possibly medicaments. In morphology and style the chest is comparable to another chest in the Benaki Museum that comes from the island of Skyros, in the Sporades, and is dated to the late eighteenth or early nineteenth century.

Delivorrias 2003, 59, fig. 64. For a comparable chest in the Benaki Museum (inv. no. 12935), see Delivorrias, Fotopoulos 1997, 424, fig. 731.

<div align="right">M.V.</div>

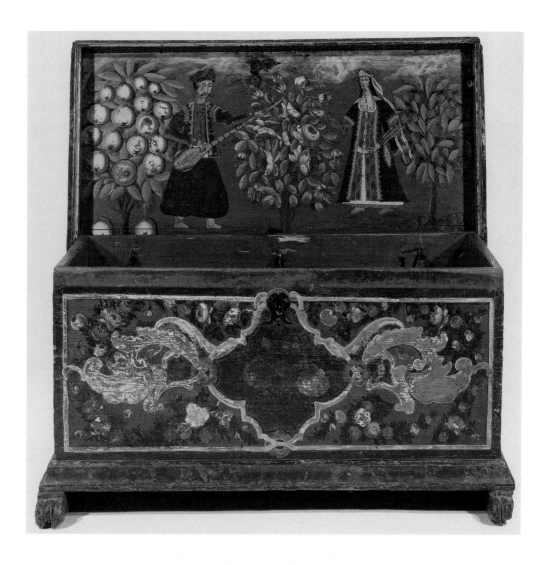

## 67. Chest

Late 18th–early 19th century
From Mytilene, Lesbos
Egg tempera on wood
Height 46 cm, length 87 cm, width 43 cm
Inv. no. 31165

On the front of the chest, within a rectangular frame, is a rocaille surrounded by convoluted monochrome Rococo palmettes. Painted in the compartments on the background are garlands of red, pink, orange, and white flowers. Bouquets of roses are painted on the sides.

On the inside of the lid is a representation of a couple in a garden. At the center of the scene is a blooming rosebush flanked by a male (left) and a female figure (right). The man, in island festival costume, plays a lute and appears to be singing love verses to the woman opposite him, who is dressed in elaborate urban attire. The composition is defined by two fruit trees, a quince on the left and a peach on the right. The idyllic element of the garden full of flowers and fruits, and the male figure with the lute, endow the representation with an erotic/nuptial air.

Chests, essential items of household furniture, generally were brought to Greek lands through the Frankish-occupied territories, where the traditional Italian *forzieri*, better known as *cassoni*, the decoration, and indeed the entire construction, were more extravagant and flamboyant. Chests with painted representations are also attested in Venetian-held Crete during the sixteenth and seventeenth centuries, where specialized craftsmen, *dissegnatori di casse*, executed the decoration.

Rizopoulou-Egoumenidou 1996, 126, fig. 116; Delivorrias 1997, 302, 349, fig. 121; Delivorrias, Fotopoulos 1997, 424, fig. 732; Delivorrias 2003, 60–61, fig. 70. For Italian *cassoni*, see Wanscher 1968, 90; Pope-Hennessy, Christiansen 1980; Welch 1997, 283–86, fig. 139. For painted chests in Venetian-held Crete, see Constantoudaki 1975, 82–85, 113–17.

M.V.

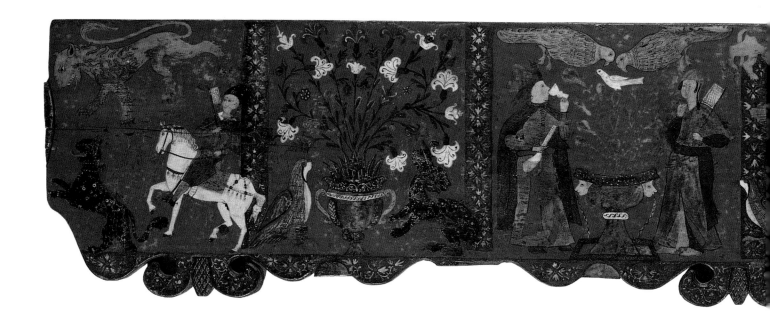

68. **Part of a Decorative Panel**
Late 18th century
From Rhodes, Dodecanese
Egg tempera on wood
Height 43.5 cm, width 232 cm, thickness 2.5 cm
Gift of Nina Aravantinou, inv. no. 8727

This panel was part of the *ambataros*, the decorated wooden partition in Rhodian houses. The upper side is straight, while the lower is edged with consoles between pinecones and disks painted with vegetal motifs. The narrow sides have been trimmed. The panel was initially very long and has an ornamented bottom edge, confirming the hypothesis that it originally was used as part of the *ambataros* of a house on Rhodes.

The surface is divided by bands of floral decoration into six horizontal compartments with a red background. It seems that there initially were seven compartments framing the central representation, a medallion with winged putti to either side of a fountain. Depicted in the upper zone of the medallion are two lions advancing toward the center and a bird between them, and in the lower zone are two partridges that turn toward the compartments that follow. The subjects in the other five compartments contain (first from the left and first from the right) a rider mounted on a white horse with fans; painted in front of the left horseman are a leopard and a lion, and behind the right horseman are an open vase with flowers, a partridge, and a hare. Depicted in the two compartments framing the central medallion is a couple flanking an open well, with masks, spouts, and flowers inside it. The man holds a glass vase with a long neck and drinks from a glass, while the woman observes him, holding her fan. The costumes of both figures have Eastern roots.

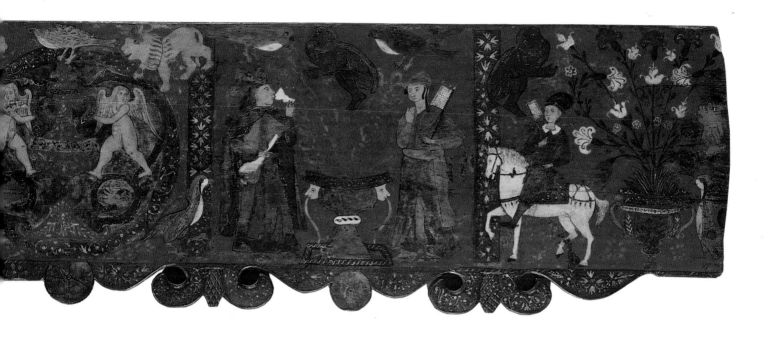

The thematic repertoire of the painted decoration on the wooden panel is influenced by Renaissance chests from Tuscany, which show scenes of hunting, horsemen, noble couples, and so forth painted in square compartments. Although the subject matter is Italian in conception, the rendering of the scenes bears witness to the influence of Ottoman art. For example, the flowers copy the characteristic flowers on Iznik tiles and the dress of the couples is purely Eastern.

The wooden panel's confirmed Rhodian provenance helps link it with other panels from the island that follow the same arrangement and decoration and have the same vivid red background. One of these pieces, now in the Rhodes Decorative Arts Collection, bears an inscription and the date 1790 and thus provides a chronological *terminus* for dating similar panels to the eighteenth century.

Delivorrias 1997, 350, fig. 124; Delivorrias, Fotopoulos 1997, 422, fig. 730; Delivorrias 2003, 57, fig. 57. For similar Renaissance chests from Tuscany, see Schottmüller 1928, pl. 81. For comparable panels from Rhodes, see Delivorrias 2003, 57, figs. 57–59. For the dated panel in the Rhodes Decorative Arts Collection, see Constantinopoulos 1977, 26; Delivorrias 2003, 57, fig. 60.

M.V.

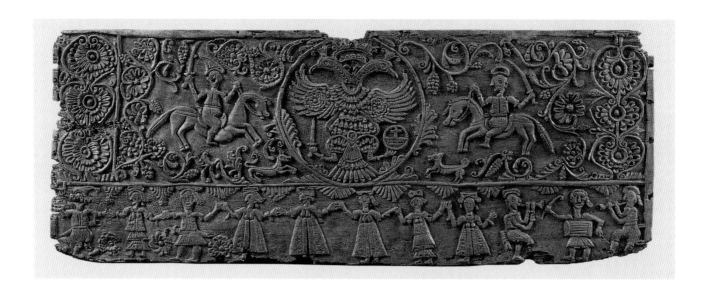

69. **Front of a Chest**

17th–18th century

From Mani, Peloponnese

Carved wood (perhaps walnut)

Height 41 cm, length 107 cm, thickness 2 cm

Inv. no. 37911

Chests were essential—if not the only—pieces of furniture in every traditional home and were used mainly for storing household textiles, clothing, and jewelry. The more carefully made chests, such as the one from which this piece comes, were intended to hold the precious embroidered trousseau of the dowry.

The carved wood surface is divided into two successive horizontal zones, the upper one with more conventional decoration. In the middle of the upper zone is an axially placed roundel enclosing an emblematic and apotropaic double-headed eagle. Developed on the remaining surface are vegetal motifs with rinceaux, leaves, and multipetaled rosettes that symmetrically surround two opposing horsemen in baggy trousers, the first with the head en face and the second in profile. Both figures hold the reins and brandish swords. The presence of two dogs probably places the scene in the heroic sphere of the hunt.

Of greater interest is the unusual representation in the lower zone of a multifigural composition of a dance. Eleven figures participate in the scene: eight dancers holding hands—a man in baggy trousers, a woman, a man in a *foustanella* (kilt), and then five women, either shown frontally or turned to the left—and three musicians—two men in baggy trousers, shown in profile and playing *zournades* (shawms), who flank a man in a *foustanella* shown en face and beating a drum. Through the alternating profile and frontal poses of the figures, the craftsman successfully rendered the rhythm and movement of the dance. The kinetic flow of the representation does not follow the established direction of left to right. The dancers move toward the left, leaving no doubt that the man in baggy trousers heads the dance.

The overall execution of the work avoids sharp outlines and displays a clear preference for supple curves. The subjects project the heroic dimension of the mounted hunter, who may also be a skilled dancer, capable of leading the dance. Thus is implicitly described an ideal of manhood, which girls surely dreamt of in terms of a future companion.

Delivorrias 2001b, 114, fig. 5; Delivorrias 2002, passim, fig. 1.

E.G.

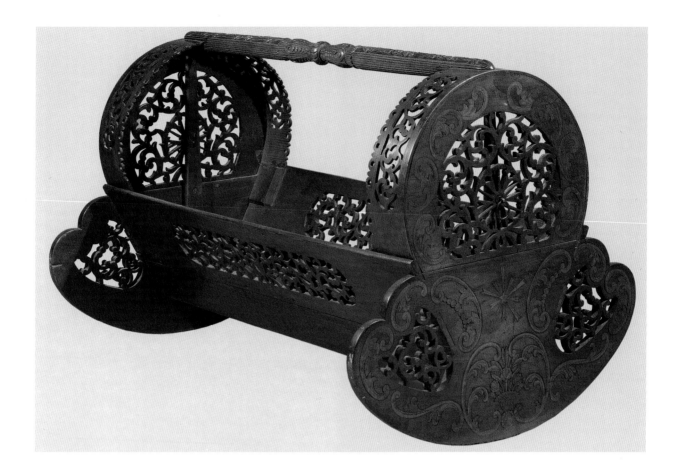

70. **Cradle**

Late 18th century
From Rhodes, Dodecanese
Carved walnut, marquetry
Length 103 cm, max width 69 cm, height 64 cm
Inv. no. 8729

The low baby's cradle is carved with lacy openwork decoration, complemented on the two narrow sides by marquetry C scrolls and potted plant with blossoms, in paler wood. The curved base of the legs served as a rocker. The small horizontal beam joining the top of the two narrow sides is carved with a floral branch in relief and facilitated the carrying of the cradle. Both the decoration and the shape of cradles differ according to regions, tribes, nations, and social strata.

Western influences are readily discernible in the style and the subjects of the decoration, which differ from the widespread tradition of eighteenth- and nineteenth-century chests with geometric and floral motifs of inlaid mother-of-pearl and ivory. Similar cradles are encountered in the Aegean Islands and it is possible that the workshops of their production were located in Constantinople. The intricate workmanship of the cradle attests to the affluence of the family that owned it and to the importance attached to this item of furniture, an importance commensurate with that of the bridal bed (see cat. no. 89). A similar cradle is exhibited in the Rhodes Decorative Arts Collection.

Zora 1994, 218, no. 56, fig. 56.

K.S.

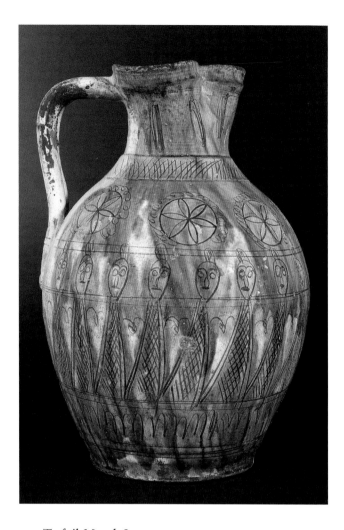

## 71. Trefoil-Mouth Jug

Late 18th century

From Epirus

Glazed, incised, and painted clay

Height 24 cm

Acquired with the aid of Rita Liambei, inv. no. 31355

The jug is thickly coated with shiny, greenish yellow glaze. Characteristic is the arrangement of the incised decoration (*sgraffito*) in zones. Below, in a strictly geometric style, are women holding hands and dancing: their bodies are indicated by a triangle filled with a lattice pattern, while their heads are oval with a summary rendering of the facial features and a small protrusion above. In the band on the shoulder are six-petaled rosettes inscribed in a circle framed by extended spirals. The rendering of the female figures is comparable to that on a silver cup, dated 1762, in the Notaras Collection, Athens, which is contemporary with the jug and also of Epirot provenance.

The incised decoration echoes the Byzantine *sgraffito* technique that changed style in the new historical circumstances prevailing in the Ottoman-held Greek territories. Nonetheless, as indicated by other examples from the wider Greek region (Ioannina, Arta, Didymoteichon, Larisa-Tyrnavos), it lived on for some time—how long is not known—and eventually was replaced by simpler techniques but not abandoned.

The subject of the dance recalls joyful moments of leisure and refers to a more comfortable lifestyle in the wider area of Epirus, which enjoyed considerable economic prosperity in the eighteenth century. The well-made domestic objects reflect, in their way, the improvement in the daily lives of their owners.

Delivorrias 1994, vol. 1, 77–81, vol. 2, pls. VIII, 36; Korre-Zographou 1995, 85–108, fig. 152; Delivorrias, Fotopoulos 1997, 404, fig. 695. For the silver cup in the Notaras Collection, see Korre-Zographou 2002, 114, ill. p. 125. For the *sgraffito* technique, see Gourgiotis 1976, 52–53; Delivorrias 1976, 21.

K.K.-Z.

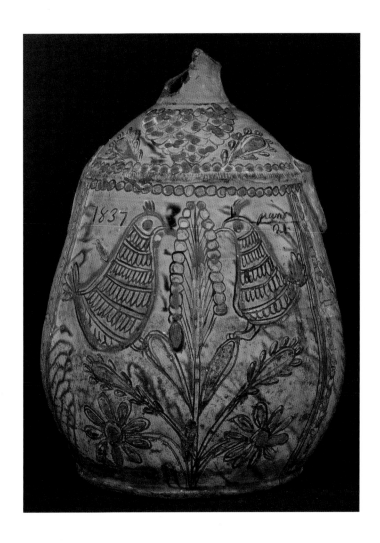

72. **Pear-Shaped Vase**
1837
Probably from Epirus
Glazed, incised, and painted clay
Height 24 cm
Inv. no. 23281

This vase, which has a swollen belly and a long narrow neck, is broken on the mouth and the handles. It is coated with mustard yellow glaze and greenish brushstrokes, while the details are picked out in brown. Within a rectangular panel covering the surface of the belly is a composition of confronted birds perched on the branches of a central vegetal motif with a tasseled finial and two large rosettes to the left and right of the base, which alludes to the ancient motif of the "tree of life." Inscribed in the upper two corners is *1837 – May 21*. Smaller independent zones on the shoulder and below the handles, defined by a chain motif, are filled with fantastical floral ornaments. The decoration is the same on the front and back.

In terms of form and decoration (imbricated triangular motif on the shoulder, chain motifs, vegetal ornaments, vertical linear patterns dividing the surface into vertical panels), the vase displays affinities with the jug dated 1855 in the Efstathiadis Collection, Athens, which is of Epirot provenance and features confronted birds. Epirus played a dominant and dynamic role in pottery production in the eighteenth and nineteenth centuries—concomitant with a general burgeoning of the arts—as a consequence of the local population's successful involvement in cottage industries and trades.

Delivorrias 1976, 20–22, fig. 11; Delivorrias 1994, vol. 1, 78–80, vol. 2, pl. X: 7–8, 37: 23; Korre-Zographou 1995, 85–108, fig. 173; Delivorrias, Fotopoulos 1997, 404, fig. 696.

K.K.-Z.

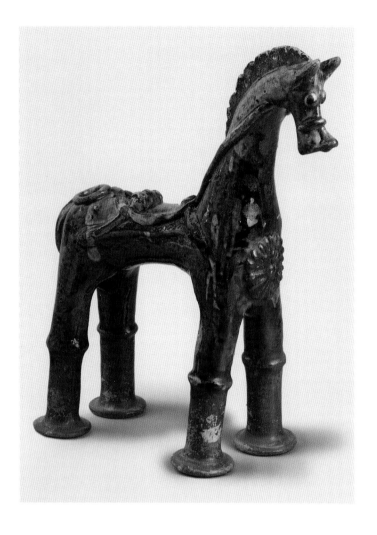

73. **Horse-Shaped Vase**
Late 19th century
Çanakkale workshop, Dardanelles
Glazed and painted clay, appliqué decoration
Height 25 cm, length 22 cm, width 9 cm
Inv. no. 8647

The little horse, of red clay with white slip and dark green glaze, is of slender proportions and has a delicately modeled face. The individual features (eyes, nostrils, muzzle) as well as the ears are rendered in a kind of barbotine technique, with appliqué pellets of clay. The mane has a jagged edge. The body is slim and the tubular stable legs end in flat wide hooves. The reins and the harness are modeled in appliqué clay. The tail ends below the legs. On the chest is an appliqué rosette framed by drop-shaped or lanceolate leaves, a characteristic motif of Çanakkale pottery. The painted decoration, executed over the glaze, preserves traces of gold pigment.

The vase was not only decorative but also functional, serving as a water jug. It was filled through a hole on the back of the neck and poured through the circular mouth. There are similar vessels in the S. Gönül and Suna/İnan Kiraç collections, Turkey, as well as in the Victoria and Albert Museum, London (the last with splashed decoration).

Many of the ceramics of the late phase of production at Çanakkale on the Dardanelles (1800–1922) were brought home as souvenirs by Greek seamen who called in at this port. The demand for Çanakkale ceramics was such that they became fashionable bric-à-brac during this period, mainly flooding the Aegean Islands, some of which had their own significant production, such as Chios, Lesbos, Samos, and the Dodecanese.

Characteristic of the late phase is an even denser penetration of Çanakkale objects into the Greek archipelago and the east coast of the Greek mainland—the result of historical events that established new maritime trade routes or reinforced old ones by opening new markets. In particular, after the Treaty of Kutchuk Kainardji (1774) and the Trade Treaty of Constantinople (1783), there was an intensification of contacts mainly between the islanders and Constantinople or the harbors of southern Russia but also, as indicated by the frequent communication, between Leonidion and the Ottoman capital, Kymi and the Black Sea ports, Volos and Pelion and coastal Asia Minor, especially Smyrna. Moreover, there was a strong wave of immigrants whose ties with their homelands meant, among other things, a two-way dispatch of diverse commodities, as confirmed by contractual documents.

Korre-Zographou 1995, 160–61, fig. 288; Korre-Zographou 2000, 75–77, 119–20, fig. 134, 354–56, no. Γ2. For similar horse-shaped vases, see Öney 1991, 140, C82; Altun et al. 1996, 112–14, nos. 160–64.

K.K.-Z.

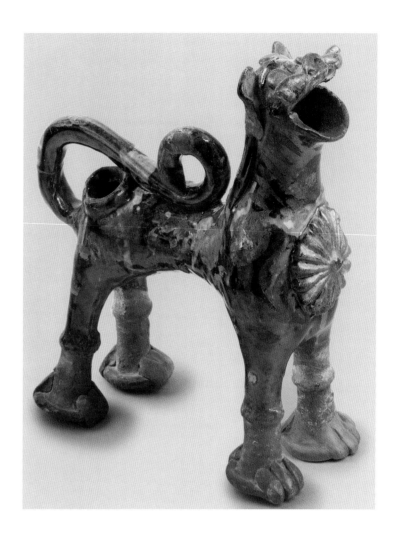

74. **Lion-Shaped Vase**
Late 19th century
Çanakkale workshop, Dardanelles
Glazed and painted clay, appliqué decoration
Height 22 cm, length 20 cm, width 8 cm
Inv. no. 19137

The vase in the form of a lion with a gaping mouth is a typical example of the late period of ceramic production at Çanakkale. The whiskers, eyes, eyebrows, muzzle and ears are appliqué. Wavy tresses encircle the back of the head and spread over the shoulders. The body is tubular and the legs are columnar, with a ring in the middle, and end in flat wide paws on which are indicated toes in front and a "hoof" in back. The tubular upturned tail runs along the length of the body and terminates in a back-turned spiral. On the front of the chest is a large appliqué, gold rosette surrounded by streaks of paint trickled rhythmically. The body is covered by painted leaves and gold spots, typical of Çanakkale ceramics, and has a hole on the back for filling the vase with liquid. The appliqué decoration is restricted to rosettes of different sizes. They are painted with gold wash after firing or sometimes with silver that is combined with the brightly colored painted decoration executed over the colorless or colored glaze. Comparisons to the lion vase are to be found in the Sadberk Hanim Museum and the Suna/Inan Kiraç Collection, both in Istanbul.

Zoomorphic vases served as jugs that were filled through the hole in the hind quarters of the body and poured through the hole in the mouth. Vases with two holes are reminiscent, in structure at least, of rhyta, the ritual libation vessels of antiquity. In general, the thematic repertoire on zoomorphic vases includes the well-known Çanakkale leaves, which are indicated symmetrically or branch along the length of the body or the limbs. Very often splashed decoration is encountered, which spreads over the entire surface.

Korre-Zographou 1995, 160–61, fig. 286; Delivorrias, Fotopoulos 1997, 404–5, fig. 697; Korre-Zographou 2000, 355–56, no Γ4.
For similar lion-shaped vases, see Öney 1991, 141, C83; Altun et al. 1996, 115, nos. 166–67.

K.K.-Z.

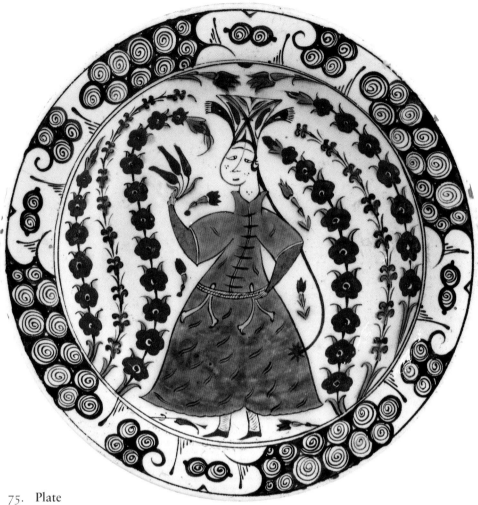

## 75. Plate

Early 17th century
Iznik workshop, Asia Minor
Fritware, painted in cobalt blue, green, black, and red, under a transparent glaze
Height 5.5 cm, diameter 28.8 cm
Gift of Emmanuel Benakis, inv. no. 36

The dish bears polychrome decoration under a transparent glaze. At the center, among windblown flowers, is a human figure, probably female, dressed in a green caftan and holding a bunch of tulips, wearing hair in a long braid and an elaborate feather headdress. On the rim is stylized breaking-wave pattern.

With few exceptions, Iznik ceramics of the late fifteenth and sixteenth centuries are decorated primarily with floral and other nonfigural motifs. Human and animal motifs became increasingly popular in the late sixteenth and the seventeenth centuries, coinciding with a shift in the clientele. Written sources and firmans from the reign of Sultan Ahmed I (1603–17) describe tension between the potters and the court, which was until then the sole patron of Iznik production.

This period of depression for the workshops, due to economic pressures mainly resulting from the court's refusal to raise prices, affected both the quality and the design of the goods produced. Potters were forced to seek new and more profitable markets in order to cover costs at a time of rising inflation, and new themes inspired by everyday life, such as the figure of a courtier holding flowers, as here, were created in order to attract a new clientele. Such motifs infiltrated Greek art of the following centuries and appear frequently in other genres—for example, in the decorative repertoire of embroidery and painted woodwork.

Korre-Zographou 1995, 61, fig. 100; Delivorrias, Fotopoulos 1997, 402, fig. 688; Carswell 1998, 80, fig. 54.

M.M.

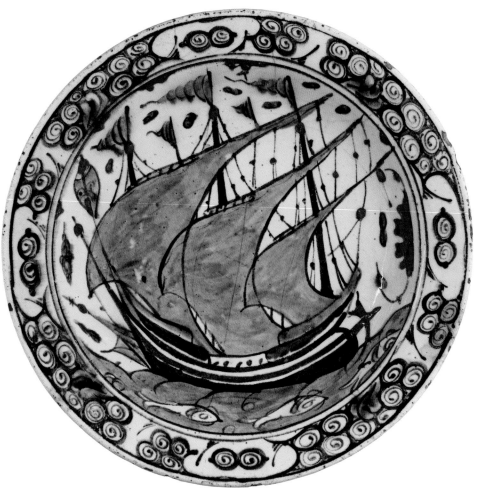

76. **Plate**

Early 17th century

Iznik workshop, Asia Minor

Fritware painted in cobalt blue, green, black, and red, under a transparent glaze

Height 6 cm, diameter 30.9 cm

Gift of Emmanuel Benakis, inv. no. 34

This large dish bears polychrome decoration under a transparent glaze. Depicted at the center are a three-masted galleon in full sail at sea and three stylized fish. On the rim is a stylized breaking-wave pattern, a common motif borrowed from Chinese blue-and-white porcelain of the fourteenth and fifteenth centuries. Chinese ceramics reached the Ottoman court from the early sixteenth century onward, either as booty from military expeditions or as imports from the Far East.

Representations of ships on Iznik pottery appear occasionally from the mid-sixteenth century but become more popular during the later part of the century and into the seventeenth. They reflect the taste of a bourgeoisie that included wealthy Greek shipowners and seamen who were widely employed to work under the Ottoman administration and manned many of these vessels. This particular galleon, however, is a European type that carried goods to Constantinople (Istanbul) and was a familiar cargo ship on the Mediterranean Sea around Ottoman territories. Production of ceramics at Iznik was under the supervision and patronage of the Ottoman court. The court covered the financial costs and also dictated the designs, which were inspired by those created in the royal workshops at the palace. Court patronage, however, became less important during the seventeenth century, and the Iznik potters were obliged to search for new markets and to accept commissions from non-Muslims in order to keep the industry in operation.

Amsterdam 1987, 308, no. 210 (A. Ballian); Atasoy, Raby 1989, 281, no. 646; Delivorrias, Fotopoulos 1997, 402, fig. 687.

M.M.

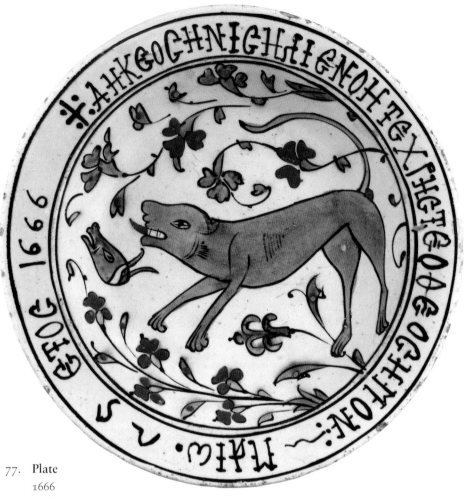

**77. Plate**

1666

Iznik workshop, Asia Minor

Fritware painted in cobalt blue, two shades of green, black, and red, under a transparent glaze

Height 4.4 cm, diameter 25.6 cm

Inscribed (on rim): *ΔΗΚΕΟCHNIC ΗΛΙΕ ΝΟΗΤΕ ΧΡΗCΤΕ Ο ΘΕΟC ΗΜΟΝ ~ ΜΑΙΩ 25 ΕΤΟC 1666*

(Intelligible Sun of Justice Christ our God ~ May 25 Year 1666).

Inv. no. 11125

The plate is decorated in the center with the figure of a canine or a wolf among sprigs of flowers and the head of another animal, possibly a boar. The Greek inscription on the rim, written in capital letters and with spelling errors, derives from ecclesiastical texts. It refers to Jesus Christ and his representation as the light of the world, the sun of justice, and the spiritual light that comes from the knowledge of God (*theognosia*). The representation of animals is probably also a reference to Christ, since this type of Christological symbolism is commonly found on fifteenth- and sixteenth-century Balkan and European metalwork and infiltrates the Iznik thematic repertoire in the late sixteenth century. This plate was possibly part of a commission, since another two plates (one in the Benaki Museum and the other in the British Museum) bear the same date of May 25, 1666, but are decorated with buildings and different texts with religious invocations.

A series of plates and tiles dating from 1640 to 1678 constitutes an important group of Iznik ceramics with Greek inscriptions. Most of these have religious subject matter, both in their iconography and text, while others bear the names of prominent figures. The commissioners of these ceramics, whether the church, important monasteries, or others, attest to the wealth and importance of the Greek community living in the Ottoman Empire.

In terms of quality of technique and design, the dish displays the decline characteristic of Iznik production in the second half of the seventeenth century. It coincides, however, with the appearance of a number of Iznik tiles with Islamic religious iconography, including the depiction of holy places such as the Kaaba in Mecca.

Atasoy, Raby 1989, 666, no. 651; Korre-Zographou 1995, 58, fig. 97; Carswell 1998, 109, fig. 87.

M.M.

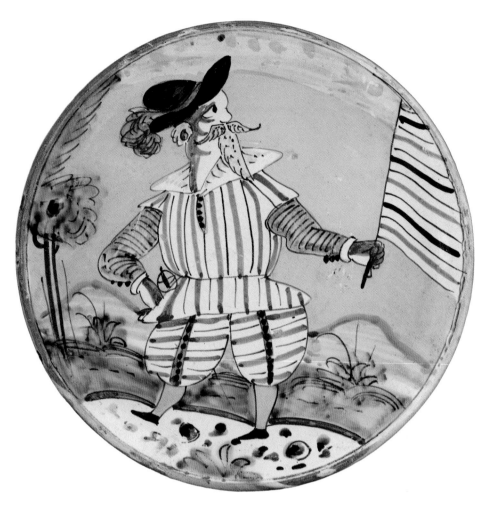

78. **Plate**
   17th century
   Monte Lupo workshop, Italy
   Glazed and painted clay
   Diameter 32 cm
   Inv. no. 30634

The plate belongs to the category of *da parata* ceramics that were made in Italy (Ceramica di Monte Lupo) between 1620 and 1640. Depicted on a yellow ground is an imposing "parading" male figure in splendid attire—luxurious striped doublet, padded breeches, feathered hat—waving a flag, hence the name *da parata*.

Plates of this type have been identified on the island of Skyros in the Sporades, where they are known as "plates bearing Franks," and in the area of Pelion built into the walls of the upper structure of post-Byzantine churches—for example, Saint George at Zagora. They belong to the decorative objects that were placed in the Skyrian house in specific places, on the basis of strictly defined conventions, according to the owner's social class. Similar objects that once expressed the aesthetic values of the inhabitants, creating a stable and specific context in which the individual lived, were placed in ranked order. In Skyros, for example, the plates bearing Franks occupied the paramount position in the decorative scheme elaborated on the basis of strict canons crystallized through tradition—that is, at the edge of the shelf below the icon stand and close to the fireplace.

Despite the local society's total ignorance of the date or the true provenance of the decorative ceramic objects, local taste was a decisive factor in the demand and, consequently, in the formulation of prices. The ceramics of Iznik and Kütahya were followed in popularity by the plates *da parata* of the Ceramica di Monte Lupo and then by trefoil-mouth jugs (see cat. nos. 79–80), which are distinguished into polychrome and blue, of Italian, French, or Spanish provenance (1600–1800); plates with roses manufactured in Marseilles (18th century); plates with a palm-tree pattern, a vine, or a bird, of Italian manufacture; plates with kings, of British origin; and, finally polychrome Chinese and Japanese plates of the interwar years.

Unpublished. For the decorative objects in the Sporades and the Aegean Islands in general, see Faltaits 1974, 58–96; Korre-Zographou 1995, 187–210; Korre-Zographou 2003, passim.

K.K.-Z.

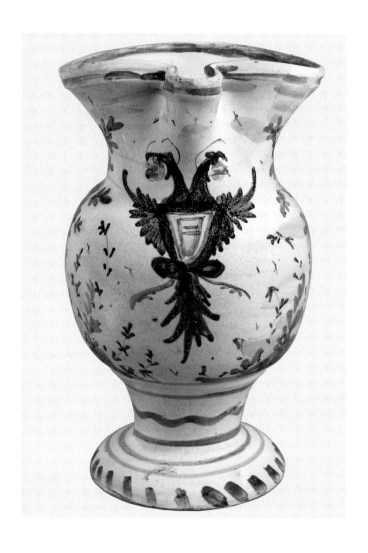

79. **Trefoil-Mouth Jug**
    18th century
    Pesaro workshop, Italy
    Glazed and painted clay
    Height 18 cm
    Gift of Dimitris St. Oikonomidis, inv. no. 38162

The trefoil-mouth jug belongs to a special category of imported ceramics known as Epirot even though examples have also been identified on the islands of Samos and Skyros. They are known from the mid-eighteenth to the mid-nineteenth century. These were domestic objects imported by the hundreds for use at the festive events and celebrations of an affluent class, mainly of merchants and manufacturers.

In form and general type the Epirot jugs follow the vessels created in the pottery workshops of Pesaro in central Italy but have a different thematic repertoire in their decoration, adapted to the preferences of new consumers in the wider region of Epirus and some of the Aegean Islands.

These glazed ceramics can be distinguished into two categories: jugs with double-headed eagle and jugs with inscriptions (see cat. no. 80). The wide-mouthed glazed vase discussed here belongs to the first category. Similar examples are encountered not only on the west coast of the Adriatic but also in German territories of the Habsburgs as well as on the west side of Dalmatia, where there was a predilection for armorial subjects. The type of jug with a double-headed eagle, standing with open wings and curved talons, probably was created between 1757 and 1762 in Pesaro by the potter Giuseppe Bartolucci; production was subsequently continued by other workshops until the mid-nineteenth century.

The technique of glazing (interior and exterior) classifies ceramics of Italian manufacture among those known internationally as majolica or faience. The subjects show the influence of grotesque, Baroque, Rococo, or Eastern themes; the dominant colors are yellow, blue, rose, and green. The foot is frequently covered with blue bands.

Korre-Zographou 1995, 127, fig 209. For this type of jug, see Chatzimichali 1925, 178–79, figs. 223–25.

K.K.-Z.

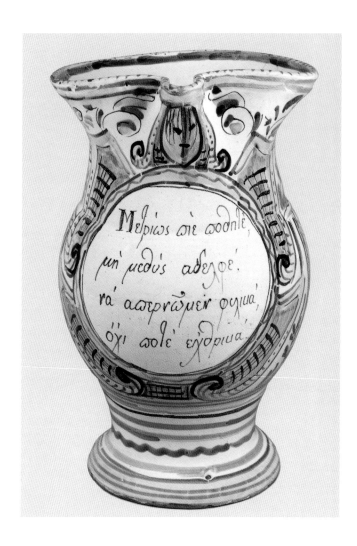

K.K.-Z.

80.  **Trefoil-Mouth Jug**
     18th century
     Pesaro workshop, Italy
     Glazed and painted clay
     Height 26.5 cm
     Inscribed (in circular medallion below mouth): *Μετρίως πίε ποθητέ,/ μη μεθύς αδελφέ,/ να απερνώμεν φυλικά,/ όχι ποτέ εχθρικά* (Drink in moderation desired one, do not get drunk brother, let us pass time as friends, never as enemies);
     (underneath base): *No I 75.C.*
     Inv. no. 8608

This type of inscribed trefoil-mouth jug was first made in the workshop of Filippo Antonio Callegari and Antonio Casali about 1770. The base was usually stamped with the logo of the workshop, while the initials of the workshop or the potters and/or the number of the design are written by hand. In some cases the initials of the customer or the merchant are noted as well.

Epirot inscriptions about merrymaking and wine-drinking are the hallmark of the second group of jugs (see cat. no. 79). The stanzas are placed in a prominent position, within a brightly colored circular medallion and are written on the white ground in fine black brushstrokes in the minuscule script of the eighteenth century that remained in use until the mid-nineteenth. The medallion is outlined by double or triple linear motifs or broad bands with volute flourishes of Baroque or Rococo inspiration.

Italian potters often copied misspelled texts, while some examples of calligraphic and orthographic script have been attributed to Greek craftsmen, presumably settled in Pesaro. The same mistakes are frequently repeated, which points to the serial copying of originals. The verses of Bacchic or anti-Bacchic character, a kind of folk poetry, are rendered in four lines in order to accommodate them on the curved surface of the vase; they are actually rhyming couplets. Various categories of meaning can be distinguished: prohibitions, exhortations, complaints, maxims, salutations. Rarely there are depictions of single birds—perching or flying—flowers, or building complexes within frames.

The jugs were exported through the port of Ancona, an important commercial center on the Adriatic, where Epirot merchants apparently had settled from as early as the fifteenth century. Trading activities gathered momentum in the mid-eighteenth century, when an annual fair for European transactions was instituted in neighboring Senigallia, where Greek merchants were a strong presence.

Kyriazopoulos, Charitonidou 1983, 86, 91, 120, fig. 8; Korre-Zographou 1995, 126–32, fig. 214.

K.K.-Z.

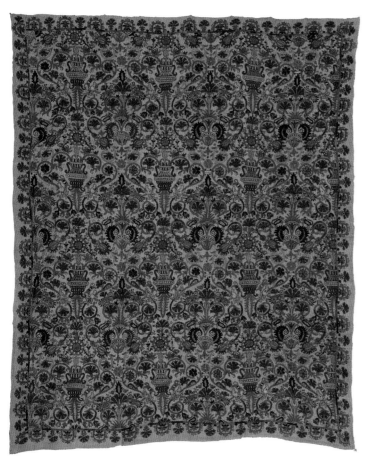

81. **Bedspread**
Late 17th–early 18th century
From Crete
Linen embroidered with silk thread in Byzantine,
stem, herringbone, feather, chain, and brick stitch
Length 151 cm, width 125 cm
Gift of Christopher Tower, inv. no. 32646

In contrast to the other Aegean Islands, there are few extant examples of household embroideries from Crete, where hand-woven textiles fulfilled domestic needs. The island's embroidery is known mainly from the skirt borders of a costume with Renaissance roots—a type that has been lost. Judging by other cases of recycled embroideries, however, it is likely that some of the narrow Cretan skirt borders originally embellished the edges of sheets. Even though this hypothesis has not been confirmed, the flourishing embroidery tradition that these borders exemplify suggests that on Crete as well there was a tradition of embroidered bedding that has been lost over time.

This rare, if not unique, bedspread is embroidered with patterns traced freely on the cloth, with a clear tendency toward for symmetry in the overall arrangement. The motif of the flowerpot with blossoms, both upright and inverted, is repeated symmetrically in horizontal rows. The surface is covered by dense, complex compositions of vegetal and floral volutes enclosing flowers—the carnation predominant—and with a wide variety of confronted and addorsed birds, strange little animals, and serpentine dragons whose tongues and tails are tipped by a flower. The whole is framed by a row of lappet patterns enclosing flowers alternating with carnations.

The embroidery is dominated by naturalistic elements and distinguished by the variety of vegetal and floral motifs. The style and the thematic repertoire are closely linked to those of the skirt borders. The carnation, which reigns in the decoration, though seeming to suggest an Ottoman provenance, almost certainly copies a motif found in sixteenth-century Italian lace pattern books that circulated in Venetian-occupied Crete (1204–1669). The floral rinceaux reflect the same influence. The lappets can be likened to the end borders woven on seventeenth-century Ottoman velvet cushions or, more likely, to Italian lace patterns of the same period.

Cretan embroideries are among the earliest examples of Greek needlework, some of which preserve the date and the name of the embroideress. In the Metropolitan Museum of Art in New York there are two skirt borders, dated 1697 and 1726; the Victoria and Albert Museum in London has three—of 1733, 1752, and 1762—the first two of which bear the name of the embroideress as well.

Delivorrias, Fotopoulos 1997, 448, 451, fig. 774. For Cretan embroideries in general, see Polychroniadis 1980, 20–21, figs. 39–42; Delivorrias 1997, 296; Taylor 1998, 107–17. For dated and signed skirt borders, see Johnstone 1972, 29, figs. 124, 127.

E.G.

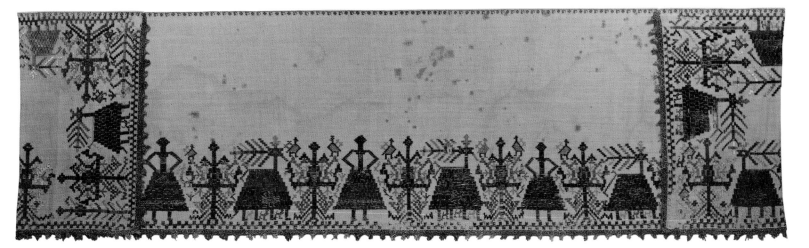

82. **Bed Valance**

    17th–18th century
    From Anaphi, Cyclades
    Linen and cotton embroidered with silk and gold metal thread in brick and satin stitch
    Length 238 cm, width 49 cm
    Inv. no. 6536

This bed valance is embroidered on three sides with a frieze showing a repeated "tree of life" motif framed by a female figure with her hands on her waist and a deer. Represented below the deer are small animals. Colorful tassels decorate the bottom edge. The valance is worked on two faces, so that when one is folded over on the bed, both right sides will be seen. Valances of this type were intended to adorn the bridal bed, which occupied a raised platform in the one-room Aegean Island house.

The "tree of life" is rendered as a schematic branch with facing birds. Symbol of the cycle of life, which secured the protection and fertility of the couple, this motif is present in virtually all compositions in nuptial needlework from the islands. The deer, a spiritual and secular symbol, is associated with the "tree of life" and occurs frequently in Christian iconography.

This valance belongs to a group of earlier embroideries from Anaphi worked in satin stitch; later examples use cross-stitch. Their subjects included animal and human figures that are filled in with embroidery and are abstract in conception and rendering.

The motif of a schematic branch is Dodecanesian in provenance and is identifiable, in several variations, mainly in the southern Cyclades (Anaphi, Amorgos, Melos, Pholegandros). Despite the differences between Cycladic and Dodecanesian embroideries—in the stitches, the colors, and the decorative subjects—certain motifs are common to both. This overlapping is due to the geographical unity of the two island groups and the communication between them, with Patmos in the Dodecanese and Amorgos in the Cyclades being central ports of call. In the view of some scholars, the branch motif, with its characteristic V shape, may well transcribe Mameluke designs that must have been disseminated to the Dodecanese and the Cyclades via Rhodes. Trade between Venice and Egypt, under Mameluke rule, is attested from as early as the thirteenth century, along a sea route that included Rhodes and Cyprus.

Polychroniadis 1980, 23, 73, fig. 61; Delivorrias 1997, 338, fig. 98. For the embroidery of Anaphi, see Taylor 1998, 31–35, 40–43, esp. 42.

K.S.

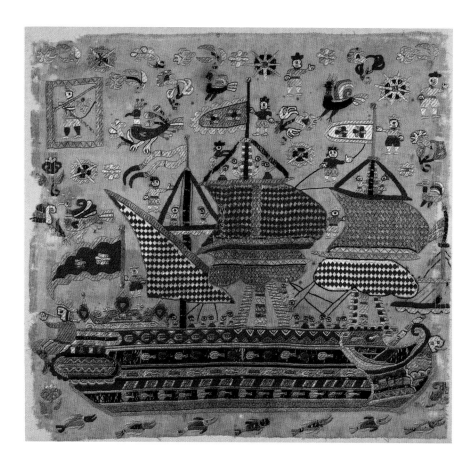

83. **Cushion Cover**
17th century
From Skyros, Sporades
Linen embroidered with silk
thread in corn, brick, chain,
back, and cross stitch
Length 43 cm, width 46 cm
Inv. no. 6389

Highly individual embroideries executed in brilliantly colored silk thread were produced on the island of Skyros. Finely woven sheets, bolsters, cushions, and towels embellished with exquisite needlework were laid on beds or hung over the banisters separating the high platforms of the sleeping areas from the rest of the living space in the one-room house. One of the earliest and best-known embroideries from Skyros is this cushion with a *goletta* (schooner) worked in stitches originating in the preceding Byzantine and post-Byzantine traditions of ecclesiastical gold embroideries.

Depicted on the embroidered surface of the textile is a three-masted schooner equipped with cannons, indicating that it is a warship, and bedecked with colorful fluttering flags. The vessel sails above a small shoal of fish, with the helmsman at the stern and members of the crew perched upon the deck and the rigging. The figure in armor, in the upper left rectangle, may represent the ship's owner. Miniature figures in striking costumes, along with cockerels (see cat. no. 84), foliate, and floral motifs fill the ground, while leaves and branches sprouting from hoopoes, with their fanlike tails, enhance the general efflorescent effect.

The little blue flag with a cross at the far right has been taken by some scholars as evidence for dating the embroidery to the nineteenth century, when this type was officially established during the reign of King Othon (r. 1833–62). It seems more likely, however, that the cross, which also appears in the large flag on the ship, was of protective, rather than national, significance.

The decorative motifs on Skyrian embroideries reveal strong influences from the designs on the Iznik and Kütahya ceramics that hung on the walls of Skyrian houses (see cat. nos. 75–77). Nevertheless, they are imbued with a distinctive local artistic style and a peculiarly merry, expressive air that is the hallmark of Skyrian needlework figures. Even though vegetal and floral motifs appear to predominate, representations of ships enjoyed a remarkable diversity, from simple boats to elaborate galleons with seamen and passengers, always in motion, primarily on household embroideries and rarely on accessories of costume.

The embroideries of Skyros differ from those of the other Aegean Islands. Their narrative character and penchant for anthropomorphic and zoomorphic subjects, together with the Oriental flavor of the patterns, align them more closely to the needlework of Epirus (see cat. nos. 85–86).

Johnstone 1961, 34–36, 54, pl. 20; Polychroniadis 1980, 23, 33, fig. 1; Paine 1990, fig. 48; Delivorrias 1997, 296, 335, fig. 91; Delivorrias, Fotopoulos 1997, 438–39, fig. 761; Taylor 1998, 87–99, ill. p. 97.

K.S.

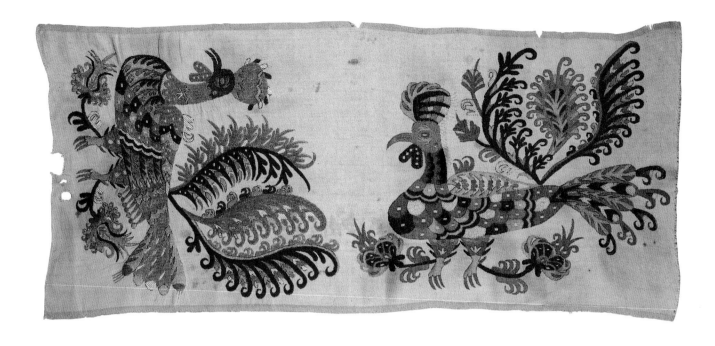

84. **Part of One Edge of a Bed Sheet**
    18th century
    From Skyros, Sporades
    Linen embroidered with silk thread in back, darning, and double-running stitch
    Length 91 cm, width 41 cm
    Inv. no. 6381

Sheets for the bridal bed are distinguished by their monumental decoration. Usually of fine linen, earlier examples are embroidered on all four edges with a large repeating pattern arranged three times on each side. On the present example, the subject—a cockerel with floriated tail and legs wearing high caplike headdress—is rendered in a painterly manner.

The cockerel, a characteristic motif of Skyrian needlework, is depicted in various fantastic versions on domestic and costume embroideries. The frequent presence of the cock, particularly in embroidery, is associated with its manifold symbolism in neo-Hellenic folk beliefs that drew upon ancient conceptions linking it with the sun and light and endowing it with protective powers and purifying qualities. Characteristic of these beliefs is the custom of sacrificing a cock in the foundations of a building, so that it becomes the protective spirit of the house. Over time, however, the bird probably lost its metaphysical symbolism in Skyrian embroideries and came to be a purely decorative motif. Under the influence of Skyrian needlework's pronounced predilection for foliate motifs, the subject more closely resembles a flower than a bird.

Skyrian embroideries are outstanding for their excellent technique, diversity of design, and delicacy of color. Various scholars discern in their style Western and Ottoman influences, a result of the island's long occupation by foreign masters, first the Venetians (1453–1538) and then the Ottoman Turks (1540–1830). Nevertheless, the assimilated elements from West and East, in combination with the rich thematic repertoire from the fantastical world of indigenous Hellenic tradition, imparts an expressive freshness to the motifs, which are rendered in a peculiar local style.

Polychroniadis 1980, 23, 37, 87, figs. 8, 81; Delivorrias, Fotopoulos 1997, 436–37, fig. 760. For further examples, see MacMillan 1974, fig. 8; Washington, D.C., 1983, 91, 107, no. 23, pl. 10.

                                                                                                        K.S.

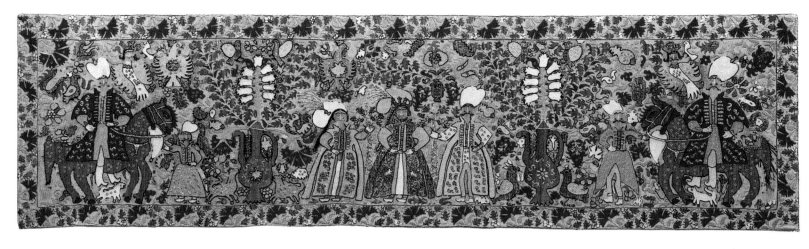

85. **Cushion Cover**
   Late 17th–early 18th century
   From Ioannina, Epirus
   Linen embroidered with silk and silver metallic thread in split, chain, and stem stitch
   Length 142 cm, width 39 cm
   Gift of Beatrice Cook, inv. no. 8269

Among the finest Epirot embroideries are the several variations of long cushion or bolster covers decorated with scenes of wedding processions, a hallmark of Ioanninan needlework. In this typical composition, the bride stands in the middle between her parents, who hold candles and are flanked by two ewers filled with hyacinth sprays. Placed symmetrically at the edges of the embroidery are two representations of the groom on horseback proceeding toward the bride and accompanied by his attendant, who holds the reins of the steed. The entire field of the embroidery is filled with a host of foliate patterns, flower vases, birds, animals, double-headed eagles, and anthropomorphic birds with crowns. The human figures are in sumptuous attire. The women wear the characteristic gold-embroidered sleeveless overgarment of the urban costume of Ioannina (see cat. no. 94), from which protrude the embroidered sleeves of the chemise. The men wear tight trousers with boots, short tunics, and long overcoats with short wide sleeves—formerly the dress of Epirot bourgeoisie. The precious frontlet on the bride's headdress echoes the diadem of the Pogoni region (see cat. no. 104).

   This composition probably depicts a customary wedding procession. Even though marriage celebrations took much the same form throughout Greek regions, the ritual was more elaborate in Ioannina, as attested by foreign travelers' accounts. The various motifs filling the composition are charged with symbolic meanings that enhance the nuptial content of the representation. The generative character of the riotous efflorescence is combined with references to the cycle of life, to which the flower vase alludes. The anthropomorphic birds with their apotropaic properties, probably variations of the talismanic winged figures (see cat. no. 87), offer protection to the newlyweds.

   Epirot cushion covers with nuptial processions form a distinct category of Greek needlework. Although they are embroidered with designs traced freely on the cloth, their imagery is subjected to the all-prevailing canon of symmetry, seen here in the bilateral arrangement and the alternating decorative motifs. These pieces are distinguished by their narrative character, enhanced by the friezelike compositions, and are outstanding for the painterly rendering of the embroidered representations.

Unpublished. For bolsters with nuptial processions, see Wace 1935, vol. 1, 49, no. 13, vol. 2, pl. XIX; Wace 1957, 102–3, no. 172, pl. XXXVIII; Delivorrias, Fotopoulos 1997, 444–45, figs. 768–69; Taylor 1998, 135–36.

E.G.

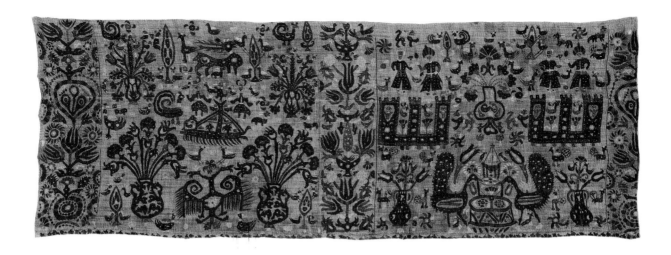

86. **Part of a Bed Valance**

18th century

From Ioannina, Epirus

Linen embroidered with silk thread in darning, chain, and stem stitch

Length 158 cm, width 57 cm

Inv. no. 6307

Valances were intended to hang from the front edge of a bed or sofa. This bed valance—which must once have had five panels, as seen in other examples——is a characteristic example of Epirot needlework. It belongs to a specific category of bridal embroideries distinguished by a crowded assemblage of decorative and symbolic motifs, consistent with the horror vacui aesthetic. The vertical strips with foliage, flower vases, and birds, which divide the field into equal, rectangular panels, fail to dispel the disorderly impression.

The main subjects in the composition of the left panel are an eccentric double-headed eagle with feathery wings flanked by flower vases and a sailing vessel with oars bearing a cargo of palm trees and birds surmounted by two male figures holding birds in their raised hands. The second panel is dominated below by a heraldic group of confronted peacocks at a fountain and above by a composition placed symmetrically at the two edges that depicts a castle with three crenellated towers and two human figures offering a flower to each other—possibly a woman and a man in erotic conversation. The remainder of the surface is crowded with vases of flowers, cypress trees, deer, and strutting birds.

The meaning of the representation is difficult to decode. The most important of the basic themes is the Eastern motif of peacocks at a fountain, which had been adopted and exploited widely in Christian art as a Eucharistic symbol. Whether revived from Byzantine representations or reintroduced from contemporary Eastern or Western models, it appears in eighteenth-century Epirot bridal embroideries and was possibly linked with the symbolic act of the couple receiving the wine of Holy Communion from the same chalice, in accordance with the pan-Hellenic custom consecrated by the wedding ceremonial of the Orthodox Church. The predilection for excessive decorative motifs also suggests that the bed valance dates to the eighteenth century, when this general aesthetic developed in both ecclesiastical and secular art under the influence of the European Baroque.

Polychroniadis 1980, 19, 34, fig. 2, 45, fig. 20; Delivorrias, Fotopoulos 1997, 449, 451, fig. 776. For other examples of this type of Epirot embroidery, see Wace 1935, vol. 1, 49, no. 14, vol. 2, pl. XX; Taylor 1998, 138–40.

E.G.

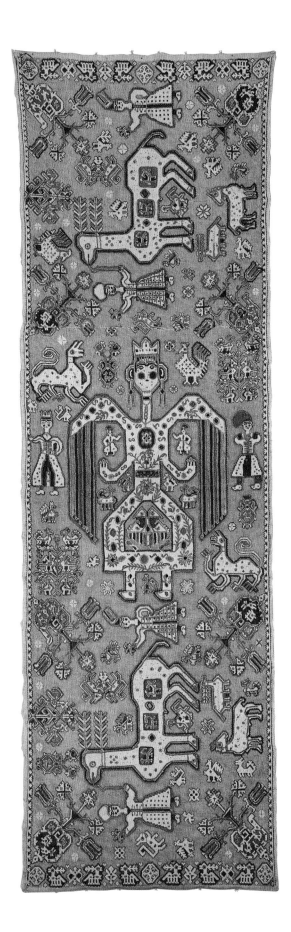

## 87. Cushion Cover

17th–18th century
From Lefkada, Ionian Islands
Linen embroidered with silk and gold metallic thread in
darning, split, and chain stitch
Length 152 cm, width 48 cm
Inv. no. 6262

This superb example of Ionian needlework, executed in twine
stitch on a drawn-threadwork ground, is directly inspired by its
function, as the symbolic and narrative nuptial scenes attest. At
the center of the composition stands an imposing winged female
figure posed in prayer and wearing a crown and long earrings,
reminiscent of the *perpendoulia* of Byzantine empresses (see cat.
nos. 98–99). She is probably a talismanic angel or a guardian
spirit that protects the bride and groom, who stand in honor at
her side. She is surrounded by symbols of power (lion), purification
(cockerel), and fertility (tree of life), and her presence endows the
embroidery with a sense of hieratic majesty.

The ground of the cushion is filled with diverse decorative
motifs (rosettes, vases, miniature human figures, animals, birds),
in which smaller ones are inscribed—a feature of embroideries
from the Ionian Islands—possibly reinforcing their protective
potency. At first glance these motifs suggest a sense of horror
vacui, but the tendency toward symmetry and pattern clearly
prevails, as in the case of the two larger deer interposed diagonally
between the human figures that are carefully aligned with the top
and the bottom of the winged female. Other secondary but
important motifs are arranged meticulously over the textile,
unlike the tiny filling ornaments occupying the spaces in between.

This embroidery from Lefkada features a host of human
and animal figures, which, though rare on other Ionian Island
embroideries, are common on those of Epirus (cf. cat. nos.
85–86). The winged figure can be compared to a similar figure in
an attitude of prayer, but executed in different stitches and colors,
found on an eighteenth-century embroidery from Epirus (Royal
Scottish Museum, Edinburgh). It is likewise comparable to a
"praying" female on a white perforated ground from Astypalaia
dating to the eighteenth century (Benaki Museum, Athens) that
perhaps has the same symbolic significance, as a variation of the
"good fairy."

Several motifs, mainly schematized, of Ionian Island embroi-
dery frequently occur in the embroideries of the Cyclades and the
Dodecanese. The technique of drawn threadwork was disseminated
from Italy, from the fifteenth century, to all of Western Europe. It
reached Greece via Venice and was used mainly in the Ionian and
Aegean Islands under Venetian rule.

Polychroniadis 1980, 20, 38, fig. 9; Paine 1990, fig. 72; Zora 1994,
86, 223, nos. 76–77; Delivorrias, Fotopoulos 1997, 442, fig. 766;
Taylor 1998, ill. p. 118. For comparable examples of winged figures,
see Polychroniadis 1980, 72, fig. 59 (from Astypalaia); Taylor 1998,
ill. p. 138 (from Epirus).

K.S.

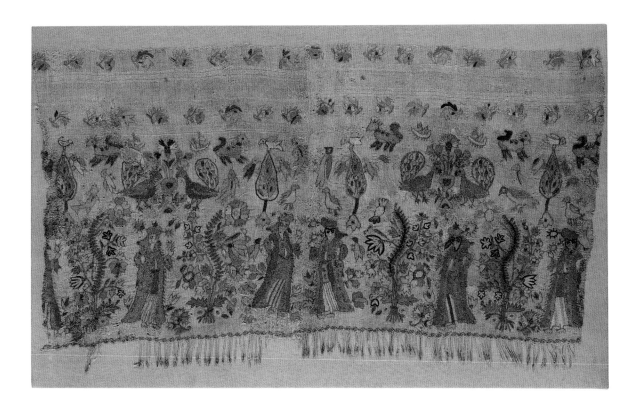

## 88. Towel Border

17th–18th century

From Asia Minor

Silk embroidered with silk, gold, and silver metallic thread in double darning, double running, and stem stitch

Length 69 cm, width 38 cm

Inv. no. 6736

The towel, preserved in fragmentary condition, consists of two pieces—probably from the two borders—sewn together vertically. The hem is embroidered with a representation of opulently attired female figures holding flowers and wandering between trees and flowers in a fantastical garden. Above is a row of confronted peacocks flanking a flower vase and small cypress trees, animals, birds, fish, sailing ships with oars, and two friezes of tiny flowers.

Towels from Asia Minor, usually of silk or fine linen cloth embroidered with silk and gold or silver thread, are distinguished by their vegetal and floral motifs, dominated by the rose and the cypress. They display general influences from the Ottoman thematic repertoire, which, however, did not include human figures. In contrast to the other embroideries of Asia Minor, of uncertain ethnic origin and problematic geographical provenance, this example with female figures is obviously Hellenic, despite the apparent Ottoman influences in the decorative motifs.

The scene of women in the ideal setting of a flower-filled garden brings to mind analogous representations painted on chests (see cat. no. 67) or murals from Lesbos, which suggests that the towel probably comes from this island, even though it entered the Benaki Museum inventory as coming from Asia Minor. In any case, the geographical location of the East Aegean Islands—Lemnos, Lesbos, Chios, and Samos—favored freer intercourse with Asia Minor, in particular its Aegean coast, where there was a large and flourishing Greek population. Needlework from these islands cannot always be easily recognized or distinguished from that from Asia Minor.

The towel was associated directly with the marriage ceremony and with the purifying function of water. It frequently was used as a kerchief or worn around the waist.

Delivorrias 1997, 298, 338, fig. 97. For Ottoman embroidery patterns, see Wace 1935, vol. 1, 34–39. For the embroidery of the East Aegean Islands, see Johnstone 1961, 36–38; Polychroniadis 1980, 25.

E.G.

## 89. Part of a Bed Tent

First half of the 18th century
From Rhodes, Dodecanese
Linen embroidered with silk thread in cross-stitch
Height 295 cm, width (below) 320 cm, (above) 185 cm
Inv. no. 6597

Bed tents are known to have existed on Rhodes since at least the late fifteenth century. They are mentioned in the *Thanatikon*, a lament written by Emmanuel Georgillas in 1498 for Rhodes after the city experienced a plague and by the travelers Pietro Casola (1494) and Pierre Belon (1550). The last mentions in his book *Les Observations de plusieurs singularitez . . .* (1555) that the women of Rhodes embroidered bed tents and the Jewish women sold such valuable embroideries.

The bed tent, a European type of bed hanging, seems to have been introduced to Rhodes by the Knights of Saint John of Jerusalem. The Greek name for the bed tent, *sperveri,* derives from the medieval Frankish word *sperwari.* The influence of the knights in the Dodecanese was as strong as that of the Venetians in the Cyclades. They brought with them a more luxurious lifestyle, a new culture that embraced architecture—both military and domestic—literature, and the textile arts, including embroidery. The residences of the Knights of Saint John and the society of merchants and craftsmen that developed in the Dodecanese were more elaborate than any others in the Aegean.

This bed tent—which when complete must have had up to twelve panels—consists of six tapering panels sewn together and an opening (*portiera,* or doorway), with woven striped silk ribbons on the joins. Each panel is embroidered in a vertical pattern, with a row of single oblique leaves on the seams and standardized vegetal compositions in the middle that gradually diminish in size toward the top. At the bottom is a horizontal hem with a row of leaves. The opening of the tent has two narrow hems decorated with columns of pairs of leaves that converge high up to form a pediment, in which are depicted a couple flanking a flowerpot, double-headed eagles, and deer. In the panel above the pediment, framed at the top by three horizontal zones with pairs of leaves, are schematic representations of two large confronted birds, a "coat of arms" motif with heraldic lions at either side of a flowerpot, diverse small birds, double-headed eagles, flowerpots, deer, and crosses. The basic alternating colors of the embroidery are various shades of green and red complemented, mainly at the opening, by light brown, yellow, and pale blue. The embroidery is distinguished by its peculiar relief or raised effect, a characteristic feature of Rhodian needlework that is achieved by executing a loose cross-stitch in thick untwisted silk.

The *sperveri* completely covered the bed, which was placed on an elevated platform, isolating it and securing privacy from the rest of the single-room Rhodian house. It hung from a round or polygonal carved and painted wooden disk, the *mylospervero* (see cat. no. 90), which was affixed to the ceiling with the decorated side facing downward. Because two sides of the bed rested against the walls of the corner, the corresponding sides of the bed tent were left plain and only the visible ones were embroidered. The voluminous *sperveri,* with the colorful sheen of its embroidery, endowed the humble island home with an air of opulence.

The decoration of the bed was completed by embroidered valances, visible through the opening of the tent. Pillows, embroidered around the edges and plain in the middle, were piled atop one another close to the bed. Close to the bed was the baby's cradle (see cat. no. 70).

In wealthy Dodecanesian houses a wooden partition with painted representations in vivid colors, the *ambataros,* separated the reception room from the sleeping area (see cat. no. 68). The traditional decoration of the house interior, still retained in many cases, included rich embroideries, hand-woven textiles, and shelves laden with jugs and plates, among the most popular of which were Iznik ceramics decorated with red paint, the so-called Rhodian ware (see cat. no. 91). Plates covered the entire long wall at the far end of the house, accordingly called the *piatelotoichos* (plate wall).

Bed tents are encountered on other islands of the Dodecanese, such as Kos and Patmos, and are surely the most splendid genre of Aegean needlework. Few intact examples have survived, as in recent times they have been shared between family members or altered by dealers.

Unpublished. For *sperveri,* see Wace 1935, vol. 1, 22–29, 56–58, nos. 40–47, vol. 2, pls. LI–LXI; Taylor 1998, 57–64. For an intact bed tent in the Benaki Museum, see Delivorrias, Fotopoulos 1997, 447, fig. 773. For Dodecanesian embroidery in general, see Polychroniadis 1980, 21–22, 66–67, 69, figs. 50–51, 54.

K.S.

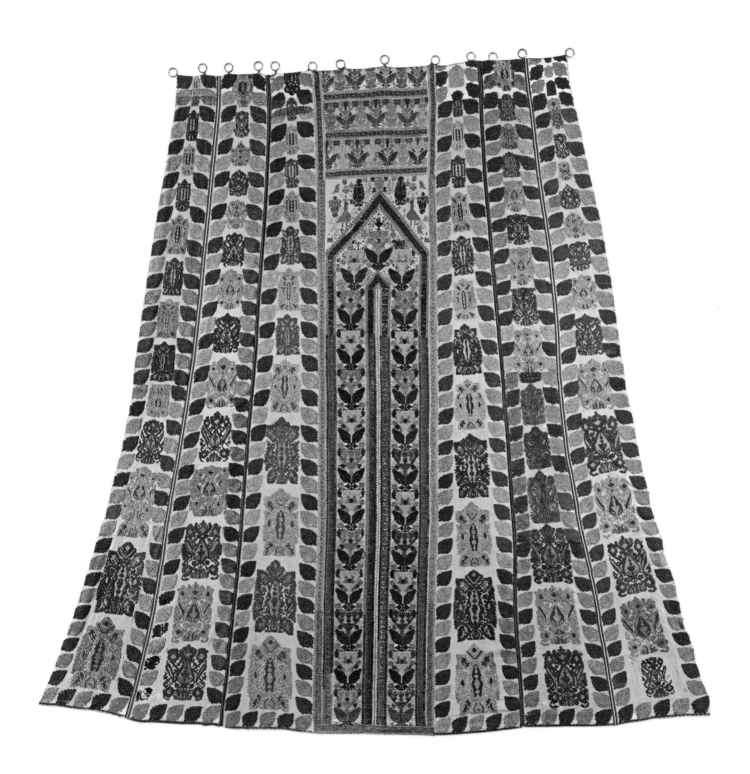

90. **Octagonal Disk from a Bed Tent**
    17th–18th century
    From Rhodes, Dodecanese
    Carved wood painted in egg tempera
    82 x 81 x 4.5 cm
    Gift of Helen Stathatos, inv. no. 8907

The octagonal wooden disk from which the bed tent was suspended (see cat. no. 89) is elaborately carved. At the center is a rosette whose eight petals converge to form a carnation. The interstices are decorated with flowers and leaves, and a zone of naturalistic palmettes runs around the central medallion. The decoration was originally picked out in colors, of which only red is preserved on the outer plain edge. On the undecorated surface of the disk is a suspension ring.

This type of disk is known by the local name *mylospervero,* which derives from the word *sperveri,* the bed tent. Round or polygonal, it was affixed to the ceiling with its decorated surface facing downward, recalling the polygonal boss on carved-wood ceilings in mansions in various Greek regions, such as Pelion and Metsovo. This particular example is part of the intact Rhodian bed tent in the Benaki Museum.

Wace 1957, 92, 107, no. 194, pl. XLIX; Johnstone 1961, 57, fig. 58; Delivorrias 1997, 308–9, 355, fig. 137.

K.S.

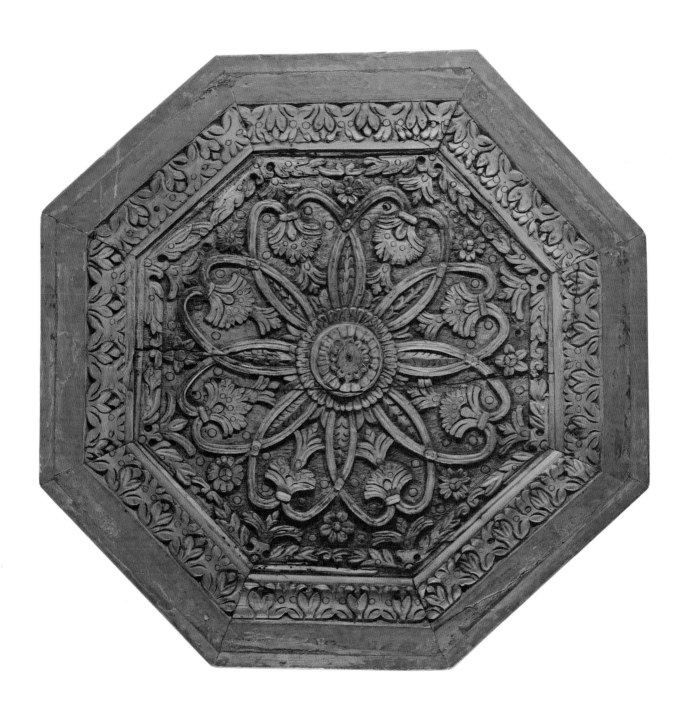

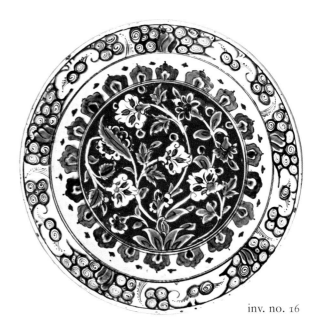

inv. no. 16

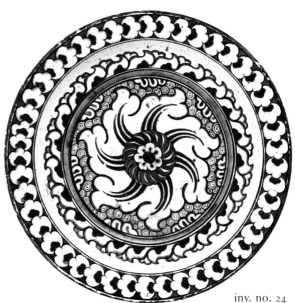

inv. no. 24

91. **Eight Plates**
17th century
From Iznik workshop, Asia Minor
Fritware painted under a transparent glaze
Diam. 28–34 cm
Gift of Damianos Kyriazis,
inv. nos. 16, 24, 11127–29, 11133, 11141, 11146

The Iznik ceramics of the Ottoman period appeared in the late fifteenth century and show a technological advancement and superiority without precedent in the Islamic world. Iznik ware, named after the city of Iznik (the Byzantine Nicaea), is a silica-enriched fritware with lead-flux glaze that has no crackle and little pooling. The hard and dense body is covered by a white slip and decorated with cobalt blue on the early pieces and with additional colors on the later ones. Production reached its peak in the sixteenth century, when it was monopolized by the sultan's court. The decorative repertoire is typical of the Ottoman period, with motifs such as windblown flowers, carnations, tulips, roses, hyacinths, and roses as well as stylized motifs, such as the fish-scale pattern.

During the seventeenth century, Iznik ceramics were popular with the Greek community living under Ottoman rule. The main church of the Great Lavra Monastery on Mount Athos was decorated with a series of Iznik tiles that, according to the inscription, was completed in September 1678. The popularity of Iznik ceramics is further attested by their use on church and house façades and in the interior decoration of mansions, especially on the island of Rhodes. Art historians in the early twentieth century erroneously believed that the ware was produced locally and thus the entire group of ceramics that featured the distinctive red in their decoration was once called Rhodian ware.

For Iznik pottery, see Atasoy, Raby 1989; Carswell 1998.

M.M.

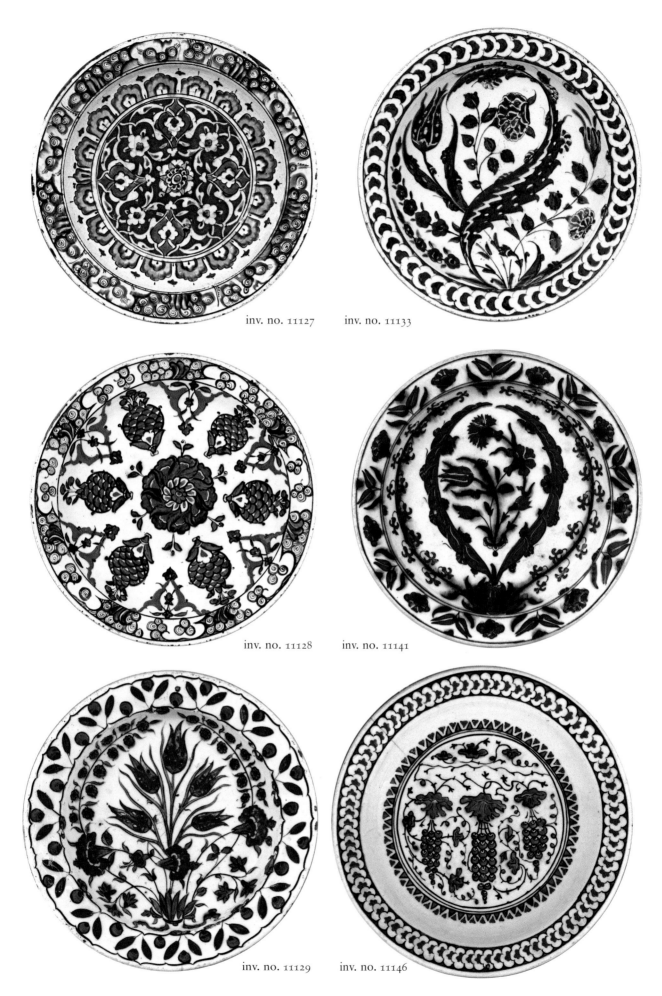

inv. no. 11127  inv. no. 11133

inv. no. 11128  inv. no. 11141

inv. no. 11129  inv. no. 11146

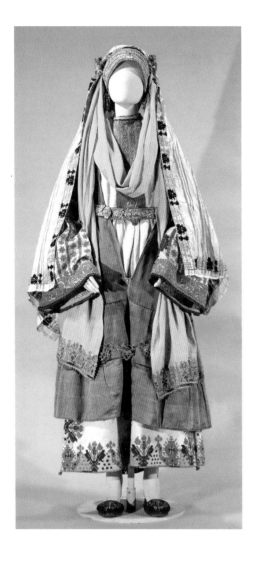

92. **Bridal Costume of Astypalaia**
    Mid-19th century
    From Astypalaia, Dodecanese
    Ensemble of 11 pieces (garments, accessories, and jewelry)
    Costume no. 96

The bridal costume of Astypalaia is one of the sartorial ensembles that survived until the early twentieth century. It belongs to the group of island costumes that are distinguished by the combination of a chemise—the basic garment of all Greek female costumes—and a Renaissance-type pleated dress, a vestige of the period of Venetian rule.

This costume from Astypalaia comprises a long homespun cotton chemise and a shorter pleated dress made of green satin imported from Constantinople. The wide sleeves and hem border of the chemise are lavishly embroidered. Each of the embroideries, of different style and coloration, has its own aesthetic content, which is incorporated into the exuberant whole. A basic element of the costume is the striking bridal headdress, with its long homespun silk veils and velvet cap with the *chrysomantilo* (gold kerchief)—a broad silk band worn on the forehead—that are encrusted with pearls and beads and embroidered with gold wire in Byzantine technique.

The costume is complemented by pearl-studded pins to hold the veils in place, hoop earrings with pearls, two silver belts; and silver pendant amulets sewn on the back of the dress. Knitted stockings decorated with gold-woven bands cover the legs, and gold-embroidered velvet slippers are on the feet.

Marica Monte Santo first studied the costume in the early 1930s, when abundant material still existed. Authorized by the Italian Ministry of Colonies, she undertook, as part of the series of studies of the colonies, a tour of the Dodecanese, which were then under Italian rule (1912–48), to record her impressions.

The distinctive silk embroidery on the chemise, among the most renowned examples of needlework in the Greek islands; the pleated dress of Renaissance provenance, sewn from imported textiles—silk-satin, velvet, brocade—that reached the island thanks to the trading activity of its inhabitants; and the gold embroideries of the headdress and footwear, a continuation of the embroidery tradition of Byzantine times, clearly endow this costume ensemble with the merging of cultural traits that is so typical of the Greek islands.

Unpublished. For the costume of Astypalaia, see Monte Santo n.d., 27–41; Papantoniou 1996, 92–93, 152. For island costumes, see Delivorrias 1997, 284–88, 326, fig. 69; Papantoniou 2000, 154–75.

I.P.

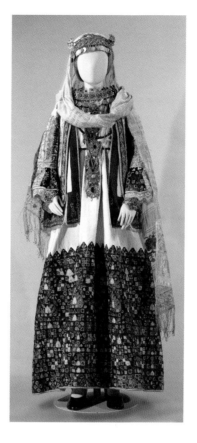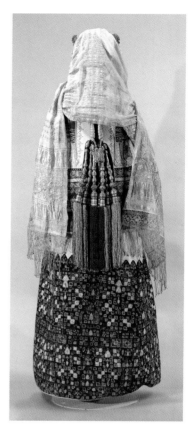

93. **Bridal Costume of Attica**
   Second half of 19th century
   From Attica
   Ensemble of 12 pieces
   (garments, accessories, and jewelry)
   Costume no. 15

The costume of Attica was worn, with minor variations, in an extensive group of villages around Athens until the early decades of the twentieth century. It is characteristic of the costume of the rural regions of central Greece, which combined a long cotton chemise with a shorter, sleeveless woolen overcoat, open at the front. This costume, which is based on the dalmatic—an evolution of the Roman tunica established during the early Christian period in the Mediterranean—emerged from the sartorial melting pot of the Byzantine Empire and was subsequently disseminated, in endless variations, to the rural populations of the southern Balkans.

The form of the costume is known from the late eighteenth century, thanks to written accounts and visual records by European travelers. These testimonies provide evidence of both the subtle changes and the preservation of the principal morphological elements. The slow development observed over this period generally reinforces, rather than refutes, the stability of the costume form, a fact directly related to the conservatism of the rural societies.

The bridal costume of Attica, one of the most elaborate ensembles in Greece, is impressive for the richness of its decoration and the exquisite art of its embroidery. The most characteristic garment is the long sleeveless chemise, with dense embroidery around the hem, often more than seventy centimeters wide. Executed by professional embroideresses in brightly colored silk thread, predominantly in shades of red, it gives the impression of a Byzantine mosaic created from polychrome tesserae. The chemise, more than any other component of the costume, reflects the social status and the economic standing of the bride. This type of chemise accompanied the costume worn in all the villages of Attica by girls of the second social "class." The more affluent brides wore a "golden costume" in which the needlework on the hem of the chemise was executed in gold thread (see fig. 23, p. 143).

Particularly intricate is the gold embroidery on the sleeves of the short tight-fitting cotton bodice. Two sleeveless mantles, worn one over the other—the inner is longer—complement the costume. Made of white woolen cloth and edged with bands of red felt, they were woven and embroidered with gold thread by expert Athenian tailors. The gossamer-silk veil draped around the head is edged with lace and fringes of gold thread. The opulence of the costume is heightened by abundant gilded jewelry, wrought in filigree technique and enlivened with inlaid colored glass-paste gems and imitation gold coins, consistent with the distinctive style and aesthetics of Attic jewelry. Down the back hangs an impressive ornament of thread, metal strips, and silk tassels that is plaited into the hair braids.

The costume of Attica was the inspiration for the formal dress at the court of King George I (r. 1863–1913), which was established by Queen Olga (1851–1926), shortly after their marriage in 1867.

Fribourg 1984, 116–17, no. 180 (E. Georgoula). For the general costume type, see Hatzimichali 1979, 26–71; Welters 1986, passim. For the evolution of the Attica costume from the dalmatic, see Papantoniou 2000, 118–27.

I.P.

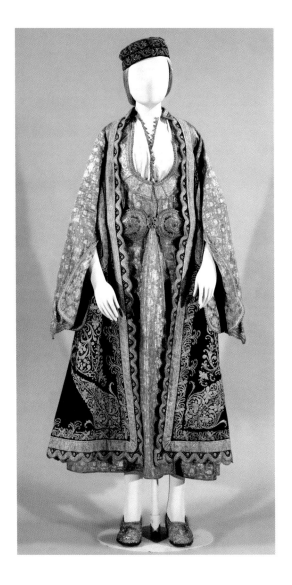

94. **Urban Costume of Ioannina**
Mid-19th century
From Ioannina, Epirus
Ensemble of 6 pieces (garments, accessories and jewelry)
Costume no. 68

The costume of Ioannina is typical of the urban dress of the Greek mainland, which, in the time of the Ottoman Empire, was common to Muslim and Christian women, with slight differentiations in format, decoration, and head covering. A long-sleeved dress, open in front, was worn over one or two pairs of pantaloons and a long chemise. A wide sash was wound around the waist and was combined with one or two belts, usually fastened by a metal clasp. According to the occasion or the season, an overcoat—long-sleeved, short-sleeved, or sleeveless—completed the costume.

The version worn in Ioannina in the nineteenth century comprised a dress of precious brocade and a gold-embroidered collar and included the typical overcoat known locally as *pirpiri*. Possibly originating in Central Asia, this outer garment is shorter than the dress, open in front, and densely pleated in the back. The famed *pirpiri* were made of felt or velvet and sewn and embroidered with appliqué gold or silk thread by the renowned craftsmen of Ioannina, whence they were distributed throughout the Balkans.

Ioannina, a commercial and artistic center, was also the source of the silver jewelry that ornamented the costume of the town and those of many neighboring regions, with silver belt buckles being the most impressive pieces. The costume is completed by a headdress and footwear embroidered in gold thread. The precious textile of the dress, the high quality of the needlework decorating the overcoat, and the accessories reflect the great economic heyday of Ioannina in the nineteenth century.

Hatzimichali 1984, 139, fig. 142. For the costume type in general, see Hatzimichali 1984, 138–71. For the costume of Ioannina, see Papantoniou 2000, 130–52. For the *pirpiri*, see Papantoniou 2000, 221–24.

I.P.

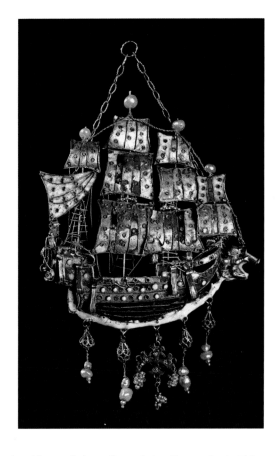

95. **Pendant in the Shape of a Four-Masted Caravel**
First half of the 17th century
From Patmos, Dodecanese
Gold sheet, filigree, enamel, pearls
Height 13.8 cm, width 9.5 cm
Gift of Helen Stathatos, inv. no. 7669

The caravel has white, deep blue, light green, and turquoise enamel on the sides and the sails and details emphasized by twisted wire. White enamel blobs indicate two tiers of cannon. Pearls top the four masts, and the rope ladders and rigging are of twisted wire. On the prow is a figure of Victory holding a trumpet. From the keel hangs an enameled Maltese cross with pendant bunches of seed pearls framed by droplets with Baroque pearls. The ship is decorated on the back with enameling, while the sails are left in gold.

In Renaissance Europe, as befitted an era of maritime explorations, miniature sailing ships, marine monsters, and mermaids were popular subjects, particularly in Italy, Spain, and Portugal. In a portrait of Lady Cobham, painted in 1567, the English aristocrat wears a precious necklace with a ship pendant. Impressive pieces of jewelry in the form of a sailing ship with enamel and pearls, which date to the sixteenth and seventeenth centuries, are recorded with various provenances: France (Thyssen-Bornemisza Collection, Madrid), the Mediterranean (Metropolitan Museum of Art, New York), the Iberian Peninsula (National Museum of Ancient Art, Lisbon), Italy (Museo degli Argenti, Florence), and the Aegean (Victoria and Albert Museum, London).

The gold caravel from Patmos is the largest and the most spectacular of a group of ship pendants encountered on necklaces and earrings from the Aegean Islands, mainly from the Dodecanese and the Cyclades. They are distinguished by the filigree wire of the enamel surfaces, the additional drop-shaped pendants, and the clusters of seed pearls that often hang like bunches of grapes. They featured imaginative and eye-catching compositions—such as swan-shaped caravels with winged dragons—as described by the British traveler J. T. Bent, who visited Siphnos in 1884, and the British consul general at Palermo in Sicily, Sidney J. A. Churchill, in the late nineteenth century, who referred to the caravel earrings of a Greek woman from Cyprus.

The quantity and the exquisite quality of these pieces of jewelry confirm that they were produced during a period of economic, social, and cultural prosperity, as also reflected in the lavish furnishing of the houses and the luxurious costumes. The Aegean Islands enjoyed two eras of prosperity: the time of Venetian rule, from the mid-sixteenth to the mid-seventeenth century, and the mid-eighteenth to the early nineteenth century. After the mid-1700s, however, the use of enamel gradually declined until it disappeared completely from Aegean jewelry and a different style of female adornment swept the islands. Furthermore, the Westernized style of this pendant and the imposing grandeur that evokes Byzantine aesthetics point to a close connection with the Venetian period.

Delivorrias, Fotopoulos 1997, 472, fig. 826; *Greek Jewellery* 1999, 371–72, no. 134 (A. Delivorrias). For examples of Mediterranean jewelry in the shape of a sailing ship, see Rossi 1956, pl. 79; Somers Cocks, Truman 1995, 74–75, no. 5, 88–89, no. 11, figs. 1–2; D'Orey 1995, 23, no. 19. For the portrait of Lady Cobham, see Phillips 1996, 84–85, fig. 67.

K.S.

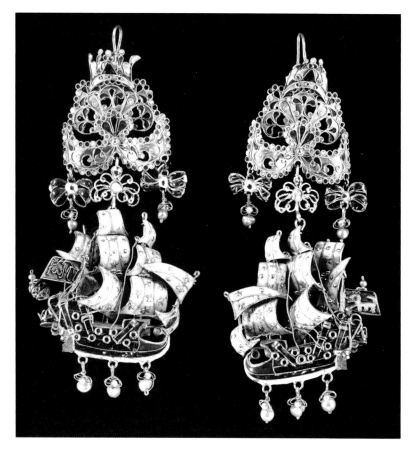

96. **Earrings with Three-Masted Caravels**
Mid-17th century
From Siphnos, Cyclades
Gold sheet, filigree, enamel, pearls
Height 12.8 cm, width 5 cm
Gift of Helen Stathatos, inv. no. 7670

These earrings, with their exquisite workmanship and spectacular synthesis, are truly impressive. The hooks are set in delicately worked fan-shaped attachments (cf. cat. nos. 98–99), with crowns at the top and hanging bows. The details are picked out in filigree enamel in green, deep blue, and white. The caravels have deep blue and green enamel on the sides and white on the keels and the sails, which are dotted with gold granules and stars. Suspended from the keels and the hanging bows are pendants with pearls. On one side of the enameled flag is the blazon of the lion of Venice, in white on a green ground, and on the other are the initials: ΙΩ[άvvης] ΜΠ[άος], or Io[annis] B[aos], and Κ. ΜΠ[άος],or K. B[aos].

The monogram of Ioannis Baos also appears on an inscribed gold pectoral pendant in the Benaki Museum, and an almost identical pair of earrings bearing the same emblem on the flag, in an Athenian private collection, is also of Siphnian provenance and originally belonged to the Baos family, according to the family papers of the owner. Members of the Baos family are recorded in legal documents of Siphnos as early as 1677, and a dowry contract of 1773 actually mentions "three pairs of earrings, one sailing ships."

The representation of the lion of Venice on the flag and the Westernized style of these pieces of jewelry found in the Aegean Islands prompted the widely held view that they were made in workshops in the Serenissima Republic or at a provincial Italian center on the Adriatic, whence, together with other luxury commodities, they were imported to Greek regions. However, this view is not corroborated by the archival evidence or by the essentially different style of contemporary Italian jewelry, which is characterized by a profusion of pearls.

Although the attribution of these creations to a particular local workshop cannot be made with certainty, there are numerous indications that their origin is Greek: their wide dissemination in the Greek islands, the correlating of the family names on inscribed examples with archival sources, and the traces of their influences on later families of insular jewelry.

All the available evidence suggests that the workshop should be sought in some insular urban center, perhaps in flourishing Candia (modern Herakleion), capital of Venetian-held Crete, from where many Cretans migrated to the Ionian and Aegean Islands during the Cretan War (1645–69) and after the island's final capitulation to the Ottoman Turks in 1669. Furthermore, the Venetian archives document the use of enamel in Crete in the early seventeenth century—which certainly reflects an existing tradition—and the integration of boat shapes in precious vessels from the fourteenth century.

Delivorrias, Fotopoulos 1997, 472, fig. 825; *Greek Jewellery* 1999, 374–77, no. 135 (A. Delivorrias); Synodinou 2001, 341–58, fig. 1. For other examples of caravel pendants in the Benaki Museum, see Thessaloniki 1997–98, 255–57, 261, nos. 304–6, 310 (K. Synodinou). For earrings with sailing ships from Sicily, see Trapani 1989, esp. 29, 31, fig. 10, 109, no. I.45.

K.S.

184

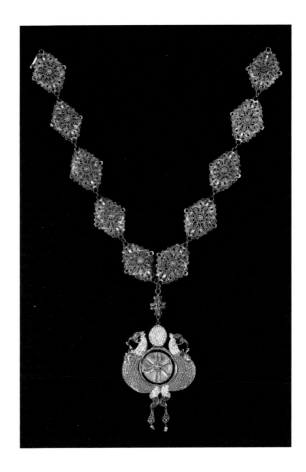

97. **Necklace with Pendant**
    Late 17th-early 18th century
    From Patmos, Dodecanese
    Gold sheet, filigree, enamel, seed pearls
    Length of chain 50 cm, height of pendant 12.5 cm
    Acquired with the contribution of Eleni Paraskeva,
    inv. no. 32943

The necklace is composed of ten lozenge-shaped segments joined by links and a pendant. The lozenges, fashioned from two openwork gold sheets, are ornamented with applied filigree floral motifs, highlighted with blue and white enamel, forming a bouquet of flowers and leaves around a central rosette. A cruciform device holds the pendant, which represents two peacocks at either side of a central wheel with a decorative motif reminiscent of the XP (Chi-Rho) monogram (Christogram). The pendant is variegated with black, blue, turquoise, dark red, and white filigree enamel. The ovoid element crowning the wheel brings to mind heraldic compositions with a crown encountered in European jewelry. Soldered to the center of the reverse are a small gold plaque with applied filigree vegetal decoration and a central cruciform motif bearing traces of green enamel.

The "Christogram" endows this piece of jewelry with both religious and decorative significance. Pendants with symbols of religious derivation, such as the pelican or the eagle, or even various insignia that hung from chains embellished with enameling or precious stones circulated in Renaissance Europe and are depicted in portraits.

Comparable chains decorated with polychrome enamel creating the impression of precious stones are also found in other Aegean Islands, outside the Dodecanese, their luxurious appearance recalling Renaissance examples. Necklaces of this type, with Venetian-style craftsmanship, usually were very long, so that their successive rows covered the entire chest. From them hung precious pendants in the form of sailing ships (see cat. no. 95), crosses, double-headed eagles, and so forth. The fragmentary state of these necklaces in museums and private collections today is due to the customary practice in more recent times of sharing them among the family members.

Delivorrias, Fotopoulos 1997, 473, fig. 828; *Greek Jewellery* 1999, 360, fig. 269. For pendants with symbols of religious derivation, see Trapani 1989, 32–35, figs. 16a,b, 38, fig. 20, 66, figs. 7a,b, 8a,b; D'Orey 1995, 39–41, figs. 47, 51–52.

K.S.

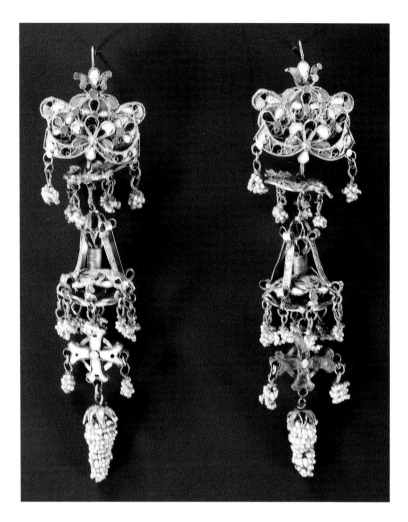

98. **Earrings with a Series of Pendants**
Ca. 1700
From the Dodecanese
Gold sheet, filigree, enamel, pearls
Height 13 cm
Gift of Helen Stathatos, inv. no. 7666

The earrings consist of a series of pendants: a stylized bow with a crown at the top, a bird with outstretched wings, a bell-shaped element with reinforced strips, an enameled Maltese cross, and a cluster of seed pearls. Details are highlighted with white, blue, and black enamel. Small clusters of seed pearls hang from each pendant. Of impressive length, these earrings must have been worn with a frontlet (now lost), as may be deduced from similar ensembles of head ornaments found widely in Greek regions. They were hooked above the ears and hung down to the shoulders, so that with the frontlet across the forehead they framed the face like the Byzantine *prependoulia*, known from Byzantine works of art and written sources.

The various components of the present earrings are frequently encountered in jewelry from the Aegean Islands. There is a close parallel, without enameled decoration, in the Benaki Museum. The most striking example, with a double-headed eagle and a crown in place of the bow—remarkable both for its length and the number of hanging bunches of pearls—is in a private collection in Athens.

*Greek Jewellery* 1999, 380–82, no. 137 (A. Delivorrias). For Byzantine *prependoulia*, see Athens 2001–2, 60–61, fig. 12, 70–72, figs. 20–22.

K.S.

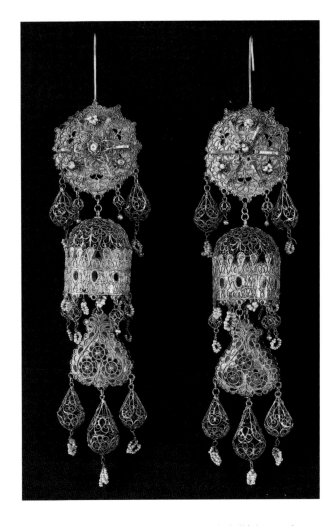

99. **Earrings with Bell-Shaped Pendants**
Mid-18th century
From Kos, Dodecanese
Gold sheet, pierced work, filigree, pearls
Height 20 cm
Inv. no. Εχρ. 265

This sumptuous pair of earrings is distinguished by its finely worked filigree decoration, elegant shape, and skillful articulation of individual elements. At the top is a rosette divided by gold strips into six compartments, with a six-petaled flower affixed at the center (one flower is missing). Suspended from the rosette is a large bell-shaped element, from the middle of which hangs a double-sided heart-shaped pendant. Large drop-shaped and small spherical filigree pendants with dangling clusters of seed pearls hang from the three main parts of the earring.

These earrings are the longest and most impressive of the four pairs in the Benaki Museum that have Kos as their recorded provenance. The earrings are called *kambanes* (bells), after the characteristic shape of their central element, and are known by this name in other Dodecanesian Islands as well as in the Cyclades. A pair of earrings of the same type but set with enamel (private collection, Athens) that is known to come from Kos, and a photograph of the pair under discussion taken before it was acquired by the Benaki Museum, attesting to its presence and its being referred to as *kambanes* on Kos in the early decades of the twentieth century, leave no doubt as to their provenance.

The filigree decoration of the earrings is mostly soldered to pierced-work cutouts of gold sheet, consistent with the earlier tradition of Dodecanesian enameled jewelry. However, the absence of color from the gold surface is compensated for by the exquisite delicacy of the filigree floral decoration. On the combined evidence of the absence of enamel—from the mid-eighteenth century onward, the use of enamel in Aegean jewelry gradually declined—and the technique, the earrings may be dated to the mid-eighteenth century.

*Kambanes* must have accompanied a type of frontlet, of which no example survives. Like the previous earrings (see cat. no. 98) and all those of comparable length (see cat. no. 107), they were hooked above the ears and framed the face, dangling to the level of the neck and forming an ensemble with the frontlet. A later type of frontlet, examples of which have survived, consists of a velvet ribbon sewn with rows of gold coins and long hooked *kambanes*.

Delivorrias, Fotopoulos 1997, 472–73, fig. 830; *Greek Jewellery* 1999, 383–85, no. 138 (E. Georgoula). For a photograph of the earrings before they were acquired by the Benaki Museum, see Monte Santo 1932, ill. p. 123. For another pair of *kambanes* in the Benaki Museum, see Sydney–Melbourne 2005–6, 190, no. 126 (K. Synodinou).

E.G.

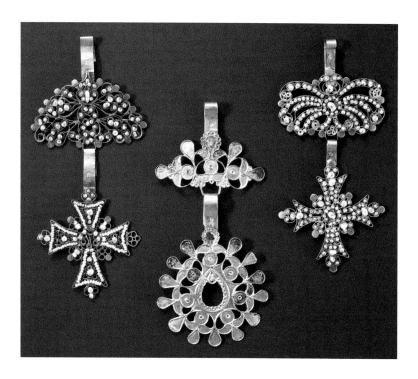

100. **Three Pendants from a Pectoral Ornament**
18th–early 19th century
From Corfu, Ionian Islands
Gold sheet, filigree, granulation, pearls
a. Height 14.5 cm, max. width 6.5 cm
b. Height 13.5 cm, max. width 6.5 cm
c. Height 13 cm, max. width 6 cm
Inv. no. Εχρ. 1517

The three pendants, strung on a plain chain of later date, arrived at the Benaki Museum as part of the pectoral ornament of a bridal costume from the village of Gastouri, in central Corfu. The two side pendants, in the form of a Maltese cross, hang by wide strips from conventionalized sprays resembling bouquets of flowers or bows, which must have been threaded on a necklace of a type now unknown. Worked in filigree with running spirals, they have small disks attached to their curved outlines and are set with pin-mounted pearls. The apparent differences in their design and decorative details suggest that they belonged to two separate pectoral ornaments. The central pendant is a stylized multipetaled rosette, likewise suspended from a floral ornament. It is worked in the older technique of appliqué filigree, forming "cloisons," perhaps for an initial decoration in enamel, and had added pearls, judging from the tiny holes visible at the bottom. A large pearl was mounted in the oval central aperture, as deduced from a comparable piece of jewelry in a private collection. All three pendants bear illegible stamps with Greek and Latin initials.

According to visual sources, including a watercolor in the Benaki Museum painted by C. de Brockdorff in the early nineteenth century, the original design of the Corfiot pectoral consisted of a series of chains of different lengths, with similar cross and pendants suspended from them, either all three together or separately. Analogous ornaments are also found on Zakynthos. This type of pectoral is known locally as *kadina*, from the Italian word *cadena* (chain), and was a gift from the bridegroom to the bride. The Benaki Museum has two similar crosses, from Corfu and from Patmos, in the Dodecanese.

Morphologically, the three pectorals recall European jewelry of the seventeenth to eighteenth century. A more luxurious version of the bow and cross, from the seventeenth century, is recorded as a *pendant vénitien,* while such pieces also circulated in Portugal and, in a simpler version, in Italy in the nineteenth century. A painting by an unknown artist, perhaps executed in Venice in the first half of the eighteenth century, depicts two comparable bejeweled crosses in a showcase in the interior of a shop.

*Greek Jewellery* 1999, 399–403, no. 144 (A. Delivorrias). For *pendant vénitien*, see Fontenay 1887, 232.
For Portuguese examples of the bow and cross, see D'Orey 1995, 46–47, figs. 60–62. For Italian versions, see Rome 1986a, nos. 406–7, pl. 83; Trapani 1989, 120, no. I.61. For the painting, see Abegg 1978, ill. p. 126.

K.S.

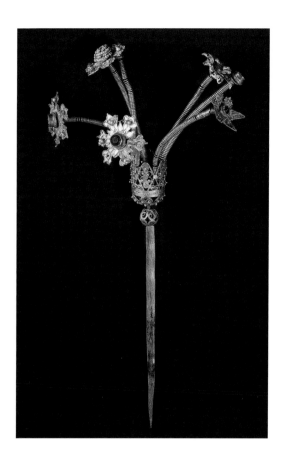

**101. Headddress Pin in the Shape of a Floral Spray**
Second half of the 18th century
From Lefkada, Ionian Islands
Gold sheet, filigree, granulation, enamel, pearls, glass beads
Height 23.5 cm
Gift of Marina Lappa-Diomidous, inv. no. Εχρ. 1707

This elaborate ornament embellishes and holds the headddress of the bridal costume worn on the island of Lefkada. It consists of a long pin from which sprout spiraling wire springs, like stems, which are topped by rosettes, with appliqué filigree decoration, seed pearls and glass beads. One of the rosettes is embellished with painted enamel.

This type of pin is known as *tremoula* (trembler or *tremblant*), because at the slightest movement of the head the stems tremble, and is mentioned by this name in notarial documents from at least 1805. Floral head ornaments of diverse materials and shapes are also encountered in other Greek regions reflecting an age-old tradition which lived on in the habit of adorning the headddress with artificial flowers. The apotropaic properties ascribed to the tremulous movement of the elements, in combination with the fertility symbolism of flowers, explains the presence of such ornaments in the bridal parures.

Head ornaments identical to the Lefkada *tremoula* in technique and style are not found in other Greek regions. Nonetheless, an example of identical type, known from a photograph taken in the interwar period and labeled as coming from Patmos, in the Dodecanese, suggests that ornaments like the *tremoula* were originally widely distributed throughout the Greek islands and must have formed a large, stylistically homogenous family.

Delivorrias, Fotopoulos 1997, 474, fig. 832; Thessaloniki 1997–98, 348, no. 400 (K. Synodinou); *Greek Jewellery* 1999, 413, fig. 300. For a photograph of the Patmian example, see Monte Santo 1932, ill. p. 116.

K.S.

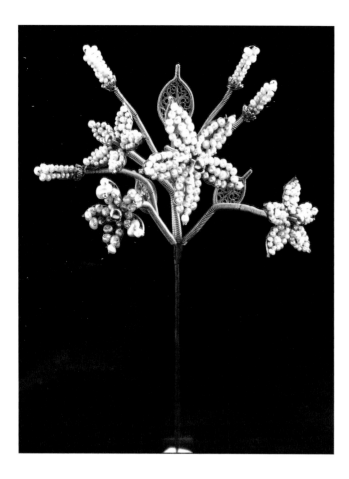

102. **Headdress Pin in the Shape of a Floral Spray**
Early 19th century
From Lefkada, Ionian Islands
Gold sheet, filigree, granulation, pearls
Height 19 cm
Maria Aiyialeidou Bequest, inv. no. 36050

The headdress ornament is similar in form to cat. no. 101 and illustrates the evolution of the type in the nineteenth century. The stems are crowned by either pearl buds or filigree floral rosettes of varying dimensions and filled with seed pearls, as well as lacy leaves edged in twisted wire. A striking feature is the lavish decorative use of pearls, which completely cover the petals.

Pieces of jewelry, whether pectorals or pins, with floral elements set on springs that trembled with every movement circulated in Europe between the seventeenth and the nineteenth century. Jewelry of comparable typology, with remarkably careful workmanship in enamel, colored stones, and seed pearls, was particularly popular in Sicily in the second half of the seventeenth century and much in demand, especially in Spain, throughout the eighteenth. The fashion continued with pins decorated with naturalistic subjects (*aigrettes*), worn on hats and in the hair.

The profusion of pearls on this *tremoula* provides a chronological link between it and the other items of jewelry from Ionian Islands (see cat. nos. 100, 103), suggesting a date in the early nineteenth century.

Unpublished. For a similar *tremoula* in the Benaki Museum, see *Greek Jewellery* 1999, 414–15, no. 149 (A. Delivorrias). For *tremblants* and *aigrettes* in Europe, see Scarisbrick 1984, 12–13, fig. 4; Bury 1991, vol. 1, 279–81, 329, pls. 142, 181. For Sicilian *tremblants*, see Trapani 1989, 80–81, fig. 43.

K.S.

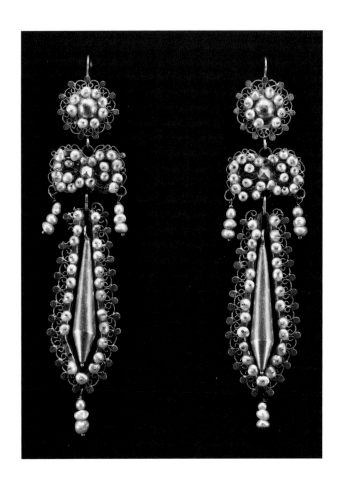

103. **Earrings**

　　Second quarter of the 19th century

　　From Lefkada, Ionian Islands

　　Gold sheet, filigree, pearls

　　Height 12 cm

　　Inv. no. Εχρ. 762

These earrings consist of a rosette, a bow and a lanceolate frame enclosing a free-hanging drop pendant. The decoration is worked in filigree with small disks soldered onto the scrolling borders, pin-mounted pearls, and hanging threaded pearls. Earrings of this type accompanied the bridal costume of Lefkada and are known as *bokoles*, the name by which they are mentioned in dowry contracts and other official documents from 1714 onward. The bride wore two to four pairs together.

　　The bow, which possibly derives from a ribbon bow that was tied to the upper part of the ornament to keep it in place, is one of the most popular decorative devices in European jewelry. It is depicted in European portraits by the mid-seventeenth century and held sway in the mid-eighteenth. In Greek jewelry it is mostly found in Crete, the Aegean Islands, and the Ionian Islands, which had direct contacts with Italy, primarily Venice (see cat. nos. 96, 98, 100).

　　The stylistic affinity of the earrings with the Corfiot crosses (see cat. no. 100), despite their simpler and less delicately worked filigree decoration, as well as with other pieces of jewelry from Corfu and Zakynthos, is obvious. At the time of the Greek War of Independence (1821), the British Protectorate of the Ionian Islands (1815–64), particularly Corfu and Zakynthos, emerged as important centers of silverwork, when Epirot craftsmen sought refuge there and gave new impetus to local production. Ionian Island goldwork displays overt Italian influences, in the shapes and in the use of copious seed pearls, as well as the influence of the Victorian Age in Britain.

Delivorrias, Fotopoulos 1997, 474–75, fig. 838; *Greek Jewellery* 1999, 406, no. 146 (A. Delivorrias). For the bow device, see Phillips 1996, 102–3, figs. 82–84; D'Orey 1995, 28.

　　　　　　　　　　　　　　　　　　　　　　　　　　　　　　　　　　　　　　　　K.S.

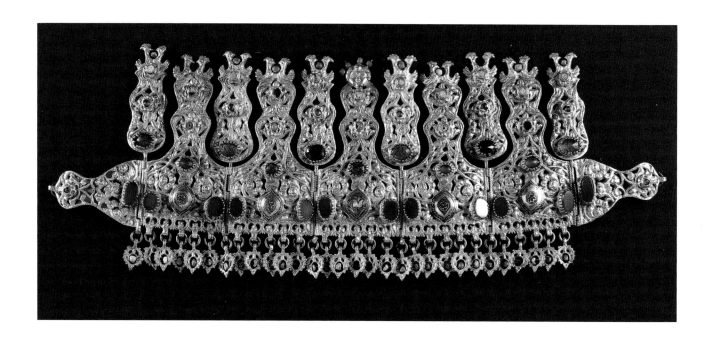

104. **Bridal Diadem**
    Late 18th century
    From Pogoni, Epirus
    Gilt, cast, hammered, and chased silver, pierced work, agates, coral, turquoise, glass gems, niello
    Height 13.4 cm, width 37.5 cm
    Inv. no. Eα 676

This diadem is distinguished by the variety of materials and the diversity of techniques employed. It is composed of cast and pierced plaques, linked by hinges decorated with chased floral motifs. The upper sections of the plaques and the plaquettes attached to the hinge pins are violin shaped and terminate in pairs of confronted birds. A female head with staring eyes—reminiscent of the ancient *gorgoneion* mask—crowns the central plaque. Suspended from a series of rings on the lower edge of the diadem is a row of pendants with glass beads at the center. Additional rings at either end of the plaques were for attaching the diadem to a headscarf. The semiprecious stones and colored glass gems in claw-tooth settings, and the appliqué silver ornaments with niello motifs, convey the impression of polychromy.

The pair of facing birds, a popular motif in traditional Greek crafts, occurs frequently in jewelry and bridal ornaments and probably had symbolic associations; the groom and bride are often described in folk songs as birds (the eagle and the dove, respectively). The nuptial use of the diadem is further enhanced by the fertility symbolism of its floral decoration. Last, the incorporation of the "mask" most likely was intended to ward off evil, since folk beliefs worldwide attribute apotropaic qualities to the human head.

This type of diadem is typical of the Pogoni area of Epirus, as attested by many examples and photographs. Local dowry contracts list this ornament, the most valuable piece of the bridal headdress, as a *corona* or *stolos*. Such items of jewelry sometimes end with rows of florins, forming larger sections on the temples (see cat. nos. 105, 113); often, they are combined with long dangling earrings, hooked at a point above the ears to form an ensemble. Worn separately across the brow or affixed to the front of a cap, the Pogoni *corona* preserves the form of the Byzantine diadem.

The Baroque-style decoration of the diadem, with a flamboyant aesthetic and extravagant use of motifs, materials, and techniques, implies a fairly late date in the eighteenth century. This opulent diadem reflects the new prosperity enjoyed in the wider area of Epirus at that time as a result of international treaties that were favorable to the expansion of trade, the improvement of the lifestyle, and the manufacture of more luxury items for use in daily life.

Delivorrias, Fotopoulos 1997, 485, fig. 859; *Greek Jewellery* 1999, 462–65, no. 163 (A. Delivorrias). For a comparable example, see Thessaloniki 1997–98, 266, no. 315 (O. Fakatseli).

E.G.

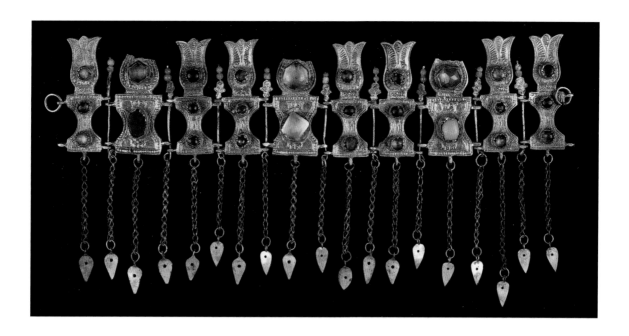

105. **Forehead Ornament**

Early 18th century
From Epirus
Gilt, cast, and incised silver, agates, rock crystal, coral, turquoise
Height 21 cm, width 31 cm
Inv. no. Εα 668

The forehead ornament, or frontlet, similar in morphology to the Pogoni bridal diadem (see cat. no. 104), consists of a row of cast and incised plaquettes with curved-in sides and upper parts in the shape of stylized tulips. They are joined by hinge pins terminating in trefoils and corals and are set with agates, rock crystal, and turquoise. Chains ending in leaf-shaped pendants dangle below.

The tulip motif, probably drawn from the decorative vocabulary of Ottoman art, was first incorporated in post-Byzantine ecclesiastical gold embroidery and patterned silk fabrics and then passed into secular silverware and embroidery. It is particularly common in Epirus, both in jewelry and, even more so, in household embroideries. Compared to the fussy decoration of the Baroque-style diadem from Pogoni, with a surfeit of motifs and materials, this forehead ornament emanates an austere simplicity that points to a much earlier date. Stylistically it belongs to the same group of earlier Epirot jewelry as the neckband and earrings (see cat. nos. 106–7). The restrained use of incising and the imposing grandeur of the ornament, with overt Byzantine allusions, corroborate its dating to the first decades of eighteenth century.

Forehead ornaments were worn widely in Greek regions in a variety of forms and materials. This forehead ornament, together with a neckband and dangling earrings such as cat. nos. 106 and 107, formed an ensemble, an integrated system of adornment of the head with incontrovertible Byzantine roots. Such ensembles, signifying the economic level of the community and the social status of the wearer, were customarily worn as part of the wedding costume in Epirus, Macedonia, and Attica.

Delivorrias 1980, fig. 76; Delivorrias, Fotopoulos 1997, 485, fig. 858. For a comparable example with Peloponnesian provenance, see Thessaloniki 1997–98, 338, no. 389 (Y. Kaplani).

E.G.

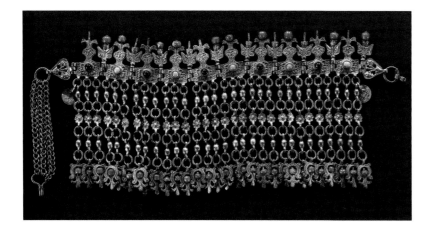
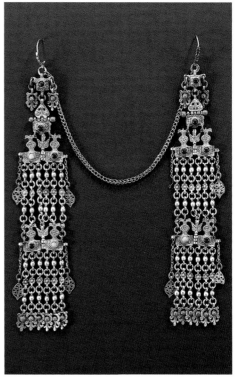

106, 107. **Neckband and Earrings with Chain Pendants**
First half of the 18th century
From Epirus
Silver with cast and gilt details, turquoise, corals, glass gems
Neckband: length 31.6 cm, height 10 cm
Earrings: height 24.5 cm
Inv. nos. Εα 733 (neckband), Εα 573 (earrings)

The neckband and the exceptionally long earrings—the longest known—originated from Epirus but were not acquired together, as is evident from their inventory numbers. Nonetheless, they are presented here as a set because they undoubtedly belonged, if not to the same parure, at least to the same ensemble of jewelry. They were combined with a frontlet of a similar type as cat. no. 105.

Both consist of a row of interdependent, articulated, and repeated cast elements and dangling chain pendants. Rectangular plaquettes, set at the center with glass-paste gems and turquoise and crowned by schematic double-headed eagles, are joined by hinge pins terminating in schematic cherubim with upraised wings. The plaquettes hold in place concatenated pendants with globules and tiny rosettes between the links, ending in pierced-work foliate finials. The two hooks with chains hanging from the terminals of the neckband were for affixing it to the garment at the level of the neck. The chain connecting the earrings for greater security and added elegance was pinned at the back of the headdress, forming two loops on either side of the head.

All the repeated elements of these ornaments were cast in molds, which facilitated their "mass-production," resulting in the diffusion and longevity of the particular types. The uniformity of the cast elements is offset by the fine hand chiseling and finishing of the details, while partial gilding of certain components enlivens the piece overall, creating an illusion of color.

The restrained, austere forms of the components of these pieces, compared with the aesthetic of the Baroque-type neckbands and earrings with an extravagant use of agates, assign them to the earlier jewelry production of Epirus, probably before the mid-eighteenth century.

The double-headed eagles and cherubim endow the ornaments with protective properties. The double-headed eagle, an ubiquitous motif in neo-Hellenic jewelry, symbol of the lost Byzantine Empire and of the resurrection of the Greek nation, even when conventionalized as a simple decorative motif, embodies a deep belief in its apotropaic power and conscious references to the illustrious past and the vision of liberty. The symmetrical presence of the cherubim, which are encountered only on Epirot jewelry, reinforces the apotropaic character of the pieces.

Delivorrias, Fotopoulos 1997, 479, fig. 846 (neckband); *Greek Jewellery* 1999, 450–55, nos. 160–61 (A. Delivorrias). For a comparable set of neckband and earrings in the Benaki Museum, see Sydney–Melbourne 2005–6, nos. 137–38 (K. Synodinou).

K.S.

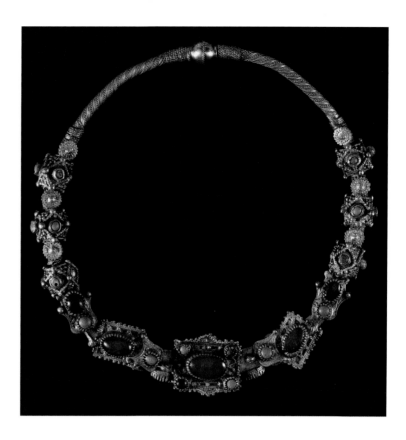

## 108. Torque

Late 17th-early 18th century
From Macedonia
Cast silver, agates, turquoise, corals
Diameter 19.5 cm
Inv. no. Eα 669

This choker consists of a tubular silver hoop twisted—hence the name torque—like a rope, with threaded polyhedral beads, riveted rosettes, rectangular appliqués, and swiveling pieces in the form of stylized birds with open wings. A rectangular central ornament masks the hook fastener. The cast decoration of the individual elements, which are embellished with large agates and small turquoise and corals in claw-tooth settings, imitates granulation and filigree work.

This rare type of choker is known from three examples of a simpler design in the Benaki Museum, two similar torques in the Canellopoulos Museum in Athens, and two in Athenian private collections. One of those in the latter is partly preserved and the other, the most striking of all, is inscribed *1691*. Although all the pieces in the Benaki Museum are said to be from Macedonia, the type is not encountered among the jewelry worn with any of the Macedonian or northern Greek costumes as they are known today. Presumably, this points to its antiquity, which is confirmed by the one extant dated example and corroborated by the form and the workmanship of many of the component parts. The faceted beads in particular are strongly reminiscent of Byzantine and early post-Byzantine earrings.

The type of the torque recalls neck ornaments of antiquity. This impression is further heightened by the "antique" effect created by the pseudogranulated motifs. Thus it seems that this type of torque is of northern Greek provenance—though the exact locality is as yet unknown—and that it is a survival of an important family of jewelry with origins going back to earlier times more closely associated with the Byzantine world.

Delivorrias, Fotopoulos 1997, 480–81, fig. 851. For the inscribed torque, see *Greek Jewellery* 1999, 424–27, no. 153 (A. Delivorrias).

E.G.

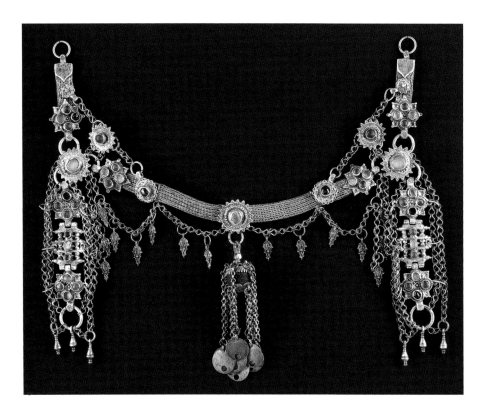

109. **Head Ornament with Chains and Pendants**
      Late 17th–early 18th century
      From northern Macedonia
      Silver with cast and gilt details, granulation, glass paste
      Height 24 cm, width 29.5 cm
      Inv. no. Eα 711

This peculiar head ornament, in the form of a broad H, consists of braids of silver wire, partially gilded round and stellar rosettes, concatenated pendants set with glass-paste gems, chains, and dangles. The cast decoration of the individual components imitates granulation and filigree work. The two vertical elements of the H were fixed to the kerchief near the temples, with the dangles framing the face, while the star-shaped rosette in the middle of the horizontal braid and the cluster of chain pendants hung at the nape of the neck. The ornament was worn with a frontlet, though the type is at present unknown.

This piece, which is entered in the inventory of the Benaki Museum as northern Macedonian in provenance, is the sole surviving example of an otherwise unknown kind of head ornament. No evidence regarding the origin of the type has been found, nor have any comparable pieces come to light in northern Macedonia or the Balkan countries bordering that region. Although the question of the geographical origin of this type of head ornament remains unanswered, similarities between the workmanship of its components and that of early examples of Macedonian jewelry, as well as its marked stylistic affinity with the torque (see cat. no. 108), suggest that it can be assigned to Macedonia and corroborate its early dating.

Delivorrias, Fotopoulos 1997, 482–83, fig. 854; *Greek Jewellery* 1999, 428–29, no. 154 (A. Delivorrias).

E.G.

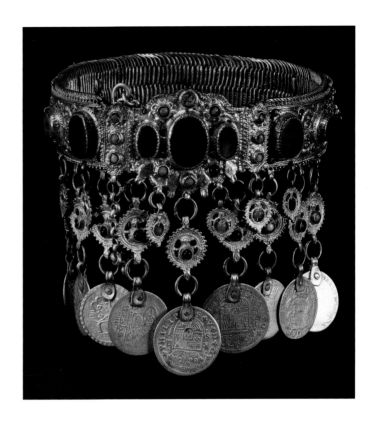

110. **Choker with Pendant Coins**
     Second half of the 18th century
     From Macedonia
     Silver with cast and gilt details, openwork, granulation, enamel, agates, turquoise, corals, glass paste
     Width of braid 3 cm, diameter 11.5 cm
     Gift of Marina Lappa-Diomidous, inv. no. Eα 1744

The choker consists of a silver-wire braid, to which are riveted gilt-silver plaquettes. The lateral plaquettes, with granulated edges, are decorated with cast floral motifs and little snakes on a green enamel ground, mounted agates, and other gems. At the front is a polygonal cast plaquette decorated with pierced work, granulation, mounted agates, and other gems, which serves as a clasp. Suspended from the bottom of the braid are chains bearing granulated openwork rosettes and coins.

The pendant coins—Austrian and Spanish pieces of 1724, 1744, and 1762 and Turkish ones minted in 1732 under Mahmud I (r. 1730–54) and in 1759 under Mustafa III (r. 1757–74)—give the year 1762 as the terminus ad quem for the choker.

This type of choker, of which there are many examples in the Benaki Museum and in other collections in Greece, was an essential accessory of the costumes of Roumlouki, Baltsa, and Drymos, in western Thrace and Macedonia. Such chokers are encountered in neighboring countries, usually in a variation with a cascade of concatenated rosettes.

As is evident from several other examples, the coin was a basic component of neo-Hellenic jewelry. The use of coins in jewelry can be traced back to the Roman period. During the Byzantine age coins were worn as amulets, the most common of which are known to this day as *constantinata* (coins of Constantine). In the years of the Ottoman occupation, the magical and metaphysical aspects of the practice were transformed by practical expediency, since coins were an easy means of saving, protecting, and transporting property in times of compulsory migration due to Turkish persecutions. After the liberation of Greece, the use of coins in jewelry continued, even though they no longer served the same need. They assumed the character of conspicuous display of wealth and economic robustness, to be transformed gradually into simple decorative practice, with the eventual substitution of false coins for real ones.

*Greek Jewellery* 1999, 466–67, no. 164 (A. Delivorrias). For a similar choker in the Benaki Museum, see Delivorrias, Fotopoulos 1997, 480, fig. 847. For comparable examples, see Thessaloniki 1997–98, 267–70, nos. 316–17 (K. Synodinou), no. 318 (Y. Kaplani), no. 319 (N. Saraga).

E.G.

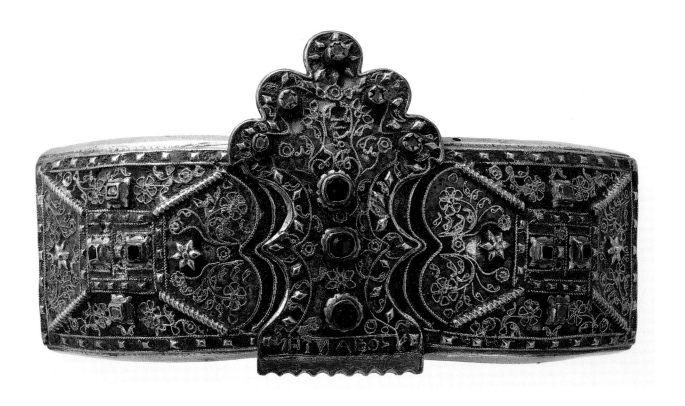

111. **Belt Buckle**

　　1798
　　From Thrace
　　Gilt silver, filigree, enamel, glass paste
　　Max height 10.5 cm, width 19.5 cm
　　Inv. no. Eα 220

The buckle comprises two rectangular sections with a five-lobed device rising above the rim in the middle—hence the name *corona* (crown), after which this type of buckle is known. Characteristic of the decoration are the delicate floral designs in filigree on a vivid green, blue, and black enameled ground. The decoration on the sides is organized around a central rectangle enclosing two large glass-paste gems and surrounded by four radial panels. On the central device, emphasis is placed on the vertical alignment of three gems in deep floral settings, which belie their origin from the more refined mounts of precious stones on Ottoman court objects of the sixteenth and seventeenth centuries. An enameled band with a series of decorative nail heads frames the buckle. The inscription *KOCTANTH* (of Constantis) is written in filigree on the lower edge of the central device, while the date *1798* is inscribed vertically above the gems.

　　The decoration on this belt buckle is closely related to ecclesiastical silverwork, which features the same type of enameled floral filigree and is presumably a product of the same workshops (see cat. no. 32). The technique enjoyed its zenith and widest dissemination in the Balkans during the seventeenth and early eighteenth centuries. By the end of the eighteenth century, the workshops that continued to produce this type, now in an established form, were located in the area of Philippoupolis. Similar buckles, dated to the nineteenth century, present a further stylization of the decoration, documenting its continuous use, which was linked with marriage customs in various regions of Thrace. This item was a gift from the prospective groom to his bride to be, which is why it is inscribed with his name and the date of betrothal.

　　Until the early twentieth century, the buckle was considered an essential accessory of the costumes of Soufli and was equally widespread in the regions of southern Bulgaria and eastern Thrace; it was also found in the earlier costumes of the Chalkidiki Peninsula and the island of Thasos.

Delivorrias, Fotopoulos 1997, 486, fig. 862; *Greek Jewellery* 1999, 468–71, no. 165 (A. Delivorrias). For an example in the Benaki Museum inscribed 1825, see Thessaloniki 1997–98, 316, no. 369 (K. Synodinou). For a nineteenth-century example in the museum of the Rila Monastery in Bulgaria, see Boschkov 1972, 281, no. 136.

<div align="right">A.B.</div>

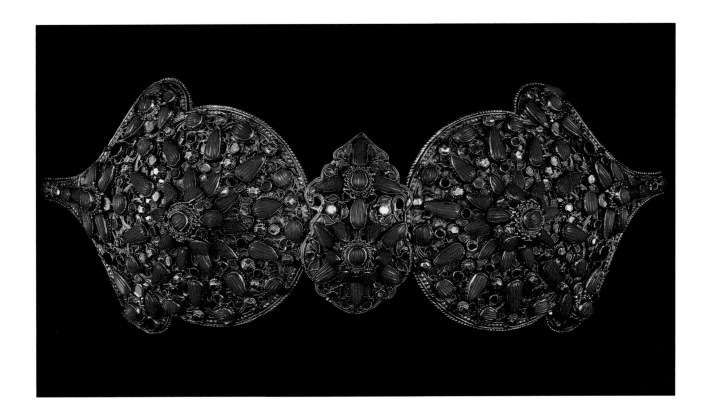

## 112. Belt Buckle

1837
From Kermira (Germir), Caesarea
Gilt silver, filigree, enamel, corals, glass paste
Height 11.5 cm, width 31.5 cm
Inv. no. 33918

This remarkably large buckle is composed of two disks with clasps shaped like ivy leaves and a smaller section resembling a stylized pomegranate that covers the hook-and-eye fastening. The buckle is lavishly decorated with ribbed corals set in deep mounts forming multipetaled rosettes. Small leaves of green filigree enamel, colored glass gems, and prismatic rivet heads complete the decoration. Incised on the back of the buckle is the date *1837*.

The extravagant coral decoration is characteristic of a group of jewelry widely found throughout Asia Minor and the Balkans, which Greek tradition attributes to the town of Saframpolis (Safranbolu) in central Asia Minor, in the area of Kastamoni, named after its main product, saffron. This tradition, which has yet to be confirmed by textual sources, seems to originate with the Greek refugees from Asia Minor, who in 1922 were uprooted from their ancestral hearths during the compulsory exchange of populations between Greece and Turkey under the terms of the Treaty of Lausanne. Many examples of this kind of jewelry came into the possession of the Benaki Museum along with the family jewels of the refugees, although it should be noted that the few extant heirlooms of the Christian community of Safranbolu are devoid of coral decoration. Nevertheless, the theory should not be dismissed before local Ottoman Turkish sources have been investigated.

This buckle is from Kermira, a large village in the province of Caesarea, which had an affluent Christian population involved in trade in leather and textiles. The piece was evidently for ecclesiastical use, because it was brought to Greece along with the sacred treasures of the refugees.

Delivorrias, Fotopoulos 1997, 486–87, fig. 863; *Greek Jewellery* 1999, 472–75, no. 166 (A. Delivorrias).

A.B.

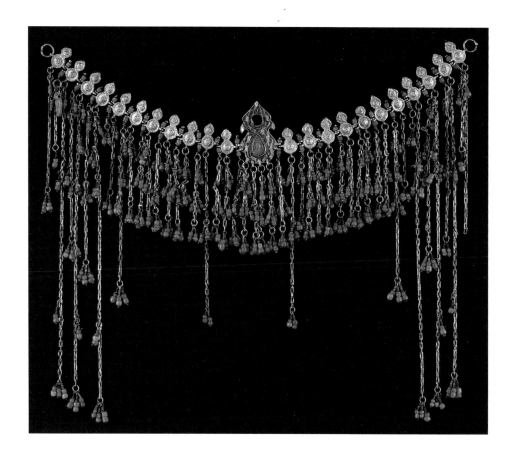

### 113. Frontlet

First half of the 19th century
Attributed to Saframpolis (Safranbolu), Asia Minor
Silver with gilt and cast details, filigree, corals, glass paste
Height 8–22 cm, width 31.5 cm
Inv. no Εα 1399

This impressive frontlet immediately brings to mind the head ornament from Priam's Treasure, worn by Sophia Schliemann. It is composed of a row of interlinked, cast, figure-of-eight segments on either side of a central plaque decorated with filigree, a large drop-shaped ribbed coral, and a red glass gem. Hanging from this are rows of short chains, each with three clusters of coral beads, with longer chains at intervals and even longer ones at the ends. At one edge of the frontlet is a blue glass segment, a charm against the evil eye. The frontlet originally must have been attached to a firm cloth-lined backing. Morphologically, it is associated with analogous frontlets from mainland Greece (see cat. no. 105).

Judging by the range of distribution of this group of jewelry, attributed to Saframpolis, such pieces must have been worn widely in Asia Minor and the Balkans during the eighteenth and nineteenth centuries. Nevertheless, after the mid-nineteenth century they began to be replaced by presumably European creations and by about 1900 had ceased to be worn in urban areas, as is deduced from the absence of such pieces in photographs of that time.

Compared to the other examples of the Saframpolis group (see cat. nos. 112, 114–15), the total absence of enamel in the decoration of the frontlet implies a later date, though not after the mid-nineteenth century, when the gradual decline in this type of jewelry commenced.

Delivorrias, Fotopoulos 1997, 484, fig. 856; *Greek Jewellery* 1999, 476–79, no. 167 (A. Delivorrias). For a comparable example, see Thessaloniki 1997–98, 292, no. 341 (Y. Kaplani).

E.G.

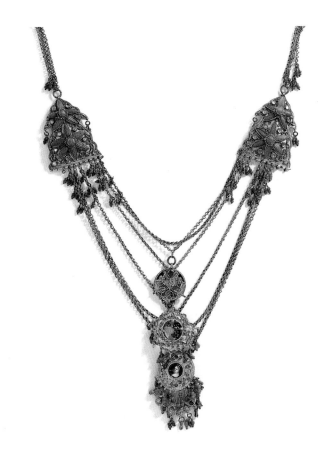

114. **Chain Pectoral Ornament**
     Early 19th century
     Attributed to Saframpolis (Safranbolu), Asia Minor
     Silver with gilt details, filigree, enamel, corals, glass gems
     Length 36 cm
     Inv. no. Eα 952

The ornament comprises six silver chains of differing lengths, held together by two large gilded plaques with appliqué filigree vegetal motifs highlighted with green enamel and attached daisy rosettes of ribbed, almond-shaped corals. In the middle of four chains—excepting the first and the fifth—is a gilt pendant ornamented with appliqué filigree enamel and a few glass gems. A miniature female figure, perhaps a saint, painted in enamel is one of the pendants. Two other pendants would have been embellished with a similar miniature or gemstone, now lost. Coral tassels hang from both the plaques and the pendants. The chain pectoral is associated morphologically with analogous pieces of jewelry from mainland Greece (see pectoral ornament, cat. no. 93).

The spread of incised corals in jewelry making, as a cheap substitute for precious or semiprecious stones, is linked with their extensive use in the decoration of Ottoman firearms and other military accoutrements, such as powder pouches, flasks, and horse trappings, from the eighteenth century onward. Corals, which was obtained through trade between the western and the eastern Mediterranean by the Late Middle Ages, was probably imported to the Ottoman Empire from Algeria. Coral decoration was known in the market of Constantinople as "Algerian work" (*Cezayir işi*). Nevertheless, the Italian influences should not be overlooked, considering that ribbed corals are frequently found in the major silverworking centers of Italy, such as Trapani in Sicily and Naples.

Delivorrias 1980, fig. 87. For Ottoman metalwork with corals, see Bodur 1987, 116, no. A.64, 118, no. A.69. For firearms, see Rogers, Köseoğlu 1987, 28, 40, 46, fig. 33 (left).

E.G.

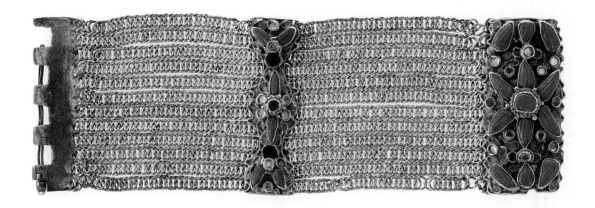

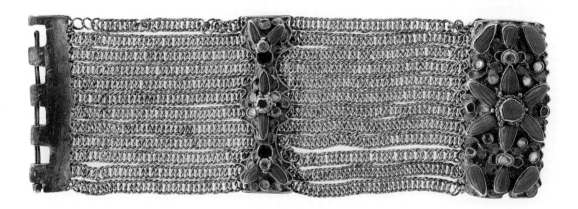

### 115. **Bracelets**

Early 19th century
Attributed to Saframpolis (Safranbolu), Asia Minor
Silver with gilt details, filigree, enamel, corals, glass gems
Length 19 cm, width 9 cm
Inv. no. Eα 946

The bracelets are formed of twelve rows of flattened silver chains and gilded plaques—larger at the clasps and smaller in the middle of the chains—with appliqué filigree vegetal motifs highlighted with green enamel and attached daisy rosettes of ribbed, almond-shaped corals. A pin secured the clasps.

Bracelets of this type, which recall the chain bracelets encountered in mainland Greece, were worn mainly in Attica—whence the type probably originates—as well as in the islands. In general, however, the group of jewelry from Saframpolis, despite its stylistic singularity and distinct aesthetic "personality," comprises a system of adornment common in all "families" of neo-Hellenic jewelry.

Thessaloniki 1997–98, 298–99, no. 347 (K. Synodinou). For jewelry sets from Saframpolis (including cat. nos. 114–15) and Attica, see *Greek Jewellery* 1999, 365, figs. 271–72.

<div align="right">E.G.</div>

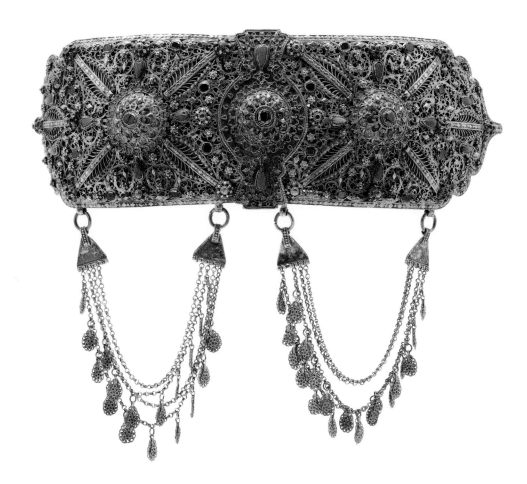

### 116. Belt Buckle

19th century
From Cyprus(?)
Gilt silver, filigree, granulation, enamel, corals, glass paste
Length 31 cm, height 11 cm
Inv. no. Eα 116

The rectangular buckle consists of two plaques with undulating, pointed finials joined by a vertical hinge-pin clasp. The appliqué filigree decoration covers the surface with scrolls and foliate motifs and is embellished with dots of pale green enamel, red glass gems, and almond-shaped ribbed corals. The most impressive elements of the buckle are the three riveted, appliqué, flower-shaped bosses set with a glass gem at the center. Large filigree leaves with added granulated decoration extend diagonally from the outer bosses to the four corners. Similar leaves are repeated at the edges of the narrow sides too. Soldered to the back of the buckle are six vertical strips for attaching the belt. Four chains with foliate pendants hang from the bottom part of each plaque of the buckle.

Buckles of this type are associated with traditional costumes, mainly of urban centers. This example is distinguished by its lavish and diverse decoration. Although Cyprus is cited as its provenance, no parallels exist in the Cypriot corpus of buckles, whereas the large almond-shaped ribbed corals recall to the group of jewelry ascribed to Saframpolis in Asia Minor (see cat. nos. 112–15). Although the buckle's production on Cyprus cannot be ruled out, since the techniques are common on Cypriot jewelry and the corals could have been imported, it probably was made in a workshop in Asia Minor or Constantinople. Judging from the surviving examples, there was nothing unusual about the importation of jewelry.

Delivorrias 1980, fig. 91.

E.R.-E.

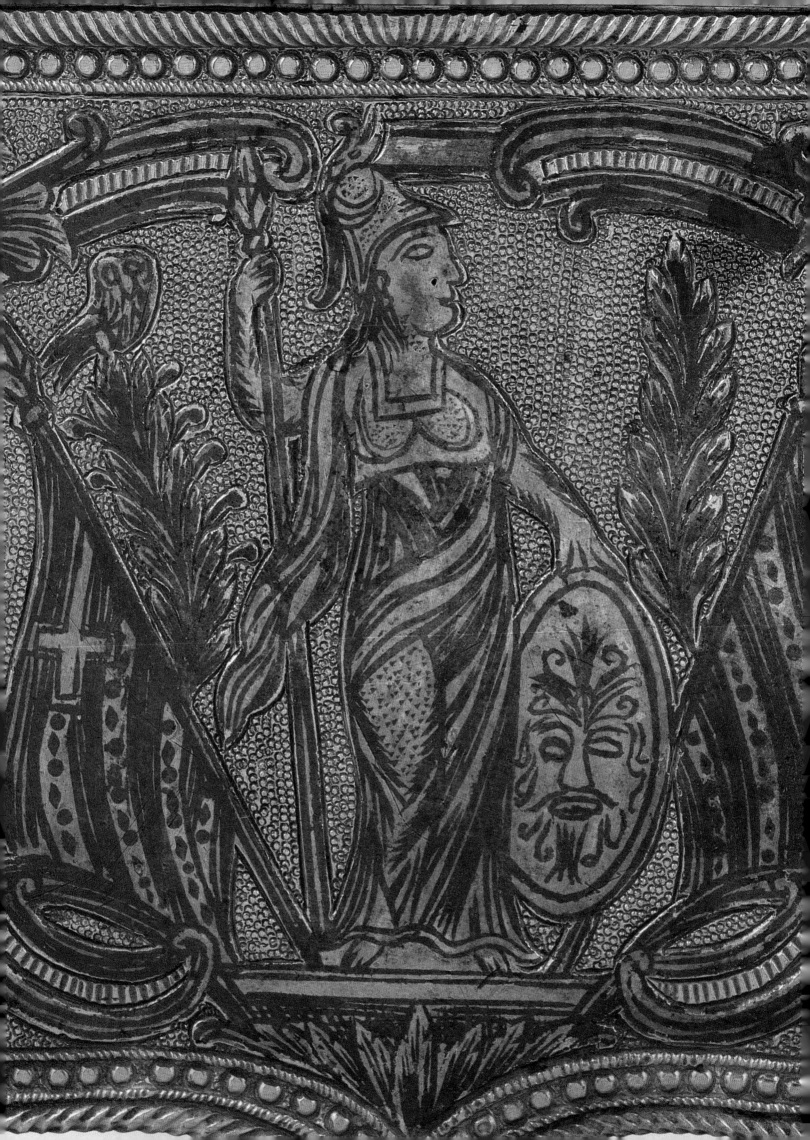

## Paschalis M. Kitromilides

The Enlightenment in Greek culture represented a protracted process of change in intellectual values and practices as well as in the prevailing forms of symbolic communication. Philosophically it presupposed all the intellectual claims and aspirations propelling the movement in the European mainstream. The urge *sapere aude* (dare to know) could be traced in the Balkans as well as elsewhere, deep beneath layers of "otherness," difference, or backwardness (depending on the observer's perspective) that distinguished the region from the more developed areas to the north and west. Because the urge *sapere aude* could be heard in Greek and gradually in other Balkan voices as well, one can speak of an Enlightenment in southeastern Europe. The shifting emphasis of a succession of scholars writing in a variety of forms of Greek in the eighteenth century illustrates the gradual reception and articulation of the claims and aspirations of the Enlightenment. In the 1720s Nicolaos Mavrocordatos discussed the quarrel of Ancients and Moderns and pointed to the superiority of the latter by suggesting that if Aristotle came back to life he would gladly become a disciple of the Moderns because they deciphered the mysteries of nature better than the Ancients. From the 1740s to the 1760s Eugenios Voulgaris launched modern philosophy in schools in the Greek cultural area (Ioannina, Kozani, Mount Athos, Constantinople) by introducing into the curriculum the ideas of Descartes, Leibniz, and Locke along with those of Plato and Aristotle (see cat. no. 117 and fig. 2). In the 1760s and 1770s Nikiphoros Theotokis (1731–1800) introduced Newtonian physics, pointing out that the Aristotelian-Ptolemaic model of the universe could not adequately explain the movements of the bodies in the skies. In the 1770s and 1780s Iosipos Moisiodax (ca. 1730–1800), in quite an uncompromising manner, promoted the philosophy and values of encyclopedism as the blueprint of a new intellectual and ethical attitude that might liberate Greek society, or what he called "Hellas," from prejudice, superstition, irrationality, and intolerable backwardness. In the 1790s, echoing a new revolutionary era in European history, Daniel Philippides (1750–1832) and Grigorios Constantas (1758–1844), authors of a remarkable geographical treatise, *Novel Geography* (1791), aired in its pages sharp social criticism, castigating ecclesiastical corruption, the idleness of monasticism, and popular superstition and appealed for the reform of language, education, and social mores as a way of overcoming backwardness and renewing society. Finally, in 1797, the culmination of the process of intellectual and moral change came about through the revolutionary vision of Rhigas Velestinlis (1757–1798), who projected a Jacobin-inspired "Hellenic Republic," uniting all Balkan ethnic, cultural, and religious communities under the rule of law, thus liberating them from Ottoman despotism (see cat. nos. 119, 122, and fig. 1).

In the context of the broader Balkan region, the Enlightenment appeared in the form of two interrelated intellectual developments. One was the gradual emergence, especially in the second half of the eighteenth century and growing apace in the fifty years between 1770 and 1820, of a greater richness in intellectual life. This was reflected in the multiplication of cultural and educational initiatives evidenced by important quantitative indicators, such as the growing number of books and the explosion in the number of subscribers to them. The other intellectual development suggesting the growth of the Enlightenment specifically in the Greek context was the secularization of knowledge, again as indicated by the number of secular books—publications of

Cat. no. 129. *Cartridge Box* (detail). Gilt, punched, and chased silver, with niello. Inv. no. 6173

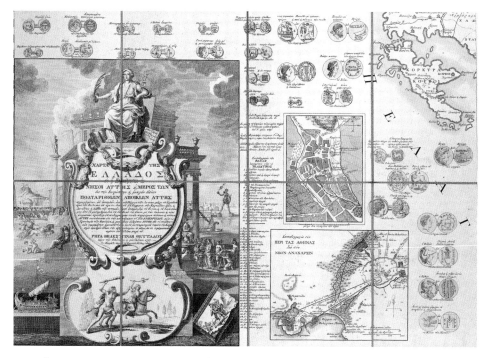

Fig. 1  Rhigas Velestinlis. *Chart of Greece.*
Painted copperplate engraving.
Vienna, 1797. Library, Benaki Museum,
Athens, inv. no. 11628

nonreligious content—appearing in the Greek language during the period in question. If the number of books supplies a concrete quantitative indicator of the flow of intellectual processes, other forms of evidence equally suggest, occasionally in indirect but revealing ways, the growth of secularization: the emergence, for the first time, of lay intellectuals—people involved in education and more broadly in the world of ideas—who were not members of the clergy. This shift was an important feature of generational change in Greek culture. Another suggestive indicator of secularization was the gradual articulation of modern political notions in the discourse of intellectuals, pointing to a transition in models of political legitimacy from the ideal of Christian monarchy to the vision of national sovereignty. Appraised in a long-term historical perspective, these new concerns surfacing in Greek Enlightenment literature initially reflect the process of secularization but also announce the eventual assertion of a modern national identity.

One of the foremost concerns in Greek Enlightenment thought was language reform. Reflection on the significance of language, on its poor state on account of the overall decline of the society of its users, and on the appropriate means for rehabilitating it to its proper form so it could authentically express the spirit of the cultural community of its speakers appears as a constant theme in the Greek Enlightenment tradition. Part of the motivation for this reflection stemmed from the aspiration to emancipate education from the weight of archaism—teaching in ancient Greek—which was seen by many as stifling the vital energies of youth and therefore acting as a stumbling block to learning. Those who argued for this change, however, knew very well that the vernacular, with its infinite local dialectical variations, was the medium of expression primarily of illiterate peasant masses. Peasant language had transmitted the core of the linguistic heritage of particular population groups, and often their diction and idioms could be shown to be of great antiquity and therefore to reflect a distinguished cultural pedigree of the populations that spoke them. But after centuries of foreign rule and cultural decline, Balkan vernaculars in their modern spoken forms hardly appeared appropriate for sophisticated intellectual and scientific discourse. Hence the focus on the reform of language that dominates the Greek Enlightenment. The language question was a central issue in Greek Enlightenment literature and remained a cultural problem of great political import in the independent Greek state throughout the nineteenth century and even in the

Fig. 2  Portrait of Eugenios
Voulgaris. Engraving.
From Eugenios
Voulgaris, *Logic*
(Leipzig, 1766)

twentieth. Language reform dominates the cultural reflections of Dimitrios Katartzis (1730–1807), who argued that the spoken Greek vernacular of his time was a perfectly appropriate medium for sophisticated cultural expression. In this he was joined by Iosipos Moisiodax, who devoted to the language question the prolegomena of his *Theory of Geography* of 1781 (see cat. no. 118). Katartzis' views were shared and put into practice by Daniel Philippides and Grigorios Constantas, the authors of *Novel Geography* (1791). But it was the Greek classical scholar Adamantios Korais (1748–1833), who, from his seclusion in Paris, argued in the prolegomena he included in volume after volume of his editions of classical Greek texts for the need to reform and purify modern Greek in order to make it an appropriate medium for the reeducation of his compatriots.

A parallel process transformed Greek society's understanding of its past. In this domain the secularization of social thought took the form of a transition from a sense of a common Christian history of the people of the Balkans to the discovery of distinct ethnic pasts by particular linguistic communities within the broader world of Balkan Orthodoxy. This realization was perhaps the most consequential of all the intellectual changes brought about by the Enlightenment. In the case of the Greeks, it led to the discovery of their ancient Hellenic origins. Enlightenment historiography in Greek from 1750 onward increasingly reflects this transition. The feelings connected with the new historiography, which was based on an agenda of secular values and aspirations, contributed to the cultivation of a new collective identity that eventually could feel vindicated only through national assertion.

No one expressed these feelings and aspirations on behalf of the Greeks better than Adamantios Korais in his famous *Memoir on the Contemporary State of Civilisation in Greece* of 1803 (see cat. no. 120). Although it was not a political manifesto but an extensive sociological essay, it was nothing less than an announcement of a revolution in the making. Indeed, Korais spoke of a "moral revolution" transforming Greek society. In so doing, Korais aired in international intellectual circles his vision of the liberation of Greece from Ottoman despotism. Another Greek patriot, Rhigas Velestinlis, had attempted in 1797 to set the revolution in motion through a revolutionary proclamation and conspiratorial activity. However, his vision of a "multicultural" Jacobin republic in southeast Europe was preempted by his execution in June 1798 by the Ottoman authorities in Belgrade, to whom he and his companions were extradited by the Austrians after their arrest in Trieste and interrogation in Vienna. This tragedy strengthened the determination of patriots to strive for the social and political liberation of Greece. These motivations inspire the fiery rhetoric of the anonymous patriot who published the republican treatise *Hellenic Nomarchy* in 1806. In the climate of Restoration Europe, Greek republican radicalism was toned down and its exponents sought to cover their sharp social criticism in anonymity. When the Greek revolution came in 1821, it was inspired by the liberal principles enunciated by Korais in the mature phase of his political thought rather than by Rhigas Velestinlis' radicalism. The vision of freedom was the Enlightenment's noblest legacy to the modern nation-state that emerged from the heroic and often tragic struggles of the 1820s.

**Selected Bibliography**

Argyropoulou 2003; Camariano-Cioran 1974; Clogg 1976; Demos 1958; Dimaras 1969; Gedeon 1976; Henderson 1970; Kitromilides 1992; Kitromilides 1994; Kitromilides 2000; Kitromilides 2003; Stavrianos 1957.

117. Eugenios Voulgaris, *Η Λογική εκ παλαιών και νεωτέρων συνερανισθείσα*
(Logic Gleaned from Ancients and Moderns)
Leipzig, 1766
Hand-bound in paper, leather spine tooled in gold
Octavo (21 x 14 cm)
Library 10424

A chartered text of the neo-Hellenic Enlightenment, *Logic* by Eugenios Voulgaris (1716–1806) circulated in manuscripts transcribing his lectures on philosophy in schools in Ioannina, Kozani, and the Athonite academy long before it was printed in Leipzig in 1766. The printed version is a vastly expanded and carefully documented text that opens with an extensive "preliminary discourse" surveying the history of the subject from remotest antiquity until the emergence of modern philosophy. Without disputing the authority of the ancients, Voulgaris shows great respect for the emblematic figures of modern philosophy and refers extensively to Descartes, Leibniz, Wolff, and Locke. The body of the book is made up of four introductory dissertations that essentially amount to a general introduction to the field. There follows a systematic exposition of the subject matter of logic and epistemology in five parts (1. Of ideas; 2. On thinking; 3. On judgment; 4. On reasoning; 5. On method).

Voulgaris' *Logic* is a richer and more comprehensive work than the *Port Royal Logic* that served as one of its models. It is a work rich in detail, minutely annotated, and intellectually ambitious, while faithfully observing the outer limits of philosophical speculation set by Christian doctrine. It has been rightly characterized a veritable *speculum mentis*.

Voulgaris wrote his text in ancient Greek, as he considered the Attic form of the language as the only appropriate medium for philosophical expression. Its linguistic form makes the work extremely difficult to read but did not prevent it from being used as the main textbook for teaching philosophy in Greek higher schools in the age of Enlightenment for more than fifty years and its extensive circulation in manuscript copies of the printed version.

The 1766 Leipzig edition contained Voulgaris' engraved portrait as a frontispiece but it is missing in most surviving copies (see fig. 2, page 207).

Henderson 1970, 41–63; Batalden 1982; Kitromilides 2000, 53–65, 169–97.

P.M.K.

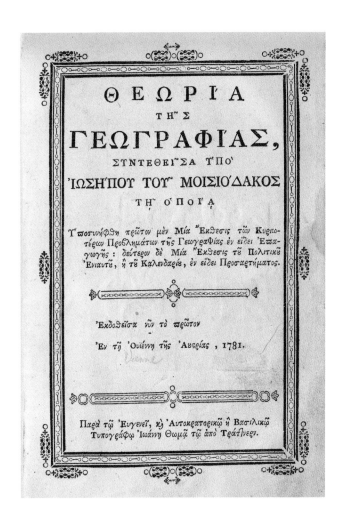

118. **Iosipos Moisiodax,** *Θεωρία της Γεωγραφίας* (**Theory of Geography**)

Vienna, 1781

Hand-bound in paper

Octavo (20.5 x 14 cm)

Gift of Maria Spentsa, Library 29185

Iosipos Moisiodax (ca. 1730–1800) was an embattled figure, a militant and uncompromising exponent of Enlightenment encyclopedism and a vociferous social critic who flirted with republican ideas. His two most important works are the *Apology* (Vienna, 1780), directed at his conservative critics, and the *Theory of Geography* (Vienna, 1781). The latter is an extensively researched treatise on mathematical geography that reflects Moisiodax's unconditional espousal of the principles of Newtonian natural philosophy and the Enlightenment's sequel to it. Moisiodax's project is uniquely interesting, as the original manuscript, which was completed in Bucharest in 1767 and served as the basis of his lectures at the academy of Jassy, survives. Comparison of the two versions shows the author's lively interest in the expansion of natural science and his vastly greater knowledge of the subject after his extensive research in Vienna. The 1781 volume is a state-of-the-art record of the subject and contains the first reference in Greek literature to Captain Cook's voyages in the South Seas.

Of special importance are Moisiodax's extensive prolegomena to the work, in which he expounds his position on the language question. He comes out categorically in favor of the vernacular as the language of Greek education and culture, supporting his position on utilitarian grounds, and openly dissents from the aristocratic linguistic viewpoint of his teacher, Eugenios Voulgaris.

Kitromilides 1992.

P.M.K.

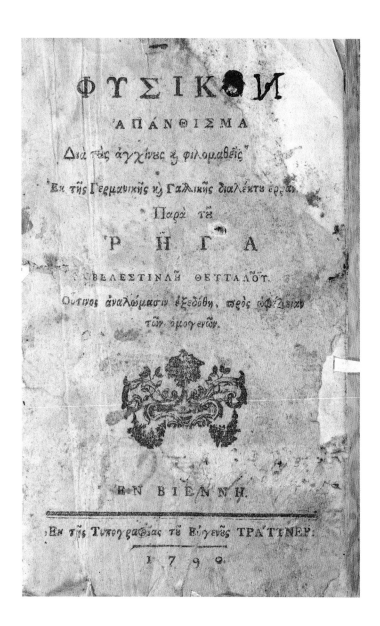

119. **Rhigas Velestinlis,** *Φυσικής απάνθισμα* (A Florilegy of Physics)
Vienna, 1790
Leather binding, blind tooled
Octavo (17 x 11 cm)
Library 1113

Rhigas Velestinlis (1757–1798) was the prophet of political and social liberation not only of the Greeks but of all Balkan peoples. Before turning to conspiratorial and revolutionary action in the late 1790s, he initiated in Vienna a publishing project designed to promote the inculcation of Enlightenment culture in the minds of his compatriots. *A Florilegy of Physics* is the most representative product of this project. The author states its patriotic and enlightening purposes in the preface, which laments the corruption and obscurantism that despotism had brought upon Greece. The main text is a popularization of the principles of Enlightenment physics in the form of a dialogue between a teacher and a pupil. The text's spirit and purpose are captured in the section that attempts to dispel popular superstitions about vampires and in the quotation from Albrech von Haller, "He who thinks freely, thinks well" (p. 24).

Woodhouse 1995; Kitromilides 1998; Rhigas 2000–2002.

P.M.K.

# MÉMOIRE

SUR L'ÉTAT ACTUEL

## DE LA CIVILISATION·

### DANS LA GRÈCE,

Lu à la Société des Observateurs de l'homme,
le 16 Nivôse, an XI (6 Janvier 1803).

PÁR CORAY,

DOCTEUR EN MÉDECINE, ET MEMBRE DE
LADITE SOCIÉTÉ.

120. **Adamantios Korais (Coray)**, *Mémoire sur l'état actuel de la civilisation dans la Grèce*
Paris, 1803
Hand-bound in paper
Octavo (20 x 12.5 cm)
Library 5900

This historical and sociological essay was originally read by Adamantios Korais (1748–1833) at a meeting of the Société des Observateurs de l'Homme in Paris on January 6, 1803. Korais, a member of the society and already a respected classical scholar on account of his editions of Hippocrates and Theophrastus, attempts to sketch the multiple forms of progress (economic, educational, cultural) underway in Greek society as so many signs of a "moral revolution" announcing the liberation of Greece. His arguments are passionate but convincing because he uses the terminology of the Idéologues, a group of liberal thinkers who were dominating philosophical discussion in France at the time. Korais draws up a genealogy of the Greek intellectual revival, paying appropriate tribute to Eugenios Voulgaris, whom he calls the "dean of Greek culture," but he also makes sure to refer to the Greeks' active resistance to Ottoman rule and to military initiatives that he sees as harbingers of the struggle for freedom. According to Korais, however, liberation could not be seriously contemplated, as long as social, economic, and cultural preconditions had not reached a stage of maturity that would prepare Greek society to make the transition from despotism to liberty. As such, Korais' *Mémoire* may be considered the founding text of Greek liberalism.

Therianos 1889, vol. 1, 340–58; Dimaras 1996; Kitromilides 2000, 387–402.

P.M.K.

121. **Constantinos Koumas**, *Ιστορίαι των ανθρωπίνων πράξεων*
(Histories of Human Actions), vol. 12
Vienna, 1830–32, 12 vols.
Hand-bound in paper, leather spine tooled in gold
Octavo (20 x 12 cm)
Gift of Maria Spentsa, Library 30457

Constantinos Koumas (1777–1836) represents the last generation of Greek Enlightenment scholars, the generation that matured under the intellectual impact at Korais' ideas and whose lives spanned the liberation of Greece. Koumas was the first systematic exponent of Immanuel Kant's philosophy in Greek. His most important work—which is, indeed, "majestic" in scope—is the *Histories of Human Actions*, which draws primarily on Karl Friedrich Becker's *Weltgeschichte* (Berlin 1824–27, 12 vols.). It surveys world history from antiquity until the dawn of the nineteenth century. In the eleventh volume Koumas provides a critical account of the French Revolution, reflecting to a large degree the hostility of Restoration Europe toward the Jacobins. In this, he follows Korais' critical attitude, but Koumas' position on revolutionary radicalism is more hostile. The most important and original part of the work is volume 12, in which Koumas provides a detailed account of contemporary Greek history, focusing on the growth of the Enlightenment in Greek culture and on the history of the Greek revolution. His account of the Enlightenment is a valuable source of details on personalities, schools, cultural initiatives, and philosophical positions that makes up a veritable gallery of the Greek cultural revival. In a way it supplies the historical documentation for Korais' conception of the "moral revolution" reviving Greek culture presented in his *Memoir on the Present State of Civilization in Greece*. In this sense Koumas' world *Histories* represents a fitting epilogue to the Greek Enlightenment.

Stasinopoulou 1992.

P.M.K.

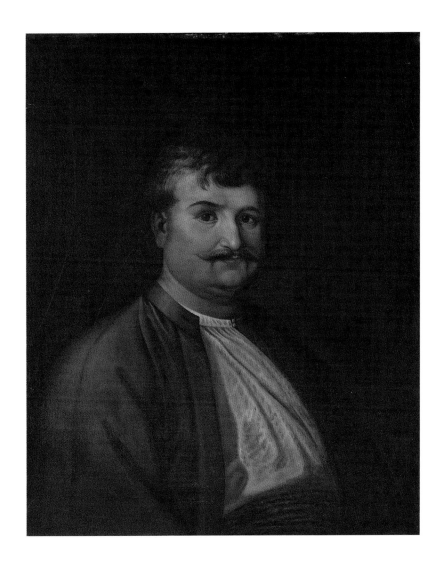

122. **Portrait of Rhigas Velestinlis**
Mid-19th century
Andreas Kriezis (1813–1880)
Oil on wood
61 x 50.5 cm
Signed (bottom right)
Gift of Damianos Kyriazis, inv. no. 11176

Rhigas Velestinlis (1757–1798) was one of the best-known precursors of the Greek liberation movement and a paramount figure of the Greek Enlightenment (see cat. no. 119). His arrest by Austrian authorities who handed him over to the Turks and his martyr's death put an end to his inspired activities.

The Greek painter Andreas Kriezis, who had studied in Paris, concentrated mainly on portraiture. This portrait of Rhigas faithfully renders the hero's features. The plasticity and the careful execution of details reveal Kriezis' knowledge of the canons of academic art, combined with vernacular traits—a typology distinctive of the artist's style.

Delivorrias, Fotopoulos 1997, 504, fig. 892.

F.-M.T.

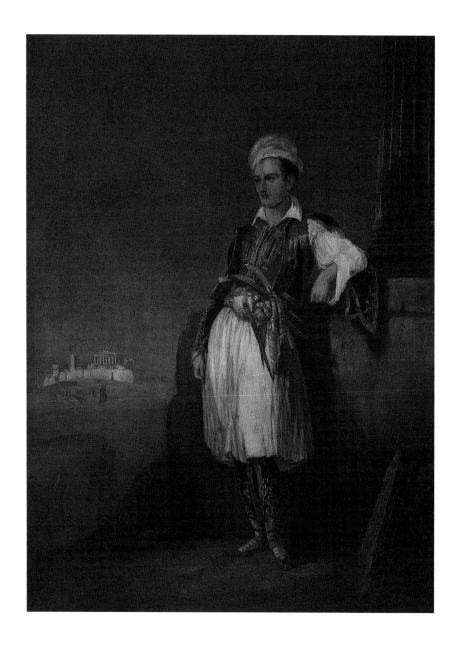

123. **Lord Byron in Greek Dress**
Ca. 1830
Unknown artist
Oil on canvas
97 x 74 cm
Inv. no. 11100

George Gordon, sixth Lord Byron (1788–1824), toured Greece from 1809 to 1811 and upon his return to Britain published the poem *Childe Harold's Pilgrimage* (London, 1812). A liberal in spirit and a satirist of his society, Byron first visited Greece as a romantic young wanderer in the ancient land of myth and legend. Unlike most of his contemporaries, however, the poet did not perceive the country as merely the timeless setting of a past heroic world. In his stanzas, Greece is revealed as a passionate, colorful land, filled with living people who deserved a better fate. In 1823 Byron was sent to Missolonghi as a member of the Philhellenic London Committee to offer his services to the Greek cause. His death there on April 18, 1824, fired the philhellenic movement in Europe, inspired artists, and forced the conditions in contemporary Greece upon the European imagination and conscience.

The representation of Byron in Greek costume is modeled on the famous portrait painted from life by the English artist Thomas Phillips (1770–1845), now in the National Portrait Gallery in London. Byron is known to have been proud of the Greek costume that he purchased during his travels. He is shown wearing it in this canvas by an anonymous artist who portrayed him in reverie against the backdrop of the Acropolis. Byron stayed in Athens for several months in 1809, exploring the city and admiring the antiquities. When he returned home, he openly condemned the despoliation of the Parthenon by Lord Elgin in letters as well as in his poem *The Curse of Minerva* (1811).

Athens 1988, 74, no. 82 (F.-M. Tsigakou); Delivorrias, Fotopoulos 1997, 538, fig. 945. For Byron's poem *Childe Harold's Pilgrimage*, see Athens 1995, 85.

F.-M.T.

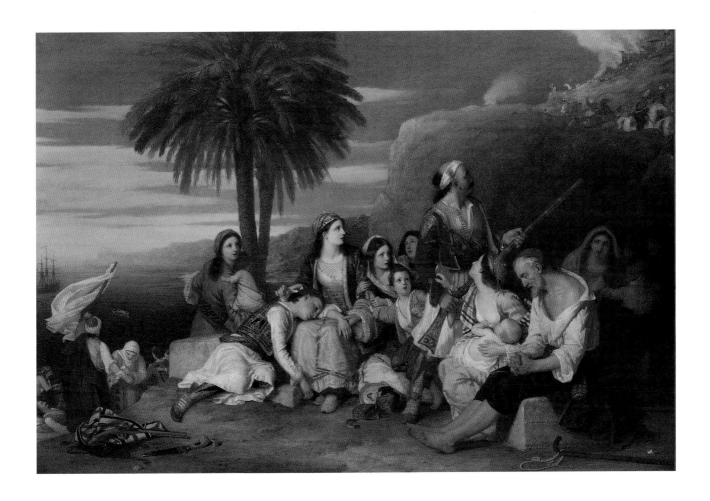

## 124. Greek Fugitives

1833
Sir Charles Lock Eastlake (1793–1865)
Oil on canvas
95 x 134 cm
Signed (lower right): *C. L. Eastlake*
Inv. no. 8996

The London philhellenic Greek committee was founded in 1822. Even though England played a major role in the philhellenic movement and in Greek affairs throughout the War of Independence, few British artists alluded to it. Eastlake, a history painter, president of the Royal Academy, and an influential artistic personality of Victorian England, visited Greece in 1819 and produced ten oil paintings of Greek subjects.

This canvas shows a group of Greeks fleeing from their town, seen in flames on the top of the hill at the right, while the enemy approaches. At the left, a wounded man waves a white flag at a ship on the horizon. In terms of subject matter, the scene may have been inspired by tragic events on the island of Chios, since it was shown at the London International Exhibition of 1862 with the title *Refugees from Chios*. In April 1822 Turkish troops raided the island, slaughtered most of its inhabitants, and dragged off women and children to the slave markets of Asia Minor. Eastlake, however, completed this painting in 1833, the year of the proclamation of the new Greek kingdom, and it was exhibited at the Royal Academy with the title *Greek Fugitives: An English Ship Sending Its Boats to Rescue Them*. We may, therefore, assume that, rather than illustrating the horrors of Chios, the artist perhaps intended to praise the British role in Greek affairs. Indeed, the ship seen on the horizon flies the British flag. According to a contemporary description, "The picture represents an episode of that devastating war in which . . . the unfortunate Greeks sometimes found safety on board the British ships stationed on the coast and which were on the watch to succor them."

Tsigakou 1981, 198, ill. p. 67; Washington, D.C., 1991, 158–59, no. 67; Athens 1995, 148–49, no. 23; Delivorrias, Fotopoulos 1997, 527, fig. 934. For the painter, see Robertson 1978, passim; Tsigakou 1981, 137, pl. XIX, 194, pl. IV.

F.-M.T.

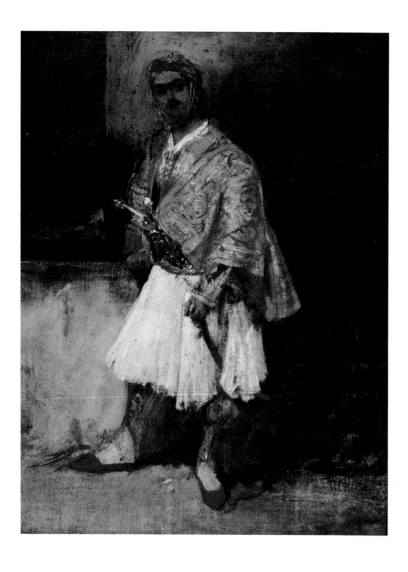

125. **Portrait of a Greek Warrior**
Ca. 1825–26
Richard Parkes Bonington (1802–1828)
Oil on canvas
35.5 x 24.5 cm
Gift of Damianos Kyriazis, inv. no. 11197

This portrait is of the Corfiot count Demetrius de Palatiano (1794–1849), who in 1825–26 resided in Paris, where he often posed for Eugène Delacroix (1798–1863) and his friends, dressed in the Greek costumes that the French painter had in his atelier. It was while Bonington was sharing Delacroix's studio in 1826 that he painted the count. The oil canvas in the Benaki Museum was once attributed to Delacroix, given that the great painter, who had created a large series of studies in oil with Greek figures in 1824–26, had exhibited a painting entitled *Portrait of Conte Palatiano* (whereabouts unknown) in the 1827 Salon.

Richard Parkes Bonington (1802–1828), who, in his brief life and career, was the idol of his Romantic colleagues, both British and French, discovered Oriental subjects through Delacroix. In fact, he took part in the exhibition "in support of the Greeks" organized by the Paris philhellenic committee at the Galerie Lebrun in 1826. He drew a series of studies for the oil painting as well as a lithograph that was published by J. D. Harding in 1830 entitled *An Albanian (Portrait Sketch of Count Demetrius de Palatiano)*. This oil, which attests to the painter's accomplished draftsmanship and skillful handling of color as well as to the refinement of his art, is the sole work by this superb Romantic painter in a Greek museum.

New Haven–Paris 1991–92, 168–69, fig. 64; Athens 1995, 144–45, no. 21; Delivorrias, Fotopoulos 1997, 543, fig. 955.

F.-M.T.

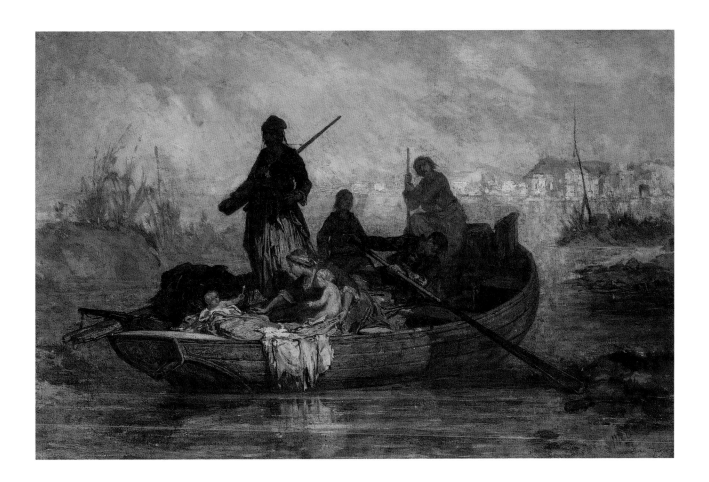

126. **Missolonghi Fugitives**
　　Ca. 1830
　　Jean Michel Mercier (1788–1874)
　　Oil on canvas
　　37.5 x 58.5 cm
　　Signed (lower right): *Mercier*
　　Inv. no. 12944

Situated on the edge of a wide stagnant lagoon near the Gulf of Patras, Missolonghi became known as the "bastion of Greek freedom." It was first besieged by the Turks in 1822 and its inhabitants forced the enemy troops to retreat. During the second siege (April 1825–April 1826), the beleaguered population, reduced by half through disease and starvation, attempted a desperate escape. Only one-third of the soldiers and a few women and children succeeded. Those too old, wounded, or weak from hunger to take part in the exodus sought refuge in the gunpowder magazines, which they set alight when the enemy approached. World opinion was deeply shaken. The epic of Missolonghi became widely known through accounts in the press, narratives in contemporary publications, and numerous poems and paintings.

　　Visual imagery related to Missolonghi generally centers around the defenders' last communion before their flight, the firing of the powder magazines, the savage slaughter of the remaining inhabitants, and the plea for assistance directed to the mighty of the world, as in Eugène Delacroix's *Greece in the Ruins of Missolonghi*. The French Romantic artist Jean Michel Mercier (1788–1874) chose to depict a family of survivors onboard a fishing boat, fleeing their city, seen at the right in flames. A man holding a musket stands in the front of the boat; two younger men row. Prominently portrayed in front of the standing man is a woman holding a child on her lap while she watches the baby lying beside her. Such representations of the victims of war, of induced homelessness, and of innocent humanity being persecuted by evil forces generated a strong emotional response among nineteenth-century viewers.

Washington, D.C., 1991, 140–41, no. 58; Delivorrias, Fotopoulos 1997, 545, fig. 957. For the theme of Missolonghi, see Athanassoglou-Kallmyer 1989, 67–91.

<div align="right">F.-M.T.</div>

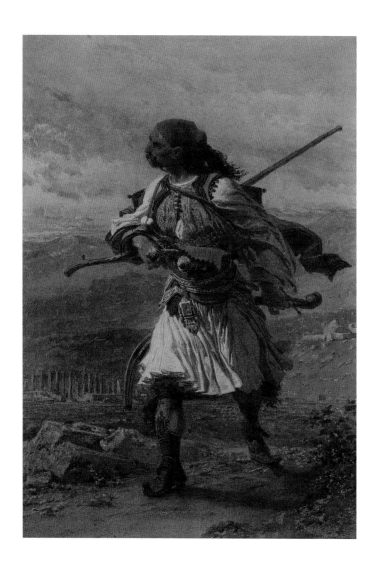

### 127. A Greek Mountaineer

1861
Carl Haag (1820–1915)
Gouache on paper
35 x 25 cm
Signed and dated (lower right): *Carl Haag 1861*
Inv. no. 23983

During the Ottoman occupation, Greek peasants who were dispossessed of their property often retreated to impregnable mountain regions, where they engaged in resistance against the Turks. These mountaineers, who both fascinated and frightened European travelers, were romanticized by artists and poets such as Lord Byron.

The man depicted here clearly represents the type of mountaineer described by Byron. To emphasize his costume and his swift movement, he appears in full gear, the sleeves of his jacket falling freely to the back as if to underscore his impulsive gesture. Pistols and knives are tucked in his belt. His right hand rests on his musket; his left hand proudly touches the tip of his sword. Haag chose to place the figure in a grand mountainous landscape, complete with a ruined temple. This sacred monument may be identified as the temple of Apollo Epicurius in Arcadia in the central Peloponnese, which was celebrated both for its architectural proportions and for its spectacular location. Haag's choice was not accidental. The specific site and the temple were used allegorically to enhance the dignity of the figure, whose nobility and heroism are worthy of the principles of his legendary ancestors. Typical of the artist's work are the rich textures achieved by the warm tones of body color. The pendant to this picture, a gouache at the Benaki Museum (inv. no. 23982), represents a Greek woman.

The German landscape painter Carl Haag (1820–1915) was established for a long period in England, where he became a member of the Society of Painters in Watercolours. After his travels to North Africa and Greece (1858–61) he specialized in Eastern subjects.

Washington, D.C., 1991, 80–81, no. 28; Delivorrias, Fotopoulos 1997, 514, fig. 910. For the painter, see Tsigakou 1981, 127, 201, ill. p. 34; Thornton 1983, 138–40.

F.-M.T.

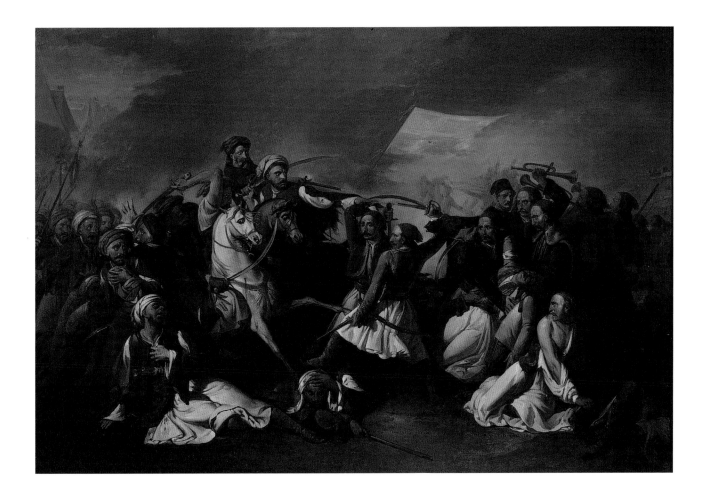

128. **The Death of Marcos Botsaris**

1836–39
Filippo Marsigli (1790–1863)
Oil on canvas
58.5 x 72.5 cm
Inv. no. 8969

The Souliot leader Marcos Botsaris (1790–1823) exhibited extraordinary bravery and military skills during the Souliots' struggle against Ali Pasha, the ruthless Albanian ruler of Epirus. Following the devastation of his native Souli in 1803, Botsaris fled to the French-held Ionian Islands, where he served in the French army. In 1821 he joined the revolution on the Greek mainland as commander of the troops in Missolonghi. The operation was successful, but Botsaris was mortally wounded in the battle at nearby Karpenisi. He was carried back to headquarters by his devoted soldiers and died that night. In European philhellenic minds, his heroic death in action conjured up a parallel with an illustrious ancestor—Leonidas of Sparta, who died with his three hundred soldiers in their effort to stall the invading Persian army at Thermopylae in 480 B.C.—while his wounding in the heat of battle fired the imagination of artists.

The subject inspired Italian artists in particular, at a time when their own homeland was experiencing the *risorgimento* (uprising) against Austrian absolutism. The history painter Filippo Marsigli (1790–1863) executed another painting of the subject (now lost) in 1836. The attribution of the present canvas to Marsigli has been recently disputed by Caterina Spetsieri-Beschi. There is no doubt that the artist's concern in this work was to capture the highly dramatic moment of the struggle over the dying warrior's body, and he succeeded in creating a powerful and romantic scene in which personal sentiment is intertwined with patriotism and heroism.

Rome 1986b, 319–20, no. C53 (C. Spetsieri-Beschi); Washington, D.C., 1991, 136–37, no. 56; Delivorrias, Fotopoulos 1997, 532, fig. 938. For an attribution of the painting by Caterina Spetsieri-Beschi, see Spetsieri-Beschi 2002, 199–214.

F.-M.T.

129. **Cartridge Box**
   Belonged to General Alexakis Vlachopoulos
   Gilt, punched, and chased silver, niello
   Height 12.5 cm, width 10.5 cm
   Inv. no. 6173

This type of box, known in Greek as a *palaska*, was used for storing ammunition for firearms. It is fashioned from gilded silver and decorated in niello technique. On the front is a heraldic composition with the figure of Athena in antique garb, holding a spear in her right hand and supporting herself with her left upon a shield decorated with the head of Medusa (*gorgoneion*). The goddess is flanked by flags—the one on the left Greek—while interposed between them are laudatory laurel branches. Visible atop the left branch is an owl, attribute of Athena. A curvaceous vegetal frame surrounds the representation. The lid of the box is decorated with a triangular pierced-work finial.

   The image, a combination of Neoclassical subject and allegory, represents the Renaissance of Greece, personified by the goddess Athena. As both decorative subject and national symbol, the armed female figure with an archaizing appearance had been established in Europe since the eighteenth century. The Greeks adopted arms-bearing Athena as national symbol during the War of Independence, and she soon became among the most popular decorative subjects, appearing on cartridge boxes and weaponry.

   This cartridge box belonged to Alexakis Vlachopoulos (1780/87–1865) who began his martial activity as an armed irregular (*armatolos*)—following the family tradition—before enrolling in the volunteer corps of the British Army, to capture French-held Lefkada (1810), during the Napoleonic Wars. A protagonist of the revolution in western Central Greece, where hostilities broke out in the last ten days of May 1821, he took part in many local battles as captain of troops in Aitoloakarnania. He served as a government minister under Governor Capodistria (1827–31) and King Othon (r. 1833–62), and in 1864 was appointed aide-de-camp to King George I (r. 1863–1913).

Delivorrias, Fotopoulos 1997, 520, 522, fig. 919. For the representation of the goddess Athena on cartridge boxes and weaponry, see Korre 1984, 197–254; Vassilatos 1989, 114–16.

<div align="right">N.V.</div>

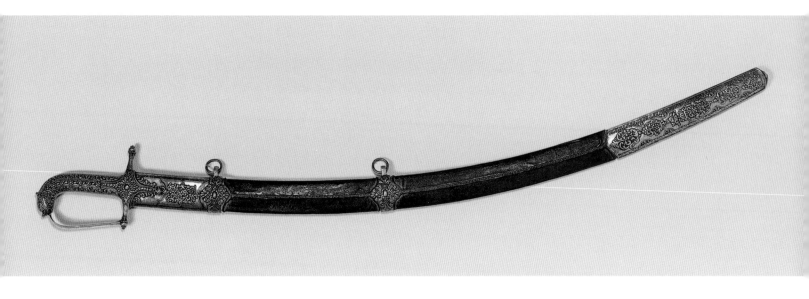

130. **Saber with Scabbard**
Belonged to Odysseas Androutsos
Steel, wood, leather, engraved silver with repoussé, and niello
Length 100 cm, width 11.5 cm, thickness 2.5 cm
Inv. no. 5691

The scabbard of the sword is made of wood, sheathed with black leather and silver, with particularly elegant repoussé decoration. The silver hilt is ornamented in repoussé and niello and topped by a zoomorphic pommel. The steel blade of the weapon was forged by Central European armorers, while the decorative style of the silver surfaces is typical of silversmiths in the region of Epirus.

The sword belonged to Odysseas Androutsos or to his father, Androutsos Verousis. It was common practice for freedom fighters in the Greek War of Independence to give their weapons names, and this sword was known by the female name "Asimo," on account of its silver embellishments.

Odysseas Androutsos (1788/89–1825) is best known for leading the strategically important Greek victory at the Hani (hostelry) of Gravia, Central Greece (May 1821), which decisively delayed the advance of the Turkish army into the insurgent Peloponnese. He took command of operations in eastern Central Greece in 1822, influencing the fortunes of the struggle in the region during the first critical years. Opponent of politicians, Androutsos was accused of making deals with the Turks and was imprisoned in the medieval tower on the Athenian Acropolis. His assassination in June 1825, staged as a fatal attempted escape, prematurely deprived the Greek revolution of one of its worthiest freedom fighters.

Vassilatos 1989, 136, fig. 11; Delivorrias, Fotopoulos 1997, 518, fig. 915.

N.V.

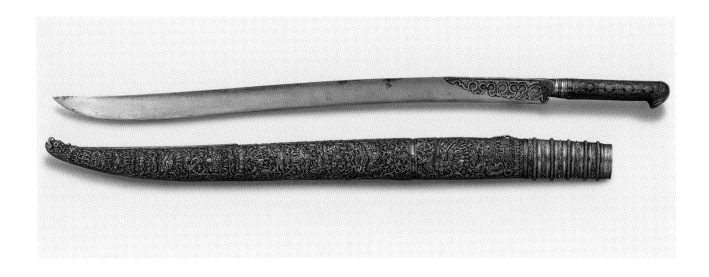

131. **Yatagan with Scabbard**
Belonged to Petrobey Mavromichalis
Steel, wood, silver with gilding, repoussé, and niello
Length 78 cm, width 5 cm, thickness 6 cm
Gift of Petros Mavromichalis, inv. no. 5741

The scabbard of the yatagan is of wood revetted with two silver sheets, the greater part of which is covered with lavish repoussé ornaments—vegetal patterns, trophies, buildings, men, and animals—worked with exceptional plasticity. Particularly striking is the decoration on the outer side of the scabbard, at the topmost point of which is a maritime tower besieged by two twin-mast sailing ships, while the corresponding inner side features a city beleaguered by a winged dragon fired upon by the guns on the fortification walls. Close to the mouth of the scabbard is a zone of five rings of intertwined silver wire. The craftsmanship and the decoration of the scabbard are reminiscent of the products of Cretan silversmiths' workshops. The hilt of the yatagan is also of silver, partially gilded and intricately embellished with details in niello.

The yatagan, or scimitar, a typical long knife of Oriental provenance, appeared in the seventeenth century and spread throughout the Balkans, Turkey, the Middle East and North Africa. It was widely used during the Greek War of Independence, being an essential item in the weaponry of Greeks and Ottomans alike.

The weapon belonged to Petros Mavromichalis (1765–1848), who assumed the office of *bey* of his ancestral land, the Mani, in 1815 and was henceforth its military and civilian governor. Endowed with leadership qualities, influential among both Greeks and Turks, and having an armed fighting force under his command, Petrobey contributed decisively to the outbreak of the revolution (liberation of Kalamata, March 23, 1821). In the course of the struggle, he coupled significant military action in the Peloponnese and Missolonghi with a leading role in the revolutionary governments, in which he repeatedly held high offices. In the years after the War of Independence, the Mavromichalis family, representing the old noble houses, linked its name with the assassination of Governor Capodistria (September 27, 1831) by the son and the brother of Petrobey, on the pretext of the latter's imprisonment. After the arrival of King Othon (r. 1833–62), Petrobey, now in old age, returned to the Greek political scene.

Delivorrias, Fotopoulos 1997, 566, 568, fig. 994.

N.V.

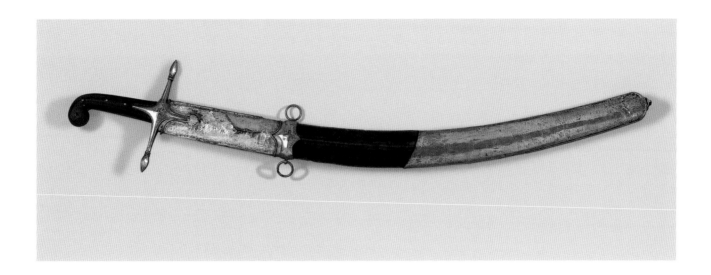

## 132. Saber with Scabbard

Belonged to Admiral Constantinos Kanaris
Steel, wood, velvet, horn, incised silver
Length 88 cm, width 17.5 cm, thickness 4 cm
Gift of Ioannis Serpieris, inv. no. 5761

The sword is of the *kiliç* type. The scabbard is wooden, covered with velvet in the middle and two silver mounts with incised linear decoration at the ends. Stamped on the back of the lower sheath is an illegible sultanic assay mark (*tuğra*). Incised on the outer side of the cruciform hand-guard is a Greek cross, with the accompanying inscription *ελευθερία ή θάνατος* (Freedom or Death). On the inner side are a similar cross and the inscription *νήσος ψαρόν* (island of Psara). On the wristband there are two incised crosses like those on the hand-guard. On the outer side of the wristband is the date 1821 and below the cross the name of the weapon's owner, *Κώνστα Κανάρης* (Costas Kanaris), while inscribed on its inner side is *νίκη λαμπρά* (splendid victory).

Constantinos Kanaris (ca. 1790–1877), who hailed from Psara and was a captain in the merchant fleet prior to the War of Independence, distinguished himself as one of the boldest "seadogs" of the struggle. His feats include setting fire to a Turkish flagship in the harbor of Chios on June 6–7, 1822, which had considerable impact in Europe and led Kanaris to be exalted as a hero. A symbol of integrity and conciliation, he became involved in politics after the revolution, serving King Othon (r. 1833–62) twice as naval minister and King George I (r. 1863–1913) thrice as prime minister, at critical moments for Greece.

Delivorrias, Fotopoulos 1997, 518, fig. 916. For *kiliç* sabers, see Vassilatos 1989, 91–92.

N.V.

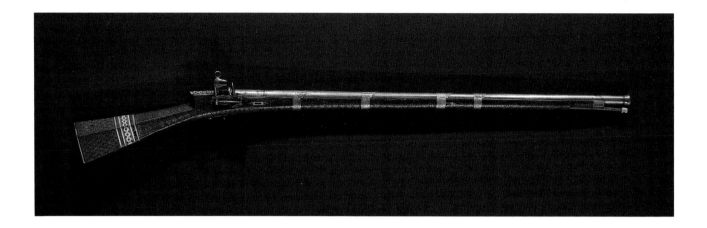

## 133. Muzzle-Loading Rifle

Belonged to Nikolaos Petimezas
Steel, wood, silver, bronze, ivory, gold
Length 131 cm, max width 10.5 cm
Gift of Herakles Petimezas, inv. no. 5791

This type of rifle, known as a *sissane*, was manufactured in Persia and the Ottoman Empire throughout the eighteenth and early nineteenth centuries and is distinguished by its characteristic pentagonal butt. These weapons were much sought after by fighters because they were considered very accurate. This example is decorated with inlaid bronze disks and ivory plaques, some painted green. The barrel is embellished with gold inlays.

The rifle belonged to Nikolaos Petimezas or Petmezas (1790–1865), scion of a historic family of Achaia. Like many of his fellow freedom fighters, he joined the Greek corps organized by the British in the time of the Napoleonic Wars to capture French-held Lefkada (1810). He participated in the Greek revolution from its early days (liberation of Kalavryta, March 21, 1821), offering his services throughout the struggle to the military operations in the Peloponnese and Central Greece. During the Othonian period (1833–62), he served as commander of army divisions and concurrently represented Kalavryta as parliamentary deputy, a seat to which he was elected repeatedly.

Today, the weapons of the eponymous and anonymous freedom fighters in the 1821 War of Independence are revered as sacred heirlooms of the nation. They are also admirable examples of the Greek silver- and goldsmiths' art in the eighteenth and nineteenth centuries.

Delivorrias, Fotopoulos 1997, 522, fig. 924. For rifles of *sissane* type, see Vassilatos 1989, 60–61.

N.V.

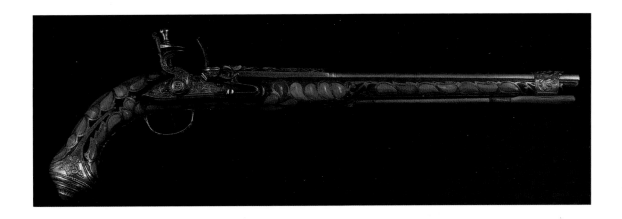

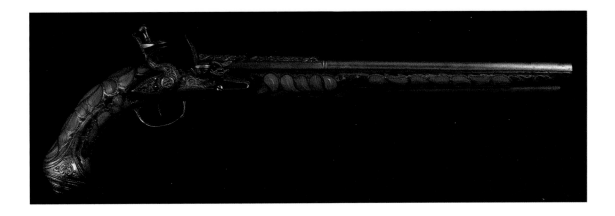

134. **Pistols**
> Late 18th–early 19th century
> Steel, wood, silver, corals
> Length 55 cm, max width 19 cm, thickness 7 cm
> Inv. no. 5776

These luxurious Ottoman flintlock pistols are probably war booty. Their firing mechanisms and the style of the decoration on their barrels reveal that they were made by northern Italian armorers. The wooden parts are lavishly embellished with large ribbed corals set in arc-shaped silver mounts with finely etched ornament.

Coral became fashionable at the Ottoman court in the eighteenth century. It was used extensively to decorate weapons and horse trappings in what was known in the empire as "Algerian work." Recorded among gifts presented by the sultan to the shah of Iran in 1746–47 are weapons decorated with corals by a master of the guild of flintlock makers. Pistols with coral decoration in Algerian and Ottoman style were also made in Italy and France for export.

Weapons of this quality were particularly expensive to produce. In Greek regions at the time, the most widespread firearm was the rifle (see cat. no. 133) and the possession of pistols was the privilege of powerful chieftains. The Greeks, like most peoples in the western Balkans, imported the principal accessories of these weapons, the barrels and the mechanisms, from Italy, an important center of pistol manufacturing. In fact, the name pistol derives from the Italian city of Pistola, where these guns were first designed in the early sixteenth century. The freedom fighters tucked their pair of pistols into a kind of broad leather belt known in Greece as a *selachi*, which was usually richly embroidered in gold. They are depicted holding such weapons in painted scenes of the struggle for independence (see cat. nos. 125, 127).

Delivorrias, Fotopoulos 1997, 569, fig. 1000.

N.V.

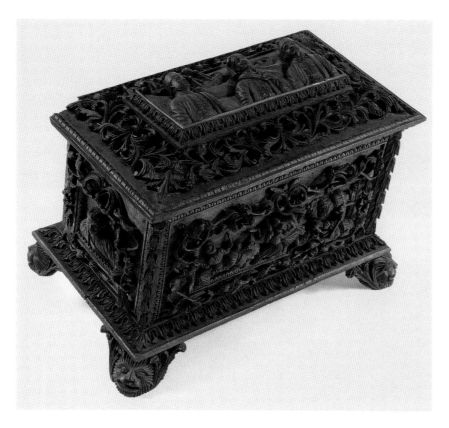

### 135. Sea Chest

First half of the 19th century

Carved wood

Length 52 cm, height 37 cm, width 33.5 cm

Inv. no. 8278

The chest bears elaborate decoration carved in high relief and openwork with incised details. It stands on a base with a molding of acanthus leaves and four legs in the form of a lion head. At the four corners are columns covered by inverted acanthus leaves. On the four sides and lid are representations inspired by recent glorious events of Greek history which are surrounded by a frame of rinceaux with foliate motifs, flowers, and fruit.

On one narrow side, in profile, is the Thessalian martyr Rhigas Velestinlis (1757–1798), one of the most important figures of the Greek Enlightenment (see cat. nos. 119, 122), while on the other is Alexandros Ypsilantis (1792–1828), who proclaimed the Greek revolution at Jassy (modern Iaşi), in Moldavia, in February 1821.

On one long side is a multifigural representation of the death of Markos Botsaris showing the wounded hero carried by his fellow fighters as the battle rages between the Greeks and the Turks (see cat. no. 128). On the other is an enchained female figure holding a flag inscribed with a cross, by a pole topped by a cross, an allusion to the allegorical representation of the Renaissance of Greece, who is liberated from her chains. She is framed by two heroes of the Greek War of Independence: at left the Souliot Markos Botsaris (1790–1823) and at right Odysseas Androutsos (1788/9–1825), who was assassinated on the Athenian Acropolis in June 1825 (see cat. no. 130). Represented on the lid are three nautical heroes: at left Andreas Miaoulis (1769–1835) with a sailing ship behind him; in the middle, Constantinos Kanaris (ca. 1790–1877) with a fire ship behind him (see cat. no. 132); and at right, Iakovos Tombazis (1782–1829).

The Greek War of Independence presented artists with unlimited material that was reproduced in all the applied arts. Lithographed sets of portraits of Greek leaders and printed images of events circulated all over Europe and eventually in Greece during the nineteenth century. The anonymous Greek craftsman who made the chest rendered the pictorial subjects and the portraits of freedom fighters with consummate skill and artistic sensitivity. The heroes' national costumes are depicted in remarkable detail, as are the facial features.

It is recorded in the Benaki Museum archives that the chest was used for storing the ship's flags. Its dimensions, however, suggest that it could have been used for the safekeeping of the ship's precious documents, especially the logbooks.

Unpublished.

K.S.

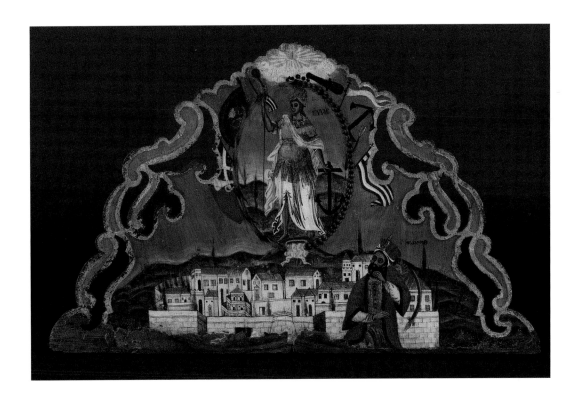

**136. Crowning with the Rebirth of Greece**
19th century
Probably from Syros, Cyclades
Wood, painted in egg tempera
Height 42 cm, width 68 cm, thickness 2.5 cm
Inv. no. 32565

The decoration on this wooden crowning of a piece of furniture is executed in the same technique as icon painting. The rocaille-shaped finial has cutout edges and the voids are in the form of palmettes. Dominating the upper part of the representation, within an oval medallion of laurel leaves, is a personification of Hellas in ancient dress. In one hand she holds a banner with the Greek flag, while the other hand rests on a ship's anchor. In an inscription to the right of the figure is the word *ΕΛΛΑΣ* (Hellas). The medallion is framed by symbols of the struggle for independence: Greek flags of land and sea, a red and blue flag with the double-headed eagle, a banner, a trumpet, rifles, cannon and artillery shells, an oar, and an anchor. At the top, Divine Grace appears in the clouds, with rays of light. In the composition is dominated by the schematic representation of Constantinople. At the front, in the right corner, Mehmed the Conqueror gazes ecstatically at the rebirth of Greece, while his yatagan drops from his hand. To his right is the inscription with his name: *Ο ΜΩΑΜΕΘ*.

The creator of the representation, who perhaps hailed from Asia Minor, was evidently familiar with both religious and secular painting of the nineteenth century.

Delivorrias 1997, 303, 348, fig. 118; Delivorrias, Fotopoulos 1997, 426–27, fig. 734.

M.V.

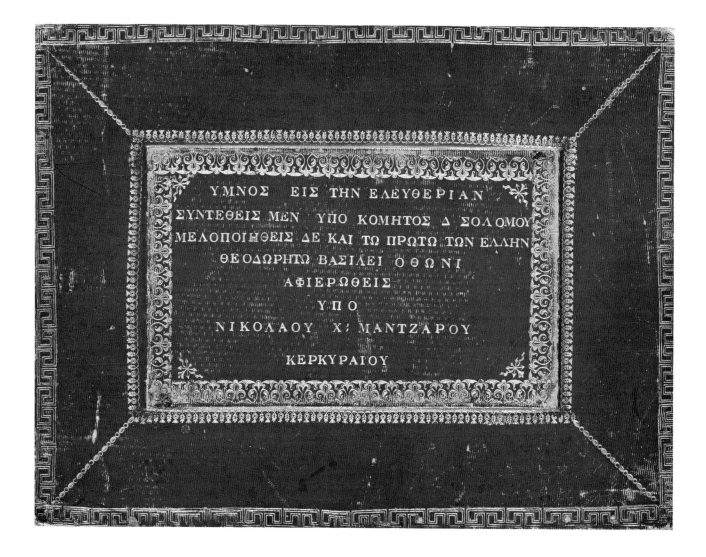

ΥΜΝΟΣ ΕΙΣ ΤΗΝ ΕΛΕΥΘΕΡΙΑΝ
ΣΥΝΤΕΘΕΙΣ ΜΕΝ ΥΠΟ ΚΟΜΗΤΟΣ Δ ΣΟΛΩΜΟΥ
ΜΕΛΟΠΟΙΗΘΕΙΣ ΔΕ ΚΑΙ ΤΩ ΠΡΩΤΩ ΤΩΝ ΕΛΛΗΝ
ΘΕΟΔΩΡΗΤΩ ΒΑΣΙΛΕΙ ΟΘΩΝΙ
ΑΦΙΕΡΩΘΕΙΣ
ΥΠΟ
ΝΙΚΟΛΑΟΥ Χ; ΜΑΝΤΖΑΡΟΥ
ΚΕΡΚΥΡΑΙΟΥ

## 137. Manuscript Score of the Music for the Poem *Hymn to Freedom* by Dionysios Solomos

April 1843
Nikolaos Mantzaros (1795–1872)
Paper manuscript, sheepskin leather binding, tooled gold decoration
Height 26 cm, width 32 cm (closed)
Gift of Ioulia Christomanou, Historical Archives 504

Title *ΥΜΝΟΣ ΕΙΣ ΤΗΝ ΕΛΕΥΘΕΡΙΑΝ/ΣΥΝΤΕΘΕΙΣ ΜΕΝ ΥΠΟ ΚΟΜΗΤΟΣ Δ. ΣΟΛΟΜΟΥ/ΜΕΛΟΠΟΙΗΘΕΙΣ ΔΕ ΚΑΙ ΤΩ ΠΡΩΤΩ ΤΩΝ ΕΛΛΗΝ/ΘΕΟΔΩΡΗΤΩ ΒΑΣΙΛΕΙ ΟΘΩΝΙ/ΑΦΙΕΡΩΘΕΙΣ/ΥΠΟ/ΝΙΚΟΛΑΟΥ Χ. ΜΑΝΤΖΑΡΟΥ/ΚΕΡΚΥΡΑΙΟΥ* (*Hymn to Freedom*, composed by Count D. Solomos, set to music and dedicated to the First of the Greeks, the God-given King Othon, by Nikolaos Ch. Mantzaros Corfiot).

The manuscript was a gift from King Othon (r. 1833–62) to his personal physician, Baron Anton von Lindermayer, and subsequently passed into the possession of his grandson Maximilian Christomanos. The manuscript includes the score for Dionysios Solomos' poem *Hymn to Freedom*, composed by Nikolaos Mantzaros in 1843 and dedicated to Othon on December 5, 1844. The king sent it to Munich to be judged by a special committee, after which he awarded the composer the silver cross of the Order of the Saviour.

In May 1823 Dionysios Solomos (1798–1857) created a transporting vision of freedom—militant, impulsive, and Greek—in this, his first composite poem (158 quatrains of trochaic eight-syllable verse with alternate rhymes), which marks a turning point in the thematic repertoire of his oeuvre, placing it in the service of the Greek struggle for independence. One of the few poems by Solomos published during his lifetime, *Hymn* circulated in Paris in 1825 as an appendix (as well as independently) to Fauriel's collection of folksongs, *Chants populaires de la Grèce moderne recueillis et publiés par C. Fauriel* (Paris, 1825), with a prose translation in French and in Missolonghi with an Italian translation.

Nikolaos Mantzaros (1795–1872), who was on amicable terms with Solomos, first set the *Hymn* to music in 1829–30, in a simple folk style. However, he considered this simplistic musical form unworthy of the lofty inspired poem and tried other musical scores using different styles and forms. This version was completed in April 1843 and is mainly an amalgamation of the two previous scores—at opposite ends of the compositional spectrum—the homophonic of 1829–30 and the polyphonic of 1837.

In 1865, during the reign of King George I (r. 1863–1913), the first two verses of the *Hymn*, in this third setting by Mantzaros, were established as the "Anthem of the Nation and the King," remaining to this day the national anthem of Greece.

Delivorrias, Fotopoulos 1997, 582–83, figs. 1027–28. For Nikolaos Mantzaros and the settings of the *Hymn*, see Leotsakos 1987; *New Grove Dictionary* 2001, s.v. *Mantzaros, Nikolaos Halikiopoulos* (G. Leotsakos); Zervopoulos 2003. For Dionysios Solomos, see Coutelle 1977; Mackridge 1989; Veloudes 2000.

V.T.

# BIBLIOGRAPHY

**DChAE**   Δελτίο της Χριστιανικής Αρχαιολογικής Εταιρείας

**DOP**   *Dumbarton Oaks Papers*

**Abegg 1978**
Margaret Abegg. *Apropos Patterns for Embroidery, Lace and Woven Textiles*. Bern, 1978.

**Acheimastou-Potamianou 1983**
Myrtali Acheimastou-Potamianou. *Η μονή των Φιλανθρωπηνών και η πρώτη φάση της μεταβυζαντινής ζωγραφικής*. Athens, 1983.

**Acheimastou-Potamianou 1991–92**
Myrtali Acheimastou-Potamianou. "Ζητήματα μνημειακής ζωγραφικής του 16ου αιώνα. Η τοπική ηπειρωτική σχολή." *DChAE* 16 (1991–92): 13–31.

**Altun et al. 1996**
Ara Altun et al. *Çanakkale Ceramics. The Suna and Inan Kiraç Mediterranean Civilizations Research Institute 1*. Istanbul, 1996.

**Amsterdam 1987**
Angelos Delivorrias, ed. *Greece and the Sea*. Exhib. cat., De Nieuwe Kerk, Amsterdam. Athens, 1987.

**Anagnostopoulou 1990**
Maria A. Anagnostopoulou. *Τα υφαντά της Λέσβου*. Athens, 1990.

**Anoyannakis 1991**
Phoebus Anoyannakis. *Greek Popular Musical Instruments*. Athens, 1991.

**Apostolopoulos 1989**
Dimitris Apostolopoulos. *Η γαλλική επανάσταση στην τουρκοκρατούμενη ελληνική κοινωνία: Αντιδράσεις στα 1798*. Athens, 1989.

**Argyropoulou 2003**
Roxanne Argyropoulou. *Νεοελληνικός ηθικός και πολιτικός στοχασμός*. Thessaloniki, 2003.

**Asdrachas 1979**
Spyros I. Asdrachas, ed. *Η οικονομική δομή των βαλκανικών χωρών (15ος–19ος αιώνας)*. Athens, 1979.

**Asdrachas 1988**
Spyros I. Asdrachas. *Ελληνική κοινωνία και οικονομία (ιη΄ και ιθ΄ αι)*. Athens, 1988.

**Asdrachas 1994**
Spyros I. Asdrachas. "Οι αναγραφές και ο κόσμος τους." In Ennio Concina and Aliki Nikiforou-Testone, eds., *Κέρκυρα: Ιστορία, αστική ζωή και αρχιτεκτονική, 14ος–19ος αι*. Corfu, 1994, 85–93.

**Asdrachas et al. 2003**
Spyros I. Asdrachas et al. *Ελληνική οικονομική ιστορία, ΙΕ΄–ΙΘ΄ αιώνας*. 2 vols. Athens, 2003.

**Astengo 2000**
Corradino Astengo. *La cartografia nautica mediterranea dei secoli XVI e XVII*. Genoa, 2000.

**Atasoy, Raby 1989**
Nurhan Atasoy and Julian Raby. *Iznik*. London, 1989.

**Athanassoglou-Kallmyer 1989**
Nina Athanassoglou-Kallmyer. *French Images from the Greek War of Independence, 1821–1830: Art and Politics under the Restoration*. New Haven and London, 1989.

**Athens 1983**
Nano Chatzidakis. *Icons of the Cretan School (15th–16th Century)*. Exhib. cat., Benaki Museum, Athens. Athens, 1983.

Cat. no. 81. *Bedspread* (detail). Late 17th–early 18th century. From Crete. Linen embroidered with silk thread.
Gift of Christopher Tower, inv. no. 32646

**Athens 1988**
Fani-Maria Tsigakou, ed. *Lord Byron in Greece*. Exhib. cat., Kostis Palamas Building, Athens. Athens, 1987.

**Athens 1992–93**
Anna Ballian. *Θησαυροί από την Μικρά Ασία και την Ανατολική Θράκη*. Exhib. cat., Center for Popular Art and Tradition, Athens. Athens, 1992.

**Athens 1994**
Manolis Borboudakis, ed. *Οι Πύλες του Μυστηρίου: Θησαυροί της Ορθοδοξίας από την Ελλάδα*. Exhib. cat., National Gallery-Alexandros Soutzos Museum, Athens. Athens, 1994.

**Athens 1995**
Fani-Maria Tsigakou. *British Images of Greece from the Benaki Museum Collections*. Exhib. cat., Museum of Cycladic Art, Athens. Athens, 1995.

**Athens 1999**
Chryssa Maltezou and Efi Andreadi, eds. *Η Βενετία των Ελλήνων, η Ελλάδα των Βενετών: Σημάδια στον χώρο και τον χρόνο*. Exhib. cat., Athens Concert Hall. Athens, 1999.

**Athens 2001**
Evangelia Kypraiou, ed. *A Mystery Great and Wondrous*. Exhib. cat., Byzantine and Christian Museum, Athens. Athens, 2002.

**Athens 2001–2**
Jenny Albani, ed. *Byzantium: An Oecumenical Empire*. Exhib. cat., Byzantine and Christian Museum, Athens. Athens, 2002.

**Avramea 1985**
Anna Avramea. *Maps and Mapmakers of the Aegean*. Athens, 1985.

**Azzopardi 1987**
Canon John Azzopardi. *The Schranz Artists: Landscape and Marine Painters in the Mediterranean*. Malta, 1987.

**Bacchion 1956**
Eugenio Bacchion. *Il dominio veneto su Corfù (1386–1797)*. Venice, 1956.

**Ballian 1991**
Anna Ballian. "Christian Silverwork from Ottoman Trebizond." In *Cultural and Commercial Exchanges between the Orient and the Greek World. Seminar Papers*. Athens, 1991, 123–37.

**Ballian 1994**
Anna Ballian. "Argana on the Tigris and Vank on the Euphrates: Pontic Mining Expansion and Church Silver from Argyroupolis-Gümüşhane." In *Θυμίαμα στη μνήμη της Λασκαρίνας Μπούρα*. Athens, 1994, vol. 1, 15–22.

**Ballian 1998**
Anna Ballian. "Post-Byzantine and Other Small Art Works." In *The Holy and Great Monastery of Vatopaidi*. Mount Athos, 1998, vol. 2, 500–534.

**Ballian 2001a**
Anna Ballian. "Dedications and Donors of Seventeenth- to Nineteenth-Century Church Silver." *Mouseio Benaki* 1 (2001): 87–110.

**Ballian 2001b**
Anna Ballian. "Ο ξυλόγλυπτος σταυρός με βαθμιδωτή βάση του Μουσείου της Ιεράς Μονής Κύκκου." In Stylianos K. Perdikis, ed., *Η Ιερά Μονή Κύκκου στη Βυζαντινή και Μεταβυζαντινή Αρχαιολογία και Τέχνη. Πρακτικά Συνεδρίου, Λευκωσία, 14–16 Μαΐον 1998*. Nicosia, 2001, 291–312.

**Baltimore 1988**
Myrtali Acheimastou-Potamianou, ed. *Holy Image, Holy Space: Icons and Frescoes from Greece*. Exhib. cat., Walters Art Gallery, Baltimore; Center for the Fine Arts, Miami; Kimbell Art Museum, Fort Worth; Fine Arts Museum of San Francisco; Cleveland Museum of Art; Detroit Institute of Art. Athens, 1988.

**Batalden 1982**
Stephen Batalden. *Catherine the Second's Greek Prelate: Eugenios Voulgaris in Russia, 1771–1806*. Boulder, 1982.

**Baumstark et al. 1999**
Reinhold Baumstark et al. *Das neue Hellas: Griechen und Bayern zur Zeit Ludwigs I.* Exhib. cat., Bayerisches National Museum, Munich. Munich, 1999.

**Beaton 2004**
Roderick Beaton. *Folk Poetry of Modern Greece.* Cambridge, 2004.

**Beck, Manoussacas, Pertusi 1977**
Hans-Georg Beck, Manoussos I. Manoussacas, and Agostino Pertusi, eds. *Venezia centro di mediazione tra Oriente e Occidente (secoli XV–XVI): Aspetti e problemi.* 2 vols. Florence, 1977.

**Bekiaroglou-Exadactylou 1994**
Aikaterini Bekiaroglou-Exadactylou. *Οθωμανικά ναυπηγεία στον παραδοσιακό ελληνικό χώρο.* Athens, 1994.

**Binos 1965**
Harilis Binos. "Ξυλόγλυπτες λεσβιακές κασέλες." *Ζυγός* 1, no. 2 (1965): 46–56.

**Bitha 2003**
Ioanna Bitha. "Remarks on an Icon of Saint Charalambos, Work of Konstantinos of Adrianople (1739)." *DChAE* 24 (2003): 333–45.

**Bodur 1987**
Fulya Bodur. *The Art of Turkish Metalworking.* Istanbul, 1987.

**Boppe 1989**
Auguste Boppe. *Les Orientalistes: Les peintres du Bosphore au XVIIIe siècle.* Paris, 1989.

**Bordeaux–Paris–Athens 1996–97**
Claire Constans, ed. *La Grèce en révolte: Delacroix et les peintres français, 1815–1848.* Exhib. cat., Musée des Beaux-Arts, Bordeaux; Musée National Eugène Delacroix, Paris; National Gallery-Alexandros Soutzos Museum, Athens. Paris, 1996.

**Boschkov 1972**
Atanas Boschkov. *Die bulgarische Volkskunst.* Recklinghausen, 1972.

**Brussels 1982**
Jaqueline Lafontaine-Dosogne, ed. *Splendeur de Byzance.* Exhib. cat., Musées Royaux d'Art et d'Histoire, Brussels. Brussels, 1982.

**Bury 1991**
Shirley Bury. *Jewellery, 1789–1910: The International Era.* Vol. 1. Suffolk, 1991.

**Camariano-Cioran 1974**
Ariadna Camariano-Cioran. *Les académies princières de Bucarest et de Jassy et leurs professeurs.* Thessaloniki, 1974.

**Carswell 1998**
John Carswell. *Iznik Pottery.* London, 1998.

**Cattapan 1968**
Mario Cattapan. "Nuovi documenti riguardanti pittori cretesi dal 1300 al 1500." In *Πεπραγμένα του Β΄ Διεθνούς Κρητολογικού Συνεδρίου. Γ΄ Τμήμα Μεσαιωνολογικόν.* Athens, 1968, 29–46.

**Cattapan 1972**
Mario Cattapan. "Nuovi elenchi e documenti dei pittori cretesi in Creta dal 1300 al 1500." *Thesaurismata* 9 (1972): 202–35.

**Chatzidakis M. 1976**
Manolis Chatzidakis. *Études sur la peinture post-byzantine.* London, 1976.

**Chatzidakis M. 1985**
Manolis Chatzidakis. *Icons of Patmos: Questions of Byzantine and Post-Byzantine Painting.* Athens, 1985.

**Chatzidakis M. 1986**
Manolis Chatzidakis. *The Cretan Painter Theophanis: The Final Phase of His Art in the Wall-Paintings of the Holy Monastery of Stavronikita.* Mount Athos, 1986.

**Chatzidakis M. 1987**
Manolis Chatzidakis. Έλληνες ζωγράφοι μετά την Άλωση (1450–1830). Vol. 1. Athens, 1987.

**Chatzidakis N. 1998**
Nano Chatzidakis. *Icons: The Velimezis Collection.* Athens, 1998.

**Chatzidakis T. 1982**
Theano Chatzidakis. *L'art des icônes en Crète et dans les îles après Byzance.* Exhib. cat., Palais des Beaux Arts, Charleroi. Charleroi, 1982.

**Chatzidakis, Drakopoulou 1997**
Manolis Chatzidakis and Evgenia Drakopoulou. Έλληνες ζωγράφοι μετά την Άλωση (1450–1830). Vol. 2. Athens, 1997.

**Chatzimichali 1925**
Angeliki Chatzimichali. Ελληνική λαϊκή τέχνη: Σκύρος. Athens, 1925.

**Chryssochoidis 2005**
Kriton Chryssochoidis. "The Portaitissa Icon at Iveron Monastery and the Cult of the Virgin on Mount Athos." In Maria Vassilaki, ed., *Images of the Mother of God: Perceptions of the Theotokos in Byzantium.* Aldershot, 2005, 133–42.

**Clogg 1976**
Richard Clogg, ed. *The Movement for Greek Independence, 1770–1821.* London and Basingstoke, 1976.

**Constantinidis 1954**
Tryphon P. Constantinidis. Καράβια, καπετάνιοι και συντροφοναύτες, 1800–1830. Athens, 1954.

**Constantinopoulos 1977**
Grigoris Constantinopoulos. Μουσεία της Ρόδου. Athens, 1977.

**Constantoudaki 1975**
Maria Constantoudaki. "Μαρτυρίες ζωγραφικών έργων στο Χάνδακα σε έγγραφα του 16ου και 17ου αιώνα." *Thesaurismata* 12 (1975): 35–137.

**Constantoudaki-Kitromilides 1995**
Maria Constantoudaki-Kitromilides. "Italian Influences in El Greco's Early Work: Some New Observations." In Nicos Hadjinicolaou, ed., *El Greco of Crete: Proceedings of the International Symposium on the Occasion of the 450th Anniversary of the Artist's Birth, Iraklion, 1–5 September 1990.* Herakleion 1995, 97–118.

**Constantoudaki-Kitromilides 1998**
Maria Constantoudaki-Kitromilides. "La pittura di icone a Creta veneziana (secoli XV e XVI): Questioni di Mecenatismo, Iconografia e preferenze estetiche." In Ortalli 1998, 459–507.

**Constantoudaki-Kitromilides 1999**
Maria Constantoudaki-Kitromilides. "Cretan Painting during the Fifteenth and Sixteenth Centuries: The Long Path toward Domenikos Theotokopoulos and His Early Production." In Madrid–Rome–Athens 1999–2000, 83–93.

**Constantoudaki-Kitromilides 2000**
Maria Constantoudaki-Kitromilides. "Ασήμι λαβοράδο και χρυσάφι φίνον: Αρχειακές μαρτυρίες για την αργυροχοΐα και τη χρυσοχοΐα στην Κρήτη της βενετικής περιόδου." In Πεπραγμένα Η′ Διεθνούς Κρητολογικού Συνεδρίου, Ηράκλειο, 9–14 Σεπτεμβρίου 1996. Herakleion, 2000, vol. B1, 365–80.

**Constantoudaki-Kitromilides 2001**
Maria Constantoudaki-Kitromilides. "Damaskinos, Theotokopoulos e la sfida veneziana." In Chryssa Maltezou, ed., *Il contributo veneziano nella formazione del gusto dei Greci (XV–XVII sec.). Atti del Convegno Internazionale, Venezia, 2–3 giugno 2000.* Venice, 2001, 49–59.

**Constantoudaki-Kitromilides 2003**
Maria Constantoudaki-Kitromilides. "The Painter Anghelos Acotantos: New Biographical Details from Unpublished Documents." In Mary Aspra-Vardavakis, ed., Λαμπηδών: Αφιέρωμα στη μνήμη της Ντούλας Μουρίκη. Athens, 2003, vol. 2, 499–508.

**Costantini, Nikiforou 1996**
Massimo Costantini and Aliki Nikiforou, eds. *Levante Veneziano: Aspetti di storia delle Isole Ionie al tempo della Serenissima.* Rome, 1996.

Coutelle 1977
Louis Coutelle. *Formation poétique de Solomos (1815–1833)*. Athens, 1977.

Dakin 1972
Douglas Dakin. *The Unification of Greece (1770–1923)*. London, 1972.

Delivorrias 1976
Angelos Delivorrias. "Στα χνάρια της παραδοσιακής κεραμικής των χρόνων της Τουρκοκρατίας."
*Ζυγός* 21 (1976): 18–27.

Delivorrias 1980
Angelos Delivorrias. *Greek Traditional Jewelry*. Athens, 1980.

Delivorrias 1991
Angelos Delivorrias. "Γύρω από την αντοχή της παράδοσης στη νεοελληνική κεραμική του όψιμου
19ου αιώνα." In *Αρμός: Τιμητικός τόμος στον καθηγητή Ν. Κ. Μουτσόπουλο*. Thessaloniki, 1991, vol. 1, 477–90.

Delivorrias 1994
Angelos Delivorrias. "Η κεραμική παράδοση του νεοελληνικού χρόνου: Νέες μαρτυρίες." In *Θυμίαμα στη
μνήμη της Λασκαρίνας Μπούρα*. Athens, 1994, vol. 1, 77–81.

Delivorrias 1997
Angelos Delivorrias. "Traditional Art on the Aegean Islands." In *The Aegean: The Epicenter of Greek
Civilization*. Athens, 1997, 281–360.

Delivorrias 2000
Angelos Delivorrias. *A Guide to the Benaki Museum*. Athens, 2000.

Delivorrias 2001a
Angelos Delivorrias. "Γύρω από την αισθητική των κεντημάτων της Σίφνου." In *Proceedings of the First
International Sifnean Symposium, Sifnos, 25–28 June 1998*. Athens, 2001, vol. 3, 311–26.

Delivorrias 2001b
Angelos Delivorrias. "Carved Wooden Chests from the Peloponnese: Questions of Stylistic and Thematic
Singularity." *Mouseio Benaki* 1 (2001): 111–26.

Delivorrias 2002
Angelos Delivorrias. "Παραστάσεις χορού στην ελληνική λαϊκή τέχνη." In Emmanuelle Moser-Karagiannis
and Eleutheria Giakoumaki, eds., *Κανίσκιον φιλίας: Τιμητικός τόμος για τον Guy-Michel Saunier*. Athens, 2002,
133–56.

Delivorrias 2003
Angelos Delivorrias. "Decoration of Houses." In Philippides 2003, 50–67.

Delivorrias, Fotopoulos 1997
Angelos Delivorrias and Dionissis Fotopoulos. *Greece at the Benaki Museum*. Athens, 1997.

Demos 1958
Raphael Demos. "The Neohellenic Enlightenment (1750–1821)." *Journal of the History of Ideas* 19 (1958):
523–41.

Dimacopoulos 2002
Iordanis E. Dimacopoulos. *The Houses of Rethymnon*. Athens, 2002.

Dimaras 1969
Constantinos Th. Dimaras. *La Grèce au temps des lumières*. Geneva, 1969.

Dimaras 1996
Constantinos Th. Dimaras. *Ιστορικά Φροντίσματα Β': Αδαμάντιος Κοραής*. Athens, 1996.

Dimaras 1999
Constantinos Th. Dimaras. *Ιστορία της νεοελληνικής λογοτεχνίας*. Athens, 1999.

D'Orey 1995
Leonor D'Orey. *Five Centuries of Jewellery: National Museum of Ancient Art, Lisbon*. London, 1995.

Doris 1969
Michalis Doris. "Anonymous Architecture: Bridges." *Architectoniki and Plastic Arts* 77 (December 1969): 50–61.

**Drandaki 2002**
Anastasia Drandaki. *Greek Icons, 14th–18th Century: The Rena Andreadis Collection.* Milan, 2002.

**Drandaki, Vranopoulou, Kalliga 2000**
Anastasia Drandaki, Lena Vranopoulou, and Alexandra Kalliga. "Icons Signed by Emmanuel Lambardos in the Benaki Museum." *DChAE* 21 (2000): 189–220.

**Drandakis 1962**
Nikolaos B. Drandakis. *Ο Εμμανουήλ Τζάνες Μπουνιαλής θεωρούμενος εξ εικόνων του σωζομένων κυρίως εν Βενετία.* Athens, 1962.

**Efthymiou-Hadzilacou 1988**
Maria Efthymiou-Hadzilacou. *Rhodes et sa région élargie au 18e siècle: Activités portuaires.* Athens, 1988.

**Faltaits 1974**
Manos Faltaits. "Τα διακοσμητικά αντικείμενα του Σκυριανού σπιτιού από ιστορική και κοινωνιολογική άποψη." *Archives of Euboean Studies* 19 (1974): 58–96.

**Fiorani 2005**
Francesca Fiorani. *The Marvel of Maps: Art, Cartography, and Politics in Renaissance Italy.* New Haven and London, 2005.

**Florakis 1980**
Alekos Florakis. *Η λαϊκή λιθογλυπτική της Τήνου.* Athens, 1980.

**Florakis 1982**
Alekos Florakis. *Καραβάκια-τάματα και θαλασσινή αφιερωτική πρακτική στο Αιγαίο.* Athens, 1982.

**Fontenay 1887**
Eugène Fontenay. *Les bijoux anciens et modernes.* Paris, 1887.

**Frangakis-Syrett 1992**
Elena Frangakis-Syrett. *The Commerce of Smyrna in the Eighteenth Century (1700–1820).* Athens, 1992.

**Franzoni, Pagella 1984**
Claudio Franzoni and Enrica Pagella. *Itinerario romanico attraverso la mostra: "Lanfranco e Wiligelmo: Il Duomo di Modena."* Modena, 1984.

**Fribourg 1984**
Electra Georgoula, ed. *Cosmèsis: La parure féminine en Grèce à l'époque post-byzantine.* Exhib. cat., Musée d'Art et d'Histoire, Fribourg. Fribourg, 1984.

**Garidis 1989**
Miltiadis Garidis. *La peinture murale dans le monde orthodoxe après la chute de Byzance (1450–1600) et dans les pays sous dominion étrangère.* Athens, 1989.

**Garidis 1996**
Miltiadis Garidis. *Διακοσμητική ζωγραφική: Βαλκάνια—Μικρασία, 18ος–19ος αιώνας.* Athens, 1996.

**Geanakoplos 1962**
Deno John Geanakoplos. *Greek Scholars in Venice.* Cambridge, 1962.

**Gedeon 1976**
Manuel Gedeon. *Η πνευματική κίνησις του Γένους κατά τον ΙΗ′ και ΙΘ′ αιώνα.* Athens, 1976.

**Georgitsoyanni 1993**
Evangelia Georgitsoyanni. *Les peintures murales du vieux catholicon du monastère de la Transfiguration aux Météores (1483).* Athens, 1993.

**Goldthwaite 1993**
Richard A. Goldthwaite. *Wealth and the Demand for Art in Italy, 1300–1600.* Baltimore and London, 1993.

**Goulaki-Voutira 2002**
Alexandra Goulaki-Voutira. "Δείγματα μαρμαρογλυπτικής του Αιγαίου στο Μουσείο Μπενάκη." *Mouseio Benaki* 2 (2002): 111–15 (with English summary).

**Goulaki-Voutira, Karadedos, Lavvas 1996**
Alexandra Goulaki-Voutira, George Karadedos, and George Lavvas. *Η εκκλησιαστική μαρμαρογλυπτική στις Κυκλάδες από τον 16ο ως τον 20ό αιώνα*. Athens, 1996.

**Gouma-Peterson 1988**
Thalia Gouma-Peterson. "The Icon as Cultural Presence after 1453." In Gary Vikan, ed., *Icon: Four Essays*. Baltimore, 1988, 48–64.

**Gourgiotis 1976**
George Gourgiotis. "Μεταβυζαντινά sgraffiti: Ευρήματα που οδηγούν στην αναθεώρηση της ιστορίας της ελληνικής κεραμεικής." *Ζυγός* 19 (1976): 52–53.

**Greek Jewellery 1999**
Electra Georgoula, ed. *Greek Jewellery: From the Benaki Museum Collections*. Athens, 1999.

**Hadjimihali 1950**
Anghéliki Hadjimihali. *La sculpture sur bois*. Athens, 1950.

**Hagimihali 1937**
Angélique Hagimihali. *L'art populaire grec*. Athens, 1937.

**Handaka 2002**
Sophia Handaka. "Re-evaluating Tamata: The Mikes Paidousis Collection of Votive Offerings." *Mouseio Benaki* 2 (2002): 147–65.

**Handaka 2004**
Sophia Handaka. "Τάματα-αφιερώματα." In Spyros I. Asdrachas, Anastasios Tzamtzis, and Gelina Harlaftis, eds., *Ελλάδα της θάλασσας*. Athens, 2004, 220–23.

**Harlaftis 1996**
Gelina Harlaftis. *A History of Greek-Owned Shipping: The Making of an International Tramp Fleet, 1830 to the Present Day*. London and New York, 1996.

**Hassiotis 1970**
John Hassiotis. *Οι Έλληνες στις παραμονές της ναυμαχίας της Ναυπάκτου*. Thessaloniki, 1970.

**Hatzimichali 1979**
Angeliki Hatzimichali. *Benaki Museum: The Greek Folk Costume*. Edited by Tatiana Ioannou-Yiannara. Vol. 1. Athens, 1979.

**Hatzimichali 1984**
Angeliki Hatzimichali. *Benaki Museum: The Greek Folk Costume*. Edited by Tatiana Ioannou-Yiannara. Vol. 2. Athens, 1984.

**Haugsted 1996**
Ida Haugsted. *Dream and Reality: Danish Antiquaries, Architects and Artists in Greece*. London, 1996.

**Henderson 1970**
George Patrick Henderson. *The Revival of Greek Thought, 1620–1830*. Albany, 1970.

**Herakleion 1990**
Nicos Hadjinicolaou, ed. *El Greco of Crete*. Exhib. cat., Basilica of Saint Mark, Herakleion. Herakleion 1990.

**Hering 1968**
Gunnar Hering. *Ökumenisches Patriarchat und europäische Politik, 1620–1638*. Stuttgart, 1968.

**Herrin 1982**
Judith Herrin. "Women and the Faith in Icons." In Raphael Samuel and Gareth Stedman Jones, eds., *Culture, Ideology and Politics: Essays for Eric Hobsbawm*. London 1982, 65–83.

**Holton 1991**
David Holton, ed. *Literature and Society in Renaissance Crete*. Cambridge, 1991.

**Hunt 1996**
Yvonne Hunt. *Traditional Dance in Greek Culture*. Athens, 1996.

**Iconomaki-Papadopoulos 1994**
Yota Iconomaki-Papadopoulos. "Το ευαγγέλιο από το Ευκάρυο Θράκης." In *Θυμίαμα στη μνήμη της Λασκαρίνας Μπούρα*. Athens 1994, vol. 1, 229–34.

**Iliou 1975**
Philippe Iliou. "Luttes sociales et mouvement des lumières à Smyrne en 1819." In *Structure sociale et développement culturel des villes sud-est européennes et adriatiques aux XVIIe–XVIIIe siècles. Actes du Colloque Interdisciplinaire, Venise, 27–30 mai 1971*. Bucharest, 1975, 295–315.

**Inalcik, Quataert 1994**
Halil Inalcik and Donald Quataert, eds. *An Economic and Social History of the Ottoman Empire (1300–1914)*. Cambridge, 1994.

**Ioannou-Yiannara 1987**
Tatiana Ioannou-Yiannara. *Lace*. Athens, 1987.

**Istanbul 1983**
NazanTapan, Filiz Çağman, and Serap Aykoç. *The Anatolian Civilisations III: Seljuk/Ottoman*. Exhib. cat., Topkapi Palace Museum, Istanbul. Istanbul, 1983.

**Ιστορία του Ελληνικού Έθνους 1974–75**
*Ιστορία του Ελληνικού Έθνους*. Athens, 1974–75, vols. 10–11.

**Johnstone 1961**
Pauline Johnstone. *Greek Island Embroidery*. London, 1961.

**Johnstone 1967**
Pauline Johnstone. *Byzantine Tradition in Church Embroidery*. London, 1967.

**Johnstone 1972**
Pauline Johnstone. *A Guide to Greek Island Embroidery*. London, 1972.

**Kanari 2003**
Triantaphyllia Kanari. *Les peintures du catholicon du monastère de Galataki en Eubée, 1586: Le narthex et la chapelle de Saint Jean le Précurseur*. Athens, 2003.

**Kaplani 1997**
Yannoula Kaplani. *Modern Greek Silverware: From the Collections of the Museum of Greek Folk Art*. Athens, 1997.

**Karagatsi 1996**
Marina Karagatsi. *Κτητορικές πλάκες της Άνδρου. Ανδριακά Χρονικά 27*. Andros, 1996.

**Kardassis 1998**
Vassilis Kardassis. *Έλληνες ομογενείς στη Νότια Ρωσία, 1775–1861*. Athens, 1998.

**Katsiardi-Hering 1986**
Olga Katsiardi-Hering. *Η ελληνική παροικία της Τεργέστης, 1751–1830*. Athens, 1986.

**Katsiardi-Hering 1989**
Olga Katsiardi-Hering. *Λησμονημένοι ορίζοντες Ελλήνων εμπόρων: Το πανηγύρι στη Senigallia (18ος–αρχές 19ου αιώνα)*. Athens, 1989.

**Kazanaki 1974**
Maria Kazanaki. "Εκκλησιαστική ξυλογλυπτική στο Χάνδακα το 17ο αιώνα." *Thesaurismata* 11 (1974): 251–83.

**Kazanaki-Lappa 1991**
Maria Kazanaki-Lappa. "Συμβολή στη μελέτη της αρχιτεκτονικής γλυπτικής στο Χάνδακα. Ειδήσεις από νοταριακά έγγραφα του 17ου αιώνα." In *Πεπραγμένα του ΣΤ' Διεθνούς Κρητολογικού Συνεδρίου. Τμήμα Μεσαιωνικό–Βυζαντινό*. Chania, 1991, vol. 2, 175–80.

**Kazanaki-Lappa 1993**
Maria Kazanaki-Lappa. "Η συμβολή των αρχειακών πηγών στην ιστορία της τέχνης. Ζωγραφική, γλυπική, αρχιτεκτονική." In Maltezou 1993, 435–84.

**Kefalas 1979**

Constantinos Kefalas. "Κασέλες, μπαούλα και σεντούκια στο Βορειοελλαδικό χώρο." In *Πρακτικά του Γ′ Συμποσίου Λαογραφίας του Βορειοελλαδικού Χώρου ('Ηπειρος–Μακεδονία–Θράκη), Αλεξανδρούπολη, 14–18 Οκτωβρίου 1976*. Thessaloniki, 1979, 325–33.

**Kitromilides 1992**

Paschalis M. Kitromilides. *The Enlightenment as Social Criticism: Iosipos Moisiodax and Greek Culture in the Eighteenth Century*. Princeton, 1992.

**Kitromilides 1994**

Paschalis M. Kitromilides. *Enlightenment, Nationalism, Orthodoxy: Studies in the Culture and Political Thought of Southeastern Europe. Variorum Collected Studies Series*. Aldershot, 1994.

**Kitromilides 1998**

Paschalis M. Kitromilides. *Ρήγας Βελεστινλής: Θεωρία και πράξη*. Athens, 1998.

**Kitromilides 2000**

Paschalis M. Kitromilides. *Νεοελληνικός Διαφωτισμός: Οι πολιτικές και κοινωνικές ιδέες*. Athens, 2000.

**Kitromilides 2003**

Paschalis M. Kitromilides. "An Enlightenment Perspective on Balkan Cultural Pluralism: The Republican Vision of Rhigas Velestinlis." *History of Political Thought* 24 (2003): 465–79.

**Kondaratos 1994**

Savas Kondaratos. "The Parthenon as Cultural Ideal: The Chronicle of Its Emergence as a Supreme Monument of Eternal Glory." In Panayotis Tournikiotis, ed., *The Parthenon and Its Impact in Modern Times*. Athens 1994, 19–53.

**Konortas 1998**

Paraskevas Konortas. *Οθωμανικές θεωρήσεις για το οικουμενικό πατριαρχείο, 17ος–αρχές 19ου αι.* Athens, 1998.

**Korre 1978**

Katerina Korre. *Η ανθρώπινη κεφαλή θέμα αποτρεπτικό στη νεοελληνική λαϊκή τέχνη*. Athens, 1978.

**Korre 1984**

Katerina Korre. "Οι παλάσκες του Εθνικού Ιστορικού Μουσείου." *Δελτίον Ιστορικής και Εθνολογικής Εταιρείας της Ελλάδος* 27 (1984): 197–254.

**Korre-Zographou 1995**

Katerina Korre-Zographou. *Τα κεραμεικά του ελληνικού χώρου*. Athens, 1995.

**Korre-Zographou 2000**

Katerina Korre-Zographou. *Τα κεραμεικά του Τσανάκκαλε, 1670–1922*. Athens, 2000.

**Korre-Zographou 2002**

Katerina Korre-Zographou. *Χρυσικών έργα 1600–1900: Συλλογή Κ. Νοταρά*. Athens, 2002.

**Korre-Zographou 2003**

Katerina Korre-Zographou. *Τα κεραμεικά του Αιγαίου*. Athens, 2003.

**Koutelakis 1996**

Haris Koutelakis. *Έλληνες αργυροχρυσοχόοι και ξυλογλύπτες*. Athens, 1996.

**Kremmydas 1973**

Vassilis Kremmydas. *Αρχείο Χατζηπαναγιώτη*. Athens, 1973.

**Kremmydas 1974**

Vassilis Kremmydas. *Το εμπόριο της Πελοποννήσου στο 18ο αιώνα*. Athens, 1974.

**Kremmydas 1986**

Vassilis Kremmydas. *Ελληνική ναυτιλία, 1776–1835*. 2 vols. Athens, 1986.

**Kyriakidou-Nestoros 1965**

Alki Kyriakidou-Nestoros. *Τα υφαντά της Μακεδονίας και της Θράκης*. Athens, 1965.

**Kyriazopoulos 1984**

Vassilis D. Kyriazopoulos. *Ελληνικά παραδοσιακά κεραμικά*. Athens, 1984.

**Kyriazopoulos, Charitonidou 1983**
Vassilis D. Kyriazopoulos and Angeliki Charitonidou. "Ελληνικά στιχοπλάκια σε Ιταλικούς μαστραπάδες."
In *Πρακτικά του Δ΄ Συμποσίου Λαογραφίας του Βορειοελλαδικού Χώρου (Ήπειρος–Μακεδονία–Θράκη), Ιωάννινα, 10–12 Οκτωβρίου 1979*. Thessaloniki, 1983, 83–125.

**Layton 1994**
Evro Layton. *The Sixteenth Century Greek Book in Italy*. Venice, 1994.

**Leon 1972**
George Leon. "The Greek Merchant Marine, 1453–1850." In Stelios A. Papadopoulos, ed., *The Greek Merchant Marine (1453–1850)*. Athens, 1972, 13–52.

**Leonidopoulou-Stylianou 1988**
Rea Leonidopoulou-Stylianou. "Πήλιο." In Dimitris Philippides, ed., *Ελληνική Παραδοσιακή Αρχιτεκτονική: Θεσσαλία-Ήπειρος*. Athens 1988, vol. 6, 11–90.

**Leotsakos 1987**
George Leotsakos. "Νικόλαος Χαλικιόπουλος Μάντζαρος (1795–1872): Για ένα μικρό του εγκόλπιο." *Μουσικολογία* 5–6 (1987): 228–71.

**London 1987**
Myrtali Acheimastou-Potamianou, ed. *From Byzantium to El Greco: Greek Frescoes and Icons*. Exhib. cat., Royal Academy of Arts, London. Athens, 1987.

**Mackridge 1989**
Peter Mackridge. *Dionysios Solomos*. Bristol, 1989.

**MacMillan 1974**
Susan L. MacMillan. *Greek Islands Embroideries: Museum of Fine Arts*. Boston, 1974.

**Madrid–Rome–Athens 1999–2000**
José Álvarez Lopera, ed. *El Greco: Identity and Transformation*. Exhib. cat., Museo Thyssen Bornemisza, Madrid; Palazzo delle Esposizioni, Rome; National Gallery-Alexandros Soutzos Museum, Athens. Milan, 1999.

**Makris 1961**
Kitsos Makris. *Υφαντά Θεσσαλίας*. Athens, 1961.

**Makris 1972**
Kitsos Makris. "Marine Motifs in Popular Art." In Stelios A. Papadopoulos, ed., *The Greek Merchant Marine (1453–1850)*. Athens, 1972, 267–98.

**Makris 1976**
Kitsos Makris. *Η λαϊκή τέχνη του Πηλίου*. Athens, 1976.

**Makris 1981**
Kitsos Makris. *Χιονιαδίτες ζωγράφοι: 65 ζωγράφοι από το χωριό Χιονιάδες της Ηπείρου*. Athens, 1981.

**Mallouchou-Tufano 1994**
Fani Mallouchou-Tufano. "The Parthenon from Cyriacus of Ancona to Frédéric Boissonas: Description, Research and Depiction." In Panayotis Tournikiotis, ed., *The Parthenon and Its Impact in Modern Times*. Athens, 1994, 163–99.

**Maltezou 1993**
Chryssa Maltezou, ed. *Όψεις της ιστορίας του βενετοκρατούμενου ελληνισμού. Αρχειακά τεκμήρια. Venetiae Quasi Alterum Byzantium 1*. Athens, 1993.

**Maniatopoulos 1939**
Ioannis P. Maniatopoulos. *Το ναυτικόν δίκαιον της Ύδρας (1757–1821)*. Athens, 1939.

**Mark-Weiner 1977**
Temily Mark-Weiner. "Narrative Cycles of the Life of Saint George in Byzantine Art." Ph.D. diss. New York University, 1977.

**Mathews 1998**
Thomas F. Mathews. *The Art of Byzantium*. London, 1998.

**Maximos 1940**
Seraphim Maximos. *Το ελληνικό εμπορικό ναυτικό κατά τον XVIII αιώνα.* Athens, 1940.

**Mayer 1935**
August Liebmann Mayer. "De pintura española." *Archivo español de arte y arqueologia* 32 (1935): 205–8.

**Mazarakis-Ainian 1995**
Ioannis K. Mazarakis-Ainian, ed. *Κοσμήματα της ελληνικής παραδοσιακής φορεσιάς, 18ος–19ος αι: Συλλογή Εθνικού Μουσείου.* Athens, 1995.

**Meletopoulos 1972**
Ioannis Meletopoulos. *Εικόνες του αγώνος I. Μακρυγιάννη–Π. Ζωγράφου.* Athens, 1972.

**Miller 1908**
William Miller. *The Latins in the Levant: A History of Frankish Greece (1204–1566).* London, 1908.

**Monte Santo 1932**
Marica Monte Santo. "Costumi e gioielli del Dodecaneso e di Castelrosso." *Dedalo* 10 (1932): 103–33.

**Monte Santo n.d.**
Marica Monte Santo. *L'isola dei Gigli (Stampalia).* Rome, n.d.

**Navari 1989**
Leonora Navari. *Greece and the Levant: The Catalogue of the H. M. Blackmer Collection of Books and Manuscripts.* London, 1989.

***New Grove Dictionary* 2001**
Stanley Sadie, ed. *The New Grove Dictionary of Music and Musicians.* London, 2001.

**New Haven–Paris 1991–92**
Patrick Noon. *Richard Parkes Bonington: "On the Pleasure of Painting."* Exhib. cat., Yale Center for British Art, New Haven; Petit Palais, Paris. New Haven and London, 1991.

**New York 2004**
Helen C. Evans, ed. *Byzantium: Faith and Power (1261–1557).* Exhib. cat., Metropolitan Museum of Art, New York. New York, 2004.

**Nicolescu 1967**
Corina Nicolescu. *Argintăria laică şi religiosă in Ţările Romăne (sec. XIV–XIX).* Bucharest, 1967.

**Odorico 1998**
Paolo Odorico. *Le Codex B du monastère Saint-Jean-Prodrome Serrès, XVe–XIXe siècles.* Paris, 1998.

**Öney 1991**
Gönül Öney. "Çanakkale Ceramics." In Ara Altun, John Carswell, and Gönül Öney, *Sadberk Hanim Museum: Turkish Tiles and Ceramics.* Istanbul, 1991, 103–43.

**Ortalli 1998**
Gherardo Ortalli, ed. *Venezia e Creta: Atti del Convegno Internazionale di Studi, Iraklion-Chanià, 30 settembre–5 ottobre 1997.* Venice, 1998.

**Paine 1990**
Sheila Paine. *Embroidered Textiles: Traditional Patterns from Five Continents.* London, 1990.

**Panayotopoulos 2003**
Vassilis Panayotopoulos, ed. *Ιστορία του νέου ελληνισμού (1770–2000).* Vols. 1–3. Athens, 2003.

**Papademetriou 1999**
Eleni Papademetriou. *Cyprus Folk Art.* Nicosia, 1999.

**Papademetriou 2000**
Eleni Papademetriou. *Cypriot Ethnography Collections in British Museums.* Nicosia, 2000.

**Papadopoulos 1969**
Stelios A. Papadopoulos, ed. *Greek Handicraft.* Athens, 1969.

**Papadopoulos 1982**
Stelios A. Papadopoulos. *Η χαλκοτεχνία στον ελληνικό χώρο.* 2 vols. Nafplion, 1982.

**Papadopoulos 1998**
Stelios A. Papadopoulos, ed. *Icons of the Holy Monastery of Pantokrator*. Mount Athos, 1998.

**Papamanoli 1986**
Loula Papamanoli. *Το παραδοσιακό κόσμημα στα Δωδεκάνησα*. Athens, 1986 (with English summary).

**Papantoniou 1978**
Ioanna Papantoniou. "A First Attempt at an Introduction to Greek Traditional Costume (Women's)." *Ethnographica* 1 (1978): 5–92.

**Papantoniou 1989**
Ioanna Papantoniou, ed. *Αφιέρωμα στην ενδυματολογία*. *Ethnographica* 7. Nafplion, 1989.

**Papantoniou 1996**
Ioanna Papantoniou. *Greek Regional Costumes*. Nafplion, 1996.

**Papantoniou 2000**
Ioanna Papantoniou. *Greek Dress from Ancient Times to the Early Twentieth Century*. Athens, 2000.

**Papantoniou, Kanellopoulos 1999**
Ioanna Papantoniou and Kanellos Kanellopoulos. *Twenty-five Years: Peloponnesian Folklore Foundation*. Athens, 1999.

**Papastratos 1990**
Dory Papastratos. *Paper Icons: Greek Orthodox Religious Engravings, 1665–1899*. 2 vols. Athens, 1990.

**Paris 2001**
Ariane James-Sarazin and Jean-Yves Sarazin, eds. *Le lion, le lys, l'abeille: Français et Vénitiens en mers Adriatique et Ionienne, du grand siècle au grand empire (1669–1815)*. Exhib. cat., Centre Historique des Archives Nationales, Musée d'Histoire de France, Paris. Paris, 2001.

**Patterson-Ševčenko 1983**
Nancy Patterson-Ševčenko. *The Life of Saint Nicholas in Byzantine Art*. Turin, 1983.

**Patterson-Ševčenko 1999**
Nancy Patterson-Ševčenko. "The Vita Icon and the Painter as Hagiographer." *DOP* 53 (1999): 149–65.

**Philippides 1982–91**
Dimitris Philippides, ed. *Ελληνική παραδοσιακή αρχιτεκτονική*. 8 vols. Athens, 1982–91.

**Philippides 1999**
Dimitris Philippides. *Greek Design Decoration*. Athens, 1999.

**Philippides 2003**
Dimitris Philippides, ed. *Aegean Islands: Architecture*. Athens, 2003.

**Phillips 1996**
Claire Phillips. *Jewellery: From Antiquity to the Present*. London, 1996.

**Phocas 1975**
Spyros G. Phocas. *Οι Έλληνες εις την ποταμοπλοΐαν του Κάτω Δουνάβεως*. Thessaloniki, 1975.

**Polychroniadis 1980**
Helen Polychroniadis. *Benaki Museum: Greek Embroideries*. Athens, 1980.

**Pope-Hennessy, Christiansen 1980**
John Pope-Hennessy and Keith Christiansen. *Secular Painting in 15th-Century Tuscany: Birth Trays, Cassone Panels, and Portraits*. New York, 1980.

**Porfyriou 2004**
Heleni Porfyriou. "The Cartography of Crete in the First Half of the Seventeenth Century: A Collective Work of a Generation of Engineers." In George Tolias and Dimitris Loupis, eds., *Eastern Mediterranean Cartographies*. Tetradia Ergasias 25–26 (2004): 65–92.

*Révolution française 1989*
*La Révolution française et l'hellénisme modern: Actes du IIIe Colloque d'Histoire CNR/FNRS, Athènes, 14–17 octobre 1987*. Athens, 1989.

**Rhigas 2000–2002**
Rhigas Velestinlis. Άπαντα τα σωζόμενα. Edited by Paschalis M. Kitromilides. 5 vols. Athens, 2000–2002.

**Rigopoulos 1979**
Ioannis K. Rigopoulos. Ο αγιογράφος Θεόδωρος Πουλάκης και η φλαμανδική χαλκογραφία. Athens, 1979.

**Rizopoulou-Egoumenidou 1996**
Euphrosyne Rizopoulou-Egoumenidou. Η αστική ενδυμασία της Κύπρου κατά τον 18ο και 19ο αιώνα. Nicosia, 1996.

**Rizopoulou-Egoumenidou, Seretis 2000**
Euphrosyne Rizopoulou-Egoumenidou and Kylie Seretis. "Folk Art Stone Carvings in Traditional Houses in the Village of Mitsero." *Report of the Department of Antiquities, Cyprus* (2000): 407–31.

**Robertson 1978**
David Allan Robertson. *Sir Charles Lock Eastlake and the Victorian Art World*. Princeton, 1978.

**Rogers, Köseoğlu 1987**
J. Michael Rogers and Cengiz Köseoğlu. *The Topkapı Saray Museum: The Treasury*. London, 1987.

**Rokou 1994**
Vassiliki Rokou. Υφαντική οικιακή βιοτεχνία: Μέτσοβο, 18αι.–20αι. Athens, 1994.

**Rome 1986a**
Patrizia Ciambelli, ed. *L'ornamento prezioso: Una raccolta di oreficeria popolare italiana ai primi del secolo*. Exhib. cat., Museo Nazionale delle Arti e Tradizioni Popolari, Rome. Rome, 1986.

**Rome 1986b**
Caterina Spetsieri-Beschi and Enrica Lucarelli, eds. *Risorgimento greco e filellenismo italiano*. Exhib. cat., Palazzo Venezia, Rome. Rome, 1986.

**Rossi 1956**
Filippo Rossi. *Chefs d'oeuvre de l'orfèvrerie*. Milan, 1956.

**Sakellariou 1939**
Michael Sakellariou. Η Πελοπόννησος κατά την δευτέραν Τουρκοκρατίαν (1715–1821). Athens, 1939.

**Scarisbrick 1984**
Diane Scarisbrick. *Jewellery*. London, 1984.

**Schottmüller 1928**
Frida Schottmüller. *I mobili e l'abitazione del Rinascimento in Italia*. Stuttgart, 1928.

**Semoglou 1999**
Athanassios Semoglou. *Le décor mural de la chapelle athonite de Saint-Nicolas (1560): Application d'un nouveau langage pictural par le peintre thébain Frangos Catellanos*. Paris, 1999.

**Sfyroeras 1960**
Vassilis Sfyroeras. Τα ελληνικά πληρώματα του τουρκικού στόλου. Athens, 1960.

**Sifakis 1998**
Grigoris M. Sifakis. Για μια ποιητική του ελληνικού δημοτικού τραγουδιού. Herakleion, 1998.

**Sinos 1976**
Stefanos Sinos. Αναδρομή στη λαϊκή αρχιτεκτονική της Κύπρου. Athens, 1976.

**Skopelitis 1977**
Stelios V. Skopelitis. Αρχοντικά της Λέσβου: Τοιχογραφίες. Athens, 1977.

**Somers Cocks, Truman 1995**
Anna Somers Cocks and Charles Truman. *Renaissance Jewels, Gold Boxes and Objets de Vertu: The Thyssen-Bornemisza Collection*. London, 1995.

**Spetsieri-Beschi 2002**
Caterina Spetsieri-Beschi. "La Morte di Marcos Botzaris di Filippo Marsigli, un quadro del filellenismo napoletano." In *Napoli nobilissima: Rivista di arti filologia e storia* 5 (2002): 199–214.

**Stasinopoulou 1992**
Maria A. Stasinopoulou. *Weltgeschichte im Denken eines griechischen Aufklärers: Konstantinos Michail Koumas als Historiograph.* Frankfurt-am-Main, 1992.

**Stathaki-Koumari 1987**
Rodoula Stathaki-Koumari. *Τα υφαντά της Κρήτης: Διακόσμηση και σύμβολα.* Athens, 1987.

**Stavrianos 1957**
Leften Stavros Stavrianos. "Antecedents to the Balkan Revolutions of the Nineteenth Century." *Journal of Modern History* 29 (1957): 335–48.

**Stavropoulou-Makri 1989**
Angheliki Stavropoulou-Makri. *Les peintures murales de l'église de la Transfiguration à Veltsista (1568) en Epire et l'atelier des peintres Kondaris.* Ioannina, 1989.

**Sugar 1977**
Peter F. Sugar. *Southeastern Europe under Ottoman Rule, 1354–1804.* Seattle and London, 1977.

**Svoronos 1956**
Nicolas Svoronos. *Le commerce de Salonique au XVIIIe siècle.* Paris, 1956.

**Svoronos 1972**
Nicolas Svoronos. *Histoire de la Grèce moderne.* Paris, 1972.

**Svoronos 1982**
Nicos G. Svoronos. *Ανάλεκτα νεοελληνικής ιστορίας και ιστοριογραφίας.* Athens, 1982.

**Svoronos 2004**
Nicos G. Svoronos. *Το ελληνικό έθνος: Γένεση και διαμόρφωση του νέου ελληνισμού.* Athens, 2004.

**Sydney–Melbourne 2005–6**
Electra Georgoula, ed. *Greek Treasures from the Benaki Museum in Athens.* Exhib. cat., Powerhouse Museum, Sydney; Immigration Museum, Melbourne. Sydney, 2005.

**Synodinou 2001**
Kate Synodinou. "Κοσμήματα της Σίφνου κατά τους νεότερους χρόνους (17ος–19ος αι.)." In *Proceedings of the First International Sifnean Symposium, Sifnos, 25–28 June 1998.* Athens, 2001, vol. 3, 341–58.

**Taylor 1998**
Roderick Taylor. *Embroidery of the Greek Islands and Epirus.* New York and London, 1998.

**Therianos 1889**
Dionysios Therianos. *Αδαμάντιος Κοραής.* Trieste, 1889.

**Thessaloniki 1997a**
Fani-Maria Tsigakou. *Edward Lear's Greece from the Gennadeion Collections.* Exhib. cat., Cultural Center of Thessaloniki–National Bank Cultural Foundation, Thessaloniki. Athens, 1997.

**Thessaloniki 1997b**
Athanasios A. Karakatsanis, ed. *Treasures of Mount Athos.* Exhib. cat., Museum of Byzantine Civilization, Thessaloniki. Thessaloniki, 1997.

**Thessaloniki 1997–98**
Evangelia Kypraiou, ed. *Greek Jewellery: Six Thousand Years of Tradition.* Exhib. cat., Villa Bianca, Thessaloniki. Athens, 1997.

**Thornton 1983**
Lynne Thornton. *Les Orientalistes: Peintres voyageurs, 1828–1908.* Paris, 1983.

**Tolias 1999**
George Tolias. *The Greek Portolan Charts, Fifteenth–Seventeenth Centuries: A Contribution to the Mediterranean Cartography of the Modern Period.* Athens, 1999.

**Tolias 2002**
George Tolias. "Erudite Pleasures: Two Portable Painted Maps in Greek Collections." *Mouseio Benaki* 2 (2002): 89–109.

**Tourta 1991**
Anastasia Tourta. *Οι ναοί του Αγίου Νικολάου στη Βίτσα και του Αγίου Μηνά στο Μονοδένδρι*. Athens, 1991.

**Trapani 1989**
Maria Concetta Di Natale, ed. *Ori e argenti di Sicilia dal Quattrocento al Settecento*. Exhib. cat., Museo Regionale Pepoli, Trapani. Milan, 1989.

**Travlos, Kokkou 1980**
Ioannis Travlos and Angeliki Kokkou. *Hermoupolis*. Athens, 1980.

**Triantafyllidou-Baladié 1988**
Yolanda Triantafyllidou-Baladié. *Το εμπόριο και η οικονομία της Κρήτης από τις αρχές της οθωμανικής κυριαρχίας ως το τέλος του 18ου αιώνα*. Herakleion, 1988.

**Tsigakou 1981**
Fani-Maria Tsigakou. *The Rediscovery of Greece: Travellers and Painters of the Romantic Era*. London, 1981.

**Vacalopoulos 1961–80**
Apostolos Vacalopoulos. *Ιστορία του νέου ελληνισμού*. Thessaloniki, 1961–80, vols. 1–5.

**Vassilaki 1997**
Maria Vassilaki. "Από τον 'ανώνυμο' βυζαντινό καλλιτέχνη στον 'επώνυμο' κρητικό ζωγράφο του 15ου αιώνα." In Maria Vassilaki, ed., *Το πορτραίτο του καλλιτέχνη στο Βυζάντιο*. Herakleion, 1997, 161–209.

**Vassilaki-Mavrakaki 1981**
Maria Vassilaki-Mavrakaki. "Ο ζωγράφος Άγγελος Ακοτάντος: Το έργο και η διαθήκη του (1436)." *Thesaurismata* 18 (1981): 290–98.

**Vassilatos 1989**
Nick Vassilatos. *Όπλα 1790–1860: Μνημεία ελληνικής ιστορίας και τέχνης*. Athens, 1989 (English abstract).

**Vei-Chatzidaki 1953**
Eugenia Vei-Chatzidaki. *Εκκλησιαστικά κεντήματα*. Athens, 1953.

**Veloudes 2000**
George Veloudes. *Κριτικά στο Σολωμό. Κριτικά—Φιλολογικά—Ερμηνευτικά*. Athens, 2000.

**Venice 1986**
Maddalena Redolfi, ed. *Venezia e la difesa del Levante: Da Lepanto a Candia, 1570–1670*. Exhib. cat., Palazzo Ducale, Venice. Venice, 1986.

**Vlachopoulou-Karabina 1998**
Eleni Vlachopoulou-Karabina. *Χρυσοκέντητα άμφια και πέπλα: Ιερά Μονή Ιβήρων*. Mount Athos, 1998.

**Vocotopoulos 1990**
Panagiotes L. Vocotopoulos. *Εικόνες της Κέρκυρας*. Athens, 1990.

**Vocotopoulos 2005**
Panagiotes L. Vocotopoulos. "Η εικόνα του Νικόλαου Ρίτζου στο Σεράγιεβο: Εικονογραφικές παρατηρήσεις." *DChAE* 26 (2005): 207–26.

**Vroom 2003**
Joanita Vroom. *After Antiquity: Ceramics and Society in the Aegean from the Seventh to the Twentieth Century A.C. A Case Study from Boeotia, Central Greece*. Leiden, 2003.

**Wace 1935**
Alan J. B. Wace. *Mediterranean and Near Eastern Embroideries*. 2 vols. London, 1935.

**Wace 1957**
Alan J. B. Wace. "Broderies grecques des XVIe, XVIIe, XVIIIe siècles." In *Collection Hélène Stathatos: Les objets byzantins et post-byzantins*. Limoges, 1957, 91–107.

**Wanscher 1968**
Ole Wanscher. *The Art of Furniture: Five Thousand Years of Furniture and Interiors*. London, 1968.

**Washington, D.C., 1983**
James Trilling, ed. *Aegean Crossroads: Greek Island Embroideries in the Textile Museum*. Exhib. cat., Textile Museum, Washington, D.C. Washington, D.C., 1983.

**Washington, D.C., 1991**
Fani-Maria Tsigakou. *Through Romantic Eyes: European Images of Nineteenth-Century Greece from the Benaki Museum, Athens*. Exhib. cat., Meridian House International, Washington, D.C.; Frick Art and Historical Center, Pittsburgh; Society of the Four Arts, Palm Beach; Knoxville Museum of Art; Dixon Gallery and Gardens, Memphis. Alexandria, Va., 1991.

**Watts 1988**
Niki Watts. *The Greek Folk Songs*. Bristol, 1988.

**Welch 1997**
Evelyn Welch. *Art and Society in Italy, 1350–1500*. Oxford and New York, 1997.

**Welters 1986**
Linda Welters. *Women's Traditional Costume in Attica–Greece*. Nafplion, 1986.

**Woodhouse 1995**
Christopher M. Woodhouse. *Rhigas Velestinlis: The Protomartyr of the Greek Revolution*. Limni Evias, 1995.

**Xydis 1995**
Alexandros G. Xydis. "El Greco's Iconographical Sources." In Nicos Hadjinicolaou, ed., *El Greco of Crete. Proceedings of the International Symposium on the Occasion of the 450th Anniversary of the Artist's Birth, Iraklion, 1–5 September 1990*. Herakleion 1995, 141–59.

**Xyngopoulos 1936**
Andreas Xyngopoulos. *Μουσείον Μπενάκη: Κατάλογος των εικόνων*. Athens, 1936.

**Zachariadou 1996**
Elizabeth A. Zachariadou. *Δέκα τουρκικά έγγραφα για την Μεγάλη Εκκλησία (1483–1567)*. Athens, 1996.

**Zervopoulos 2003**
Kostas Zervopoulos. "Οι μελοποιήσεις του σολωμικού Ύμνου εις την Ελευθερίαν από το Νικόλαο Χαλικιόπουλο Μάντζαρο." In Haris Xanthoudakis and Kostas Kardamis, eds., *Νικόλαος Χαλικιόπουλος Μάντζαρος: Ερευνητική συμβολή στα 130 χρόνια από το θάνατο του συνθέτη*. Corfu 2003, 59–100.

**Zora 1960**
Popi Zora. "Η Γοργόνα εις την ελληνικήν λαϊκήν τέχνην." *Παρνασσός* 2 (1960): 331–65.

**Zora 1966**
Popi Zora. "Συμβολή στη μελέτη της ελληνικής λαϊκής γλυπτικής." *Ζυγός* 5 (1966): 35–56.

**Zora 1981**
Popi Zora. *Embroideries and Jewellery of Greek National Costumes*. Athens, 1981.

**Zora 1990–92**
Popi Zora. "Συμβολική και σημειωτική προσέγγιση της ελληνικής λαϊκής τέχνης." *Λαογραφία* 36 (1990–92): 1–77.

**Zora 1994**
Popi Zora. *Ελληνική τέχνη: Λαϊκή τέχνη*. Athens, 1994.

# PHOTOGRAPHY CREDITS

**Archaeological Receipts Fund, Hellenic Ministry of Culture**
ill. p. 137 (fig. 8)

**Byzantine and Christian Museum, Athens:**
ill. p. 44 (fig. 1)

**Spyros Delivorrias:**
ill. p. 138 (fig. 12)

**Constantinos Manolis:**
cat. nos. 15, 17–18, 35, 62, 65–66, 73–77, 80, 82, 85, 89, 91–94, 107, 111, 114–16, 129, 131–32;
ill. pp. 30–31 (figs. 1–2), 106–7 (figs. 1–2)

**Costas Manolis:**
cat. nos. 1–2, 4–6, 34, 37–38, 40, 43–48, 53–54, 57–59, 70, 79, 84, 102, 117–21; ill. pp. 138–40
(figs. 11, 15, 17–18), 206 (fig. 1)

**Photographic Archives, "Melissa" Publications:**
ill. pp. 135–36 (figs. 3–6), with the permission of the 7th Ephorate of Byzantine Antiquities, Hellenic
Ministry of Culture, the Municipality of Siatista, the Society of Cretan Historical Studies, and the
14th Ephorate of Byzantine Antiquities, Hellenic Ministry of Culture

**Photographs from Publications:**
ill. p. 44 (fig. 2), from : *Ιερά Μονή Αγίου Διονυσίου: Οι Τοιχογραφίες του Καθολικού* (Mount Athos, 2003);
ill. p. 207 (fig. 2), from Konstantinos S. Staikos and Triantaphyllos E. Sklavenitis, *The Publishing
Centres of the Greeks from the Renaissance to the Neohellenic Enlightenment* (Athens, 2001)

**Makis Skiadaressis:**
cat. nos. 3, 7–14, 16, 19–33, 36, 39, 41–42, 49–52, 55–56, 60–61, 63–64, 67–69, 71–72, 78, 81, 83,
86–88, 90, 95–101, 103–6, 108–10, 112–13, 122–28, 130, 133–37; ill. pp. 134 (figs. 1–2), 136–38
(figs. 7, 9–10, 13), 140–43 (figs. 16, 20, 22–23)

**Nicos Smyrnakis:**
ill. p. 139 (fig. 14), with the permission of the 4th Ephorate of Byzantine Antiquities, Hellenic
Ministry of Culture